Drawing on Life

the autobiography of Paul Hogarth

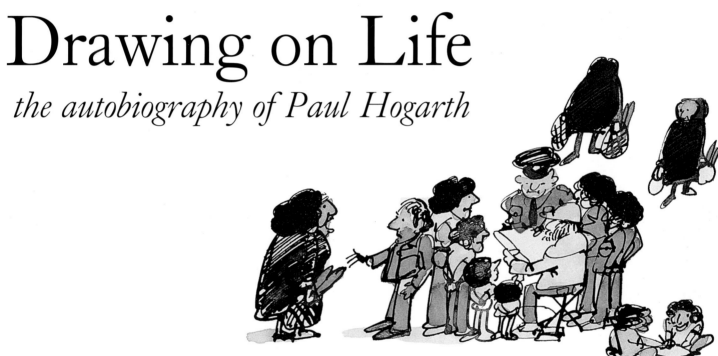

Drawing on Life

the autobiography of Paul Hogarth

introduction by Richard Ingrams

Royal Academy of Arts

Acknowledgements

'Yore life…, it's like a bewk, you should write it all down one day!'
THE ARTIST'S MOTHER, CIRCA 1970

First published in the UK by David & Charles in 1997
New, revised edition published by the Royal Academy of Arts, London, 2002

Text copyright © Diana Hogarth 2002
Illustrations copyright © Diana Hogarth 2002 unless otherwise credited

Paul Hogarth has asserted his right to be identified as author of this work in accordance with the Copyright, Designs and Patents Act, 1988.

British Library Cataloguing-in-Publication Data
A catalogue record for this book is available from the British Library

ISBN 0-8109-6642-5 (paperback)
Distributed in the United States and Canada by Harry N. Abrams, Inc., New York
ISBN 1-903973-06-6 (paperback)
Distributed outside the United States and Canada by Thames & Hudson Ltd, London

Book design by Michael Whitehead

Printed in Singapore by C. S. Graphics Pte Ltd

Royal Academy of Arts
Burlington House
Piccadilly
London W1J 0BD

FRONTISPIECE: *Paul Hogarth*
Courtesy: Peter Wedgewood

Opposite: STREET CHARACTER, CAIRO (1987)
Sketchbook study in pencil and watercolour. 9x7in (23x18cm)
Collection: the artist

I AM ESPECIALLY grateful to Philip Hodgkinson of the Simons Group for making this new edition possible, and to Richard Ingrams for his incisive introduction. Many of the watercolours and drawings are in my possession, but many more are in private collections, museums and libraries. I am, therefore, most grateful to those collectors for allowing their works to be published, while acknowledging those who prefer to remain anonymous.

I would also like to express my gratitude to my dear wife Diana, and good friends Robin Rook and Mark Robson, for their advice and encouragement; and to my son Toby for permission to include his photographs.

I would like to thank the curators, editors and librarians of the following institutions for allowing me to include works in their collections: the British Museum; Penguin Art Collection, London; Royal College of Art Collection; University of Victoria, British Columbia; Strathmore Artists Products, East Granby, Connecticut; Riveredge Foundation, Calgary, Canada; National Geographic Society, Washington DC; Boston Public Library; Imperial War Museum, London: Library of Congress, Washington DC; Victoria & Albert Museum; and Dudley Dodd, Director of the the Foundation for Art, National Trust, London. I also have to thank Antonio Silva of the Portuguese Trade and Tourist Office, London.

I wish to convey my appreciation to the estates of the late Robert Graves and the late Graham Greene for their courtesy in permitting me to quote from various letters written by these authors to myself. Howard Gerwing, Librarian of Special Collections, University of Victoria, British Columbia, kindly provided photocopies of Robert Graves's letters (to me).

I have also drawn on my own published writings and therefore make grateful acknowledgement to the following publishers: Lawrence & Wishart (Defiant People and Looking at China); the Hutchinson Group (Brendan Behan's Island and Brendan Behan's New York); Pavilion-Michael Joseph (Graham Greene Country and The Mediterranean Shore); Hamish Hamilton (The Illustrated A Year in Provence); John Murray (In Praise of Churches); and Richard Ingrams, editor of The Oldie, for various articles and cartoons published in his unique periodical.

Contents

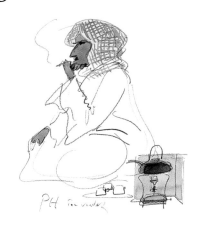

Introduction

THE RUINS OF DRESDEN (1955)
Conté 20x15½in (50.7x39.4cm)
Private collection.
The buildings are drawn against the afternoon sun for
dramatic effect. The detail in the right foreground was
drawn with conté leads 1 and 2.

I FIRST BECAME aware of Paul Hogarth's work when *Brendan Behan's Island* was published in 1962. This book, now a classic, combined the rambling reflections of the great Irish playwright and raconteur with Hogarth's altogether more precise, not to say delicate, pencil drawings of Ireland's scenery, buildings and people. It seemed to me, and still does, a wonderful combination.

Since then Hogarth has worked with a number of authors: Graham Greene, Robert Graves, Lawrence Durrell, Malcolm Muggeridge and, most recently, the late D. H. Lawrence and the late Sir John Betjeman. Graves apart, the others were notable travellers with whom Hogarth, a traveller himself (as readers of this book will learn) plainly feels an affinity. In each case he was able to complement their writing with his artistic eye.

Readers of this fascinating book will discover that Paul Hogarth began his career more as a reporter than an illustrator, and a very committed reporter at that. As his friend and associate Ronald Searle tells me: 'At the outset, in the tradition of his namesake, Paul was the original Angry Young Man. All aggressiveness and pure crusader-earnestness in his graphic battle against the "wrong 'uns"! Once the enemy became a bag of feathers, Paul was somewhat disarmed. But since then his work has never been less than interesting and in the best sense delightful. The political animal was transformed into the sort of freelancing beast that we hired scribblers, scratchers, splashers and blotters have been transformed into since politics lost its teeth and the world became no longer a black and white situation.'

Black and white applies as well to the art as to the politics. For whereas the early Hogarth uses his pen or pencil, the later Hogarth is in exuberant colour, revelling in lush landscapes and exotic locations. 'Even when he is all charm,' says Searle, 'trying to make Peter Mayle, for example, presentable, he is never less than thoroughly enjoyable and above all, professional.'

Inimitable is a word much bandied about by journalists like myself, yet in the case of Paul Hogarth it is the *mot juste*. A Hogarth is immediately recognisable as such. It could not be the work of anyone else – there is colour, there is humour

and there is that bold but deliberate brushwork that all combine to mark it out as original. Working in watercolours, as he does now, makes his task all the more difficult. You have to get it right first time. It is the artistic equivalent of doing television or radio live.

When I started *The Oldie* magazine in 1992 many people concluded, perhaps rightly, that I had finally gone mad. After twenty-five years or so at *Private Eye* there were times when even I began to think it was an act of folly. Still, there were a great many compensations. Having always been interested in artists, illustrators and cartoonists (generally speaking, the nicest of men), it was a particular pleasure to be able to use colour after a lifetime spent in black and white. Equally gratifying was the way in which writers and artists responded to the launch. There was very little need for me to commission work. It just seemed to arrive spontaneously, courtesy of the Royal Mail. And there were certain features like 'I Once Met', in which someone described a chance encounter with a famous person, which were specially provided to tempt the would-be freelance contributor.

Reluctant as I was to commission work from my favourites (given the meagre nature of the fees on offer) I had few more pleasant surprises than the arrival one day in the office of 'I Once Met Paul Getty' by Paul Hogarth, complete with colour drawing of the millionaire recluse and patron of the arts. It was to be the first of many contributions to the magazine, taking the form of cartoons, topographical drawings, sketches from Croatia, a feature on the new Hogarth pied-à-terre Hidcote, not to mention a number of spectacularly colourful covers. Paul, as I can now refer to him, seemed ready to turn his hand to anything. Thus when an account of Rebecca West's expedition to Mexico arrived (again unsolicited) on my desk, Paul was the ideal man to illustrate it, as he had not only travelled in Mexico but had met and drawn Rebecca West.

In volunteering for *The Oldie* Paul was not alone among veteran artists and illustrators. There were a few gallant survivors from the Muggeridge *Punch*, the eighty-year-old John O'Connor was providing a monthly wood engraving to ornament the 'Unwrecked England' feature and we were later to attract Patrick Reyntiens, famous for his stained glass windows (many of them made in collaboration with John Piper), a mere stripling of seventy. John Ward, an R.A. like Paul Hogarth, turned out to be a fan of the magazine. All these artists were not only active but were doing work every bit as good, if not better than anything they had done in the past. Yet, it seemed to me that the artistic establishment (as opposed to the art-buying public) had turned its back on them. Was it that they

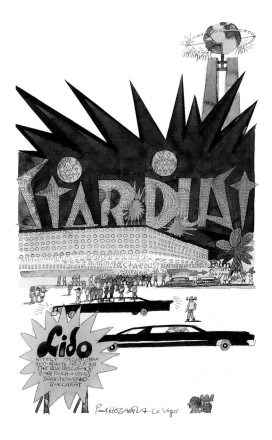

LAS VEGAS (1978)
Ink, pencil and watercolour. 20x12in (51x30.5cm)
Private collection, UK.
In America, vernacular architecture is usually inspired by what is locally exploitable. Not in Las Vegas, however, where nothing less than eye-smashing versions of the places of legendary kings and emperors are permitted.

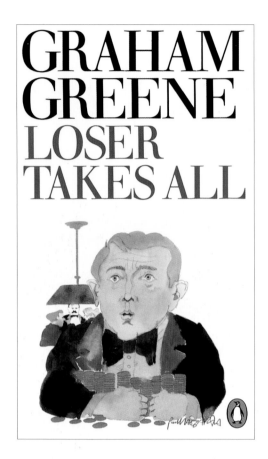

were old and therefore considered to be 'past it' in an age when youth was the be-all and end-all, or was it that critics, used to paying homage to the experimental, the avant-garde and the ridiculous, felt embarrassed in the presence of old-fashioned draughtsmanship?

Whatever the truths of these matters, I doubt if Paul Hogarth will be too bothered one way or the other. Throughout his career he has shown an admirable disdain for the passing fads and fashions that come and go in the world of art. It has been especially interesting for me, as it will be, I am sure, for his other admirers, to learn something here of the man behind the pictures. Paul, we read, is an artist who has had to fight his way up from humble beginnings and in the face of parental opposition. I imagine this has imparted a certain toughness and indifference to critical brickbats. It is also instructive to learn of his radical youth, of which I knew nothing, his involvement with the Communist Party and his association with figures like Joan Littlewood with whom I myself was privileged to work in the Sixties.

'He is among the top artist-reporters of the last hundred years or so,' says Searle. 'Always backed with concern, awareness, plenty of experience in on-the-spot rough and tumble. Above all, he, like his work, is transparently honest. Oh, and never boring.' As well as being an artist-reporter, Hogarth is one of the great illustrators and one of the things which emerges strongly from this book is his enthusiasm and respect for the writers with whom he has worked. The mark of a great illustrator is a certain humility, the mark of a bad one the unresisted urge to assert himself at the expense of the writing. What made Paul such a perfect foil to Graham Greene (for example) was his admiration for a great writer, and it is very pleasing to learn that this admiration was mutual and that Greene bought a number of Hogarth paintings.

What a pity that John Betjeman was not alive to appreciate Paul's recent illustrations for *In Praise of Churches* (published by John Murray in 1996). Betjeman, I am sure, would have relished the humour of the drawing combined as it is with a great affection for architectural detail. Lured into his Maddox Street gallery by that most persistent of salesmen Mr Francis Kyle, I was persuaded to bring out my cheque book and buy two of the originals which have now joined the magnificent picture of Byron Villas Hampstead (from the D. H. Lawrence series) on my walls. In this way I can be reminded every day of that great oldie, now my friend, Paul Hogarth.

CHAPTER ONE
Growing Pains

FOR THOSE OF MY GENERATION WHO CAME FROM THE VILLAGES, COUNTRY TOWNS AND PROVINCIAL CITIES OF BRITAIN, THE ARTS WERE THE CASTLE ON THE HILL. MY SCHOOLFRIENDS DISAPPEARED INTO THE MAW OF OFFICE AND FACTORY, UNABLE TO DECIDE WHAT THEY REALLY WANTED TO DO IN LIFE . THROUGH A COMBINATION OF LUCK AND NOT A LITTLE PERSEVERANCE, I AVOIDED THAT FATE.

PERHAPS SUCH qualities are genetic. My forebears were persevering enough, if not always lucky. Little is known about them beyond the fact that many generations of Hoggarths raised sheep and cattle throughout Westmorland after Henry VIII's dissolution of Shap Abbey in 1540. One of the consequences was the seizure of the monastic lands of the Augustinian canons of Shap by the local nobility, who leased the less desirable portions of that wild and hilly country to the peasantry, among whom were the Hoggarths.

The family name has undergone many changes. Hoggard, or Hogard, was the original version, derived from Hogherd, Old Norse for hog-keeper or swineherd. It was subsequently altered to Hoggarth by changing the Norse *d* into the Saxon *th*. The antecedents of the eighteenth-century painter, William Hogarth, sprang from the same roots, the Hoggarths or Hoggarts of Kirby Thore, descendants of Norsemen who raided the Cumbrian coast from Ireland and settled in the Lake District towards the end of the ninth century. William Hogarth's father, Richard, the youngest of three brothers, moved to London in the late 1680s, leaving his older brothers to farm in Bampton and Troutbeck. More than likely, my own father's family had descended from one of these branches. When in London, Richard had dropped a 'g' from his name. I liked the idea that I might be a collateral descendant of the great William and followed suit.

The Hoggarth family tree shows that my grandfather, Edward Hoggarth (1838–1923), rented his 97-acre farm, 'Davybank', at Lowgill near Firbank, from Lord Henry Bentinck of Underley Hall, Kirby Lonsdale. On this farm, my

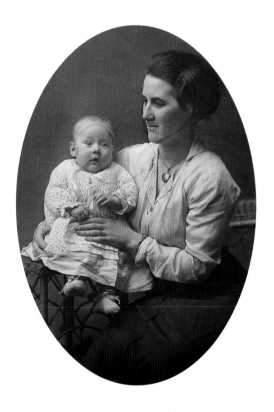

IN MY MOTHER'S ARMS (1917)

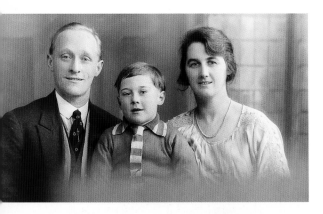

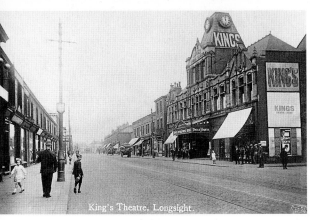

Top: WITH MY PARENTS (1924)

Above: KING'S THEATRE, STOCKPORT ROAD, MANCHESTER
Courtesy: Central Library, Manchester.
Opened in 1905 as the King's Opera House, the King's Theatre later offered entertainment of a more macabre nature calculated to make audiences shriek with horror. During a performance of Sweeney Todd, the Demon Barber *I had to be taken home by my equally terrified mother.*

grandmother, Emma Swinbank, gave birth to 13 children. The youngest, Arthur Hoggarth (1890–1966), was my father. In 1910, he turned his back on farming and emigrated to Western Ontario.

He returned to Kendal in 1913, hoping to find a wife to take back to Canada. He did find someone, but her father forbade her to marry before she was 21. So my father stayed, and in January 1916 married Janet Bownass (1894–1991), second daughter of James Bownass of Staveley, a surgical shoemaker, and Elizabeth Willan Bownass, daughter of a Kendal policeman. That same year, my father was conscripted into the army, in which he served as a despatch-rider in the Royal Engineers. I, their only child, was born at 28 Caroline Street, Kendal, on 4 October 1917.

When I was a child, vendors in Kendal peddled hot muffins in wooden trays balanced on their heads, ringing handbells to announce their wares. On Saturdays, freshly caught fish was brought to Finkle Street Fish Market in horse-drawn carts from Morecambe and Flookburgh. The market hall, built to commemorate Queen Victoria's Jubilee in 1887, bustled with farmers' wives and daughters selling butter, cheese and vegetables amid raucous cries and sing-song chatter. Children wore clogs, and there was a pervasive odour of horse manure and leather.

My father had planned to take us back to Canada, but the heavy losses suffered by Allied shipping during World War I had created a severe shortage of passenger space. After waiting for several months, he decided instead to move the family to Manchester, where he opened a sweetshop in the affluent suburb of Prestwich. Two years later, in 1923, we moved to the rapidly growing suburb of Longsight in south Manchester, where my father opened a butcher's shop.

I began my education at St Agnes Church of England Primary School in Clitheroe Road. Here, we recited arithmetic tables and rules of grammar. It was boring, but effective for reaching higher peaks of knowledge.

While my parents worked in the shop, I was left to entertain myself. Sitting at the kitchen table, I illustrated my father's wartime adventures with a stubby carpenters' pencil on the white newsprint used to wrap meat. The corner sweetshop and newsagent also provided welcome relief from school as, succumbing to the spell cast by children's comics, I became a regular reader of *Chips*, and *Bullseye*, a somewhat sinister weekly printed on pale blue paper.

It was around this time, at the beginning of the era of the 'picture palace', that I saw my first film, Cecil B. de Mille's silent epic, *The Ten Commandments*, and I at once became a film fan. Cartoons also fascinated me, especially Felix the Cat,

who had the habit of breaking off his tail when things got difficult and sending it on adventures of its own. Later, westerns became firm favourites. My mother preferred music hall, usually at the Ardwick Empire and the Gaiety Theatre, Market Street; while melodrama was my father's passion. We seldom missed a Saturday-night performance of *Sweeney Todd: the Demon Barber*, *Dracula* or some other classic at the King's Theatre on nearby Stockport Road.

In the autumn of 1927, I commenced senior school at St Agnes. School reports praised my studies in drawing, geography, English and history, but not algebra, chemistry or geometry. I was good at drawing maps and writing essays, and I especially enjoyed the Friday afternoon readings from Dickens's *David Copperfield* and Robert Louis Stevenson's *Treasure Island* given by Miss Coe. A second phase of interest in periodicals began with this increase in literacy. I became a regular reader of the *Gem*, the *Magnet* and the *Penny Popular*.

In the late 1920s dirt-track racing on motorcycles became a craze. My father, a fanatical motorcyclist, dragged my mother and me to Belle Vue every Saturday, where we watched bikes careering around the black cinder track. For a while, speedway racing replaced the Boer War, World War I and the British Empire as a subject for my newsprint chronicles.

By 1930 I had become restless with parental companionship and the never-ending round of weekend car excursions to Blackpool, Bardsea Island, Froggat Edge, Kimnel Bay, Leeds, Robin Hood's Bay, Southport, Scarborough, York and Whitby. On an impulse, I joined the local Boy Scouts after learning that they went to Belgium and France during the summer holidays.

On holiday at Kimnel Bay, North Wales (1928)

Rusholme St Agnes School, Longsight, Manchester (1930)
Aged 13, I am seated in the centre row, third from the left. St Agnes, which opened in 1885, offered a sound, if basic, education. The headmaster, Mr Jones (middle row, right) was a strict but kindly Welshman, assisted by a comforting pair of female teachers, the Misses Coe and Jones, who taught English and History. Mr Geary (centre, back row) was the most influential teacher, urging me to take up art.

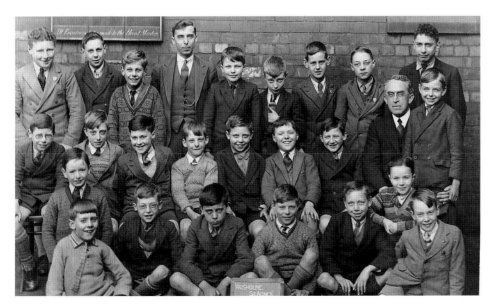

I even became dissatisfied with my newsprint drawings. I gazed at newspaper advertisements for Percy Bradshaw's Press Art School Course. 'You, too, can learn to draw and earn £££££££s' went the caption under a fluently executed brush drawing of a genial pipe-puffing, bearded artist with beret and floppy tie. 'Copy this drawing and send it to me for FREE criticism.' I complied and received an encouraging letter, together with a request for £5, a sizeable sum in those days. My parents, however, would not hear of my becoming an artist, let alone provide money for the lessons.

I had, anyway, already begun to teach myself. During my Sunday walks I discovered the Charles Rutherston Collection of modern paintings and drawings housed from 1927 in Platt Hall, a Georgian mansion in nearby Platt Fields. The collection was especially rich in drawings and watercolours by Augustus John, Wyndham Lewis, William Orpen, John and Paul Nash, and the artists of the Camden Town Group – Charles Ginner, Harold Gilman and Spencer Gore. Shortly afterwards, I graduated to the City Art Gallery in Mosley Street, where I sometimes spent entire Sunday afternoons gazing at paintings such as *Work* by Ford Madox Brown, *Autumn Leaves* by John Everett Millais and *The Lady of Shalott* by William Holman Hunt.

Inevitably, my weekly visits to Platt Hall, the City Art Gallery, the Whitworth Art Gallery in Manchester and, occasionally, as far away as the Salford Art Gallery, heightened my ambition to be a professional artist. My mother admonished me, not without sympathy, 'You've got yore 'ead in the clouds!' How could I possibly hope to make a living in depression-troubled times? Any further education was equally out of the question, and my parents therefore decided to ask the local bank manager to take me on as an office boy. Obviously, I had to move fast if I were to escape such a fate. I went to Mr Geary, a sympathetic teacher at my old school, St Agnes, for advice. He told me about art classes at the nearby Ducie Avenue Evening Institute, and suggested that I submit a portfolio. I did so, and was admitted free of charge.

I was set to work drawing plants, cubes and pyramids, and did so with great determination, motivated by the thought of what would happen if I failed. My efforts aroused the interest of the female teacher, who urged me to try for a scholarship to the Manchester School of Art. I sat the entrance examination with great trepidation, and, to the astonishment of my parents, was awarded a full-time scholarship. I began the four-year course in September 1933.

BREAKING THE MOULD (1933–6)

Manchester School of Art occupied a blackened, Victorian Gothic building facing All Saints Parish Church behind Oxford Road. We drew plaster casts of Greek and Roman ornament, and studied the history of architectural style, composition and still life. The classes on the 'Prelim', or Foundation Course, were large and noisy, being mainly made up of students who had little interest in art or intention of applying themselves. For me, however, art school opened up the only way of furthering my education. To this end, and in order to relax after the discipline of a very academic approach to drawing the human figure, I turned to reading. New perspectives opened up. I already knew the work of A. J. Cronin, Warwick Deeping, Louis Golding and Somerset Maugham. Now I discovered the verse of John Donne, and Constance Garnett's translations of Chekhov, Dostoyevsky, Gogol and Tolstoy. I read Zola and D. H. Lawrence, especially *Sons and Lovers*, the saga of Paul Morel, a miner's son whose struggles to enter the world of art seemed so much like my own.

ART STUDENT (1934)
If I appear troubled, as indeed I was, it was caused by the conflicting demands of a strictly academic curriculum and my parent's insistence that I really should get 'a proper job', if not a haircut!

I let my hair grow long and sported a red poloneck sweater. Inevitably, my newly acquired student habits and appearance provoked parental ire. 'You'll go bloody mad,' hissed my mother, one wintry evening, 'if you go on reading so much!' She was an avid reader of romantic fiction herself, but classed the books that I read as 'deep'; read too many and they would drive me insane. My father, who seldom read anything but the *Daily Dispatch*, the *Manchester Evening News*, and at weekends the *News of the World*, felt completely at sea. Not that he didn't keep an eye on what I was reading. On one occasion, after we had had a furious argument about the influence of 'that bloody art school', he grabbed my library copy of *Crime and Punishment* and threw it on the fire, convinced that Dostoyevsky had to be a Bolshevik!

By the third year at art school, I was drawing from life as well as from plaster casts, and the study of anatomy, which involved dissection classes in the Waterhouse Gothic splendour of the University of Manchester's medical school in Oxford Road, helped me a great deal with drawing the human figure.

Few of my generation emerged from their student years unscathed by radical politics. There we were, impressionable students learning to draw and paint, when outside lay Manchester's poverty-stricken, working-class neighbourhoods of Moss Side and All Saints, whose back-to-back terraced housing made up some of the worst slums in Europe. At this time, I became

NIGHTMARE (CA 1935–6)
Ink drawing. 4x6in (10x15cm)
Collection: the artist.
An early art school illustration drawn as an exercise
in composition.

acquainted with an older circle of students. Some were Marxists, led by Ray Watkinson, writer and lecturer on Victorian art and design, and the Manchester-born Social-Realist painter, Ern Brooks. I was also drawn to a group of aesthetes, but their idealism was no match for the glamour of revolutionary activism.

My continuing interest in the cinema led me to join the Manchester Film Society, where I saw Pabst's *Kameradschaft* (1931) and Eisenstein's *The Battleship Potemkin*. Wanting to find out more about the events that inspired them, I visited Collets Bookshop. Known as the 'Deansgate Bomb Shop', it was the archetypal left-wing bookshop of the period. Soviet posters depicted Lenin gripping his lapels while exhorting unseen masses, and unsold piles of upbeat magazines invited inspection. *USSR in Construction* portrayed a Utopia in the making, where bronzed, cheerful men and women happily built vast industrial enterprises. I did not realise that they were models – or worse, political prisoners.

The New York weekly, *New Masses*, exposed a world of the oppressed and the underprivileged, as seen by American artists John Heliker, Herb Kruckman and William Gropper. George Grosz's savage album, *Ecce Homo*, impressed me even more. Among the British periodicals, I discovered *Left Review*, in which the trenchant imagery of the 'Three Jameses' – Boswell, Fitton and Holland – satirised the villainy and corruption of the establishment. On seeing the work of these artists, the idea took root in my mind that an artist could reach an audience through the media. Should I, too, use my pencil to help the poor and oppressed by exposing the selfish wickedness of the rich?

I took the first step along this perilous path when Ray Watkinson introduced me to the painter Barbara Niven, leader of the Manchester art world's fashionable radicals. Very much the liberated woman of the 1930s, she was motivated not so much by her art as by a powerful and subliminal urge to serve the revolution; she eventually abandoned her art and became a fundraiser for the *Daily Worker*. Intense green eyes looked through me as if to ascertain my commitment to the cause. With the benefit of hindsight, it would be difficult to say who was more naive, Barbara or myself.

Barbara had given up the privacy of her rambling, top-floor studio at 111 Grosvenor Street and turned it into the workshop of a circle of artists and students who became the Manchester group of the Artists International Association (AIA), an organisation founded in 1933 to oppose Fascism, war and much else. Like the London parent body, the Manchester group offered its services to the Left, and produced a stream of posters, banners and printed propaganda. I was taught the

agitprop skills of graphic design and put to work on a huge pictorial banner celebrating the anniversary of the so-called Peterloo massacre of 1819, when a meeting held in Manchester in support of parliamentary reform was broken up by soldiers, killing 11 people and wounding 500.

As my parents supported the Conservative Party, my political opinions became a source of friction. A parental ban on reading and working in my room – which led to the removal of the lock on the door – brought matters to a head, and I moved to Ward Hall, a pleasant vegetarian boarding-house in Victoria Park. My room, which looked out on a leafy old garden, was large enough to live and work in. I was happy there. But then the real world intervened.

In July 1936, following General Franco's revolt against the Republican Popular Front government in Spain, civil war broke out and Manchester became a hive of political activity. The Left's support for the Republican cause generated a spate of demonstrations, protest meetings and cultural events, in which Joan Littlewood's first repertory company, Theatre Union (established in Manchester in 1934), played a prominent part. Joan was the heart and soul of Theatre Union, together with the folksinger Ewan MacColl (then known as Jimmy Miller) and Gerry Raffles, a precocious sixth-former at Manchester Grammar School. Harold Lever (later Lord Lever) was business manager. Although Joan attracted talents as diverse as Avis Bunnage, Les Goldman, Howard Goorney and Rosalie Williams, she was always desperate for more actors and stage-hands, and any unqualified assistance she could train. I was recruited into the company along with other art students, all of us mesmerised by her salty vocabulary and her single-minded command of unnerving situations.

Life was frantic; by day I wrestled with my studies at art school, by night with agitprop meetings and wall-chalking sorties. Barbara Niven, now art director of Theatre Union, exhorted us to make even greater efforts, and when not painting flats, I was given walk-on parts in numerous productions of *Last Edition*, a living newspaper concerned with comment on current affairs. Three or four of us would march back and forth across a narrow opening at the back of the stage to simulate an endless procession of black-faced miners. Joan mimed the shambling gait of a miner, which we had to get absolutely right. Except for the occasional performance at Manchester's Free Trade Hall, venues were usually church halls, working-men's clubs and pub meeting-rooms, although several productions of *Last Edition* were staged in the market-places of mill towns such as Accrington, Burnley, Bury, Huddersfield, Halifax and Oldham.

LAPEL BADGE OF THE INTERNATIONAL BRIGADE

REPUBLICAN MILITIAMAN (1962)
7x6in (17.8x16.5cm)
Collection: the artist.
This jacket illustration for the Penguin edition of
George Orwell's Homage to Catalonia *is actually*
an idealised portrait of myself as a member of the
International Brigade.

THE SHADOWS OF WAR (1937–46)

The rise of Fascism in Germany, Spain and Italy during the mid-1930s raised the possibility that it could also happen in Britain. Sir Oswald Mosley's paramilitary British Union of Fascists, with its uniformed guards, bugle-calls and orchestrated public demonstrations, frightened every thoughtful person. Big rallies in support of Mosley took place at Manchester's Free Trade Hall or Belle Vue, and usually ended up in violence as hecklers were ejected, frogmarched away and beaten up by jack-booted Black Shirts.

Because of my political activities I had neglected my studies and in the autumn of 1936, at the beginning of my final year, I gave up art school completely. Spain's future seemed much more important than my own. That winter, I heard Harry Pollitt (General Secretary of the British Communist Party) give an impassioned plea on behalf of the Republican cause, at an Arms for Spain rally in the Free Trade Hall, and I joined the International Brigade. A group of us travelled to London, where we were interviewed by Bill Robson, a Comintern-trained bureaucrat in the Communist Party's King Street headquarters. He told us not to expect adventure. We would be short of food, medical supplies, and even arms and ammunition. We were not given a medical examination, nor asked our ages. None of us was much older than 18. We then left for Spain via Paris.

After a traumatic eleven-hour slog over the Pyrenees, we arrived at an ancient farmstead over which flapped a ragged Republican flag. Gaunt frontier guards gave us a half-hearted cheer. We were given jaw-breaking lumps of bread dipped in olive oil and taken by truck to the huge old Napoleonic fortress of San Fernando above Figueras. Here, our youthful idealism underwent its first test, as the absence of the most elementary facilities – and habits – brought lice and disease.

We spent two weeks guarding convoys of food trucks from France with useless old rifles, and then travelled to Madrigueras, the base of the British Battalion of the International Brigade. Here, we were kitted out in a variety of old uniforms and given a rough and ready training course, reminiscent of *Dads' Army* (the television sitcom of the British Home Guard during World War II).

I was not, however, destined to remain on Spanish soil for long. The heavy casualties which were sustained by the British Battalion at Jarama in the Madrid–Toledo sector in February 1937, and at Brunete and Belchite in July and August, brought a flood of protests from anguished parents – although not from mine, who didn't know where I was. The Communist Party panicked, and a group

of youthful and under-age volunteers were repatriated – myself among them.

Back in London, I picked up the threads of being an art student with renewed zeal. To support myself, I hitchhiked across the south of England doing odd jobs on farms. I sold newspapers outside the Dominion Theatre in London on Saturdays. Occasionally, I worked as a kitchen porter at various Lyons Corner Houses in the City and West End. At the same time, I attended life-drawing classes at St Martin's School of Art. It was a lonely and daunting route to becoming an artist, and, wanting an objective assessment of my progress, I decided to assemble a portfolio and seek advice. The illustrator and engraver, John Reginald Biggs, Head of Design at the London School of Printing, agreed to see me. He looked carefully through my work, and an awkward silence followed. 'Frankly,' he exclaimed, 'you are wasting your time!' He did not, however, realise how determined I was to succeed.

As Europe slid closer to war, I worked in an East End agitprop studio run by a genial Jewish woman who led a double life as a Mayfair fashion artist by day and a radical studio directrice by night. She was an inspiration to us all; a mother to a boisterous bunch of art students, struggling young painters and jobless designers willing to work for 5 shillings a day and a luncheon voucher.

The focal point of our activities was the annual May Day procession to Hyde Park and Trafalgar Square. In 1938, the banners and floats were more colourful than ever, thanks to the Surrealists. The Irish sculptor F. E. McWilliam devised masks of the Prime Minister, Neville Chamberlain, which Roland Penrose, Julian Trevelyan and others wore with top hats and umbrellas, as they marched along bawling 'Chamberlain *Must* Go!'

I lived in a tiny attic bedsit in Guilford Street, Holborn, a run-down neighbourhood of lodging-houses and cheap hotels. Young artists and writers were attracted by its cheapness and Dickensian atmosphere. Working Men's Dining Rooms – as they were called – on Gray's Inn Road served bowls of thick pea soup for a penny, egg and chips for sixpence, and a pint mug of strong tea for twopence. For companionship I attended the local branch of the Communist Party, very much a party of jobless young men and women from the provinces, lonely and unattached, and not a little intimidated by London. Our meetings usually took place in the studio of the sculptor Gordon Cruikshank (later a foreign correspondent for the *Daily Worker*). Our shared ideals created an easy camaraderie and made me feel that I belonged to a movement intent on changing society for the better.

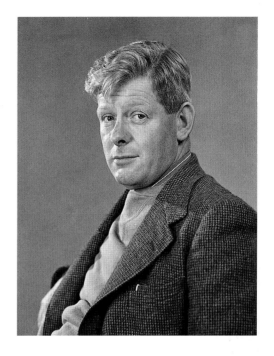

JAMES BOSWELL (CA 1946)
Courtesy: Derrick Knight.
Collection: Paul Hogarth.
The painter and caricaturist James Boswell was a legendary figure in the 1930s and 40s. A New Zealander, he both loved and hated class-conscious Britain. Without his constant encouragement I would have given up. If he was the father I should have had, I was the son he never had. I worked as his assistant for three years (1946–49) before he became the art editor of Lilliput.

We had innumerable talks on art and society. At one of these, on English caricature, I encountered the art historian Millicent Rose, an irresistible blue-eyed goddess who ran the AIA's Charlotte Street Centre with fellow art historian Francis Klingender. Millicent, who brought stimulating personal insight to a subject, stressed the importance of aesthetic input into social statements by artists, whereas Cruikshank believed that Marxist dogma was absolute.

It was through Cruikshank that I met the poet Philip O'Connor, under whose influence I briefly entered an uncharacteristic bohemian phase. I became an *habitué* of 'Coffee An', a basement café in Flitcroft Street close by St Giles-in-the-fields, Bloomsbury. Invariably crowded to the point of suffocation, it was home for struggling actors, poets and artists, who dined there on a bowl of soup and a large chunk of bread, before ending their evenings at one of their favourite pubs – the Fitzroy, the Marquis of Granby, the Wheatsheaf or the Bricklayer's Arms.

1938 ended with an unexpected bonus. In September, the European powers had signed the Munich Agreement, under which Czechoslovakia gave the Sudetenland to Germany, which Chamberlain declared would guarantee 'Peace in our time'. However, a feverish outburst of trench-digging erupted in the parks and squares of London. I was given a job digging trenches in Russell Square. My total take-home pay was no more than £3 a week, but in those days it seemed like manna from heaven. I stocked up with paper, pencils and paint as though there would be no tomorrow.

In January 1939, Republican resistance in Spain collapsed, bringing a merciful end to the sufferings of the people there. I quickly disposed of my paintings and drawings to Mendelssohn, a London art dealer who bought the work of young artists, and departed for the South of France. Alas, I had left it far too late. After making a pilgrimage to St Rémy and Arles, I had settled in an *Auberge de Jeunesse*, near Aix-en-Provence. Here, heavily under the influence of Cézanne, I was trying to depict Mont St Victoire and the surrounding countryside, when news of the German invasion of Poland reached me. By the end of September I was back in England, and soon received my call-up papers.

Unfortunately, because of the infamous Nazi-Soviet pact, which divided Poland between the two countries, known members of the Communist Party were thought undesirable in the armed forces, while I, feeling belatedly patriotic, wanted to be of some use. I applied for a transfer from my infantry unit to a camouflage unit – after all, I had received an art training. It soon became apparent, however, that I had been classified as a member of the awkward squad.

'Despite your name,' drawled a CO, 'there's nothing in your file to suggest you would be suitable for such a transfer. Dismissed!'

'But sir ...'

'SHUN!' roared the sergeant. 'Left wheel, quick march, left-right, left-right-left!'

During training, a gunnery instructor asked if anyone knew how to strip and assemble a Lewis gun. I did. But no one knew such things in those days, unless they had been in the Territorial Army, the IRA or the International Brigade. My army days ended in humiliation when I was discharged shortly afterwards.

Early in 1940, after seven short months in the army, I nevertheless found myself in camouflage after all, when a London Labour Exchange (Job Centre) directed me to the Design Research Unit, who gave me a job as a brush-hand on their industrial camouflage contracts around the western outskirts of London. My agitprop skills, however, enabled me to make a more appropriate contribution to the war effort. Carlton Studios, the biggest design studio in London, were recruiting layout artists and illustrators to work on Ministry of Information propaganda aimed at the Home Front and, later, the invasion of Europe. I got a job there as an illustrator, working on an assortment of posters, press advertisements and leaflets exhorting civilians to dig for victory, and telling them what to save and what to cook.

In June 1942 I met and married Doreen Courtman, the daughter of a Cheshire businessman and his radical Scots wife, 'Ma C'. We lived at 11 Upper Park Road, Hampstead, where married bliss prevailed despite air raids, V1 and V2 rockets, and rationing.

The end of the war found me still at Carlton Studios. By now the studio had switched to peace-time work, and I was grappling with impossible deadlines to produce illustrations for women's magazines. Whatever I may have learned there was overshadowed by the conviction that I never wanted to get involved with commercial illustration again. My membership of the AIA provided an alternative. While serving on its central committee I met James Boswell, the hero of my art school days, who was then acting as its chairman. He was also art director of Shell International when he wasn't observing the low life of Camden Town, and he took me on as his assistant, three days a week for three years, from 1946 to 1949. Furthermore, through my contacts in the Communist Party, I started to receive invitations to make working trips, on behalf of various Communist-sponsored friendship organisations, to record the rebuilding of war-torn eastern Europe.

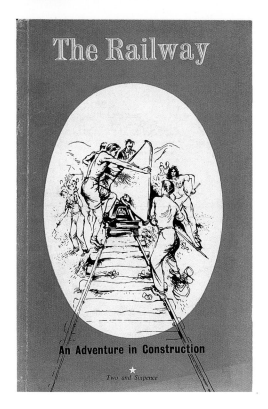

RONALD SEARLE AND EARLY TRAVELS (1947–48)

In the spring of 1947 I was asked to select four artists to record the building of a railway in the wilds of eastern Bosnia, then part of Yugoslavia. At once I thought of Ronald Searle, who was becoming known through the pages of magazines such as *Punch* and *Lilliput*. His remarkable chronicle of life in Japanese prisoner-of-war camps had made a big impression on the public, and had he not helped to build another railway, a railway of death? Still gaunt from the experience, he looked like a Grunewald Christ. The other members of the group were Laurence Scarfe, who represented the English pastoral tradition of topographical watercolour painting; Percy Horton, the distinguished tutor of drawing at the Royal College of Art; the art historian Francis Klingender; and myself.

We departed in high spirits and, after an arduous train journey, finally arrived at Llubljana, the Slovene capital, in the sweltering heat of August. The next day we began a demanding week drawing in the *souks* of Sarajevo and Zenica, before continuing to the construction sites of the 'Youth Railway', where we drew brawny, sun-bronzed students, wizened peasants and smooth-talking officials with varying degrees of enthusiasm. What finally happened to the Youth Railway is something of a mystery. When I returned to Yugoslavia in 1966 to depict the country's return to a free market economy for the US magazine *Fortune*, it had disappeared without trace. Whether by decree or by design, no one could say.

Inspiration on the trip did not come from our subject matter, but from Ronald Searle himself. His appetite for drawing was prodigious and totally undiminished by travel or fatigue. He would produce three or four large ink-and-wash drawings of construction scenes each day, plus numerous figure studies in pencil or conté. At night he would update his journal. It was the first time I had become acquainted with a working artist of my own generation and we became good friends. The business of getting to grips with the reality in front of you was not something that had been taught at art school, and, seeing Searle work, I realised that this was something I needed to master. On the other hand, Percy Horton, who was an excellent portraitist, would ask people to pose for him, and I also learnt a lot from watching him work.

Klingender was no less stimulating. I am indebted to him for urging me to study the work of the Victorian illustrator, Arthur Boyd Houghton (1836–75), especially his chronicle of post Civil War America entitled 'Graphic America',

Top: RONALD SEARLE (PRAGUE 1948)
Courtesy: Ludwig Perkski, TV Polska.
After our visit to Yugoslavia in 1947, Searle and I became friends. We revelled in the adventure of depicting the reconstruction of war-ravaged Eastern Europe. Searle was astonishingly prolific. For him, there was never 'a day without a line'.

Above: PAUL HOGARTH
Cover design (illustration by Ronald Searle) for The Railway, *edited by Edward Thompson. British-Yugoslav Association 1948.*

published in the early issues of the London weekly *Graphic*.

In the summer of 1948 I arranged a trip to Poland. Besides Ronald Searle, I invited the art historian, Millicent Rose. Ronald again displayed incredible versatility in tackling a wide variety of subject matter. We stayed in Prague *en route* for several days and drew the picturesque lanes of the Mala Strana below Hradcany Castle. We visited in succession Warsaw, Gdansk, Cracow, Zakopane and Katowice, ending our stay in Wroclaw. We made a brief appearance at the Congress of Intellectuals for Peace, where we drew literary luminaries making fools of themselves by siding with the Soviets against the Americans, who were branded imperialists and warmongers.

The extent of the destruction in Poland stunned us. In Warsaw, the Old Town's once-exquisite churches and grandiose palaces – indeed, any buildings of distinction – lay in ruins. Yet Ronald executed a series of dramatic scenes drawn on the spot in his famous 'ink', which wasn't ink at all but Stephen's Liquid Stain! He may have sounded like the British actor, David Niven, but in his company I witnessed at first hand the degree of creative interpretation that only the artist can bring to pictorial reporting.

Gdansk presented much the same picture as Warsaw. The old quarter of this historic Baltic port had been almost obliterated. Its fifteenth-century City Hall was reduced to an empty shell and, with few exceptions, so were the fine town-houses of the Hanseatic merchant princes. Old Nazi slogans could still be seen on the shell-pocked walls of shattered warehouses and burnt-out factories. In the harbour lay the twisted, rusting hulk of the battleship *Gneisenau*, once the pride of the German navy.

Only Cracow had escaped destruction. The beautiful old city sparkled like a diamond in the summer sunshine. We walked around the vast Rynek Square and stood in homage before the statue of Adam Mickiewicz, Poland's national poet. We viewed the florid Gothic altarpiece of the Ascension at the Mariacki church, carved by Wit Stwosz (Veit Stoss). We looked into peaceful courtyards and climbed the Wawel Hill to view the cathedral, resting-place of Poland's old kings and warrior knights.

At Janov, near Katowice, we entered the grimy world of the Silesian coalfield, where fiercely moustached miners hacked and shovelled in almost total darkness. The air was thick with coal dust and the temperature well above 80°F. Many miners had served with the Polish forces in Britain and bitterly regretted having returned to their homeland. Our next stop, some 20 miles to the south,

RONALD SEARLE 'MILLICENT ROSE'
(PRAGUE 1948)
Ink. 6x5in (17x13cm)
Courtesy: Ronald Searle. Collection: the artist.
The art historian Millicent Rose was anything but a dogmatic Marxist, and I learnt a lot from her. She grew up in India as the daughter of an Indian Army general, and was a Newnham graduate.

reduced us to silence. Here, outside the small town of Oswiecim, preserved as it had been when liberated in January 1945, was Auschwitz-Birkenau, the focal point of the Holocaust. Immense warehouses contained great mounds of human hair, false limbs and dentures. Huge piles of children's clothing, and suitcases that each bore a name, date and place of birth, and address, were so unbearably poignant that I was unable to put pencil to paper.

The year after my trip to Poland, I at last got the opportunity to return to Spain. It was 1949. Industrial unrest had erupted there sporadically over the last two years, and the Left thought that, if pushed, the Franco régime might collapse. Lon Elliot, who edited *Volunteer for Liberty* (the monthly journal of the International Brigade Association, of which I was then art editor), suggested I make a series of appropriately damning drawings to help sustain the myth that only Franco represented the world of darkness.

The journey, which I made in a very dilapidated Hillman convertible, was not without adventure, and included being trapped for two days in a forest fire north of Bordeaux. Eventually, I arrived at Irun and crossed the frontier. Surely, once inside Franco's Spain, I would see grim evidence of an oppressive régime.

My first stop was Guernica, some 30 kilometres from Bilbao. On 26 April, 1937, this ancient Basque capital had been savagely attacked by the Heinkels and Junker 52s of the Nazi Condor Legion. The raid had provided the Republican

UNEMPLOYED METAL WORKERS OUTSIDE THE BREDA PLANT, MILAN (1951)
Ink and conté. 6x4in (15.7x10cm)
Private collection.
In 1951 I made a pilgrimage to Italy. I visited Milan, Rome and Siena. Milan was a depressing place to visit, let alone draw. Yet I felt morally obliged to depict the anomaly of giant, mostly silent, factories and the unemployed who reported to them each day in the hope of finding work. I preferred Rome and Siena but didn't then like to admit it!

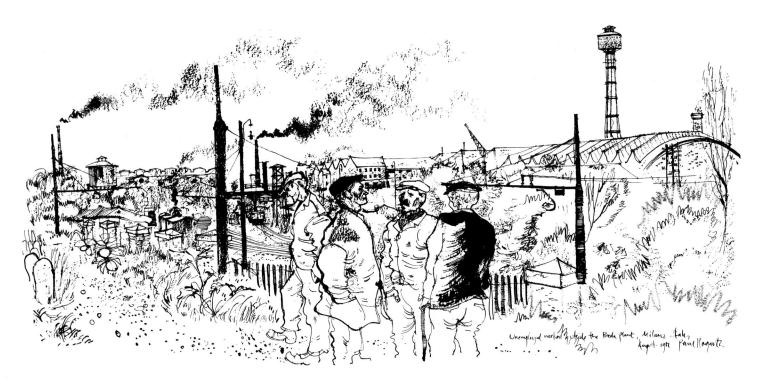

propaganda machine with a story that made the world shudder and alienated public opinion from support for Franco's cause. On entering the town over a decade later, however, I found that reconstruction had largely healed the wounds of war. The terrible scenes of death and destruction now depended on Picasso's painting, *Guernica*, for their memorial.

Elsewhere, however, Spain presented the same aftermath of war that I had seen in Poland: shattered towns and cities; banks and public buildings guarded by armed security police; and a populace anxious to talk of shortages, the high cost of living and much else, but afraid to do so. Much of Oviedo, the one-time capital of the ancient kingdom of the Asturias, still lay in ruins. The cathedral stood desolate at the end of the Plaza Alfonso II, flanked by row upon row of posters applauding Cardinal Mindsenty's stand against Communism. Whole neighbourhoods where Republican and Fascist forces fought one another remained as though the war had ended yesterday. Close by were the grim Santa Clara barracks that the Asturian *dinamiteros* had so often blasted in vain, their steeply-raked walls pitted with shrapnel and bullet holes.

I continued south to Mieres, a grim mining town that had been a staunchly Republican stronghold. Walls still bore the exhortations inscribed by the agitprop units of both sides. Stencilled portraits of a grinning Franco jostled with the odd *Viva la Republica*, in turn montaged over by '*Mola Presente*' (Mola is here!), the latter conjuring up a picture of more death and terror, this time at the hands of the Moorish *tabores* of Franco's Army of Africa.

I drove southwards on the old Zaragoza-Barcelona highway, once the main artery of the Aragon front, still pitted with half-filled shell and bomb craters. Along the River Ebro, peasants toiled in the parched fields surrounding their ruined farmsteads. The country looked as if it had suffered 30 years of war. But I was no Jacques Callot, illustrator of the siege of La Rochelle in the seventeenth century, to chronicle such destruction and misery with the artistry it so obviously required. Indeed, at the age of 32, my powers as a draughtsman left so much to be desired that I was on the point of giving up.

Travel, I hoped, would ultimately bring out the artist in me. Like a Christian pilgrim of old, I sought spiritual adventure. After Spain, I visited France many times, then Italy in 1951. Post-war Italy was a magnet for artists of the Left. Led by Gabriele Mucchi in Milan and Renato Guttuso in Rome, a new generation of artists had aligned themselves with the Communist Party, believing it to be a force capable of transforming the country. My party card – the modern

THE REPUBLICAN MECHANIC (1949)
Ink and conté. 6x4in (15.7x10cm)
Private collection.
A portrait sketch made spontaneously after the mechanic had repaired a broken starter cable on my old Hillman Minx while I was travelling in Leon, Spain. He had spent eight years in prison for fighting against Franco.

A SHOEMAKER OF THE ATHENS
AGORA (1952)
16½x13in (41x33cm)
Private collection.
Through constant drawing in streets and markets,
I eventually developed a fluency that had previously
escaped me. I also realised what would make a
drawing work.

STREET SCENE, HYDRA (1952)
Conté. 18x12in (46x35cm)
Collection: Ministry of Culture, Warsaw.
This Greek street scene, my first really successful
drawing, was made only after I had worked out
a preliminary design in a pocket sketchbook. Searle's
method was the direct approach: to look, then draw
non-stop from the top of a sheet of paper to the
bottom. In Yugoslavia and Poland I tried this but
failed miserably, and realised that I had to put
down my thoughts about how I might draw a subject
before I began.

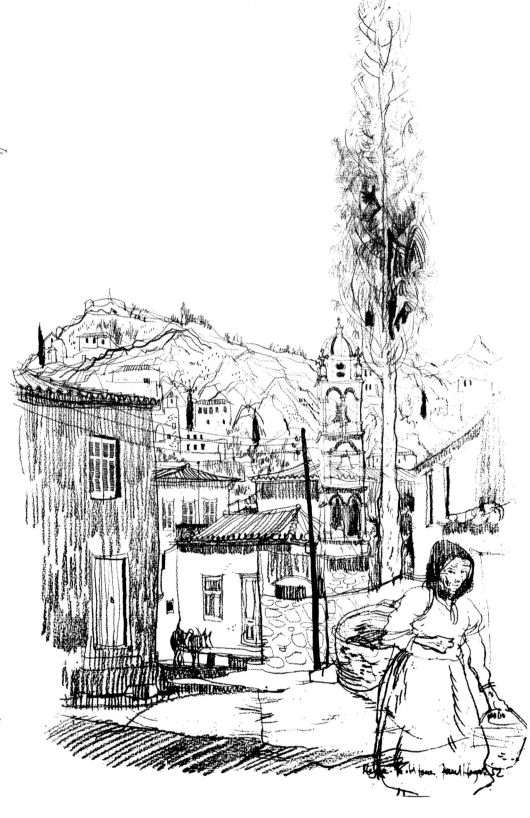

equivalent of the certificate that the medieval pilgrim carried – allowed me to stay at the many Houses of Culture. It was in such a House in Milan that I first saw the work of Mucchi, Treccani and Zigaina. Briefly I was inspired to follow their example and draw life in the industrial suburbs of that grim city.

Then, in 1952, fate intervened in the person of Betty Ambatielos, the indomitable Welsh wife of Tony Ambatielos, a Greek Communist, a former resistance fighter against the Nazis in World War II, and a leader of the seamen's union. Tony faced execution by the military régime of Marshal Papagos, and the long campaign for his freedom had become a *cause célèbre*. Betty had seen my drawings of Spain, which had been published in the left-wing press, and asked me to record Tony's trial against the background of Greece, the first victim of the Cold War (the US had supported the royalist army in defeating the Communists). At last, I thought, this would be something I could really cut my teeth on.

I arrived in Athens during August 1952 and found a country exhausted by five years of civil war between the royalist army and the Communists that had ended in 1949 with the restoration of the monarchy. Atrocities, committed by both sides, had left a legacy of hatred and suspicion. Military tribunals conducted trials of Communist politicians and trade union leaders who defied the régime. I lived in cheap hotels and safe houses, from which I ventured into the old quarters of Athens, the courtrooms of the tribunals, the working-class districts of Peristeri and Kokkina, the port of Piraeus and the island of Hydra. Through sheer necessity, and constant practice, I began to acquire the resourcefulness of a pictorial reporter. I had to keep on interpreting what I was seeing, and I now occasionally brought off a drawing that I could feel reasonably proud of. After Greece, the last of my travels in war-shattered Europe, I began to feel much more confident about achieving my ambition of becoming a compassionate observer.

THE LITERARY LIFE (1949–52)

Unlike the cities I visited on the continent, post-war London wallowed in an afterglow of misplaced optimism. A Labour government had been in power since August 1945, but its New Jerusalem was as far off as ever. Yet the next few years were a stimulating time, as I worked on a succession of magazines in between my travels and met many writers and artists who helped to shape my ideas and tastes.

Randall Swingler was the first writer I worked with. We were introduced by James Boswell, and I became his protégé. He looked very much like the popular

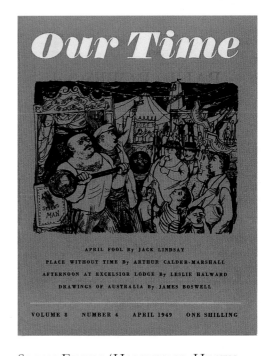

SUSAN EINZIG 'HAMPSTEAD HEATH FAIR', *OUR TIME* APRIL 1949.
Collection: Paul Hogarth.
A special feature of Our Time *was its lively covers, usually of London life, by James Boswell, Susan Einzig, James Holland, Nigel Lambourne, John Minton, Ronald Searle, Elizabeth Shaw and Laurence Scarfe.*

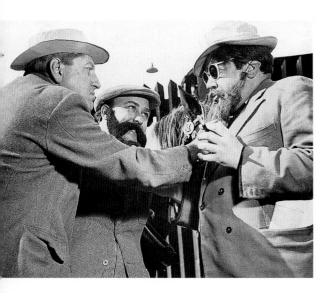

THE EDITORS OF *CIRCUS* AT PLAY IN
COVENT GARDEN
Courtesy: Mike de Wyke (Michael Wickham).
Collection: Paul Hogarth.
Left to right: Randall Swingler (Dr Hogler), Paul
Hogarth (Lord Swinegarth) and John Davenport
(Sir John Portaven).

French film star Jean Gabin, although there was nothing histrionic about Randall. His father was the Bishop of Wells, his great-uncle, Archbishop Randall of Canterbury. Like them, he faced life with the resignation of a Christian martyr, as if anticipating his fate – heart-failure at the age of 58, the result of alcoholism and despair. As a poet he never received the recognition his friends Louis MacNeice and Cecil Day-Lewis had been given. During World War II he had served with great distinction in Tunisia and throughout the Italian Campaign, and had returned to London traumatised by the horrors he had gone through. With the poet and critic Edgell Rickword (who was equally scarred by World War I), Randall co-edited *Our Time*, a once-influential left-wing monthly that had flourished during the war years. In January 1949, he became the sole editor, and for what were to be the last few issues I was his art editor.

There was never a dull moment at the magazine, but getting it out on time each month was an uphill task. Although the Communist Party neither owned *Our Time* nor even helped to establish it, the magazine reached its readers largely through a national network of party-controlled bookshops. Proofs had to be checked and double-checked and, if need be, Randall himself called to account by the Communist Party's cultural commissar, the autocratic Emile Burns, before an issue could be printed. In 1947, Rickword and Randall had frequently been reprimanded for their political and financial 'mistakes'. In October 1949, *Our Time* ceased publication.

As his disillusionment with Communism deepened, Randall joined forces with the disgruntled *literati* of Chelsea and Soho. Six months later, *Our Time* was followed by *Circus*, on which he was managing editor, with the writer John Davenport as literary editor and myself as art editor. I wondered if we could all work together. Randall and Davenport were the opposite sides of the same coin; Randall a disillusioned Communist, John a right-wing Catholic. Yet they were highly efficient men of letters, with a profoundly comic sense of humour. I, of course, was the absolute beginner. For a time, John had flourished as a scriptwriter in Hollywood, but had recently been reduced to writing the occasional review for the *Observer*. He had wealthy friends, however, who relished his biting wit. Saddened by the collapse of *Our Time*, he produced Anthony Hubbard, who, it was said, had claim to part of the immense Woolworth fortune and was interested in backing a critical journal of the arts. It seemed too good to be true.

We set to work on the new periodical with gusto. In new offices at 34 The Strand, we feverishly planned 'the pocket review of our time'. 'It would be,'

proclaimed Randall, 'the magazine which Britain had never yet had. Wit, wisdom, sanity and enjoyment of life, without pomposity, exclusiveness or wailing self-pity.' The first issue appeared on April Fools' Day, 1950, its 64 pages crammed with short stories, verse and features, cartoons, drawings and reviews. Reaction was swift and not always friendly. 'The intention, one gathers,' carped the *Times Literary Supplement*, 'is to produce a slightly higher-tone *Lilliput* [our rival, published 1937–59] but most of these Left-Wing Gullivers are ill at ease in their chosen Lilliput.'

Randall called on members of the literary Left such as Walter Allen, James Hanley, R. D. Smith and Ruthven Todd, to contribute the occasional story or review, but John lined up the more impressive talent, including the genial Angus Wilson, then toiling in the bowels of the British Museum as a deputy superintendent; Joyce Cary, Edith Sitwell, and, most memorably, Dylan Thomas, who would turn up at the local pub, pockets stuffed with hastily typed poems – usually already published – that could be purchased for a fiver (£5.00) each, cash down – with which he would buy a round of drinks.

I commissioned covers, cartoons and illustrations from a wide range of artists – including John Minton, Leonard Rosoman and Keith Vaughan – at derisory fees. No one turned me down; not because work was thin on the ground, but rather because of a revival of interest in drawing for publication, especially among painters. The great Augustus John was urged to contribute a clown for an article on that endangered species by Antony Hippisley-Coxe (*Circus*: 3, 1950). Wild of eye, with beret and bulbous nose, like a latter-day king of Bohemia, Augustus generally held court at The George behind the BBC in Portland Place. My God, I thought, will I look like him one day?

Among the caricaturists, I had André François and Ronald Searle. The first cartoons of the inimitable Michael Ffolkes of the *Daily Telegraph* appeared in *Circus*. Another discovery was the talented Mary Scholten, whom I asked to draw Ronnie Scott's Club 11 (*Circus*: 3, 1950). Mary had the figure and face of a sturdy Victorian doll, heightened by bobbed black hair and huge brown owl-like eyes, which later bewitched the elderly Gerald Brennan at his mountain retreat in Andalucia.

Alas, *Circus* was not to last long. While on a weekend visit to Paris, John was overheard at the *Deux Magots* to say that the joke of it all was that both Swingler and Hogarth were Reds! This proved to be our undoing as his listener was a close friend of Tony Hubbard, who was duly informed that his money was

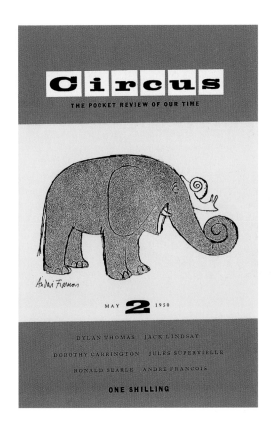

ANDRÉ FRANÇOIS, COVER ILLUSTRATION FOR THE SECOND NUMBER OF *CIRCUS*, MAY 1950
Courtesy: André François and Hubbard Publications, London. Collection: Paul Hogarth.

MYSELF AS ART EDITOR (1950)
Photo: Julian Sheppard.
Between 1949–50 I was art editor of Our Time *(six issues);* Circus *(three issues);* Contact *(one issue), besides numerous other equally ephemeral publications such as* Spain Today, Arena, AIA Newsletter *and* Vox Pop.

being spent, if not wisely, then certainly much too well on what was probably a subversive enterprise – no laughing matter in those bleak Cold War years. Two days later, our bank account was closed, and so was the magazine, with six issues in proof and a large company of contributors unpaid.

Then, to our surprise, Randall and I were summoned by George Weidenfeld to take on *Contact*, his bi-monthly book magazine. Randall, however, was tired of journalism and decided to retire to his Essex cottage to work on his *magnum opus*, a critical study of Dostoyevsky. I immediately responded to Weidenfeld and his ambitious ideas, and accepted.

Launched in 1945, *Contact* had originally been designed by the great Hubert de Cronin Hastings of the *Architectural Review*. He also acted as its art director for the early numbers and introduced artists such as Edward Bawden, Hugh Casson, John Minton, Michael Rothenstein and Leonard Rosoman to its pages. The magazine's style made it irresistible to writers and artists, a fact brought home to me each Thursday, a day I set aside to look through the portfolios of aspiring illustrators. The stairs to my offices, located in the attics of a Georgian town house in Cork Street, would be jammed with a jostling throng, intent on breaking into *Contact*'s magic circle. Sometimes, a writer, unable to penetrate the sanctum of the editor's office, then occupied by Clarissa Churchill, got into my queue. On one occasion, an enraged Margaret Rutherford look-alike barged through my door waving a manuscript, stopping short before my desk to inform me that *she* was Lady Rose.

'You simply *have* to publish my article,' she bellowed. 'My husband, sir, is Sir Francis Rose!'

'Madam,' I replied, 'I am but the art editor.'

'I don't care *what* kind of editor you are,' she snarled.

I do not know whether she had George Weidenfeld's ear, but this job lasted no longer than the others.

CHAPTER TWO

Travels Behind the Iron Curtain

BRITAIN IN THE 1950S WAS AN AUSTERE PLACE. FOOD AND PETROL
WERE STILL IN SHORT SUPPLY AND SO, IN LARGE MEASURE, WAS THE SPIRIT
OF ADVENTURE. HOWEVER, THE PUBLICATION OF MY DRAWINGS FROM MY
RECENT TRAVELS PROVIDED AN INCOME WHICH, ALTHOUGH SMALL,
ENABLED ME TO BE INDEPENDENT.

NOT UTOPIA (1953–54)

I DROPPED MOST of my magazine work and concentrated on my real ambition –
to travel and draw. I continued with my trips behind the Iron Curtain, to
Poland again, and the wholly misnamed democratic republics of Eastern
Germany, Czechoslovakia, China, Romania, Bulgaria and the Soviet Union. Life
there appeared to have a sense of purpose, or so I imagined then. Much has since
vanished into the quicksands of history. Nonetheless, I recall those days with
nostalgia. The only snag was that I always had to have a minder, an interpreter –
at best urbane and educated, at worst, a party hack – whose job it was to make sure
I saw the right places. Yet they enabled me to act on James Boswell's wise advice
to draw anything and everything.

The Civil War in Greece during the 1940s had aroused strong partisan
feelings among the left-wing faithful and, despite their artistic shortcomings, the
drawings I had made there were the first chronicle of its tragic aftermath. After
being shown in London in December 1952, they were exhibited in Warsaw,
Prague, Bucharest and Sofia. I was invited to attend each opening as though I was
the prophet of a new approach to drawing. I was accommodated in the best hotels,
acclaimed and feasted. Then, as if to provide an example, I would be invited to
remain and portray the new Socialist Man at work.

After my exhibition at the Book and Press Club in Warsaw, the Ministry of
Culture invited me to make a three-week tour of Poland, and I took up the
invitation early in 1953. During the trip I made the drawings that were

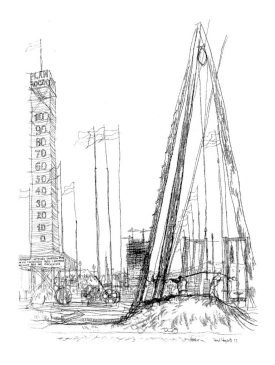

ON THE SITE OF THE GHETTO (1953)
Conté. 1953. 20x15in (50.7x39.4cm)
Collection: the artist.
The epic sense of collective endeavour was a
characteristic of post-war Eastern Europe. I felt
a moral obligation to depict the rebuilding of great
cities devastated by the war. Reconstruction,
therefore, became a motivating theme of my travels
between 1953–55.

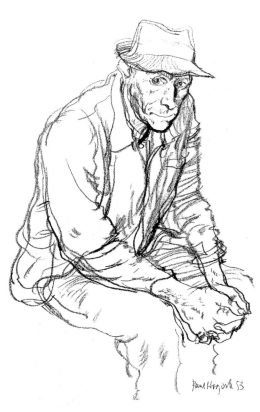

FELIKS KROLIK, STONEMASON, GDANSK
(1953)
Conté. 20x15in (50.8x38cm)
Collection: John Holder, Cambridge.
I drew Krolik spontaneously after he had watched
me complete the drawing of City Hall (opposite) where
he was working. This way of drawing people
is unpredictable and depends on good timing, intuition
and luck, but Krolik's confidence and interest helped
me rise to the occasion.

subsequently exhibited throughout Britain as 'Drawings from Poland'. The trip was to prove an eye-opening experience.

Since my visit in 1948, the Sovietisation of Poland was very marked. Moreover, the entire country was gripped by a xenophobia reminiscent of Nazi Germany. There were orchestrated mass demonstrations, marching songs and strength-through-joy youth camps. Buildings and factories were covered with huge portraits of Marx, Engels and Lenin and with exhortations to fulfil production quotas. Statues of Stalin had sprung up like mushrooms. Massive blocks of Soviet-style offices and apartments now dominated inner Warsaw, while its centrepiece was the ornate Palace of Culture and Science. Below ground, a metro based on Moscow's was under construction. I felt much more at home depicting the architecture of the past, such as the Krakowskie Przedmiescie and the now largely restored Old Town, the fifteenth-century City Hall of Hanseatic Gdansk and the monasteries and palaces of Cracow than I did drawing the Soviet-style modern buildings.

In Warsaw I had become friendly with the caricaturist Jerzy Zaruba, a passionate Anglophile who had lived in Britain during World War II. Jerzy invited me to join him for a week at his retreat at Szlembark in the Tatra Mountains of southern Poland. In this unspoilt alpine community, the local people and their customs had remained untouched, despite the tidal wave of authoritarianism and industrialisation that had all but engulfed Poland. The famous printmaker, Tadeusz Kulisciewicz, and his wife also had a cabin in the village. Both men were incredulous that I, an Englishman, a Westerner, could possibly believe in the edicts Socialism imposed on artists and writers to portray a perfect world.

In Prague, the exhibition of my Greek drawings was shown at the gallery of the Union of Czechoslovak Artists on Slovansky Ostrov (Slavonic Island). Again, I was asked to 'capture the spirit of the working people building Socialism'. The more down-to-earth Czechs, however, suggested that the drawings could more usefully illustrate a book. I could think of no better person to handle this challenging task than Randall Swingler. His irreverent wit and poetic wisdom were essential requirements for what would be another propaganda chronicle. At least it would be well written. Randall reacted favourably to the idea; the change, he thought, would do him good. Besides, he said, Dylan Thomas had spoken glowingly of the hospitality he had received in 1949 as a guest of the Union of Czechoslovak Writers.

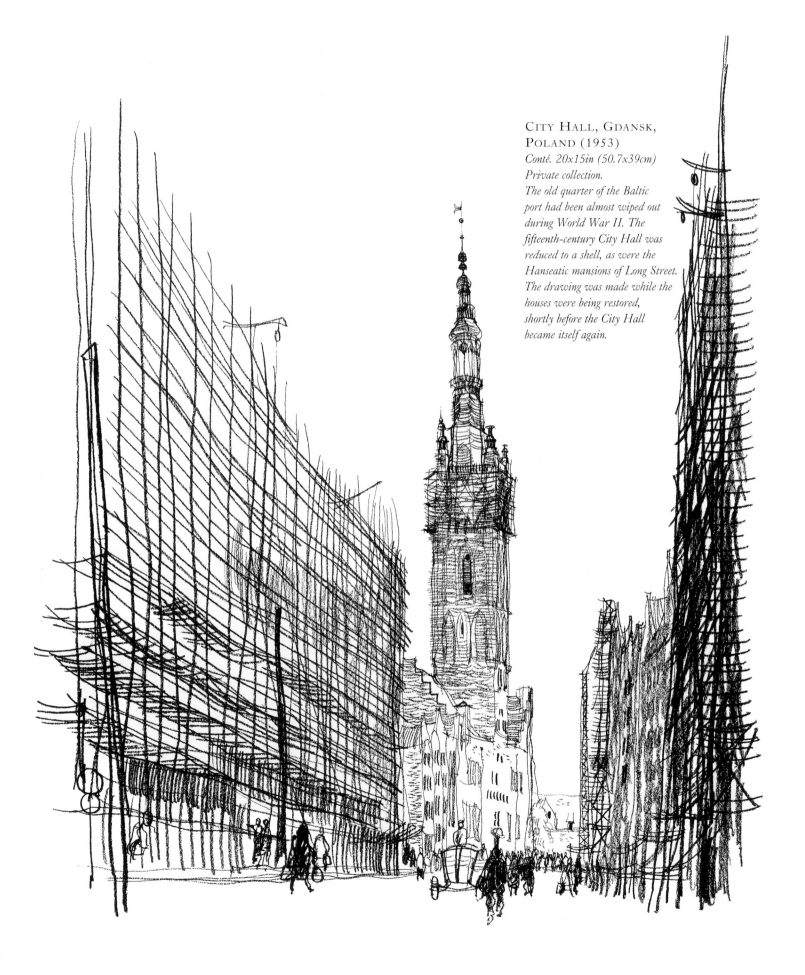

CITY HALL, GDANSK,
POLAND (1953)
Conté. 20x15in (50.7x39cm)
Private collection.
The old quarter of the Baltic
port had been almost wiped out
during World War II. The
fifteenth-century City Hall was
reduced to a shell, as were the
Hanseatic mansions of Long Street.
The drawing was made while the
houses were being restored,
shortly before the City Hall
became itself again.

BUILDING NOWA HUTA NEAR CRACOW, POLAND (1953)
Conté. 16x20in (40.5x50.7cm)
Courtesy: Victoria & Albert Museum, London.
Throughout Poland, I witnessed industrial expansion on an unprecedented scale. On the outskirts of Cracow, I depicted the Lenin Steelworks at Nowa Huta (now the Sendzimir Steel Plant) which was little more than a vast, muddy site. Built by Soviet engineers from out-dated American designs, the huge plant was to account for 80 per cent of the pollution that was to corrode the spires and statuary of historic Cracow.

Early in the summer of 1953, we duly arrived in Prague and were met in style by our minder-to-be, Olga Klusakova. She gazed at Randall's rumpled, ink-stained Oxford bags and dingy tweed jacket with unconcealed dismay. His only piece of luggage was an ancient rucksack from his undergraduate days. It was not a promising start to our three-week stay.

Randall did not know that Olga had been Dylan Thomas's interpreter during his visit! Bill Read in his *Days of Dylan Thomas* (1964) wrote that Olga so incensed the poet that he embraced a baroque statue on the Charles Bridge and threatened to jump into the Vltava River unless she was banished from his sight. I had heard Olga's side of the story on my previous visit. 'Did I know an English (sic) poet – Dylan Thomas?' I replied that he was Welsh and one of our leading poets. 'But not a very neece man,' huffed Olga.

Randall and Olga continued to clash. We were invited to the gilt-encrusted splendour of the National Theatre for a performance of Smetana's opera, *The Bartered Bride*. After the airport encounter, some kind of formal attire was essential. While Randall slept off a hangover in the art deco splendour of our suite at the Alcron, I had his Oxford bags and tweed jacket cleaned and pressed. Olga was still not pleased but she seemed to appreciate the effort.

Reluctantly, we left the delights of Prague and embarked on our conducted tour in a black Tatra limo, then the ultimate status symbol of the party bureaucrats. At Kladno, we inspected the Koniev Steelworks of the vast Poldi complex. Olga translated production figures while I drew one foundry worker after another. We had hoped to visit Marianské Laźně (formerly Marienbad) or Karlovy Vary (Karlsbad), not realising that they were in what had been Sudeten territory. 'It is not recommended,' snapped Olga. 'They are very much centres of anti-party activity.' We then headed south through picturesque Bohemia to Tabor and Telc, with their arcaded squares and quiet charm. I had fully expected to be given the chance to draw these ancient towns, but we were driven to a State Farm at Podoly, where Randall spent much of the afternoon inspecting middens while I drew prize cows being milked!

Still further south, we spent a day in historic České Budějovice. Again, I hoped to draw the old town. Instead, we visited the newly nationalised Hardtmuth pencil factory, where I had to be placated with a gift of enough graphite and charcoal pencils to last a lifetime. But things did not go at all well in this frontier town. We were put up at the old Hotel Ruze in the cobbled medieval quarter, while Olga retired to a different inn. However, Olga had inadvertently brought us into a forbidden zone close to the border with Austria. After enjoying supper by ourselves for a change, Randall and I retired to our beds, only to be rudely awakened by a squad of armed frontier guards, who hammered on our bedroom doors and demanded that we accompany them for questioning. 'My gawd,' chortled Randall in mock dismay, 'Orwell *was* right after all!' I was able to contact Olga just in time.

Perhaps the happiest interlude on this tedious Odyssey, was an impromptu wine-tasting, which took place at Moravia Znojmo between Brno and the Austrian border. We were taken to the cellars of the picturesque old castle and invited to sample various vintages of white wines ranging from Müller-Thurgau, Sauvignon Blanc, Grüner Veltliner to Riesling. After we had been welcomed, the master wine maker and Olga foolishly left us in the company of a trio of burly red-faced

SZLEMBARK (1953)
Conté. 20x15in (50.7x39cm)
Collection: the artist.
Szlembark, a Podhale village in the High Tatras of southern Poland, provided a welcome respite from the demanding task of depicting industrialisation.

JAN OTRUBA, FOUNDRYMAN,
KONIEV STEELWORKS, KLADNO,
CZECH REPUBLIC (1953)
Conté. 20x20in (50.7x50.7cm)
Private collection.
A typical portrait from my 'Socialist Realist' period.
On these occasions – assisted by a minder – I looked
for a strongly featured worker, then waited for a break
in his work routine. The minder would translate my
request that he pose for 15 minutes, which usually
enabled me to get the drawing I wanted.

cellarmen, who immediately recognised Randall as a true son of Bacchus. Our glasses were filled and refilled amidst peals of raucous laughter which followed a succession of toasts to the oppressed of one capitalist country after another. It was one of those rare occasions when I did not make any drawings. Olga in despair, threatened to call Prague and cancel the rest of the tour. We were in disgrace for days afterwards. Randall's text became a saga. Not only did it take him ages to complete, but it fell well short of expectations, at least as far as the Czechs were concerned. The first version, admirable as it was, would have been ideally suited for a British audience, and indeed a London publisher was found. But the Stalinist ideologues intervened, objecting that the text was not sufficiently upbeat in tone. And as they also insisted that both Czech and English editions of the book be printed in Prague, no agreement was ever reached, and our book never saw the light of day.

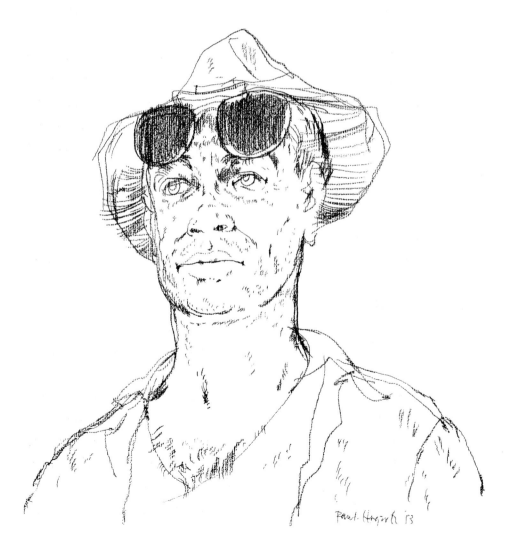

LOOKING AT CHINA (1954)

In 1954, all roads led to China. The revolution was only five years old, but the leaders of the People's Republic of China were determined to celebrate the occasion in style. Numerous Western observers were invited in the hope of establishing closer relations in the frosty aftermath of the Korean War. As word got round that the various trips were to be paid for by the Chinese, a formidable pilgrimage took shape.

Labour Party parliamentarians of the Bevanite Keep Left Group and trade union supremos were followed by a group of Labour back-benchers. Last, but not least, a top cultural delegation was led by the geologist Herbert Hawkes, and included the philosopher A. J. Ayer, the architect Hugh Casson, the painter Stanley Spencer and the poet and novelist, Rex Warner. Much to my astonishment, I was given a fellowship by the World Peace Council to depict the life and landscape of the New China.

Sir Hugh Casson has recalled the interminable flight across Siberia and the Gobi desert with nostalgic amusement: the word-games and donnish conversation as the cultural group grappled with the tedium of long-distance air travel in those jetless days. I, on the other hand, on a different flight, grappled with the demands of chaperoning a hard-drinking delegation of trades union shop stewards, none of whom had ever been out of Britain before.

We travelled via Moscow, the flight from Moscow to Peking taking three days in that piston-prop era. First we landed at Sverdlovsk. Then we took several hours to cross an expanse of Russia equal in size to Europe itself. On the horizon lay Siberia. At Novosibersk we changed aircraft, and while we waited, short-skirted waitresses with Betty Grable hair-styles and wedge heels served an enormous lunch with champagne. After Irkutsk, the vast forests and endless steppes gave way to the convoluted foothills of Mongolia. We crossed the vast Gobi desert. Then, as we flew over the Great Wall of China, terraced fields came into view and, finally, we reached Peking.

Peking (Beijing) was still largely medieval in character, with a population of three million. In addition to the temples and palaces of the Forbidden City there were sprawling neighbourhoods alive with bazaars and street markets, by far the biggest of which was the Tien Shiao. Situated near the Temple of Heaven, and occupying three square miles, this vast market pulsated with life such as is represented in the paintings and prints of Peter Breughel the Elder.

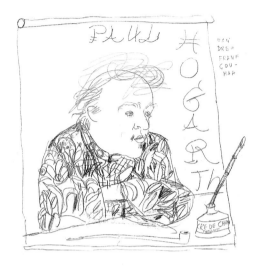

ANDRÉ FRANÇOIS 'PAUL HOGARTH'
(PARIS 1955)
Pencil on bistro paper. 11x11in (28x28cm)
Courtesy: André François. Collection: Paul Hogarth.
Impressed by my adventures in China, André
impulsively dashed off this endearing caricature of
myself as a Mandarin.

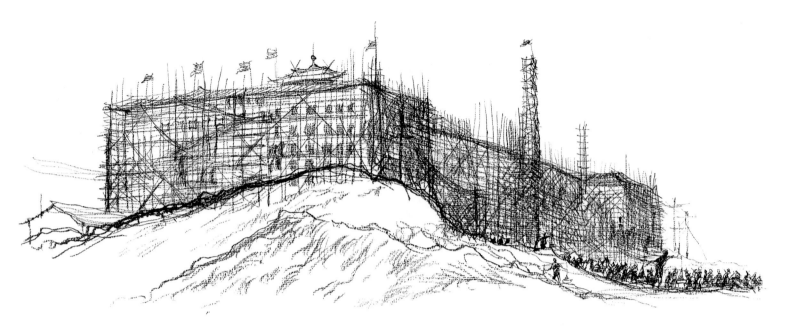

BUILDING A NEW HOTEL, BEIJING
(1954)
Hardtmuth charcoal lead. 16x20in (40.5x50.7cm)
Courtesy: Penguin Art Collection, London.
Throughout China, the scale of construction was
monumental. In Beijing alone, in the absence of
mechanical equipment, tens of thousands of workers
toiled like ants on immense projects such as this new
hotel (now the Grand Hotel).

The workshops of tinkers, gilders, wood-carvers, cobblers and blacksmiths jostled for space with wheelcarts piled with jars of sweetmeats, bowls of exotic fish, fur hats and ear-cleaning devices. There were scribes and chestnut-sellers, jugglers, conjurors and mountebanks. Performers recounted ancient ballads in crowded tents to the accompaniment of two-stringed fiddles and clashing cymbals. The intensely popular culture had remained unchanged for centuries, and was astonishing for the very fact that it still flourished.

The days followed one another at a breathless pace. 'The Summer Palace,' I wrote, 'looked too Chinese to be real.' Willows dipped into the waters of a lake in which the inverted image of a distant pagoda shimmered in the clear heat of the day. I strolled along decorated pathways and crossed the lake on an ancient brass-spangled punt. The steam yacht of the Dowager Empress Tzu-hsi quietly rusted beneath gnarled cypresses beside a marble quay. Peasant families gazed in awe at the richly lacquered pavilions.

Over the next three months I made a series of long journeys that took me into almost every region of China, accompanied by Comrade Tu of the Ministry of Foreign Affairs and Ho-i-Min, a 23-year-old tutor of drawing at the Peking Central Academy of Art. First we went to the industrial north by train. By daybreak we were in Jehol (Chende) with its golden-brown sorghum fields set against a backdrop of mauve-tinted mountains. By the end of the afternoon, we raced past factories and tenements smudged with the dust and grime of smokestack industrialisation. Shengyang (Mukden) – the coal and steel centre of

the Chinese north – came into view, a dreary city of Russian and Japanese brick buildings, a legacy of the occupation of the region by these two powers, and wooden shacks. Huge telegraph poles festooned with power cables gave the place the appearance of a nineteenth-century Pennsylvanian steel town.

The city became our base for a series of excursions to smaller towns, notably Anshan where I made drawings of men and women toiling like slaves in a new steelworks and machine-tool plant built by the Russians. At Fushun I depicted one

ANSHAN BLASTFURNACEMAN (1954)
Hardtmuth charcoal lead on bamboo paper. 19x14in (49x37cm)
Courtesy: Bucharest Art Museum, Romania.
Much of the Manchurian city of Anshan was an insubstantially built amalgam of old Russian and Japanese steel mills. Open-hearth furnaces roared day and night, tended by hooded figures labouring in what seemed like vast industrial cathedrals. Steelworkers in such old mills have much in common with miners – products of an earlier industrial age – and possessed the same natural dignity.

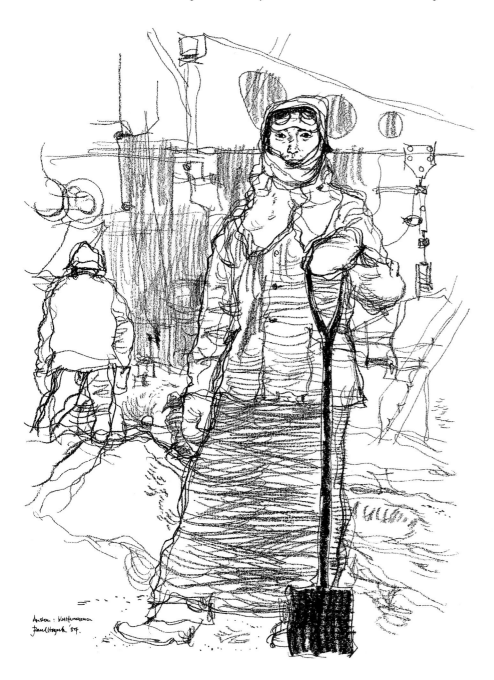

of the world's biggest open-cast coal mines set against a giant complex of cooling towers and oil-refining stacks, the whole scene laced with power lines and railway tracks – a subject more to the taste of Joseph Pennell, that indefatigable American draughtsman of heavy industry.

From Shengyang, we flew west to Sian (Xi'an), the capital of China for four dynasties before Beijing took its place in the fifteenth century. In 1954 it was an unresolved mixture of ancient and modern; the centre of a cotton-growing and spinning region. Some 15 miles from the city, on our way to the mountain spa of Hua Ching Chi, we stopped off at a Buddhist monastery where the monks' way of life dated back to the seventh century. Gargantuan in size, they lumbered about like wrestlers. A tiny village woman chuckled and chirped, pointing out a prime example for me to draw as though choosing a plump chicken for the oven. The monk posed on a prayer table, resting one huge hand on the other in assumed contemplation. Somewhere, a bell tolled, and a flock of white doves fluttered over our heads. We drove on through hamlets where poultry outnumbered people. Columns of geese marched across sun-baked mud roads. We passed over a bridge said to date back to the seventh century. The bridge was shaped like a horseshoe and supported a row of ancient houses in the middle. Groups of women ginned cotton while bewhiskered elders wearing traditional black gowns sat in doorways smoking long clay pipes.

We flew south to Chungking (Chongqing) in an ancient Dakota, which somehow managed to steer a route between Sichuan's precipitous mountains. From time to time, swirling mists intervened as we gazed down with a mixture of apprehension and delight on pine forests and scalloped rice-paddies. Seen from the air, Chungking looked like a fabulous city-state straddling the confluence of two great rivers, the mighty Yangtze (Chang-jian) and the lesser Kialang (Jial-jing). Masts of countless junks and sampans formed a vast thicket of yellow ochre against which a blue-grey wood-smoke haze drifted from bamboo-stilted dwellings. Along the waterfront men worked like beasts, carrying great bales supported on bamboo poles up congested stairways on their sweating shoulders; everything people needed from machinery to food had to be transported by river-steamer or junk.

Canton (Guangzhou) with its Mediterranean climate presented yet another face of China. Bazaars displayed a great variety of merchandise, with brilliantly lit arcades and tea houses topped by huge neon signs. However, people's curiosity made drawing impossible. I worked surrounded by motley groups of pedlars,

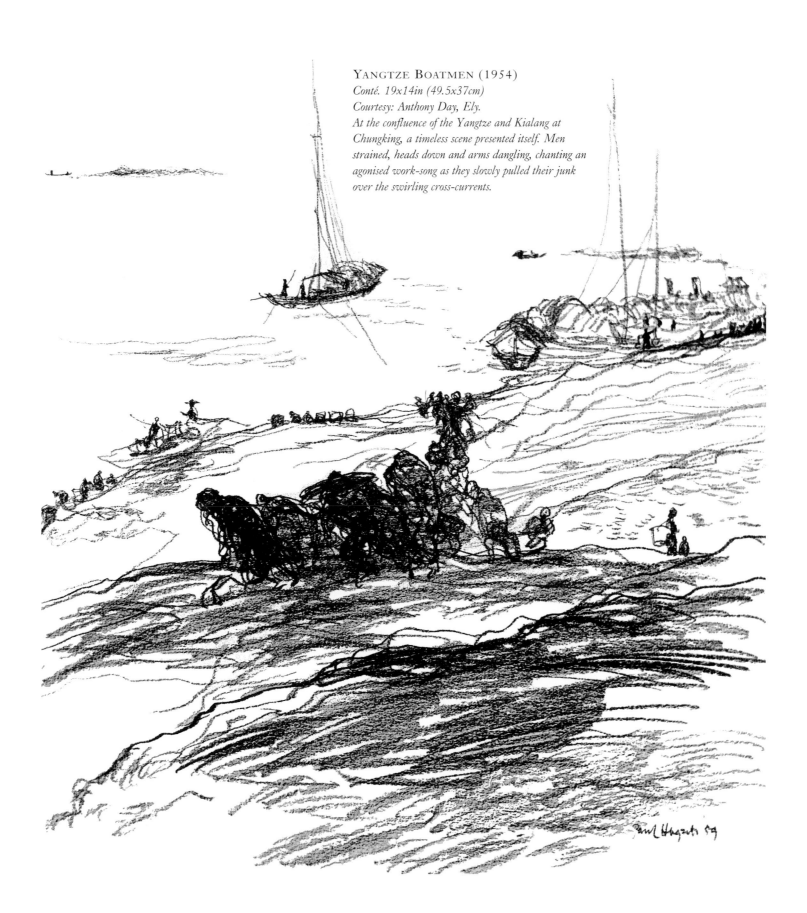

YANGTZE BOATMEN (1954)
Conté. 19x14in (49.5x37cm)
Courtesy: Anthony Day, Ely.
At the confluence of the Yangtze and Kialang at Chungking, a timeless scene presented itself. Men strained, heads down and arms dangling, chanting an agonised work-song as they slowly pulled their junk over the swirling cross-currents.

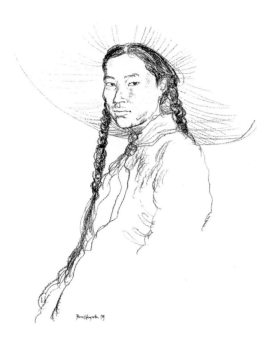

CANTON SCHOOLGIRL (1954)
Conté. 20x15in (51x38cm)
Courtesy: Michael Silver.
This 12-year-old girl pioneer, or girl guide, was
brought to my room one rainy day for a formal portrait
sitting. Quiet and self-controlled, of strong character,
she was an ideal, if inscrutable model. The drawing
was made in about an hour on bamboo paper.

muleteers, housewives and hordes of nimble, chattering children, who at that time had never seen 'a long nose', as Westerners were called.

On one occasion, desperate to escape attention, I entered a shop and took up my position behind the window. After only a few minutes, a mass of grinning faces were peering in through the window, obscuring my line of vision. I ascended a flight of steep, rickety stairs and continued drawing from a second-floor verandah, only to see the whole scene changed by a crowd of grinning faces leaning out of the tea house opposite.

Over a lunch of doves' eggs and baked carp, our hosts recounted anecdotes about the tribulations of artists in foreign lands. I recalled how Edward Lear usually attracted the attention of hostile village dogs; so much so, that he always kept a pocket of stones to drive them away. He had, however, to concede defeat in Macedonia, when a dog returned with a pack of 40 others, forcing Lear to climb a nearby tree to escape being torn to pieces. My artist-hosts, after listening to this cautionary tale, came up with the notion that I should work from inside a covered army truck, which was duly provided. I sat in its suffocating interior, peering through slits in the canvas, and somehow managed to complete my drawing.

Shanghai presented a completely different picture. We sped along wide, illuminated boulevards lined with the skyscrapers that had once been symbols of entrepreneurial capitalism. From my window on the fifteenth floor of the art deco Peace Hotel (formerly the Cathay) I gazed upon a vista of junks and sampans plying the river against a background of 1930s banks, department stores and office blocks, and recalled that Noël Coward, confined to his bed with influenza, wrote much of *Private Lives* there.

Hankow (Hankou), one of three cities together known as Wuhan, straddled the middle reaches of the Han and the Yangtze. One had the sensation of being on the edge of an ocean rather than hundreds of miles inland. Seen from the far bank, the city looked like the Venice of Whistler's drypoints. One evening, I drew a flotilla of tiny wooden boats as they moved against the setting sun. Ringed cormorants perched like hens on the boats. Now and then, they dived silently into the water, and returned with fish, which were deftly removed from the reluctant birds' beaks by watchful fishermen.

I returned to Beijing in late autumn. Leaves whirled about the streets and leaden skies threatened snow. I bought a blue padded suit, a heavy leather jacket and bushy fur hat to cope with the drop in temperature. At the Xinqiao Hotel, where some of us stayed on when the main party had left, the restaurant began to

SHANGHAI (1954)
Conté. 20x15in (51x38cm)
Courtesy: Jane Ritchie, London.
The vast flatness of the Yangtze prompted me to adopt a
Chinese-style composition. I drew this from my window
on the fifteenth floor of the art deco Peace Hotel built by
the cotton tycoon E. V. Sassoon.

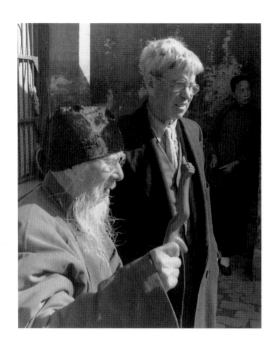

Stanley Spencer (right) believed that love could be found everywhere, even in Red China. Strangely enough, this view was shared by the celebrated Chinese painter Qi Baishi (left), whom we visited in Beijing. Courtesy: Denis Mathews.

assume the atmosphere of an exclusive travellers' club: among them the journalist James Cameron, Hugh Casson, the painters Denis Mathews, José Venturelli and Stanley Spencer, and the enigmatic Swedish man of letters, Artur Lundqvist.

Cameron, then a highly regarded foreign correspondent, had been covering the Liberation Day celebrations and other aspects of the New China. Many of my drawings illustrated his articles when they appeared in the London *News Chronicle* in November and December 1954. Hugh Casson, no less discerning, also expressed a wish to see my drawings. Not only was he keenly appreciative, but on his return to London he persuaded Hubert de Cronin Hastings of the *Architectural Review* to publish a lavishly illustrated essay by its art critic, Robert Melville, in August 1955. Melville praised 'the peculiar excellence' of my drawings, and concluded that if I managed to emblemise without making aesthetic concessions I would give topographical drawing 'a new *raison d'être*'.

Stanley Spencer, who also remained behind, had come to China at the behest of his mildly radical brother-in-law, the painter Richard Carline, and had arrived clutching a copy of William Blake's *Songs of Innocence*. He had not liked the journey and he didn't like China, but now he was engaged in making a series of Holbein-esque pencil portraits of Chinese officials. He had been provided with a servant who carried his paintbox and stool, and in this way he had painted the Ming Tombs and the Summer Palace Gardens. He also gave an informal talk about his work to an appreciative audience at the Central Academy of Arts, at which the Chinese took an immense liking to him. Ho informed me that Spencer possessed the same bemused charisma as their own elderly maestros, notably Chi-pai-Shih (Qi Baishi).

One day at lunch, a courier announced that we were invited to an audience with Zhou Enlai, then premier and minister for foreign affairs. Stanley, however, startled the courier by saying he had to take a nap and afterwards finish 'a rather important drawing'. He was sure that Mister Zhou 'wouldn't mind'. The courier looked most alarmed. Stanley reluctantly gave way after several bemused MPs grappled with this unexpected display of artistic temperament.

When we arrived, we were greeted by Zhou himself, who invited us to discuss our impressions of China. A somewhat embarrassed silence followed. Then, much to our astonishment, Stanley Spencer was heard to say that he lived in a typical English village called Cookham, a *real* and everyday world, where people loved one another. Love, Stanley added, could be found in China. Love should and could prevail everywhere in our world.

Zhou's wily face lit up on hearing Stanley's simple words. Unwittingly, Stanley had broken the ice, and however simplistic it must have seemed to a suave master-politico, the discussion began to get started. Zhou announced that he would be very happy to receive the Old Vic or the Sadler's Wells Ballet to the New China. As he went on to discuss the relative virtues of Oxford and Cambridge, I recalled that he came from a great Mandarin family. In his youth he had studied in England, France and Germany, and he possessed an inner serenity and sophistication that made him exceptional among the rough-and-ready henchmen of the Chinese Party establishment.

After three months of constant travel, during which I had worked for nine or ten hours producing eight to ten drawings each day, I was now exhausted physically and mentally. Yet my journey through this unusual and exotic country had reshaped my artistic taste. China itself – the landscapes, the people working on the land and the traditional way of life – not its revolution, had increased my visual awareness. I began to see subjects for their own sakes, rather than for their value as social comment. Although I continued to make Social-Realist drawings, I started to develop another side of my abilities. In particular, my work would now begin to celebrate the beauty of landscape.

MOVING ON (1955–57)

My later travels behind the Iron Curtain, to Romania and Bulgaria, although less adventurous, were to reach a dramatic climax in Warsaw in 1956.

In the autumn of 1955 I visited Romania with a cultural delegation, which gave me little time to work. I travelled with the journalist Montague Slater and his wife Enid, a talented photographer. Monty had worked on *The Times* and published several novels. He had also written the libretto for Benjamin Britten's opera, *Peter Grimes*. Dr Otto Samson, a curator of folk art at the Horniman Museum, and his wife, Elizabeth, were also in the group. In Bucharest we stayed in the plushy grandeur of the Athenée Palace Hotel, a flamboyant survival from the reign of Carol I, the Hohenzollern prince who became king in 1866. The rooms, once used by the gilded youth and women of easy virtue of the royal court, were now frequented by red-faced party officials in baggy suits and their stout wives in print dresses.

Outside Bucharest, the country retained a medieval look, enhanced by painted churches and tranquil villages encircled by high walls, while herdsmen,

WARSAW: I (OCTOBER 1956)
Hardtmuth lead. 17x14in (43x35.5cm)
Collection: the artist.
Despite the threat of Soviet military intervention,
a vast crowd gathered in front of the Palace of
Culture to express their solidarity with the Hungarian
freedom-fighters and their own demand for more
democratic government. The only concession they were
to get was a slightly less hard-line Communist régime
led by Gomulka.

AT WORK IN ROMANIA (1955)
Photo: Enid Slater. Collection: Paul Hogarth.
My visit to Romania lacked the challenge of Poland
and, in particular, China. By this time, I was
beginning to tire of drawing be-medalled party activists
who had distinguished themselves as heroes and
heroines of Socialist labour.

dressed in the style of their ancestors, tended flocks of sheep and goats. The narrow roads were crowded with peasants seated on low-slung wagons drawn by teams of scraggy horses or oxen, occasionally making way for truck, tractor or bus. Women were swathed in black shawls that covered most of their faces, while the men, often strikingly handsome, wore black or white cone-shaped astrakhan hats. And despite Hitler's attempts to exterminate the gypsies, a group would occasionally pass by in their gaily decorated caravans.

The following year, in October 1956, I attended the opening of a retrospective exhibition of my drawings and prints (covering the years 1949–56) in Sofia, Bulgaria. At these occasions, I would invariably be approached by artists – young and old – determined to leave the country, and hoping that I could help them. This time, it was Christo Javacheff, then 21, who asked about life in Britain. He longed to go there, but at the time it did not seem possible. Shortly afterwards, however, he managed to reach Prague, before making it to Paris and fame as the maestro of the wrapped building.

Bulgaria had the dash and colour of a Mediterranean country. Its people were friendly and excitable despite the rigours of the régime. Outside Sofia, an Arcadian landscape was punctuated by great stands of poplars growing along rushing rivers. Country towns such as Velicka Tirnovo, which had been the medieval capital before the Turkish conquest in the early 15th century, pulsated with life. Built on a huge escarpment overlooking a tributary of the Yantra, its crowded cafés and restaurants throbbed with violin music and folk song. I visited the nearby Preobrazhensky Monastery, a nineteenth-century reconstruction of a far older structure that had been pillaged and destroyed by the Turks. I gazed at the grave of J. D. Bourchier, an Eton schoolmaster and Balkans correspondent of *The Times* in the 1870s. Bourchier had supported the Bulgarians in their struggle for independence from the Ottoman Empire, and was the first Westerner to expose Turkish atrocities there.

I left Sofia by train and headed for Poland, via Hungary. I had no idea, however, that following the recent appointment of Imre Nagy's moderate government there, violent demonstrations were taking place on the streets of Budapest calling for democratic government, or that Soviet troops had already invaded the country in support of the deposed hard-line leader, Janos Kadar. By the time I arrived in Budapest a state of emergency had been declared in the country, and as no one was allowed to leave the train, I continued on to Warsaw to attend a Congress of the International Brigades.

I arrived on the morning of 25 October, just as huge demonstrations in support of the Hungarians were taking place. 'Welcome, you've arrived at a historic moment,' quipped my old friend, Jerzy Zaruba. 'Our revolution is beginning!' As our taxi threaded its way through animated crowds, Zaruba recounted the events that had followed Soviet premier Khrushchev's five-hour visit to Warsaw. We stopped at the editorial office of *Swiat* (*World*), an illustrated weekly, and *Szpilki* (*Pins and Needles*, the Polish *Private Eye*), where editors and staff listened with tears in their eyes to the grim accounts on the radio of the bitter street-fighting in Budapest.

By midday, the news had created an unprecedented display of popular support for the Hungarian freedom fighters. Trucks roared along the Marzalkowska jammed with workers and students waving Polish and Hungarian flags. The government of Boleslav Beirut, the hard-line Stalinist Polish premier, had resigned, and by mid-afternoon, 150,000 people had gathered in front of the Palace of Culture and Science. Suddenly, the slogan-chanting multitude swept across the front of its great façade. Rumours had spread – true, it turned out – that units of the Soviet Army had surrounded Warsaw with tanks. Khrushchev had threatened military intervention. It was an inspiring spectacle of protest that I drew rapidly in my pocket sketchbook.

Eventually, Khrushchev agreed that the more moderate Wladyslaw Gomulka be released from gaol to form a new government. Then Gomulka himself appeared to roars from a large section of the packed square. Satisfied, they then dispersed to the accompaniment of the *Internationale*. An equally large crowd demanding complete democratisation stood its ground – but not for long, as squads of riot police launched a series of savage and brutal attacks, driving people before them like shepherds driving sheep.

Stormy scenes were also taking place at the Congress of the International Brigades. Russian observers were being challenged by Polish and Hungarian delegates to produce *their* heroes of the Spanish Civil War. According to one embittered Polish delegate, they had all been executed on the orders of Stalin. Only in Warsaw, at this conference, did I realise that the destructive activities of the Communist Party reported by Arthur Koestler in *Spanish Testament* in 1937 and George Orwell in *Homage to Catalonia* in 1938 were, in fact, all too true!

At the bar of the Hotel Bristol, the week's events had given the foreign press corps, as well as myself, much to think about. Basil Davidson of the *Daily Herald*, Mark Arnold Foster of the *Guardian*, and Nicholas Carroll of *The Sunday*

THE PREOBRAZHENSKY MONASTERY, RILA, BULGARIA (1956)
Conté. 20x25in (51x28cm)
Courtesy: Peter Elstob, London.
The huge old monastery provided welcome relief from drawing Socialist endeavour.

WARSAW: II (OCTOBER 1956)
Hardtmuth lead. 14x17in (35.5x43cm)
Collection: the artist.
A large crowd demanding complete democratic
government was brutally dispersed by police riot squads.

Times were every bit as stunned as the newsmen from the world's Communist press, such as Gordon Cruikshank of the London *Daily Worker*. When Davidson remarked that 'it was difficult to imagine this happening in England', I realised I had nurtured too many illusions. I had always found it difficult to swallow the myth of the Soviet Union as the beacon of aspiring mankind. One way or another, during my travels behind the Iron Curtain I had picked up bits of the truth, yet I had forbidden myself total disbelief. Now, in Warsaw, I reached the point when I should speak out. But to whom?

I then thought of Robert Harling, editor of *House and Garden* and design consultant, for whom I had written and illustrated various articles. He also worked for the London *Sunday Times* as a consultant. He must have been aware that one day I would have a story to tell, and he had always kept in touch. I have since learnt that he had contacts with MI6. I called Harling from Warsaw, and he put me on to *The Sunday Times* newsdesk. Feeling like Judas, I dictated an eyewitness account of the events in Warsaw to a news editor, and it appeared on the front page on the very day I returned to London.

Inadvertently, I had been witness to the first cracks that appeared in the façade of the Soviet Empire.

TO RUSSIA WITH AN EXHIBITION (1954–57)

My first visit to Russia took place in the summer of 1954, when I was en route to China. I spent five days in Moscow, where I found not the future, but a visually fascinating past of *belle époque* hotels and department stores, gold-topped cathedrals and ornate office blocks. This impression was reinforced on my second visit, in December that same year, when I took up an invitation that I had received in Beijing from the Soviet Society for Cultural Relations with Foreign Countries. I was flown to Moscow and given a splendid room at the Hotel National with a stunning view of Manezh Square and the Kremlin.

I spent the next few days viewing huge exhibitions reminiscent of Royal Academy Summer Exhibitions of a century ago. I visited the Kremlin and gazed upon the embalmed face of Lenin in Red Square. In the Tretyakov Gallery I ploughed through acres of ponderous historical pictures. I met one academic painter or sculptor after another, but never any of the artists who really interested me, such as Aleksandr Deineka, Yuri Pimenov and others of the *Ost* group, or members of the Society of Easel Painters of the 1930s. Deineka, in particular, had been influenced by the Italian Futurists and felt that Futurism provided a better basis for Soviet art than the academic tradition of the nineteenth century, but was criticised for his 'modernism' and 'formalism'. These artists were, I was informed, 'too busy', which meant they were not approved to receive foreign visitors.

My irritation vanished, however, on being shown the incredible hoard of French Impressionist and Post-Impressionist paintings accumulated by the Morozov brothers and Sergei Shchukin, on view at the Pushkin Museum in Moscow and the Hermitage in St Petersburg (Leningrad as it was then). I was also able to sneak a day in the labyrinthine Saltykov-Shedrin Library leafing through their definitive collection of the satirical periodicals of the 1905 Revolution. My evenings were usually spent at the opera or ballet, which engendered a life-long affection for Russian classical music. I attended impressively old-fashioned performances of Tchaikovsky's *Eugene Onegin*, Mussorgsky's *Khovanshchina* and Glinka's *Ivan Susanin* (*A Life for the Tsar*) at the Bolshoi, and I also saw the great Galina Ulanova give an electrifying performance in *Giselle*. The theatre, I decided, was what sustained me through my unrelenting agenda.

It was time to visit St Petersburg. I was given a first-class berth on the Red Arrow night express, which I shared with a fair-haired, blue-eyed giant of uncertain age. With great diffidence, I was introduced to Nazim Hikmet,

the celebrated Turkish communist poet whose trial and imprisonment was a *cause célèbre* in the 1950s. Hikmet had been accused of inciting the Turkish navy to mutiny, and spent 18 years in prison, where he was brutally treated. After a worldwide campaign, he was given his freedom and had accepted asylum in the Soviet Motherland.

Hikmet at once reminded me of Randall Swingler. He had the same haunted, disillusioned look of a man who had lost faith. The minder spoke to him in Russian; perhaps he did not know that Hikmet spoke fluent English. After the minder departed, we talked, mostly about my impressions of China and the Soviet Union. 'Ah yes, China,' he sighed. 'It's different there!' About Russia, however, he made no comment.

We were met at the Moscow Station in Leningrad and driven to the luxurious Astoria, *Moderne* in style and the best hotel in the city. During our three-day stay, we frequently dined together. On one memorable evening we attended the première of Prokofiev's *Romeo and Juliet* at the Kirov Theatre. Almost as memorable, however, was Hikmet confiding his disillusionment with the Soviet régime. 'You must not believe all you have been told!' he concluded. 'This is no paradise!' Little did I realise how much of an understatement this was.

Back in Moscow, I met the poet and writer Ilya Ehrenburg, who looked more like a melancholy columnist than a disillusioned idealist. Yet, like Hikmet, he too had visited China and was optimistic about its future. He had expressed great interest in my visit, and told Ralph Parker, Moscow correspondent of the London *Daily Worker*, that he would like to see my drawings. He and his wife, Lyubov Mikhailovna, a painter, lived in a vast apartment on the top floor of an enormous pre-Revolutionary block off Gorky Street. Every inch of wall space was hung with drawings, prints and paintings by Picasso, Léger, Matisse and Modigliani. In addition there were icons, Chagalls, and several interesting canvases by a close friend, Nathan Altman, a Russian painter of the 1920s who thought that Socialist-Realism should have taken the form of Futurism and whose outspoken criticism of Soviet art policy led to his being ignored by the Soviet art establishment.

Madame Ehrenburg received me with Russian warmth tempered by Parisian grace. She was sympathetic and discerning, and looked through my portfolios of drawings with respectful curiosity. I suspected that they were not to her taste, but so great was Russian fascination with China at the time that she found them an absorbing chronicle. Halfway through, she became impatient.

Ehrenburg had not yet made an appearance and she shouted to him to join us. Shortly afterwards, he shuffled in from his study and greeted me with a friendly handclasp. That very day, an article by me attacking Abstract Expressionism had appeared in *Soviet Culture*, an influential weekly. Abstract Expressionist work was making such a big impression on the London art scene that figurative painters felt neglected as a result, and I wrote about this dilemma. Ehrenburg, however, considered the abstract painters to be the true realists, their work representing a degree of artistic freedom forbidden in the Soviet Union, where artists and writers were told what to do and what to write. 'You have done a great deal of harm,' admonished Ehrenburg, 'by writing such an ill-advised article.' In his opinion I was betraying the interest of genuine art in the Soviet Union, whereas as a Westerner I should be defending it.

I made my third visit to Russia in May 1957. By then, following Khrushchev's revelations of the excesses of the Stalinist régime, made in his

MONASTERY OF THE HOLY TRINITY, ZAGORSK, USSR (1954)
Hardtmuth leads. 23x18in (59.5x46cm)
Courtesy: Ms Haseldon, Wrotham, Kent.
Zagorsk (formerly Sergiyevo) was the Canterbury of Russia during the reign of the Tsars. Within the candle-lit interior of the Holy Trinity, however, nothing had changed: wrinkled babushkas chanted hymns and kissed the hands of heavily-bearded priests.

THE OPENING OF 'LOOKING AT
PEOPLE' WHITWORTH ART GALLERY,
MANCHESTER (AUGUST 1955)
*Betty Rea (left), myself (centre) and Carel Weight
(right). Courtesy: Manchester Evening News.*

'secret' speech in February 1956, and after the brutal Soviet suppression of the Imre Nagy government in Hungary and the intimidation of the Poles in the autumn of 1956, I had become disenchanted with the Soviet régime; but I believed that cultural exchange with the Soviets could contribute to détente, and possibly, in time, help to bring about the liberalisation of the régime. This conviction led me to accept an invitation to the opening of an exhibition in Moscow of contemporary British art entitled 'Looking at People'.

I had devised 'Looking at People' in the spirit of the old Artists' International Association theme shows of World War II. Figurative art in the 1950s was being swamped by the New York School, and something had to be done to defend it. The sculptor Betty Rea and the painter Carel Weight, long-standing members of the AIA, and the art critic John Berger (who wrote the introduction to the catalogue), agreed to participate. We decided to take people as our theme and planned an exhibition of paintings, sculpture and drawings to open, if possible, in a big provincial gallery, in the hope of arranging a nationwide tour later. In August 1955, 'Looking at People' had its première at the Whitworth Art Gallery, Manchester. Within a few hours, we had sold over a third of our works, and the exhibition broke all attendance records there.

Before the exhibition went on tour, I decided to widen the range of work on show by including two more painters: Ruskin Spear, who worked in the tradition of Manet and Sickert, and Derrick Greaves, who represented the controversial

'Kitchen Sink School'; also Edward Ardizzone whose drawings demonstrated great affection for people; and Alistair Grant, then producing Bonnard-esque lithographs of everyday life. A third sculptor was needed, and I had the youthful temerity to call on Jacob Epstein. Although he was attracted to the idea, his formidable wife, Kathleen Garman, put her foot down. At the suggestion of John Berger, the pugnaciously talented George Fullard took Epstein's place.

By the summer of 1956, the exhibition had been seen by 250,000 people throughout Britain. It had aroused sympathetic media coverage, and after I had received an official telegram from the Union of Soviet Artists to send the exhibition to Moscow, there was even more publicity. I approached Geoffrey Cox, then chief editor of ITN, who ran an extended item after *News at Ten*, which had great impact on both the Russians and the attendance figures.

Not all coverage was sympathetic, however. 'These pictures,' growled the celebrated columnist Hannen Swaffer in the *Daily Herald*, 'won't help Britain. I praised Ruskin Spear's social satires when I saw them in the Royal Academy. But in Moscow and Leningrad where they are bound, his *Success Story* as bitter criticism of a profiteer and his overdressed wife will obviously incite the comment, "Ah, we knew capitalism was like that!"' 'Edward Ardizzone,' Swaffer continued, 'has contributed three tarts on the prowl in *Evening in Soho*. Carel Weight includes *Anger*, a street fight between gangsters, one of whom is attacking the other with an axe! They call the show "Looking at People". I hope the Russians won't call it "Lenin Proved Right!"'

Ruskin Spear, Derrick Greaves and I attended the opening in Moscow. Spear was a piratical-looking personality not unlike Long John Silver in appearance. I had long admired his strongly drawn portraits of publicans and

THE OPENING OF 'LOOKING AT PEOPLE' AT THE PUSHKIN ART MUSEUM, MOSCOW (1957)
Ruskin Spear (left), myself (centre) and Derrick Greaves (right) lead a milling throng up an enormous red-carpeted staircase, at the top of which hung a broad red ribbon. The three of us joined hands to cut the ribbon in a symbolic gesture. In the background (centre) is Konstantin Yuon (1875–1958), a Russian Post-Impressionist painter.

sinners, usually set in one of his favourite Hammersmith pubs. Derrick Greaves, the youngest in the group, was a counterpart of Jimmy Porter, the archetypal 1950s anti-hero of John Osborne's play, *Look Back in Anger*. At this time, his work was derived from the day-to-day events taking place in his family life. Russian embassy officials were deeply shocked by his nine large canvases which chronicled explicitly the pregnancy of his wife Johnny and the birth of their son, Simon. Derrick was asked to replace them with less 'offensive' pictures, but this he rightly refused to do, and I backed him up, until eventually the Russians relented.

Ruskin, Derrick and I arrived in high spirits, and were given a palatial suite in the newly built Hotel Leningradskaya, probably the world's most hideous skyscraper. Although in many respects this visit resembled that of 1954, it was also different. Instead of the usual humourless minder, we had Nikita Sannikov, the handsome 29-year-old son of the Symbolist poet, Boris Sannikov. He was quick-witted and endowed with a great sense of humour equal to his mastery of colloquial English, and we grew immensely fond of him.

The opening took place at the Pushkin Museum of Fine Arts, or Museum of Western Art. An array of bureaucrats and diplomats were present, including a bemused Cecil Parrott, the *chargé d'affaires* of the British Embassy, and I had prepared a speech for the occasion. 'We have been moved,' I heard myself saying, 'by the fact that artists as well as statesmen can and are able to contribute to international understanding.' Vociferous applause greeted these words.

'Looking at People' closed three weeks later. Over 100,000 Muscovites had seen the show and filled three books of comments with every degree of insult or praise. '"Looking at People" – all right,' wrote one enraged visitor, 'but why distort them?' 'These pictures,' wrote another, 'have made me sick and I regret the time I spent here.' There were many in favour, however: 'To those who write insulting remarks,' scribbled a supporter of the British side, 'I want to say if you wish for naturalism then look at colour photographs. Here is a breath of fresh air!'

Although none of us was avant-garde, our work appeared to the Soviet public no less novel than an exhibition of Post-Impressionism would have been to Londoners half a century earlier. It transpired later that 'Looking at People' had added fuel to the flames of a long-fought battle between the ultra-conservative art establishment and those hungry for contact with Western ideas and with a keen interest in creating a modern, non-academic Russian art. In 1957, that struggle was far from being resolved. So much so, in fact, that the Leningrad venue was suddenly cancelled without an explanation or apology.

At Home in England

AFTER MY EARLY TRAVELS AND MAGAZINE JOURNALISM IN THE LATE
1940S, I TURNED TO TEACHING TO SUPPORT MYSELF. THE MONEY WAS
POOR, BUT THE CONTACT WITH FELLOW ARTISTS AND, OCCASIONALLY, WITH
MORE TALENTED STUDENTS, RELIEVED THE TEDIUM OF THE CLASSROOM
AND PROVIDED SOME INTERESTING INTERLUDES.

ART TEACHER (1950–54)

MY FIRST teaching stint, at the Guildford School of Art in 1950–51, is best
forgotten. I spent more time browsing in the bowels of Thomas Thorp's
celebrated bookshop in the High Street than with my largely diffident students,
who had little interest in becoming professional artists. Albums of drawings by
Randolph Caldecott, John Leech, Phil May and Charles Keene, as well as
Gustave Doré's *London,* were to be had for a few shillings, and I lost no time in
acquiring such treasures.

My second post, at the Central School of Arts and Crafts in London, from
1951 to 1954, proved more demanding and more enjoyable. The 'Central', then
in its heydey, offered a great variety of courses taught by a large and diverse group
of practising artists and craftsmen. Besides teaching my own classes in
illustration, I took the opportunity to acquaint myself with etching and
lithography under the guidance of W. P. Robins and Ernest Devenish.

Jesse Collins ran the Illustration Department with a light and congenial
touch. Besides myself, his tutors included John Minton, Mervyn Peake,
Laurence Scarfe and Keith Vaughan. Other members of the part-time staff
included Victor Pasmore, Eduardo Paolozzi and Louis le Brocquy. Pasmore
solemnly assured me that as the Impressionists had all been Communists, I was
in good company. I hadn't the heart to tell him that only Camille Pissarro had held
left-wing opinions. On the cue of the morning coffee break, Paolozzi would
emerge grunting from the basement world of the Ceramic Department, looking

ILLUSTRATION FOR CHARLOTTE
BRONTË'S *JANE EYRE* (1953)
Hardtmuth charcoal leads and ink wash. 1953.
15x10in (38x27.3cm)
Mlada Fronta, Prague 1954.
Collection: the artist.
Jane Eyre *was the first English classic I illustrated,*
even if it was for a publisher from 'behind the Iron
Curtain'! All went smoothly, however, and not only
did it go into a second edition, it was also published in
Slovak and Romanian.

like the engineer of a surreal ocean liner. Le Brocquy, expansively Irish, related rambling stories, usually set in the art world of his native Dublin, where he ruefully confessed, 'no one had even two pound notes to rub together'.

For the most unpolitical of reasons, my trips behind the 'Iron Curtain' aroused much interest among my colleagues, if not my students. At the time, artists found it especially frustrating not to be free to venture abroad, £25 then being the maximum sum that could be taken out of post-war Britain owing to currency restrictions. The principal of the school, the distinguished Scots painter William Johnstone, was very curious indeed. During my increasingly frequent absences Jesse Collins had good-naturedly arranged substitutes to do my teaching, but, on reading in his newspaper that I would be leaving for China in September 1954, Johnstone summoned me to his office. He came straight to the point. 'Either,' he said in a not unfriendly manner, 'ye arrange for me to be invited to China, or indeed to any of those damned countries, or I'll have to ask ye to resign.' I did my best, but without success, so my days at the Central ended, just as those at the magazines had done.

COUNTRY LIFE (1953–59)

My first marriage had ended in 1946, and between my teaching stints and travels behind the Iron Curtain, I got married again, this time to Phyllis Hayes (née Pamplin). We had met on the embassy circuit in London, where Phyllis worked as a journalist for the Hungarian News and Information Service. She longed to live in the country and have children, and in 1953 I borrowed £500 and took out a mortgage on a house at Little Maplestead, on the borders of Essex and Suffolk, between Halstead and Sudbury.

The Red House resembled a Kate Greenaway illustration. Its bow-fronted windows and mellow red-brick walls matted with ivy dated back to the middle of the eighteenth century. It was on a quiet country lane, almost hidden by an ancient box hedge. A huge chestnut tree stood beside a small croquet lawn, and there was a square-shaped orchard and vegetable garden at the back. Phyllis and I lived here until our divorce in 1959, but alas, we did not have any children.

I had a large and pleasant studio on the top floor of the house with fine views across a peaceful landscape, and I turned to book illustration for a living, thus beginning a more contemplative phase in my life. The Czech publishers Mlada Fronta and the State Publishing House for Children's Books (SDNK)

asked me to illustrate Charlotte Brontë's *Jane Eyre* (1954) and Charles Dickens's *Pickwick Papers* (1956). This subsequently led to my illustrating Conan Doyle's *Adventures of Sherlock Holmes* for the Folio Society (1958) and Rider Haggard's *King Solomon's Mines* for Penguin (1958).

Once or twice a day, I cycled to the nearby Cock Inn to enjoy a pint of beer and a chat with my old mentor, Randall Swingler, who lived at 'Mount Pleasant', his cottage near Pebmarsh. Bill, the landlord of the Cock, enjoyed the talk of those he called 'bowemians' – so much so, that he gave us unlimited credit and cashed our cheques. Not surprisingly, the number of 'bowemians' in the area increased dramatically as a result, providing diverse, but not always entertaining company that included the painters Michael Ayrton and Isabel Rawsthorne; the composers Christian Darnton, Alan Rawsthorne, Humphrey Searle and Bernard Stevens; the writers Louis MacNeice, Jack Lindsay, Edgell Rickword, W. R. (Bertie) Rodgers and Maurice Richardson, as well as actors, musicians, producers and editors such as Mark Dignam, James Gibb, R. D. Smith and John St John.

'Mount Pleasant' and The Cock became the focal point for impromptu entertainment, and MacNeice, James Gibb, Humphrey Searle and R. D. Smith endured the most primitive accommodation as weekend guests. Occasionally, Randall would respond to an unpredictable urge to return such visitations. I had acquired a white pre-war Austin Twenty saloon, known as 'the White Lady'. With Randall ensconced in the back, we visited an ever-widening circle of friends in the remote villages of East Anglia, where I encountered celebrated writers, critics and composers. Perhaps the most memorable was Nancy Cunard, who then lived in Paris but frequently visited England. At sixty, she remained tall, elegant and compellingly attractive, resembling a depraved flapper drawn by Felicien Rops, the Belgian painter who portrayed women as flawed goddesses. I longed to draw her, but simply could not draw such people in those days.

During 1958, scenting fresh prey, more hardened Soho-ites moved into East Anglia. These included the Scots painters, Robert Colquhoun and Robert MacBryde. They were a bellicose pair who had known the good times, but were now finding the going harder. Unable to find accommodation near The Cock Inn, they eventually settled in a medieval weavers' house in Kersey.

In time, two fellow-Scots, the painters William Crozier and Pat Douthwaite, came down on weekend visits. Finding life cheaper, they too settled near Pebmarsh. Pat at once endeared herself to me, and we became lovers. With

ILLUSTRATION FOR 'A RULER OF MEN', SELECTED SHORT STORIES OF O. HENRY (1960)
Hardtmuth charcoal leads. 14x10in (35.5x25.5cm)
Courtesy: Folio Society. Collection: the artist.
The Czech editions of Jane Eyre *and* Pickwick Papers *got me* O. Henry, *my first commission from the Folio Society.*

'THE AFTERMATH OF THE BLACK
PLAGUE' (1961)
Ink drawing with mechanical tint. 7x5in (19x14cm)
East Anglian Magazine, *July 1962. Private
collection.*
*During the winter of 1960–61 times were hard, and
poverty compelled me to take whatever I was offered.
On this occasion, I was asked to illustrate a feature
article for the (now defunct) Ipswich-based* East
Anglian Magazine. *I thought I had reached the rock
bottom of my career when I was paid £3 for the above,
but I was so wrong! Charles Rosner selected it for an
enthusiastic article on my work for* Graphis (103,
1962), *then required reading for art directors world-
wide. I was summoned to the New York office of* Life
Magazine, *where Bernie Quint, then art director,
liked it so much that he commissioned me to illustrate
a special Shakespeare number! I was to draw the
events in the Bard's life in celebration of the 400th
anniversary of his birth (see pages 58–9). 'Your little
illustration,' said Quint 'had the essential feeling for the
period.' I was paid $20,000 for 16 pages of paintings;
enough then not only to pay my debts, but also to buy
both a new house in Cambridge and a new car.*

the support of the Swinglers, she encouraged me to break finally with the increasingly tyrannical Phyllis, whose latest edict – a complete ban on working with hard-drinking writers, including the Irish writer Brendan Behan, whom I had met in 1958 – proved the last straw. Seeking pastures new, I eloped with Pat in the spring of 1959 and set up house with her in a rambling old farmhouse at Stansfield, near Bury St Edmunds. Life at once became difficult after I gave Phyllis the Red House and agreed to provide for her.

CAMBRIDGE AND THE ROYAL COLLEGE OF ART (1959–71)

Pat and I had to live on £7 a week, but not for long, as teaching again came to the rescue. Alec Heath, the new principal of the Cambridge School of Art, invited me to organise a graphic arts department. I agreed with enthusiasm as I now felt I had much more to teach. I recruited my team with care: the animal illustrator John Norris Wood prepared first-year students with a course in tactility. I taught drawing, as did the garrulous Bobbie Hunt, who gave sharp critical assessments of the students' work. Edward Middleditch taught printmaking.

Our aim was to give the students a strong graphic vocabulary in which drawing was paramount. For more than two years we worked at fever pitch with a most receptive group of students that included Roger Law and Peter Fluck of *Spitting Image* fame; Julian Allen, who moved to New York to revive the lost art of illustrating the news; Deirdre Amsden, who later married Roger Law, and 'Big John' Holder. With its large community of students, Cambridge seemed a vitally important place for an art school to be, but the full-time staff of local artists were not aware of this. Even more baffling was their lack of encouragement to those students who were interested in working with undergraduate editors and writers. This was put right, however, when another of my more talented students, Wendy Snowden, then girl Friday to the actor and comedian Peter Cook, introduced Roger Law and Peter Fluck to the turbulent world of varsity journalism.

By 1962 I had more or less handed over the running of the department to others. I was getting more and more work, and over the next two years trips to America and a sojourn in Majorca intervened in my teaching career. Then, in 1964, I was invited to talk about my work at the Royal College of Art in London. Over lunch Richard Guyatt, professor of the Faculty of Graphic Arts, invited me to join his staff as a senior tutor: the news of my success in turning Cambridge

School of Art around had reached him. I was to follow Edward Bawden, he said, as *éminence grise*. It was an offer I could not turn down.

I continued living in East Anglia, and commuted to London. If only for two days a week, the job gave me further opportunities to share my passion for drawing and to establish illustration as an art in itself to more generations of talented students. Between 1964 and 1971, these included Philip Castle, Adrian George and Nigel Holmes, and later on, Linda Kitson, Glynn Boyd Harte and Paul Cox. I re-introduced the human form as a living theatre that could be depicted with imagination and fantasy. Dancers, midgets, dwarfs, unemployed actors and Chelsea pensioners enlivened many an afternoon. One of the more memorable models was Daisy, a beguiling midget lady who loved to dress up as a fairy in a diaphanous tutu complete with wings. Word got round and one day, David Hockney, also a visiting tutor, stuck his tousled peroxide-blond head around the studio door. 'May I,' he cried, 'drore yore meedgeets too?'

The Royal College of Art at that time was an élitist institution, but year after year it produced an impressive harvest of creative talent. Moreover, it was a congenial place to meet one's colleagues. Under the benign and civilised eye of Robin Darwin, the Senior Common Room flourished as a sort of South Kensington outpost of the Garrick Club: a cultural hub where distinguished figures in the arts could be encountered on any given day. The high point of the academic year was, of course, Convocation Day, which Robin Darwin transformed into an event comparable to those at Oxford and Cambridge universities. Before the great occasion, departmental banquets were held. The more successful students were invited, and seated beside professionals who could be of help in their respective disciplines. On the day itself, a trumpet chorus from the Household Cavalry would announce the arrival of Prince Philip, or some such dignitary, who would start the proceedings with a brief, high-powered address, usually followed by the puckish eulogies of Sir Hugh Casson, who performed the role of orator. Then, after graduating students had received their degrees, staff and students mingled in the great marquee; strawberries and cream were served to the popping of champagne corks and the lilting strains of a baroque ensemble.

LONDON À LA MODE (1964–70)

By the middle of the 1960s, as post-war austerity was replaced by the pursuit of pleasure, London took on the riotous gaiety of the age of William Hogarth.

PAT DOUTHWAITE HOGARTH WITH FAGIN (CAMBRIDGE CA 1966)
Photo: courtesy Nathan Silver. Collection: the artist. When this was taken, Pat and I (now married) were living in Cambridge at Highsett, Hills Road.

THE BURNING OF THE GLOBE
THEATRE (1964)
Conté, ink and watercolour. 20x30in (51x76cm)
Courtesy: Life Magazine, *Time-Life Inc.*
Collection: the artist.
To illustrate this fateful episode in the life of
Shakespeare, I divided the crowd into the terrified
audience rushing from the burning theatre; the fire-
fighters running towards it; and the static throng of
spectators enthralled by the spectacle. Although the fire
was reported to have blazed wildly, everyone escaped
unscathed except one man, who had to douse his
burning breeches with a flask of ale. This was too good
to miss, so I brought him into the foreground.

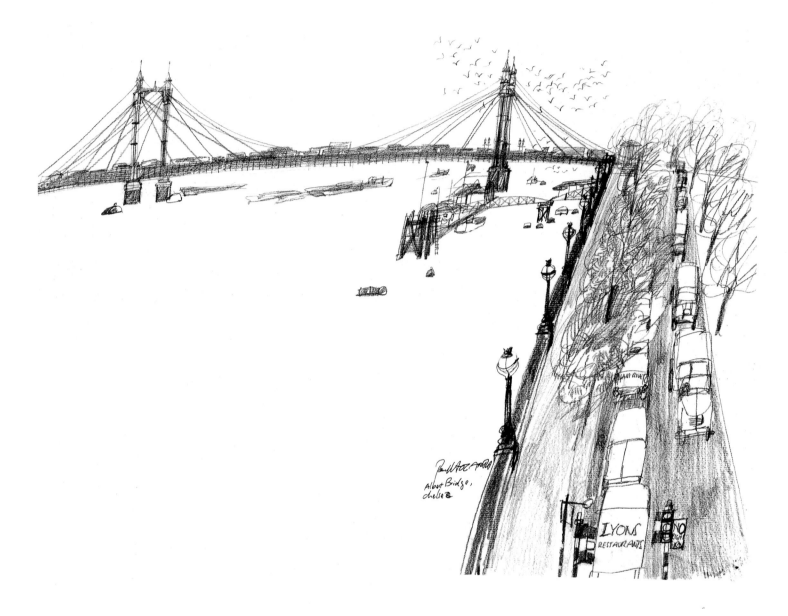

ALBERT BRIDGE, BATTERSEA, LONDON
(1966)
Faber 702 sketching pencil. 20x25in (51x63.5cm)
Courtesy: Dr Richard and Margaret Oddy, Cumbria.
Early morning traffic crosses one of London's more
elegant bridges. The almost oriental grace of suspension
bridges makes drawing riverscapes a delightful task.

Strip clubs proliferated, and within their smoke-filled interiors industrious apprentices watched the girls gyrate. It prompted me to revive the convention of *Points du Jour* or 'Times of the Day' as a way to comment on this changing face of London: morning, noon, evening and night for an album entitled *London à la Mode* (1966). I couldn't think of anyone better qualified to write the text than the journalist Jeffrey Bernard. But David Herbert of Studio Vista, the book's publisher, thought he was not famous enough and preferred Malcolm Muggeridge. Malcolm contributed an incisive introductory essay, but was less than fascinated by the subject. And now, having long since reached his age at that time, I can well understand his reservations.

It was a time when every kind of popular music made an appearance. Country and Western had its British debut at Ken Collyer's Jazz Club in Great Newport Street. The Flamingo, a cellar discothèque in Gerrard Street, was just the opposite, no lights and a throbbing beat that galvanised all on entry. I also spent many nights at The Establishment in Greek Street, the satirical nightclub modelled on those in Berlin during the days of the Weimar Republic.

As I was only in London for part of each week, I ate out regularly. One especially popular place at that time was a small upstairs restaurant run by Gaston Berlemont above the York Minster in Dean Street, better known as the French Pub. Gaston, who provided this additional facility for his more favoured clientèle, did the marketing himself. He had a remarkable, if eccentric, staff. Besides his

CHELSEA FLOWER SHOW (1966)
Faber 702 pencil. 17x12in (43x30.5cm) Private collection.
Not an easy drawing to make – there was hardly room to take out a sketchbook, let alone draw in one. I began by following the movements of the crowd, building up the drawing by selecting one figure of each type to give maximum variety and reveal the social nature of the event.

CHRISTIE'S AUCTIONEER (1973)
Watercolour over pencil. 16x11in (40.5x30cm) Collection: the artist.
London life has changed dramatically since Henry Mayhew and Charles Dickens walked its streets and observed the immense variety of odd but always intensely human characters. But has it? Not all, I discovered on this assignment, had vanished into the limbo of history. 'The fascinating thing,' wrote Lawrence Durrell, 'is that Dickens's characters still haunt London'. ('People of London', Illustrated London News, *May 1973–April 1974.*)

SATURDAY AFTERNOON, CARNABY STREET, SOHO

12x17in (30.5x44.5cm)
Private collection.
Once described by Dickens as 'bygone, faded, (and) tumbledown', the Mecca of fashion and music in the 1960s was sold in 1996 for £90 million. At the time I made this drawing it was home to 'Mod' boutiques, whose regular clientèle included the Beatles, the Rolling Stones, the Kinks, the Who and Frankie Vaughan.

CHELSEA PENSIONER

Watercolour over pencil. 16x11in (40.5x30cm)
Private collection.
Dickens's characters may still haunt London, but this does not mean they always consent to be drawn. Chelsea pensioners are especially elusive, but I obtained his permission after crossing his palm with silver! ('People of London', Illustrated London News, *May 1973– April 1974.)*

volatile chef, whom we never caught sight of, was a pair of elderly waiters who always wore shabby black jackets together with ankle-length, dingy white aprons. Louis, a Swiss-Italian, was slow but sure while Tony, a Swiss-German, had shaky hands, on which bets were made as to whether or not you would get all the soup you had ordered.

Lunch, served bistro-style to a maximum of a dozen or so people, was invariably excellent. On any given day, Lionel Bart, James Boswell, Jeff Bernard, John Davenport, Daniel Farson, Frank Norman, Alan Rawsthorne and Maurice Richardson could be seen enjoying succulent steaks, accompanied by the appropriate burgundy or claret, not generally available below the stairs.

One day we were startled to learn that Tony had won £9,000 on the pools, a huge sum in those days. He promptly informed Gaston that he 'was off' and disappeared. Six months later, however, he returned broke, and asked for – and was given – his old job back. Possibly because of this temperamental pair, Gaston reluctantly decided to close down his much-loved restaurant in 1965. Even more reluctantly, Louis and Tony took their leave, never to be seen again.

Over the years, Louis had saved his tips, and this now sizeable nest-egg decided the old waiter that it was time to return to his native village in the Ticino where, as was the custom, his wife and now grown-up children had long awaited his return. But he never made it – at least not with his savings. *En route* he passed

'THE FRENCH MAID' SOHO STRIP
CLUB (1966)
*14x17in (35.5x43cm) sketchbook of Ingres paper
and Faber 702 pencil*
Private collection.
*Strip clubs are usually crowded; they play to every
pocket. I went early to get a good seat – essential to
catch the rapid movement with any quality of line
in the semi-darkness, but not too near to be noticed by
the strippers.*

GARRY FARR AND THE T-BONES (1966)
Collection: the artist.
*Another sketchbook drawing made with a Faber 702
pencil at great speed at a Soho discothèque.*

YOUNG THIEF AND HIS INCREDULOUS
MOTHER ARE VISITED BY A PROBATION
OFFICER (1975)
One of a series drawn in a 12x10in (30.5x25.5cm)
sketchbook with a Faber 702 pencil.
Courtesy: Central Office of Information, London.
Like most big cities, London has its fair share of crime.
This assignment for the Home Office plunged me into
a series of human dramas involving the work of the
Probation Service, then faced with a shortage of
recruits. Rather than the traditional probation officer,
usually a fatherly ex-policeman, the Home Office was
anxious to recruit social-science graduates, idealistic
young men and women willing to work like
missionaries, their main purpose being to give their
charges a realistic chance to go straight. (The
Probation and After-Care Service in a Changing
Society, *HMSO, 1977.*)

REX JAMESON AS 'MRS SHUTTLEWICK'
IN PERFORMANCE AT THE MOTHER
REDCAP TAVERN, CAMDEN TOWN
(1973)
16x11in (40.5x30cm)
Courtesy: John Hedgecoe, Oxnead Hall, Norfolk.
Drawn for 'People of London' but not published.
At the time, Middle England wasn't ready for
female impersonators.

through Paris, where he spent them all in one week carousing and whoring with the girls of Les Halles. Finally, with little more than a few pounds in his pockets, he arrived home to the bosom of his family. As far as we know, all was forgiven, and he spent the last few years a poor but contented man.

On some evenings after the pubs had closed, I would go with Randall Swingler or Bobbie Hunt to the Colony Room, an after-hours, members-only drinking club in Dean Street, much frequented by bands of literary hacks and camp alcoholics. Muriel Belcher, the owner, sat on a stool by the bar like a bewigged gargoyle, clutching a poodle on her lap, striving to live up to her reputation as an outrageous wit, which you had to be inebriated to appreciate. I depicted her thus, very late one night, egged on by that prince of darkness, the

BRUCE LACEY AT 'THE
ESTABLISHMENT' (1966)
Drawn in a 14x17in (36x43cm) sketchbook with a
Faber 702 pencil.
Collection: the artist.
London's first satirical nightclub founded by Peter
Cook, although by this time the satirists had moved on
to New York.

painter Lucien Freud, who admitted never having dared even to think of asking her to sit for him, although he did eventually change his mind.

Among the *habitués* of the Colony Room, Jeff Bernard springs to mind. He was then thuggishly handsome: almost a Dorian Gray look-alike in the early phase of self-destruction, waiting in the wings, as it were, like a naughty schoolboy, to be deployed by any editor brave enough to hire him. Nonetheless, when he did start writing in the late 1960s, notably his sketches of racetrack life for Jocelyn Stevens's *Queen*, it was obvious he was very much part of the English tradition of popular knockabout journalism. That he ever became a writer at all was due to Maurice Richardson, who encouraged him to write about his life. 'You poor sod, you'll probably make a good writer!' Richardson had reflected.

This crowded period of my life was also one of personal fulfilment and worldly success. Back in Kendal, however, where my parents had retired, it cut little ice. My first collection of published drawings, *Defiant People* (1953), contained too many barefoot children and disabled beggars. 'Why,' huffed my mother, 'don't you look on the bright side of life?' I continued sending them copies of my books, but there was never any reaction. 'You don't even look like an artist,' barked my father during one disastrous flying visit. 'Ronald Searle does, 'e was on television,' chimed my mother. ''E's got a luvely beard.' Perhaps the biggest put-down took place at the entrance to the Whitworth Art Gallery on the occasion of the opening of 'Looking at People' in 1956. Although they both turned up, my father refused to enter and my mother was too timid to urge him to do so.

My father died in 1967 and only then did my mother relent. After her death in 1991, at the age of 97, I discovered a complete collection of my books among her things, their jackets carefully protected by transparent film.

Adventures with Writers

BEGINNING IN THE MID-1950S, WHILE I WAS STILL BASED IN ESSEX AND IN BETWEEN MY TEACHING COMMITMENTS IN CAMBRIDGE AND AT THE ROYAL COLLEGE OF ART IN LONDON, I EMBARKED ON MY FIRST COLLABORATIONS WITH SOME OF THE MAJOR LITERARY FIGURES OF THE TIME, INCLUDING DORIS LESSING, BRENDAN BEHAN AND ROBERT GRAVES. THIS STRAND OF MY CAREER WAS TO CONTINUE, ON AND OFF, UNTIL THE 1980S AND TOOK ME ALL OVER THE WORLD: TRAVELS WHICH EVENTUALLY ENABLED ME TO BE MUCH LESS DOCTRINAIRE AND DEVELOP A PERSONAL STYLE OF DRAWING.

THE RHODES CLUB, SALISBURY (1956)
Conté. 17x14in (43x35.5cm)
Private collection.
In 1956, Rhodesia was part of the old British Empire, with an entrenched white society that resisted any change or reforms. Named for the great imperialist, the Rhodes Club was the inner sanctum of this colonial régime. While Doris Lessing interviewed influential politicos, I surreptitiously sketched this scene, to me more reminiscent of the Empire's heyday than its twilight.

TO AFRICA WITH DORIS LESSING (1956)

IN DECEMBER 1955, at the private view of the exhibition of my drawings of China, I was approached by a dark-haired woman in her middle thirties. Doris Lessing had arrived from Rhodesia in 1949, clutching the manuscript of her first novel, *The Grass is Singing*, in one hand and her small son, Peter, in the other. By the time I met her, she had published a string of powerful novels and short stories and had announced her intention to return to Africa to collect material for a personal but revealing exposé of colonialism and apartheid. She did not wish to make the trip alone, however, and John Berger suggested that I might be interested in a collaboration. Moved by her strong sense of mission and flattered by her interest in my work, I agreed to go with her and provide illustrations for her proposed book, which was to be published in 1957.

Neither of us had money for the plane fare, let alone for expenses. We had to beg, cajole and, in my case, borrow against the drawings I hoped to make. One day, Doris, who was even more determined than me, walked into the London office of TASS, the Soviet News Agency, and demanded that they pay her fare in return for articles. Finally, we raised the money – £250 each – and left London in March 1956 for Salisbury, capital of what was then the Federation of Rhodesia and Nyasaland.

Rhodesia was not what I had expected. The country had a vitality lacking in Britain at the time; its entrepreneurial middle-class immigrants were attempting to apply the lessons engendered by the Festival of Britain in a much more agreeable climate. Convinced that the old country would be torn apart by Labour governments, the trade unions or atom bombs, they had optimistically concentrated their efforts on modernising an old-style colony, only to find themselves outwitted by an entrenched establishment.

We stayed in the protected isolation of a park-like suburb reserved for white settlers, guests of one of Doris's old friends, Nathan Zelter, a former revolutionary from Central Europe, and now a wealthy businessman. Doris called upon her old comrades in a never-ending cycle of 'sundowners', high teas and dinner parties. She seemed glad to be back among her old friends, if only to question their intentions and their idealism, or what was left of it. As the socialising eased up, we began a series of excursions into Southern Rhodesia (Zimbabwe) and Northern Rhodesia (Zambia). We drove to Umtali, a sleepy town on the border with what was then Portuguese Mozambique. We visited a tobacco farm north of Salisbury

and an African township in nearby Harare. We flew north to Lusaka, then on to Ndola and the copper mines of Luanshya. Another excursion took us to the Kariba Gorge, the site of the huge dam then under construction on the Zambezi River, 200 miles below the Victoria Falls, now the second-biggest artificial lake in the world.

BEMBA WOMAN AND CHILD, NDOLA, NORTHERN RHODESIA (1956)
Soft Hardtmuth charcoal lead. 16x11in (40.6x29.2cm)
Private collection.
African women are natural models, and posed with bemused dignity for long periods. Not everyone gazed at white men with such good humour in this part of Africa. I drew her seated outside her house, chatting to neighbours in the late afternoon sun, when everyone felt relaxed enough to cope with the intrusion.

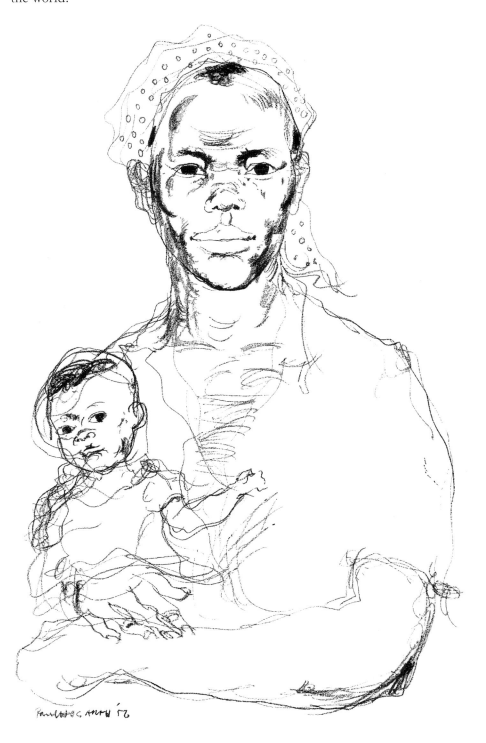

LAMP BOY, RAND GOLD-MINE, NEAR
JOHANNESBURG (1956)
Hardtmuth lead. 21x16in (52x42cm)
Private collection.

While Doris interviewed Lord Malvern, the prime minister Roy Welensky and other notables, I flew down to Bulawayo, the industrial heart of the Federation. I drew mainly industrial subjects: animated crowds of black workers milling against the background of power-station cooling towers and modern factory blocks as they made their way to and from the ramshackle townships on the fringe of the city. Doris then suggested we should try to get into South Africa. She had been assured by the South African embassy in London that she would be admitted without question, but she was not convinced. We decided to sit well apart from each other on the airplane, which was just as well because on arrival at Johannesburg's Jan Smuts Airport, Doris was immediately declared a prohibited immigrant and bundled on to the next plane back to Salisbury.

I was questioned by an official on the purpose of my visit, and replied that I was visiting relatives in Johannesburg; to my amazement, I was allowed in. The relatives in question were the family of my mother's youngest brother, my Uncle Jim. He thought I should see how the other half lived and arranged for me to visit the gold mine where he had worked as an overseer. Early the next morning, I found myself in a cigar-shaped express elevator descending an acutely angled mine shaft at the speed of sound. We clambered out on the twenty-fifth level, 1½ miles below the surface, and wormed our way down precipitous slopes streaming with water. Above our heads we could see the glint of strata of quartz and living rock in which lay the gold. Extraordinary scenes of human labour were revealed in the flickering light of our carbide helmet lamps. I tried to draw as best I could sprawled against the wet, sloping walls of the mine, my lamp feebly illuminating the pages of my sketchbook.

The following day I was taken to visit the compounds, or living quarters, of the miners. Here, I saw the proletarianisation of tribal Africa in action. Many tribal groups, including Zulus, Hottentots, Swazis and Shaagans, were living there together, a mixture of Southern Africa's black races who are as different from one another as an Englishman is from a German, or a Frenchman from a Russian. There were peasants from the *kraal* (village) wearing the traditional decorated blankets. Some men were dressed in European-style clothes. Others wore jeans and woollen balaclava caps. It was Sunday and the miners relaxed by dancing to jazz broadcast over a public address system.

I took my leave of Uncle Jim and his family and spent the next few days in Johannesburg. Here I made contact with Ruth First (assassinated by a letter-bomb in Mozambique in 1982) and Bram Fischer (Nelson Mandela's chief legal

ORLANDO SHELTERS (1956)
Hardtmuth lead. 21x16in (52x42cm)
Courtesy: Phillipe de Roux.
Orlando was the worst of the African townships
that circled Johannesburg. Bands of drunken men in
grubby tribal costumes danced outside beer-halls and
chebeens. Older men with staring eyes and gaping
mouths drifted by, addicts of dagga, *the local narcotic,*
derived from hemp.

adviser), both veterans of the struggle against apartheid. Ruth and her husband, the ANC (African National Congress) leader Joe Slovo, lived with their three children in a comfortable white suburb of the city, waited on by a squad of black servants. Ruth did not fit the stereotype of a revolutionary leader, and was well turned out at all times, as was Joe, who always looked immaculate in well tailored suits. Doris's plight at the airport had been widely reported in the newspapers, and I was given a warm welcome at a party thrown by Bram Fischer, at which I met a number of ANC activists of all races.

Anxious that I get 'my bristles up', Ruth arranged sorties into the African townships that circled Johannesburg – Jabavu, Moroka, Orlando Shelters and Sophiatown. The conditions made me think of medieval Europe. Streets were caked with animal and human excreta and the oozings of open sewers, and littered with great mounds of fetid garbage. Although I was accompanied by an ANC minder, the residents watched me with deep suspicion and resentment until I sat down and began to draw. Hostility then gave way to wonderment. Hordes of children would crowd around, while others were presented by insistent mothers for their portraits to be drawn.

I left the Transvaal and drove south through the Orange Free State, and across the dun-coloured desert of the Karoo. I tempted fate by stopping for lunch

at a restaurant that bore the historic name of *Commando*. The old flags of the Transvaal and Orange Free State Republics flapped lazily in the breeze outside. The owner had amassed a collection of prints and drawings of the Second Boer War (1899–1902), among which were watercolour sketches by the Special Artists of *The Graphic* and *The Illustrated London News*, which provided a unique record of the major defeats of the British Army; the bloody battles of Colenso, Elandslaagte, Spioen Kop and Magersfontein. When the Afrikaans waiter forgot my steak for the third time, I concluded that, as far as he was concerned, the war was not yet over.

I drove on through the fertile valleys of Cape Province, where ragged children held up huge clusters of juicy black grapes. Dutch colonial-style farmhouses nestled within clumps of gum trees, surrounded by vineyards and orchards. Was I in South Africa? It looked more like the Garden of Eden.

Soon Capetown came into view, flanked by the Atlantic on one side and the Indian Ocean on the other. In the city itself, palm trees and gracious Regency façades created an ambience of refined elegance. I lingered for a day in District Six – a picturesque old quarter of Victorian and Edwardian houses, now demolished – before driving on through the Transkei to Natal. Seeing the parched appearance of the Transkei, it was not difficult to guess why Africans left the land for the cities. Gaunt shepherd boys tended emaciated flocks of sheep on overgrazed hillsides, while hordes of undernourished children worked a line of passing cars for pennies.

I continued my odyssey with a trip into semi-tropical Natal. In Johannesburg, at my request, I had drawn the leaders of the African National Congress, but with a sense of disappointment as most had the expressions of Communist party *apparatchiks*. Then Ruth First took me to meet ex-chief Albert Luthuli, Nobel Peace Prize winner and founder of the ANC, living in exile in Groutville, a remote village some 50 miles west of Durban.

When I had finished his portrait, Luthuli took me to visit a colony of sharecroppers, Shaagan families, who lived by cultivating fields of sugar cane. Embittered couples emerged from the smoky interiors of huts built of cane stalks and sacking. Women clutched scrawny infants. Men scowled at the intrusion. Nothing Luthuli said, or could say, could ever bridge the gap. The face of the starkest poverty I had seen anywhere to date ruled out communication. I could react only by summoning up the courage, if one can use the word in this context, to make a drawing as they stood there – a *tableau vivant* of the landless African peasant, living symbol of a troubled continent.

When I returned to London, everything that could go wrong, did go
wrong. The Leicester Galleries – my gallery at the time – refused to show my
drawings because of their challenging content. I left them with Michael Joseph,
then Doris Lessing's publishers, who were enthusiastic about using them to
illustrate her book, *Going Home*. In due course, a proof copy arrived: a handful of
my drawings had been reproduced as chapter headings, not much bigger than
postage stamps.

BRENDAN BEHAN (1996)

Ink, pencil and watercolour. 11x8in (29x20.5cm)
Courtesy: The Oldie. *Collection: the artist.*
Brendan was never lost for hilariously witty one-liners,
interspersed with song. One memorable occasion,
however, rendered him speechless. Joan Littlewood,
who had produced his highly successful plays, The
Quare Fellow *and* The Hostage, *jealously regarded*
him not only as one of her leading discoveries, but also
as a source of continued inspiration. She was anxious to
*stage a third play (*Richard's Cork Leg) *on which an*
advance had long ago been given. Incensed to learn
that Brendan appeared to be working on another
project (our Irish book) she arrived in Dublin
determined to get her money's worth. Instead of rattling
the letterbox, the street-wise Joan came in through the
back door, metamorphosing into a female commando.
'Brendan, you effin' BASTARD!' she roared.
'Where's my bloody play?' Behan cringed with fear
and remorse. If there was a woman who could strike
the fear of God into the toughest man, it was Joan
Littlewood in her prime.

BRENDAN BEHAN (1959)

In 1958 the York Minster, 'The French Pub' in Dean Street, Soho, was a favourite haunt of the working *literati*. I had arranged to meet Randall Swingler there one lunchtime, and when I arrived Randall was standing at the bar with none other than the Irish writer Brendan Behan, who was in town to promote his autobiographical *Borstal Boy*, published that year. I wished him all the best and hoped it would be a great success. He grunted with a puckish charm that he liked my work. He always preferred drawings to photographs, he added, as photographers seldom missed a trick at someone else's expense. My literary agent, whom we shared, had sent him a copy of *People Like Us*, the recently published book of my drawings of South Africa.

'Yere an effin' gud drower, m'lad,' said Brendan, 'but phwat next?' I replied that I had always wanted to draw Ireland and boldly suggested that we might do a book together.

Some weeks later Iain Hamilton, editorial director of Behan's publisher, Hutchinson, suggested we meet for lunch. Brendan had agreed to write a book about Ireland, and Hamilton was very keen on the idea. Although Hamilton, anxious to follow on the runaway success of '*Borstal Boy*', was sceptical that he would ever get a manuscript from Brendan, we discussed an idea that would consist of text and drawings in equal parts – an update of Thackeray's *Irish Sketchbook*.

I arrived in Dublin early in June 1959. Brendan and his wife Beatrice lived in an Edwardian terraced house in Anglesea Road, Ballsbridge. Behan was plainly relieved to be told that I was not teetotal. 'I don't give a damn,' he said, 'whether or not an artist is effin abstract or effin realist, jes so long as they're not effin illiterate or teetotal!'

I soon gave up trying to discover what Brendan had in mind for his text, nor could I get any ideas out of him for subjects to draw. Then one day over breakfast, Beatrice prompted him to hand me a crumpled piece of paper: Michan's Church was the first on the list, followed by the tigers in the Dublin Zoo, Stop Jerry's in Moore Street, the house in which the playwright Sean O'Casey lived in Mountjoy Square, Seapoint, the Four Courts, and the Customs House. Most of these found their way into our book, together with the old gas-lit bars of Joycean Dublin, crowded with old women who had once been the girlfriends of the Black and Tans (the British security forces combating the Irish

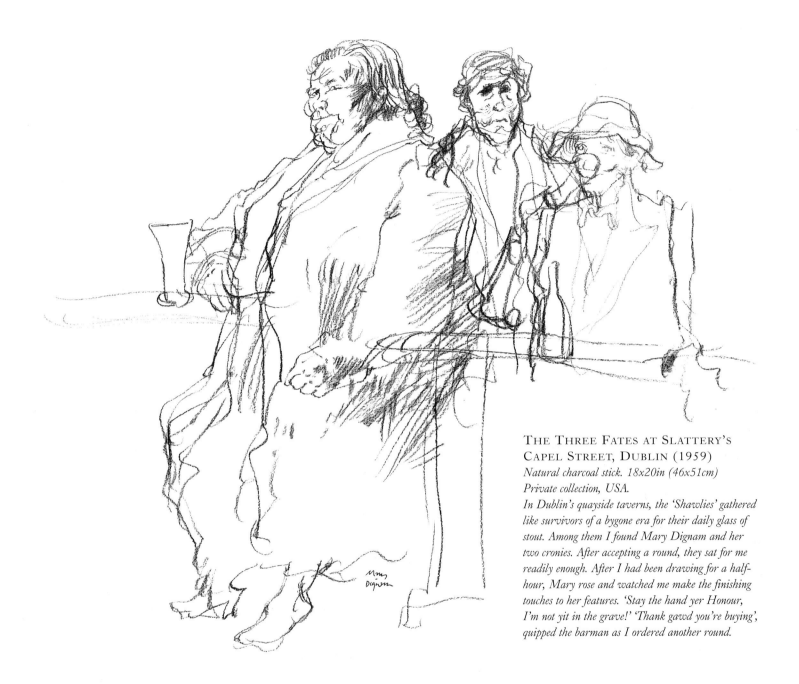

THE THREE FATES AT SLATTERY'S
CAPEL STREET, DUBLIN (1959)
Natural charcoal stick. 18x20in (46x51cm)
Private collection, USA.
*In Dublin's quayside taverns, the 'Shawlies' gathered
like survivors of a bygone era for their daily glass of
stout. Among them I found Mary Dignam and her
two cronies. After accepting a round, they sat for me
readily enough. After I had been drawing for a half-
hour, Mary rose and watched me make the finishing
touches to her features. 'Stay the hand yer Honour,
I'm not yit in the grave!' 'Thank gawd you're buying',
quipped the barman as I ordered another round.*

Nationalists in 1920–21). In those days Dublin was appealingly unspoilt and
I drew its noble Georgian façades with as much enthusiasm as I tackled its more
idiosyncratic backwaters. Life in the city was unhurried, its ornate bars intact,
its restaurants, such as the Dolphin and Jammet's, providing memorable
gastronomic experiences.

Brendan's wife Beatrice looked after me as if I was one of the family. She
had led a sheltered, if unconventional life before she met Brendan, but life with

BIDDY KELLY IN THE BLUE LION,
PARNELL STREET, DUBLIN (1959)
Conté Pierre Noir. 20x18in (51x46cm)
Courtesy: Donald Holden, New York.
Despite her unpopularity as a moneylender to the
poor, Biddy aroused reluctant admiration for her
raucous songs, born out of bitter experience and intoned
in a strident voice with the edge of an old file.

him soon made her resourceful. What money came into the house was usually spent the same week, if not the same day, so Beatrice always made it a priority to get to the front door before Brendan! She had a sure instinct for those letters which had a cheque inside, and made sure they went straight into the bank. 'Fat chance,' she muttered one morning after reading a letter with a cheque enclosed from *Atlantic Monthly* tactfully enquiring when they might expect the article for which they had already made one advance payment.

When I had been in Dublin for two weeks, Beatrice invited me to Carraroe, Gaelic-speaking Connemara, where she had rented a cottage. We decided to go by car: an unwise decision on my part as I was the only one who could drive. It took us two days to make a two-hour journey across Ireland, having stopped at almost every bar on the way.

'Brendan,' I implored, after yet another command to stop for a jar, 'we'll never get to Connemara at this rate.'

'Stop this effin car,' he bellowed in reply, 'or bejasus, I'll put me foot through the effin windscreen!'

Brendan was a congenial authority on the history and folklore of Ireland. He knew what had taken place in every town and village in the struggles against the British and in the civil war between the Free Staters and the IRA in the 1920s. And as we drove on, his rich tenor voice would punctuate the narrative with songs of joy or lament.

Carraroe, situated on a spectacularly craggy coastline, was a rich subject for my pencil. The two-storeyed cottage where we stayed had an unrivalled view of green fields and stone walls from its tiny windows. We settled down to a week of sun and sea, but Brendan soon disappeared for sessions of drink and song at the local bar, run by his old friend, the folk singer Stiofan O'Flaitheartaigh.

We made a few excursions, including a memorable trip to Inishmore, the biggest of the three islands of Aran. We sailed from Galway city one sunny June morning in a steamer crowded with fishermen returning home. For Brendan, the day began with a monologue on James Joyce and George Bernard Shaw, laced with oaths, delivered apropos of nothing at all, to a baffled, very English family. After a while we adjourned to the lounge bar where, in a fog of pipe smoke, a pretty dark-eyed girl lugubriously trilled 'When Irish eyes are smiling'. Brendan listened for a few moments, and cocked his head like a blackbird listening for worms. Suddenly, when he could stand it no longer, he burst into a rousing song about sudden death in Crossley Tenders outside the old town of Macroom.

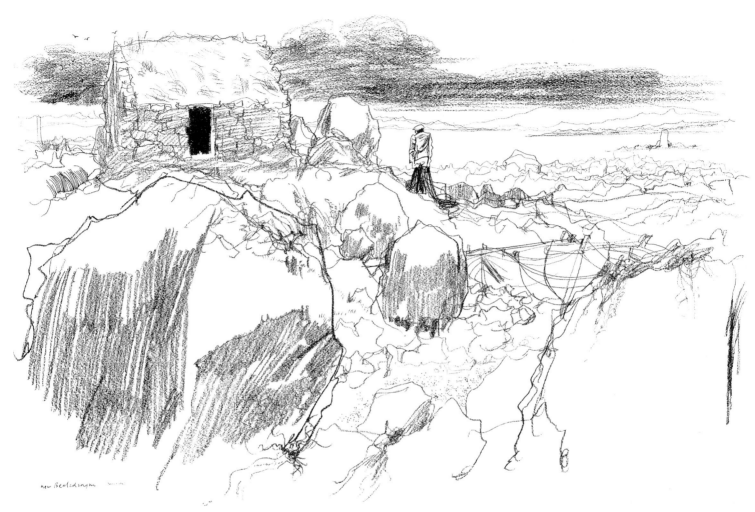

near Bealadangan

SEASCAPE NEAR BEALANDANGAN (1959)
Hardtmuth lead. 18x20in (46x51cm)
Private collection, USA.
I discovered another Ireland on the windswept West
Coast, one that seemed to belong to a previous century.
Life there moved slowly under the wide Atlantic skies,
and fisherfolk talked in a soft and lilting accent. The
fisherman was noted in a pocket sketchbook and added
later in ink.

Brendan sang on, stopping only to make sure that everyone had a big glass of stout in his fist. The stout flowed like water. Two hours and what seemed like 200 songs later, the boat steamed into Kilronan harbour with an inebriated company of singing fishermen. It was an extraordinary spectacle. Still singing, they left the ship, led by Brendan up the quayside, heading for the nearest bar to have one for the road. Many fell out, however, when confronted by a hostile throng of grim-faced wives and tight-lipped girlfriends.

We were only on the island for the day, and I knew that I had to stop taking part in what had become a beguiling and hilarious pantomime and find time to put pencil to paper. While Brendan and Beatrice went on to the second of the island's two bars, I leapt off the horse-drawn trap we had hired and got to work drawing the harbour and the landscape round about. I was now drawing subjects I really wanted to draw, without grinding an axe.

Fierce brows and a shaggy mane of hair gave Behan a rebellious appearance

OFF THE FALLS ROAD, BELFAST (1959)
Conté Pierre Noir. 20x18in (51x46cm)
Private collection, USA.
In this grim industrial city, streets were battlegrounds.
Slogans covered walls exhorting Nationalists and
Loyalists to 'Remember 1916' and 'The Crossing of the
Boyne 1690'.

that demanded, whatever else, a striking profile study, but as we rushed around the bars of Dublin and Connemara, there seemed to be no time to make such a drawing. However, an opportunity presented itself one day at the cottage at Carraroe. A local fisherman presented Brendan with two huge lobsters, which we spent the rest of a sunny afternoon eating. During this impromptu feast, accompanied by champagne, I started a full-face portrait. Then Brendan stood up and gazed pensively at the turbulent Atlantic through a window, and I saw the portrait I had hoped to make. When I had finished, he stood behind me to view the result. 'Time marches bloody on,' he sighed, 'I must bloody well look like that! Sure, it would be a bloody miracle if I didn't!'

Reluctantly, but with some relief, I took my leave of the Behans and travelled south through Meath to Skibbereen and Killarney. Then I retraced my steps and continued north to Sligo and Donegal before making my way across Ulster to Derry, and, finally, Belfast.

Hamilton was unable to get a text out of Brendan. My wife Pat, much of whose background had been the theatre, as actress, dancer and set designer, suggested that Brendan put the text on tape in the form of answers to questions. He was, she thought, essentially a talker and wrote as he spoke. Speaking into a tape-recorder would not, therefore, inhibit his thoughts. Brendan agreed to the idea – he had no choice as he could no longer look at a typewriter – and in October 1962 *Brendan Behan's Island* was published, and became a Book Society Choice and a bestseller on both sides of the Atlantic. Its appearance with illustrations by an Englishman was greeted with resentment by some – mostly Irish – journalists. 'Your drawings,' said Brian Inglis – then editor of *The Spectator* – on the occasion of the launch, 'would have been nothing without Brendan's text.'

'There wouldn't have been any text at all without my drawings!' I retorted.

Brendan's untimely death in March 1964 marked the end of Dublin as I had known it. Redevelopment was gradually stripping the city of its unique heritage of Georgian and Victorian buildings, especially its fine old bars and saloons. Almost all the Dublin subjects I had drawn had vanished, or were demolished or refurbished beyond recognition. Brendan had made me feel at home with the Irish and he took me into situations where I could get close to what was going on. In bars and pubs, rather than people's places of work, the barriers always came down, and I developed a knack of making a portrait drawing, in about half an hour, that brought out my subject's Irishness – the special character of their faces and their sense of humour.

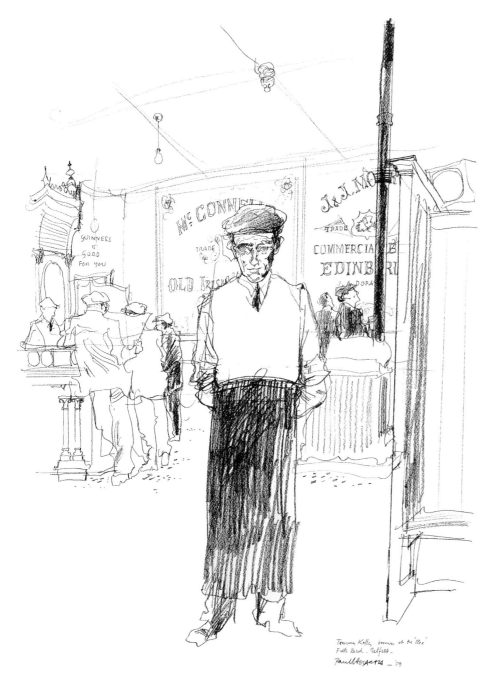

Tommy Kelly, barman at the 'Bee'
Falls Road. Belfast.
Paul Hogarth — '59

TOMMY KELLY, BARMAN AT THE BEE, BELFAST (1959)

Hardtmuth lead. 20x18in (51x46cm)

Formerly in the collection of Sir Alec Guinness; present whereabouts unknown.

Drawing on location can be stimulating because it is so unpredictable. Initially, I was attracted to this subject by the ornate atmosphere and started drawing the interior. Then Tommy Kelly appeared, with a face that completely related to the Victorian-Irish flavour of the place. Persuading him to pose, however, was not easy. He was afraid of being teased and agreed only with the encouragement of his interested customers. What started out as an interior with figures ended up as a setting for a portrait of a warm and sensitive character of wistful charm.

WITH GREAT DIFFIDENCE, I SHOW
ROBERT GRAVES MY DRAWINGS OF
MAJORCA (SUMMER 1963)
Courtesy: Andrew Valente, Palma de Mallorca.

WITH MY SON, TOBY (SON RAPINA,
1963)
Courtesy: Donald Holden, New York.
Toby loved growing up in Majorca and quickly learned
to speak Mallorquin – a dialect of Catalan – as well as
Castillian Spanish.

ROBERT GRAVES'S ISLAND (1963–83)

I first met Robert Graves in the summer of 1963. At that time I needed a break from England, and the success that followed *Brendan Behan's Island* provided a means of escape. Desmond Flower – literary director of Cassells, Graves's main London publisher – approached me with the idea that a series of drawings of life and landscape on Majorca, Graves's home, might tempt the great man and bring another bestseller into being. It was to be a memorable odyssey that began a completely new chapter of my life. The result of our collaboration, *Majorca Observed*, remains my favourite book, although I don't think the great man took it all that seriously.

My wife Pat and our three-year-old son Toby came with me, and we established ourselves in a rambling old villa at Son Rapina, on the northern outskirts of Palma. I sent Desmond Flower's letter of introduction to Robert Graves, who immediately responded: 'Any time you care to come here, do. Afternoons are best, but not Tuesdays or Fridays when we are apt to shop in Palma.' A few days later, I paused at the gate of Graves's house, Canellun. A tall figure in baggy khaki shorts and leather sandals strode vigorously around the

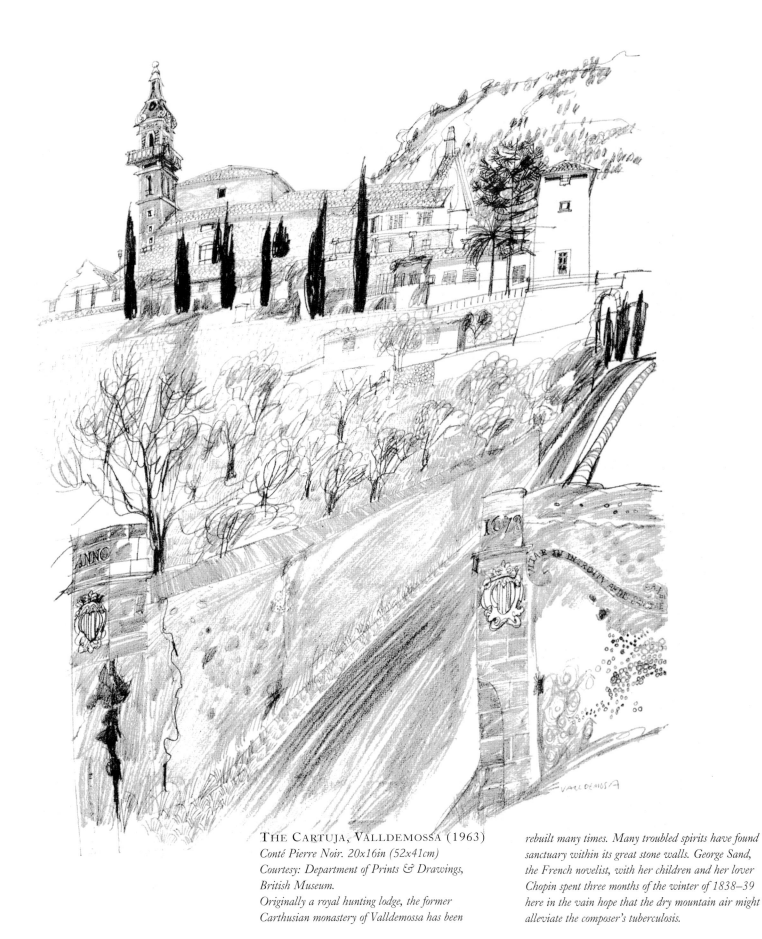

THE CARTUJA, VALLDEMOSSA (1963)
Conté Pierre Noir. 20x16in (52x41cm)
Courtesy: Department of Prints & Drawings,
British Museum.
Originally a royal hunting lodge, the former
Carthusian monastery of Valldemossa has been
rebuilt many times. Many troubled spirits have found
sanctuary within its great stone walls. George Sand,
the French novelist, with her children and her lover
Chopin spent three months of the winter of 1838–39
here in the vain hope that the dry mountain air might
alleviate the composer's tuberculosis.

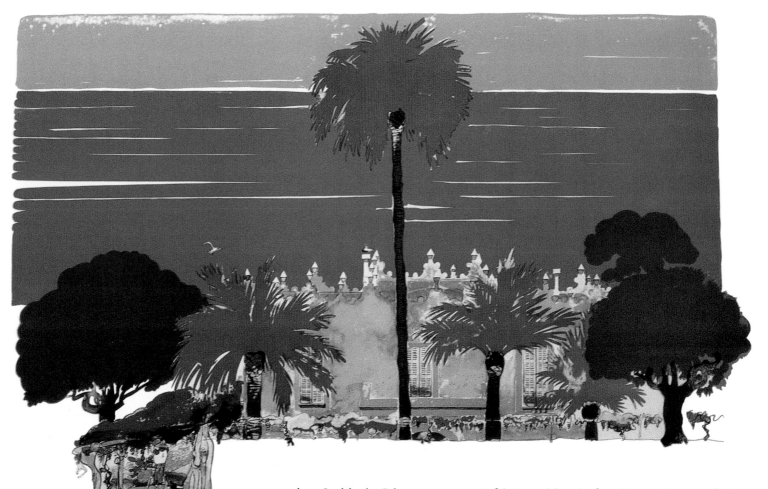

VILLA BY THE SEA (S'ESTACA) (1982)
Lithograph. 17x23in (43.2x59.7cm)
Printed by Curwen Studio for Royal Academy
Graphics.
Collection: the artist.
S'Estaca, or the Villa of the Shaft, was built in the
1880s by the Archduke Luis Salvador – nephew of
Emperor Franz Joseph of Austria – for his mistress
Catalina Homar, a young peasant girl who managed
his vineyards. Her premature death almost caused the
good Archduke to commit suicide. Nowadays, however,
the house belongs to the film star Michael Douglas.

garden. Suddenly, I lost my nerve. I felt I could only face him with a portfolio bulging with superb drawings under my arm. And so, from April to August, 1963, I made a large number of drawings of the island's rustic life and landscape. It was a labour of love. At that time most of Majorca was unspoilt as tourists generally kept to the beaches and resorts to the west of Palma. Narrow highways linked obscure towns and remote villages empty of buses and trucks. Cars were few, the main form of transport a two-wheeled trap drawn by mules or ponies. The island's architectural heritage reflected Roman and Moorish influences. I revelled in exploring remote, deserted estates such as Alfabia and Raxa, with their tranquil pools fringed by tall palms and carpeted with waterlilies – seldom visited by Majorcans, let alone foreigners.

By the end of the summer, I had completed some 40 large drawings on a hand-made Saunders paper. I took the bit between the teeth and wrote to Graves. 'I'll be glad,' he replied, 'to see what you have reaped.' This time I opened his gate and strode up to the house. All went well, with Graves relating anecdotes about

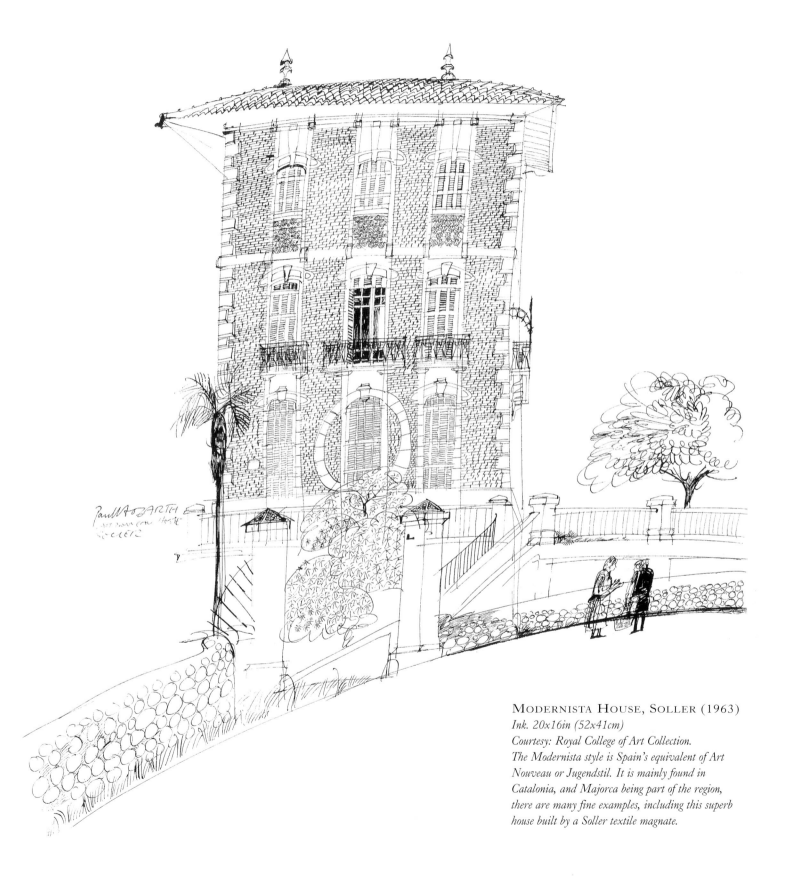

MODERNISTA HOUSE, SOLLER (1963)
Ink. 20x16in (52x41cm)
Courtesy: Royal College of Art Collection.
The Modernista style is Spain's equivalent of Art
Nouveau or Jugendstil. It is mainly found in
Catalonia, and Majorca being part of the region,
there are many fine examples, including this superb
house built by a Soller textile magnate.

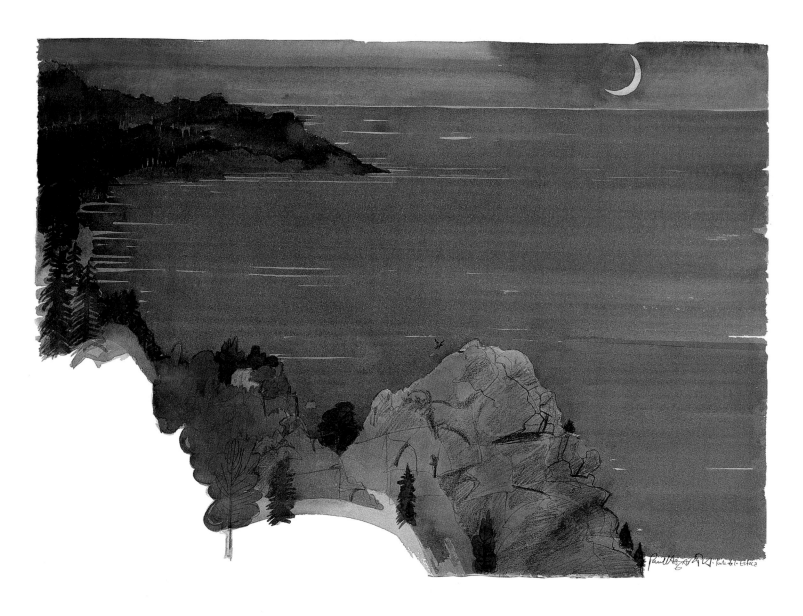

SHAFT POINT (PUNTE DE LA ESTACA)
(1979)
Watercolour. 17x23in (43x58.5cm)
Collection: the artist.
It was at the Punte de la Estaca that the Archduke's
guests, after disembarking from the ducal yacht, were
driven by horse-drawn carriage to Son Marroig,
another of the Archduke's residences, which served as a
guesthouse.

the many artists he had known. An empathy quickly developed between us, but even so, I was on tenterhooks as he began to look through my drawings. However, not only did he like them – especially those he described as 'the humorous ones', some of which were of people he knew – but he started to think about his text, listing previously published essays and stories as well as new pieces he had just written or would write (which he never did). He went on to tell me of his great love for Majorca and how he had walked over most of it, pointing to various towns and villages on my map that I should not miss. For an island no more than 60 miles long and 50 miles wide, there seemed a great variety of subject matter, and it was clear that I would need to return, which I did in the spring of 1964.

Desmond Flower had insisted that I draw Robert's portrait, and I dreaded having to do so. Even after a year of working with him on and off, I still found him awe-inspiring; his erudition tripped me up without mercy over any rash assumption I was bold enough to make. At 68, he had the appearance of a Roman consul, although he rejected the analogy. He clearly saw himself as a matinée idol, as was indicated by his unqualified approval of some sketches made by his current muse, Cindy Laracuen, who saw him as a lookalike for the actor Jean-Louis Barrault in his younger days.

Towards the end of the 1960s, I succumbed to the heady ambience of Deia and the Camelot-like court of King Robert, and bought Ca'n Bi, a sixteenth-century *finca*, or farmhouse, that had sheltered many painters, writers and musicians over the years. The Catalan painter Santiago Rusinol stayed there, as had Manual de Falla, and the English illustrator and Hispanophile, Arthur Rackham. Life and work there were always conducted at a leisurely pace. With Robert's encouragement, Pat started work on a series of pastel and gouache drawings with goddesses as their theme: one for each letter of the alphabet. I

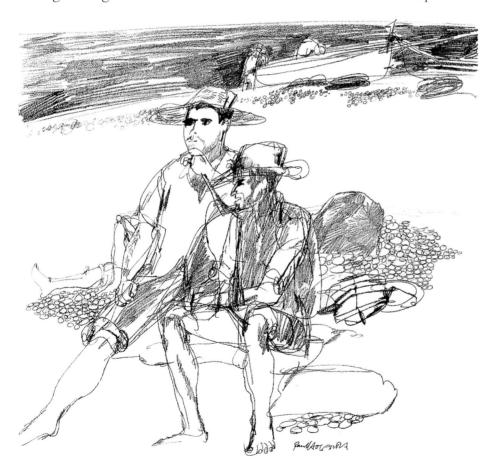

ROBERT GRAVES (1963)
Conté Pierre Noir. 20x16in (52x41cm)
Courtesy: Estate of the late Desmond Flower.
The great man was in a bad mood when he sat for his portrait. He did not want me to go away empty-handed, but on the other hand, he would not respond to requests that he try on his varied repertoire of stylish headgear. 'Draw me as I am or not at all,' he commanded. I came up with a strongly expressive characterisation, only to be told he didn't like it! I was talented, he said, but I should always remember that people have a favourite age and prefer to be seen thus.
 'And what is yours?' I asked.
 'Thirty-five,' he snapped.

MALLORCAN FISHERMEN,
LA CALOBRA (1963)
Conté Pierre Noir. 20x16in (52x41cm)
Collection: the artist.
Fishermen always make ideal models. The strenuous activity of their working hours is relieved by periods of conviviality and relaxed isolation, repairing their nets and boats. These are the times to draw them!

PROFILE OF ROBERT GRAVES (1979)
Watercolour over pencil. 20x15in (51x38cm)
Collection: the artist
My sketch for this portrait was drawn on the poet's eighty-fourth birthday: a sad occasion as by this time he suffered from loss of memory and was unable to speak coherently. Yet he sensed that I was not involved in the conversation and turned towards me. 'What,' he gasped, 'are you doing?'

'Paul' interjected Beryl 'is drawing your portrait for the book.'

'Well,' Robert rejoined, 'let him get on with it!' We all laughed – it was a flashback to the Robert Graves of yesteryear.

Receiving the Francis Williams Illustration Award for Robert Graves: Poems *from Sir Roy Strong at the Victoria & Albert Museum, London, June 1982. Courtesy: Victoria & Albert Museum.*

began work on a portfolio of lithographs incorporating handwritten poems by Robert (published *Deya*, in 1972).

We lived at Deia more or less throughout the year, and had become more closely acquainted with the Graves family. Robert himself made regular visits to our home. He loved Ca'n Bi and reminisced about the many good times he had spent there as the guest of its former owner, Don Gerardo Tomas de Sabater.

On one memorable occasion, Robert and Beryl joined us for dinner. Pat had not been nicknamed 'the High Priestess of the Grotesque in British Art' for nothing. Facing Robert that evening was one of her latest and most disturbing pictures: a huge, gothic extravaganza that portrayed a witch-like Lady MacBeth figure sucking the lifeblood from a gaunt, reclining figure, which I was horrified to note resembled Robert himself. He shot Beryl a nervous glance and apologetically murmured that they really must leave, perhaps they might join us on another evening. I quickly passed the bad news on to Pat, busily at work in the kitchen. 'They're bloody *not* going,' she hissed. Pat (who had danced with Margaret Morris's Celtic Ballet as a teenager) re-appeared and began to execute a writhing erotic dance. Robert was completely enchanted. 'Beryl,' he grinned, we'll stay after all!'

America, America!

DESPITE MY VOW THAT I WOULD NOT GO THROUGH THE EXPERIENCE OF PRODUCING A BOOK INVOLVING BRENDAN BEHAN EVER AGAIN, THE SUCCESS OF *BRENDAN BEHAN'S ISLAND* AND HIS DETERMINATION TO WRITE ABOUT HIS VERY PERSONAL DISCOVERY OF AMERICA CHANGED MY MIND. PRESSURED BY PUBLISHERS ON BOTH SIDES OF THE ATLANTIC, WE THUS EMBARKED ON A SECOND COLLABORATION, A BOOK ABOUT NEW YORK, WHICH BRENDAN THOUGHT 'THE GREATEST CITY ON THE FACE OF GOD'S EARTH'.

NEW YORK (1962–63)

ALL WAS NOT plain sailing. I arrived in New York during the autumn of 1962, expecting to find him at the Chelsea Hotel, but the opening of a revival of his play *The Hostage* at the One Sheridan Square Theatre in Greenwich Village had again exposed him to temptation. Brendan, I was informed, had fallen off the wagon with a resounding crash and was in a clinic receiving treatment. Drinking sprees alternated with increasingly frequent spells in city hospitals and country clinics and, not surprisingly, we always missed one another.

This was, perhaps, just as well. It would have been difficult, if not impossible, to work as we had done in Ireland. On the other hand, we both embraced New York with such a strong degree of affection that frequent reference to each other's ideas proved unnecessary. Messages and the odd scribbled note on the back of a grubby envelope – and a tour of Brendan's West-Side haunts – more than sufficed to act as pointers to the special places he thought might make good subjects.

It goes without saying that they were usually bars, mostly the Irish saloons of Third and Seventh Avenue, owned, it seemed, by Dubliners known to Brendan or his parents. Few people can equal the natural ability of the Irish to keep a good bar. Once found, an Irish saloon is affectionately remembered for the caustic

THE STATUE OF LIBERTY (1962)
Conté Pierre Noir. 20x16in (51x41cm)
Courtesy: Library of Congress, Washington DC.
My second collaboration with Brendan Behan took me to America for the first time in the autumn of 1962. The glass and steel I had anticipated, but not a New York of O. Henry and Damon Runyon, with cast-iron ferry stations, vintage suspension bridges, old-time barbershops and Irish saloons. The Statue of Liberty, however, was given top priority, but how to draw it? I thought the sightseeing helicopters might give the famous landmark a piquancy it otherwise might not have possessed.

BABY SANDRA (1963)
6B Venus graphite pencil. 20x16 (51x41cm)
Private collection, USA.
'Baby' Sandra of Sammy's Bowery Follies recalled
Brendan with stagey affection. 'He wuz good company,'
she chortled. Once a star, she now sang Cole Porter
songs like 'Night and Day' to a sleazy audience of
rowdy drifters. Between acts, she liked a double
bourbon and a smoke. As I drew her, a hand edged
towards her pack of cigarettes, which lay on the table
between us. Seconds later, without batting an eyelid,
she slammed down her great ham-like arm on the
impertinence. 'You must be a greenhorn,' she growled
to a cringing bum nursing his fingers.

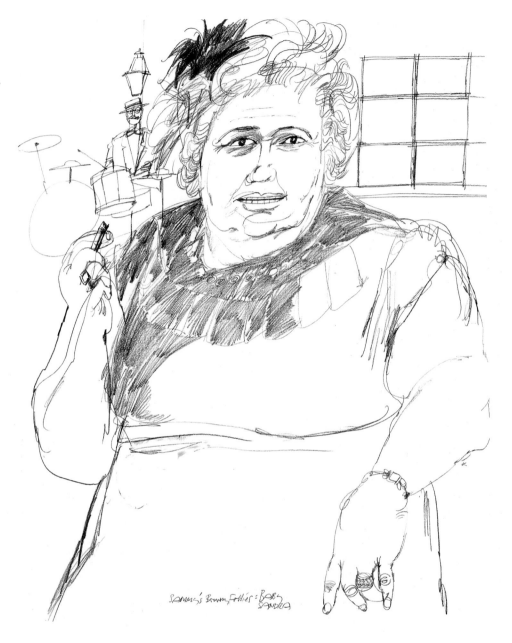

repartee offered by a resident company of convivial characters. I chatted with owners and bartenders, and received in turn a barrage of anecdotes. At the time, it was as though Brendan would appear at any moment.

There was, for example, McSorley's Old Ale House, the oldest Irish saloon in New York. Before World War I, it had been a favourite haunt of Ashcan painters like John Sloan and was always popular with artists and writers. The floor was caked with sawdust, the walls hung with memorabilia of convivial occasions and a sign that cautioned, 'Be Good or Be Gone'. Only ale was available,

light or dark, 20 cents a glass, 30 for two. 'Save yourself a dime, mister,' urged the bartender.

'Visit Ma O'Brien on Third Avenue,' read another of Brendan's scribbled notes, 'and don't forget to watch her put the money in the till.' 'That Brendan Behan,' she hissed when I dropped by one day, 'he owes me 100 dollars, which if you're a friend of his and a gennelman, you'll pay me.' I didn't pick up the tab – it could have been incurred by any of the thirsty bands of camp-followers Brendan attracted – but I bought her a drink and watched her jump like a sparrow to reach the cash register. She was so tiny she had to stand on a beer crate behind the bar.

Not all Brendan's haunts were Irish; they included English-style pubs, German *stubes*, Spanish *bodegas* and French *bistros*. There were womb-like traps, such as the Silver Rail at the corner of Seventh Avenue and West Twenty-Third Street, a bar much frequented by Dylan Thomas, who died at the nearby St Vincent's Hospital. Since then, the Silver Rail has been a 'gourmet' delicatessen, and much else, but during the 1960s it radiated a sinister brilliance, like Van Gogh's *Night Café*, 'a place where one could ruin oneself, go mad or commit a crime', as Van Gogh wrote to Theo. A predatory clientèle of pimps, prostitutes and conmen divided their time between the bar and a Horn and Hardart automat next door. Nearby, a circle of aged bird-like actresses talked incessantly about the good old days when Twenty-Third Street was the centre of the theatre district and everyone who was anyone took them to dinner at Cavanagh's.

Brendan was afraid of the Silver Rail – 'Jasus, it's like lookin' in on the Depression' – and preferred the more genial Oasis Bar, a few doors along towards the Chelsea Hotel. The chromium-plated, art deco Oasis had Willy Garfinkle, its golden-hearted Jewish proprietor, laying down the law. He and his wife, Jeannie, were good Samaritans to Brendan in his many hours of need and ran an honest-to-goodness joint where you took your liquor straight, told a good story if you felt like it and no fancy business.

I found myself in a city which outweighed – in any way – every other I had ever visited. New York was the metropolis *par excellence*. Much of its fascination emanated from the aggregation of buildings of every possible style and shape, creating an ordered chaos of skyscrapers, tenements, expressways and ethnic neighbourhoods: in a word, a cityscape. On that first visit to New York, 'cityscape' entered my artistic vocabulary with a bang. I viewed with awe the thrusting mass of buildings jostling each other in a dramatic free-for-all. A Circle Line boat trip around Manhattan, a ride on the elevated subway to Coney Island, a crossing on

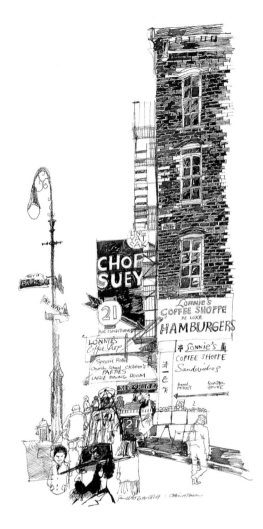

NEW YORK STREET CORNER (1963)
Ink and Conté Pierre Noir. 20x16in (51x41cm)
Private collection, USA.
The multi-ethnic make-up of New York City
contributed to a lively series of street drawings.

THE SILVER RAIL, NEW YORK (1963)
Ink. 20x16in (51x41cm)
Private collection, USA.
In New York City I started to use pen and ink to capture its gritty character. This was one of the first ink drawings made on location. The Silver Rail on the corner of West Twenty-Third Street and Seventh Avenue was a well-known haunt of the 1960s.

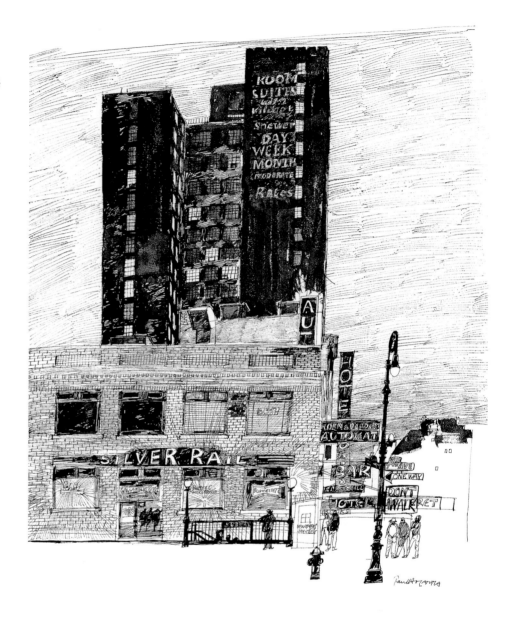

the Staten Island or Brooklyn Ferry; all were revelations to me. It all expressed, as nothing else did, before or since, the vital, energetic and competitive pulse of America. It was as if I was giving birth to a new Hogarth. A much less romantic style evolved. I resorted to ink, instead of pencil or conté, to give more vigour and strength to my line.

The city's ethnic neighbourhoods were a rich source of subject matter. Such places, although not for the timid, turned out to be less tough than they appeared. I recall drawing a row of Jewish and Puerto Rican stores on the Lower East Side. A teenage gang, 'The Assassins', stopped by and watched. After reluctantly

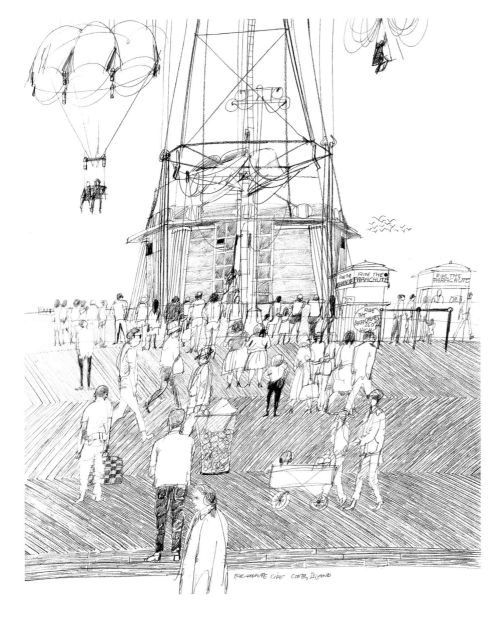

Parachute Ride, Coney Island
(1963).
6B Venus graphite pencil. 20x16in (51 x41cm)
Collection: the artist.
Detailed drawing of both character and movement is
easier with graphite lead pencils. I used two grades –
3 and 6B for this drawing.

accepting my reason for being on their territory, they became deadly serious about being drawn. I complied, assembling the gang around their leader.

It may have been Behan who told me about Greenwood Cemetery, Brooklyn, as he was a devoted necrophiliac. Established in 1843, and criss-crossed by a network of wide roads and footpaths, it is a city in itself; a megalopolis of the illustrious departed with mausoleums as big as mansions. Here, too, are the elaborate tombs of Elias Howe, the inventor of the sewing machine (sewing machine on top); of the inventor of the street-car (street-car on top); of the Englishman who drafted the rules for baseball (large baseball on top); of Horace

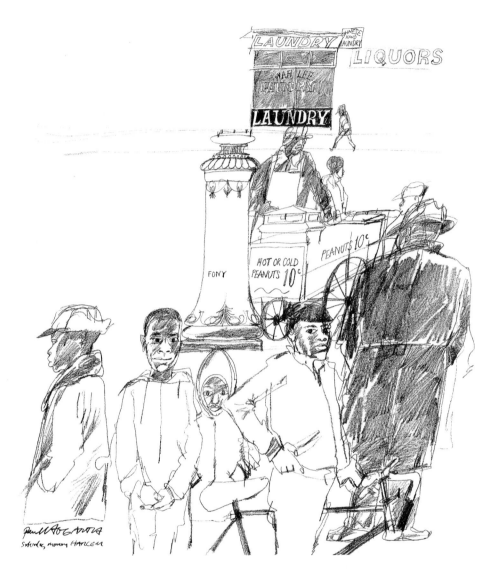

SATURDAY MORNING, HARLEM (1962)
Charcoal pencil. 20x16in (51x41cm)
Collection: the artist.
Harlem was best visited on Saturday mornings, when children did the shimmy-twist outside the record shops and housewives listened to the nostalgic ballads of Bruce Benton in the laundromats. Chestnut-sellers plied a busy trade as winter approached.

Below: ON THE BOWERY (1963)
Bamboo pen and ink. 20x16in (51x41cm)
Courtesy: Victoria & Albert Museum, London.
Like the survivors of some obscure catastrophe, the men of Skid Row struggle to adjust to the light of yet another day.

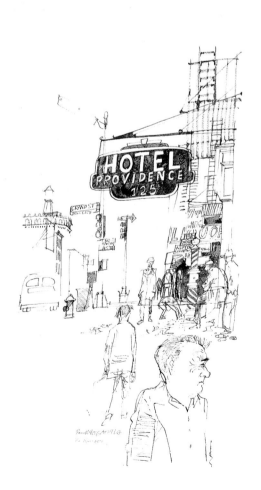

Greeley the founder of the *New York Tribune*; and of Lola Montez, one-time mistress of Ludwig I, King of Bavaria, and saloon queen of the Old West, who nonetheless died a respectable woman.

By the time *Brendan Behan's New York* was published in November 1964, Behan was no longer alive; he died in March of that year. Like *Brendan Behan's Island*, it was a bestseller on both sides of the Atlantic.

MY GOOD FORTUNE (1962–67)

Shortly before I left for America to work on *Brendan Behan's New York*, I had received my first commission from the US magazine, *Fortune* – to depict the

construction of a transcontinental oil pipeline, the 2,600-mile-long Colonial System, then being built through the southern United States, from Houston, Texas to Greensboro, North Carolina. I worked on this during August 1962 and found it a welcome break from the stifling heat of New York.

In view of my political past, getting into America was easier than I had imagined. In 1962, applicants for visas were asked if they were or ever had been a member of the Communist Party. Unable to deny that I had, I was refused a visa. But a kindly visa official advised me to apply for the 'Kennedy Waiver', an amendment to the McCarron Act (which barred Communists and ex-Communists). This made it possible for former Communists who had resigned as a result of the events of 1956 to be given temporary visas to practise their profession in the United States. A lengthy interview with two CIA officers followed. One was obviously of Irish descent. 'You mean,' he said, 'you have been asked to illustrate a book about New York City by Brendan Bee-han!' His more WASP-ish colleague was equally impressed that I had been given a *Fortune* assignment. After proof was supplied, I got my visa, the first of many.

Fortune was Time Inc.'s flagship magazine, and to quote John Kenneth Galbraith, 'one of the best written magazines in the English language'. Its editorial approach was unique. Writers, photographers and artists were assigned to collect their material on location and were given complete freedom to interpret a story in their own way. The result, a 'portfolio', ran to 12, sometimes 16 pages of photographs, drawings or paintings, usually in colour. Poets wrote the articles, in the form of investigative essays. In the first two decades, these included James Agee, Gilbert Burck, Buckminster Fuller, J. K. Galbraith, Archibald McLeish and Dwight Macdonald. The photographers included Ansel Adams, Margaret Bourke-White, Walker Evans and Arnold Newman, and the artists involved were just as numerous. 'I know what I'm going to get when I send in a photographer,' quipped the magazine's founder, Henry Luce, 'but I like to be surprised, so I send in an artist!' To his surprise, Luce discovered that, with rare exceptions, good artists, like his best writers, were either liberals or socialists. They ranged from the painters of the American regional school, such as John Steuart Curry, Thomas Benton and Ben Shahn, and imported talents such as André François, Richard Lindner, Ronald Searle and myself.

On my trips behind the Iron Curtain I had recorded the so-called 'New Man' building socialism. Could American Man building capitalism be so different? Indeed he was, and did a much better job. In Poland, and more so in

MYSELF SOMEWHERE IN THE DEEP SOUTH (1963)
Photo: Ken Trotter, Atlanta.
I had two weeks to depict the building of the 2,600 mile Colonial Oil Pipeline from Texas to New Jersey, in its first and most difficult stage through the almost impenetrable back country of Alabama, Georgia and Mississippi. Any other form of travel than by air would have taken months. This four-seater Cessna plane plus pilot was rented, and I made notes of what looked interesting as we flew at treetop height over the line. We had radio-telephone contact with construction crews to tell us where to land, and they would come and collect us.

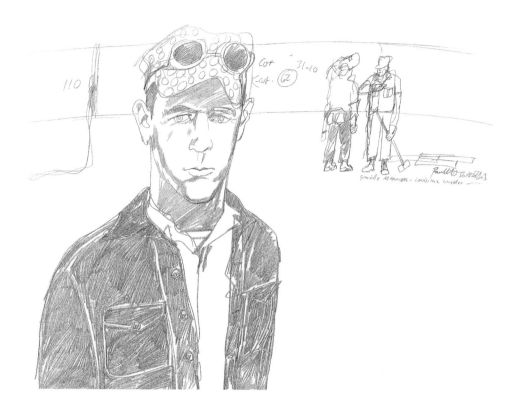

China, industrial construction had been characterised by the use of manpower on a massive scale. Here, state-of-the-art machinery had replaced muscle and brawn. In August 1962, I found myself in the sweltering heat of the Deep South, flying over rough terrain, driving over dirt roads, and following the pipeliners and their equipment on foot. Bulldozers, ditchers, bending machines, cleaners and primers, coating and wrapping machines, manned by as few as 200 men, who worked across 11-mile 'spreads', cleared the land, strung the pipes, dug the ditches, welded, cleaned, wrapped, lowered-in and back-filled, at the incredible speed of 1 mile a day. I worked from moving supply-trucks, occasionally stopping off to make a portrait of a welder or foreman, whose leathery faces and easy-going manner frequently belied the complexity of their work.

A few months later I undertook to produce a second portfolio, this time of the Connecticut Valley, the cradle of America's industrial revolution. Again, I revelled in the freedom of being able to work on location without a minder. With a three-week deadline – broken halfway by a brief meeting with the writer Katherine Hamill – I drove out of New York City and followed the Connecticut River from Old Saybrook situated at its mouth on the Atlantic coast to Turner's Falls, Massachusetts, up through Brattleboro, Vermont, as far as White River

PIPELINERS AT WORK NEAR
CAUDERDALE, MISSISSIPPI (1962)
Charcoal pencil. 17x20in (43x52cm)
Courtesy: Library of Congress, Washington DC.
The pipe is bent to fit the contour of the ditch.

Junction, New Hampshire; then I turned southwards again, crossing and recrossing the river as it wound its way through New England.

From the early seventeenth century, the Connecticut River had been a highway for the early English settlers. As they moved north, they built shipyards, fur-trading posts and sawmills. After Independence, Yankee ingenuity asserted itself. Connecticut Valley firsts are said to have included the steamboat (1793), the revolver (1846), the first practical motorcar (1892), as well as the submarine and the humble airtight fruit jar. Many of the original plants were still there, looking grim and satanic in their old age. At Ivoryton, the old Platt Read Plant (founded in 1866) turned out piano keyboards, although instead of ivory from Africa, it now used plastic. Further up the river, Hartford produced the richest crop, notably the huge, bizarre Colt Patent Fire Arms Manufacturing Plant (founded in 1836) with its blue dome, the gift of a grateful Sultan of Turkey, Abdul-Hamid II, for a rush order of Colt 45s ('the gun that tamed the West'), which had been delivered ahead of time. In Massachusetts, I drew 'The Paper City' of Holyoke, so-called because of its numerous papermills. Great canals gave it an almost Venetian appearance. Then I went on to Springfield, the headquarters of the giant Westinghouse Company, whose main plant, situated in a neighbourhood of decorative wooden

HOLYOKE, MASSACHUSETTS (1963)
Ink. 21x16in (53.5x42cm)
Courtesy: Fortune, *Library of Congress,*
Washington DC.
The anarchic medley of power and telegraph lines
characteristic of older American cities. Drawn on
Saunders paper with a Japanese brush and a school pen.

Opposite: SPRINGFIELD, MASSACHUSETTS
(1963)
Ink on Saunders paper; watercolour added later.
21x16in (53.5x42cm)
Courtesy: Library of Congress,
Washington DC.
The giant Westinghouse plant lacked visual impact,
but in the context of a suburban neighbourhood of
vintage frame houses and a corner drugstore the
composition did somehow work.

BROOME STREET GUN SHOP, NEW
YORK (1965)
Pencil. 13x11in (34.2x28cm)
Courtesy: Fortune*. Collection: the artist.*
During the 1960s many American cities experienced
a rising crime wave. Matrons took judo lessons.
Ordinary citizens carried tear-gas canisters. Yet
nothing was done to restrict the sale of firearms.

houses dating from 1910–20, gave me one of my best images of New England.

The sheer magnitude of American industry outstripped anything I had ever seen before, although I had mixed feelings about the unrestricted exploitation of such a vast, largely unspoiled land, and the impact of this on the environment. This was brought home to me when *Fortune* asked that I 'go West' to Colorado in December 1964 to depict the largest mining operation in North America.

Climax, 100 miles north of Denver and 13 miles from the old mining town of Leadville, was the scene of this immense project. In a snow-capped mountain setting of spectacular grandeur 11,200ft above sea level, 40,000 tons of molybdenum ore were blasted, crushed, milled and refined in a non-stop process every 24 hours. Not that mining itself was new to the Rocky Mountains. In the boom-or-bust years of the nineteenth century, every type of mineral that could be extracted from the earth had been extracted. Abandoned gold, silver and lead mines, and their attendant ghost-towns, still lined the valleys and gulches. Yet even these reminders of the Old West were in danger: for instance the old silver mine, 'Queen of the West', near the picturesque ghost town of Kokomo (where half-a-dozen old miners and their wolf-like dogs lived out their last years), lay directly in

SPRINGFIELD, MASSACHUSETTS

FREDERICK PHILIPS (1965)
Watercolour over pencil. 23x11in (60x28cm)
Collection: the artist.
Among the 1965 series of Fortune *portraits was*
Frederick Philips, then head of one of the world's
biggest manufacturers of electrical products. He looked
much younger than 60, despite having spent World
War II in a Nazi prison camp. Perhaps because of
this, he was a man of great restraint who listened
rather than talked. I placed him against a seventeenth-
century grandfather clock with a painted inset of an
eighteenth-century Dutch merchant fleet as he so
obviously stemmed from the staunch merchant-
capitalists of that period.

the path of a vast, slow-moving mass of silt and sludge – the innards of an entire mountain – which emanated from the Climax Mine above.

The new mine ran with eerie efficiency. Few workers could be seen, yet there were signs everywhere: 'Be Careful – It's Hell to be a Cripple'. Huge, complex machines executed successive operations. One machine, operated by compressed air, cleared 'muck' out of the mine after blasting. Great scoops shovelled rocks into long lines of cars, which transported them to batteries of gyratory crushers. The crushed rocks were then moved on to a vast grinding mill operated by a single figure. Here, molybdenite particles were drained off from the water, and the by-products (iron pyrite, tin and tungsten) piped off. Eventually, the finished product was packed into steel drums for export to the steel mills of Britain, France, Germany and Japan.

Fortune also concerned itself with the downside of American society. The growth of drug-related crime in the big cities of the United States created a law enforcement crisis in the mid-1960s, and I was asked to report on the nightmare world of the unfortunate, the misguided and the corrupt in New York city. 'Unless society combats crime,' warned *Fortune*, 'the crime rate will certainly go on rising.' In October 1965, I spent a week riding in patrol cars and with crime squads, in the somewhat naive hope that I might witness some spectacular incident. This never happened, but I did fill my sketchbook with many scenes of human pathos ('Crime in the Cities', *Fortune*, December 1965).

My career as a portraitist reached its climax in 1965 with a series of characterisations of European captains of industry for *Fortune*. Most were drawn in the inner sanctums of palatial offices, which ranged in style from the Italian Renaissance to the Weimar Republic. All were prominent public figures who had been elected to the ranks of *Fortune*'s prestigious top '500'. In the world of commerce there could be no greater accolade short of a peerage or its equivalent. My subjects were especially anxious to present a favourable image of themselves to the world. Paradoxically, this gave me the freedom to interpret their faces as I wished. Nothing was left to chance. Time Inc.'s incredibly efficient researchers supplied me with complete dossiers on the habits and appearance of the sitters.

One of the most elusive subjects was Gianni Agnelli, the boss of Fiat. I had flown to Turin for the sitting, but a complicated deal made him late by several hours, and when he finally arrived, he could give me only 30 minutes. In addition, he was unable to relax for more than a few moments at a time, not long enough to pin him down to a characteristic pose. Just when all seemed lost, I recalled his

friendship with Francis Bacon, with whom he played roulette at Baden-Baden and Monte Carlo. His face lit up as he described his admiration of Bacon's painting. We talked while he held a stylish pose, and the portrait was completed on time.

Fortune got me to places I could never otherwise have dreamt of visiting, let alone drawing, and I still get pleasure from looking at the drawings done for the journal so many years ago.

SIR MAURICE BRIDGEMAN (1967)
Watercolour over pencil. 19x15in (50x40cm)
Collection: the artist.
Sir Maurice was chairman of British Petroleum. A gallery of silver-framed, signed photographs of outwitted sheikhs lined the walls of his chambers. With great politeness I was asked to leave these out. There was only one way to draw him – as a master poker player!

**BUFFALO BILL'S TRADING POST,
NORTH PLATTE, NEBRASKA (1965)**
Faber 702 pencil and markers. 14x11in (36x28cm)
Courtesy: Strathmore Paper Company, USA.
*The vast region of the United States known as the
Great Plains States (Nebraska, Wyoming and the
Dakotas) was once part of the Old Wild West. Myth
and legend have combined to lend themselves to a host
of trading posts, motels and pioneer villages. I found this
one at North Platte, Buffalo Bill's home town.*

NOT SO WILD WEST (1965–78)

The explorations of artists, unlike those of tourists, are sometimes rewarded by the discovery of places not mentioned in guidebooks. Artists also discover subjects of remarkable interest overlooked or unnoticed by more academic observers, although such deviations are bound to get them into trouble sooner or later. This was my experience when, in the autumn of 1965, the celebrated American manufacturers of fine papers for artists, the Strathmore Paper Company of Springfield, Massachusetts, commissioned a series of drawings and watercolours of American life and landscape, and agreed to my suggestion that these should be made in what had once been part of the Old West.

Without realising the immense size of that land of myth and legend, I naively decided to follow part of the itinerary of the Victorian painter and illustrator, my old hero, Arthur Boyd Houghton. Houghton visited the West in January and February of 1870 to depict pioneer life along the newly completed Union Pacific Railroad – the frontier of 'savagery and civilisation' – for the London weekly, *The Graphic*. He boarded a train at Jersey City, bound for Cincinnati, where he embarked on a steamboat that took him westwards on the Ohio River to Louisville and Cairo, then northwards up the Mississippi to St Louis. There, he boarded another train to Chicago, finally arriving in Omaha, the terminus of the Union Pacific Railway.

Houghton responded with enthusiasm to the still Wild West, and found 'medieval knight' and 'noble savage' in the shape of young Buffalo Bill Cody and Black Silk, a Pawnee chief. 'Off to the Plains,' he wrote, before leaving on a three-day buffalo hunt with Cody, 'is nothing less than inspiring, this thought of leaving all civilisation behind.' He even illustrated a buffalo hunt, stayed in a Pawnee village, and visited Salt Lake City, capital of the Mormon Utopia.

I boarded the early morning United Airlines flight from New York City to Omaha, where I rented a big Chevrolet Impala station-wagon. By the afternoon, I was speeding along the Platte River through the sandhills region of Western Nebraska, once the ancestral home of the long-gone northern herd of buffalo, now a vast oceanic expanse of marsh-like meadows and rolling wheatland. There was, of course, no trace of Indian villages or US cavalry outposts.

Unlike New England, where the past was still part of the present and concentrated in a relatively small region, the historic fabric of the Old West was scattered thinly over a vast plateau the size of Western Europe. Houghton's

SIOUX TRADING POST, OGALLALA,
NEBRASKA (1965)
Faber 702 pencil and markers. 11x14in (28x36cm)
Courtesy: Strathmore Paper Company, USA.
This hoarding assumed the form of a giant cut-out of
Nebraska-born film star Paul Newman.

itinerary took me from Omaha through Western Nebraska to Cheyenne and
Laramie. I then followed my own itinerary up through Wyoming to the Black
Hills of South Dakota and Rapid City, where I swung eastwards to Mitchell,
before returning northwards to Omaha.

I soon found myself driving an average of 400–500 miles a day. In two
weeks I covered 4,000 miles. In terms of subjects, the pickings were good, but
having to drive so much meant that there was never enough time to draw them! I
would arrive in some interesting township with rather less than an hour to draw
the place. But on *what* paper? The terms of my contract laid down that I must use
the full range of Strathmore's excellent papers. Here I was, with a carload of
around 20 different kinds, suitable for an equally wide range of media, when most
artists use two, possibly three, kinds throughout their entire careers!

There was Ingres paper in all colours of the rainbow, Script, Alexis
Drawing, Alexis Watercolour (rough, medium and smooth), Bristol board (in
four degrees of thickness and three different surfaces), to name just a few, in great
packages of pads and loose sheets that I collected from various post offices
between Omaha and Rapid City. 'What in hell are you, stranger?' drawled a
curious State Trooper drawing alongside as I drove through the wilds of
Wyoming, 'some kind of paper salesman?'

I strove to retrieve the situation by hastily acquiring the historical background to every place of interest. At Minden, Nebraska, Harold Warp's 'Pioneer Village' temporarily saved the day. In 22 buildings, gathered together in one location, were prairie schooners, sod houses, log cabins, an authentic wooden fort, a land office and many other artefacts of frontier life. Grandparents, accompanied by their married offspring and grandchildren, chuckled at old coffee-pots, Winchester rifles, six-shooters and Model T Fords as though they belonged to the Middle Ages.

At North Platte, Buffalo Bill's hometown, I officially entered Buffalo Bill Country. Buffalo Bill trading posts, diners and motels were everywhere. I had just missed the Annual Buffalo Bill Blowout, but I drew his favourite ranch, 'Scout's Rest', the winter quarters of his travelling roadshow and now a museum. It was a spacious, comfortable old house built in 1889 in the Shingle style by carpenters with the instinct of artists. Here, the celebrated scout and showman, with his sister, Julia Goodman, entertained everyone from royalty to cowhands.

Further west, through the North Platte Valley, I followed the Old Oregon Trail in Wyoming. A vast, treeless prairie was dominated by Chimney Rock and Scotts Bluff, landmarks visible for many miles around, and which had guided the wagon-trains of the early pioneers bound for California or the forested Eden of Oregon. At Fort Laramie, originally a fur-trading post, the buildings of the famous old fort, abandoned in 1890, were still standing, being restored as a National Historic Site.

The fine autumn weather broke as I reached Cheyenne, and snow began to fall. In the warmth of my room at the Old Plains Hotel, I watched westerns on television, and wondered what my next move might be; even with thermal underwear, it was much too cold to work outside. Perhaps some of the old pioneers might still be alive? I was just in time. The State Historical Society were delighted to inform me that they could introduce me to two.

The first was 82-year-old Russell Thorpe, Jnr, an ex-rancher whose father had owned the celebrated Cheyenne-Deadwood stage-line. Faded sepia photographs of stagecoaches, heavily moustached cow-punchers, prize cattle and long-departed town marshalls lined the walls of his simply furnished house. A spiked pile of letters stood on a tiny mahogany roll-top desk in his drawing room. 'They write to ask me if it was fact or fancy,' he chuckled, 'but it was fact all right. Those settlers who headed out here had a helluvalot of nerve. They made America what it is!'

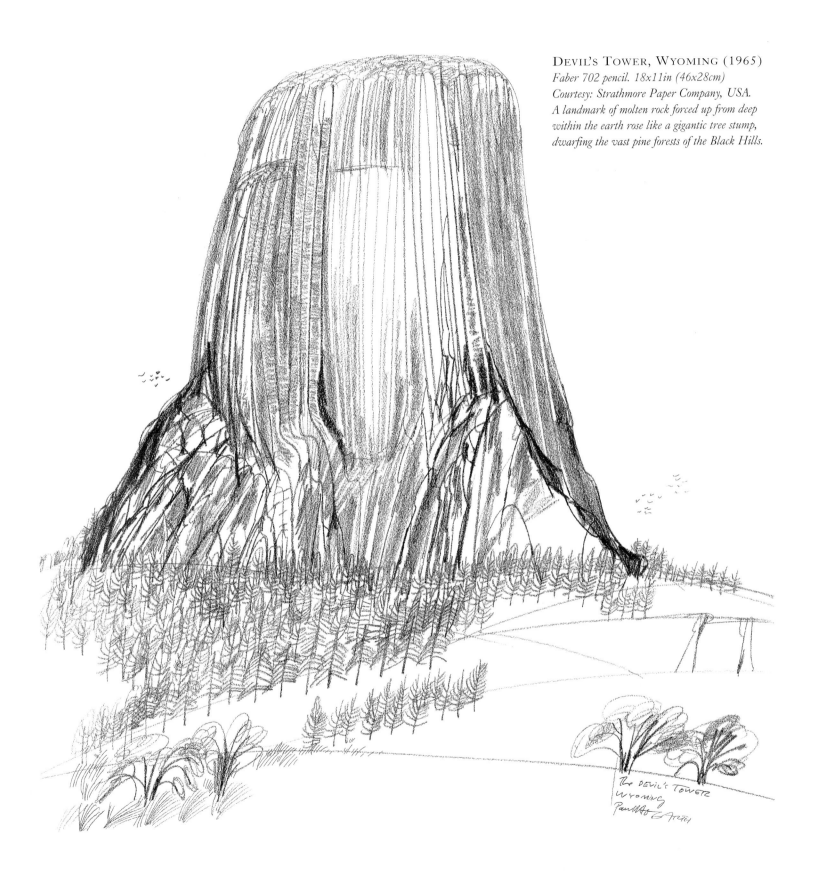

DEVIL'S TOWER, WYOMING (1965)
Faber 702 pencil. 18x11in (46x28cm)
Courtesy: Strathmore Paper Company, USA.
A landmark of molten rock forced up from deep
within the earth rose like a gigantic tree stump,
dwarfing the vast pine forests of the Black Hills.

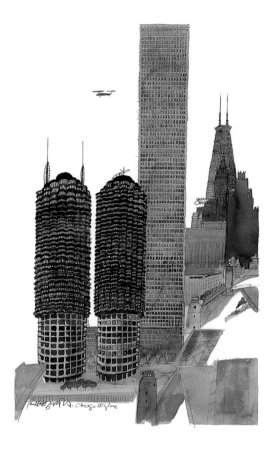

The second pioneer was the aristocratic Mrs Boice, the widow of a wealthy rancher, who lived in a large mansion on a quiet street in the old downtown neighbourhood. A Bostonian and proud of her English ancestry, she did not like to be thought of as a Westerner. 'I came here from Boston as a young married woman,' she announced, 'and helped to civilise this town.' Although still handsome, even in old age, she could not forget how regally beautiful she had once been. Seated in an elkhorn chair with a ruby-red, plush footstool under her feet and a Venetian grape-cluster glass chandelier above her head, she would have made an extraordinary portrait, but she declined to sit for me.

From Cheyenne I drove northwards to the densely wooded Black Hills. I lingered for a day in the former gold-mine town of Deadwood, which had reverted to its rip-roaring past of saloons, dancehall girls and gambling. Tourists were entertained by enactments of the last hours of Wild Bill Hickock, who was shot in the back while playing poker, and made pilgrimages to his grave and that of his true love, Calamity Jane. Further north still, I entered the eerie Badlands of South Dakota, a sculpted chaos of buttes, razor-edged ridges and savage ravines. The Sioux called the region *Ma-Koo-Si-tuha*, the impassable country, a vast repository of what they called 'stone bones', the fossilised remains of dinosaurs.

I gazed over the plain where Custer made his last stand against the Sioux at Little Big Horn, then I turned eastwards into the heart of South Dakota, through an endless succession of small towns remarkable only for their uniformity. Mitchell, the exception, boasted a flamboyant Russian-style, onion-domed Corn Palace built in 1892. Most, however, consisted of a main street with a grocery store or two, a hardware store, a movie theatre and a bank, bisected by straight highways as wide as a Paris boulevard. The novelist Sinclair Lewis described such towns as 'strongholds of contentment' and 'dullness made God'.

It was in one such Plains town that I experienced the parochialism of regional America. I was in a diner, tucking into a huge T-bone steak, and a farmer sat down beside me. He heard me ask for a second portion of pumpkin pie with cream, and we got talking about the weather. 'You speak pretty durned good English, young feller,' he said, 'where didya learn it?'

'England,' I roared, 'I *am* English!'

'Waal, I'll be a son-of-a-gun,' he laughed.

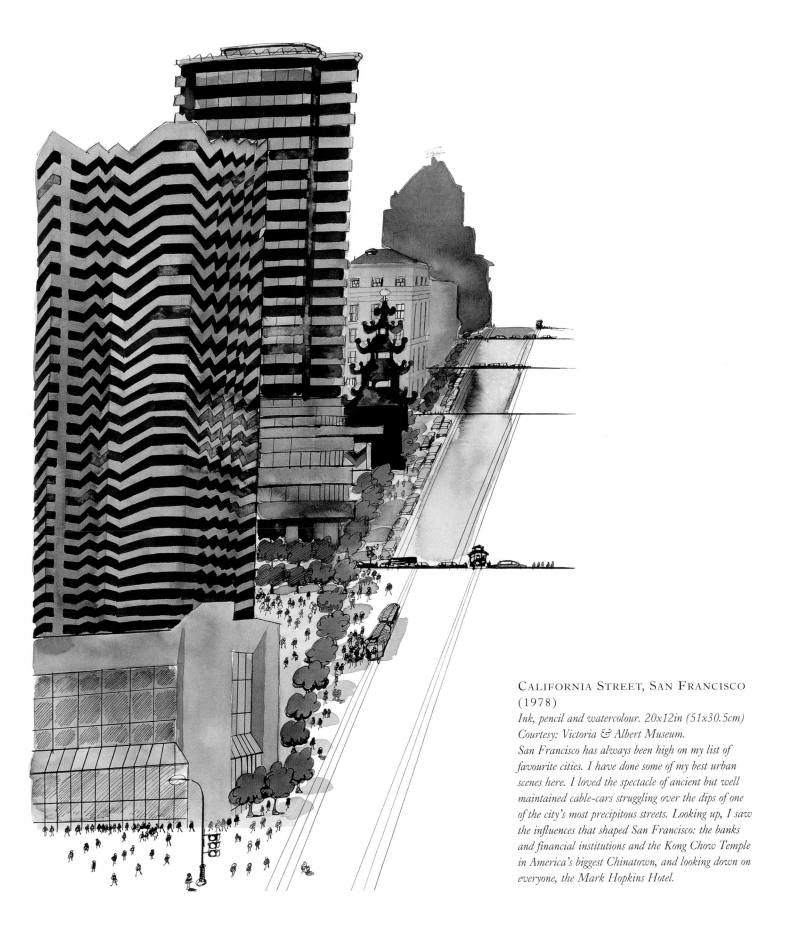

CALIFORNIA STREET, SAN FRANCISCO (1978)

Ink, pencil and watercolour. 20x12in (51x30.5cm)
Courtesy: Victoria & Albert Museum.
San Francisco has always been high on my list of favourite cities. I have done some of my best urban scenes here. I loved the spectacle of ancient but well maintained cable-cars struggling over the dips of one of the city's most precipitous streets. Looking up, I saw the influences that shaped San Francisco: the banks and financial institutions and the Kong Chow Temple in America's biggest Chinatown, and looking down on everyone, the Mark Hopkins Hotel.

SPORTS ILLUSTRATOR (1965–73)

Ted Riley will not be a name known to the general public. He would not have liked it any other way, yet he was the doyen of Manhattan's, if not all America's, art agents. By the middle 1960s, Ted's stable, besides myself, included Quentin Blake, Mel Calman, John Glashan, Domenico Gnoli, Sara Midda, Jean-Jacques Sempé and Pierre Le Tan. Certainly, my career in America would not have been the same without him.

Our first meeting was predictably low key. He saw my potential, but the problem, as he put it, was that I was 'a fine arts illustrator' for whom the market would be limited. The getting of work, therefore, was a matter of approaching the right people. To my surprise, he succeeded in doing so simply because of the trust and immense confidence he inspired. I became not only a reporter of industry and a portraitist of tycoons, but an observer of popular sporting events.

Ted kept track of advances in a small black leather notebook, and had the disconcerting habit of pulling out a bulging wallet and peeling off a $2,000 advance in public. Once I mildly protested at this lack of prudence as we stood outside Pennsylvania Station, only to be rebuked: 'Really Paul, you've read too many reports on crime over here.' London, on the other hand, he thought 'really dangerous'!

Ted persuaded Richard Gangel, art director of *Sports Illustrated*, to let me cast my jaundiced British eye on the American sporting scene. Such stars of American magazine illustration as Austin Briggs, Albert Dorne and Al Parker

LOS ANGELES DODGERS VERSUS THE SAN FRANCISCO GIANTS (1973)
Watercolour over pencil. 14x11in (37x28cm)
Drawn at the Los Angeles Stadium.
Collection: the artist.
Without doubt, baseball involved imagination and intelligence besides brute strength. But to my jaundiced non-ball-player's eye, it seemed more difficult to understand than cricket. What impressed me most was the non-stop, round-the-clock eating!

could always be relied on to produce a predictable result with impressive expertise. Gangel, under Ted's guidance, now preferred more of a cutting edge, despite the prejudices of his white-shirted editors (one for each major sport), and sport was presented with a much greater variety of style. Quentin Blake got the Henley Regatta; Domenico Gnoli, South American Indian games; Ronald Searle, spring baseball training in Arizona and California. In the autumn of 1965, I was given the Sixth Annual Charlotte National 400, at Charlotte, North Carolina, then the biggest stock-car racing event in America.

The sport had started in the 1950s on the country roads of Alabama, the Carolinas and Tennessee. Young country boys, usually poor farmers' sons, ran bootleg moonshine whisky in hotted-up Chevrolets, Fords and Pontiacs at breakneck speeds to elude state police patrols. When the FBI broke up the illegal traffic, the moonshiners turned to racing among themselves. Clubs and meetings were organised and the fans began to gather. By 1960, stock-car racing was big business, with top drivers making small fortunes in prize money.

As the big day dawned, mechanics fussed and drivers tried to relax. The drivers themselves were big and strong. They needed to be. Their cars, braced inside with tubular steel, were so heavy that they required strength as well as nerve to manoeuvre. The drivers' wives stood in groups, anxious and protective of one another. Girlfriends, on the other hand, remained in pairs, wide-eyed and excited by the atmosphere of danger.

As the cars roared around the huge, snaking track, a day out for the family turned into a terrifying gladiatorial contest. In the first lap, a five-car pile-up took the life of a former army major who had survived World War II and the Korean campaign. Behind the scenes, in the pits, dedicated men kept things moving. Many were ex-drivers, willing to do anything from changing tyres to driving recovery vehicles, or even hosing down the over-heated track. The winner, 28 year-old Fred Lorenzen, drove a 1965 Ford around the 2-mile track 400 times for three hours, at an average speed of 120mph. According to one rugged individual, who had given up driving when he broke both his legs and pelvis, 'It takes a very special kind of bastard to drive those babies'.

Gangel let me loose on several more assignments, from desert bike racing to the London Boat Show. One of the more interesting was the Calgary Stampede in the summer of 1969. Western Canada had been as much the home of the cowboy (and the Indian) as the United States and, since 1912, the venue of the biggest rodeo on the North American circuit. For ten days every July, Calgary

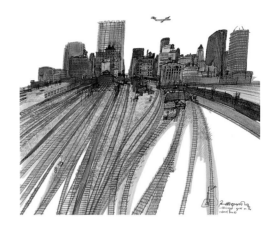

GRASS ON THE TRACKS (1973)
Ink, markers and watercolour. 11x14in (28x36cm)
Private collection, UK.
Every now and then, I stumbled across an image worth a thousand words. Chicago, once the hub of America's vast railway freight system, had by the 1970s lost out to the airplane.

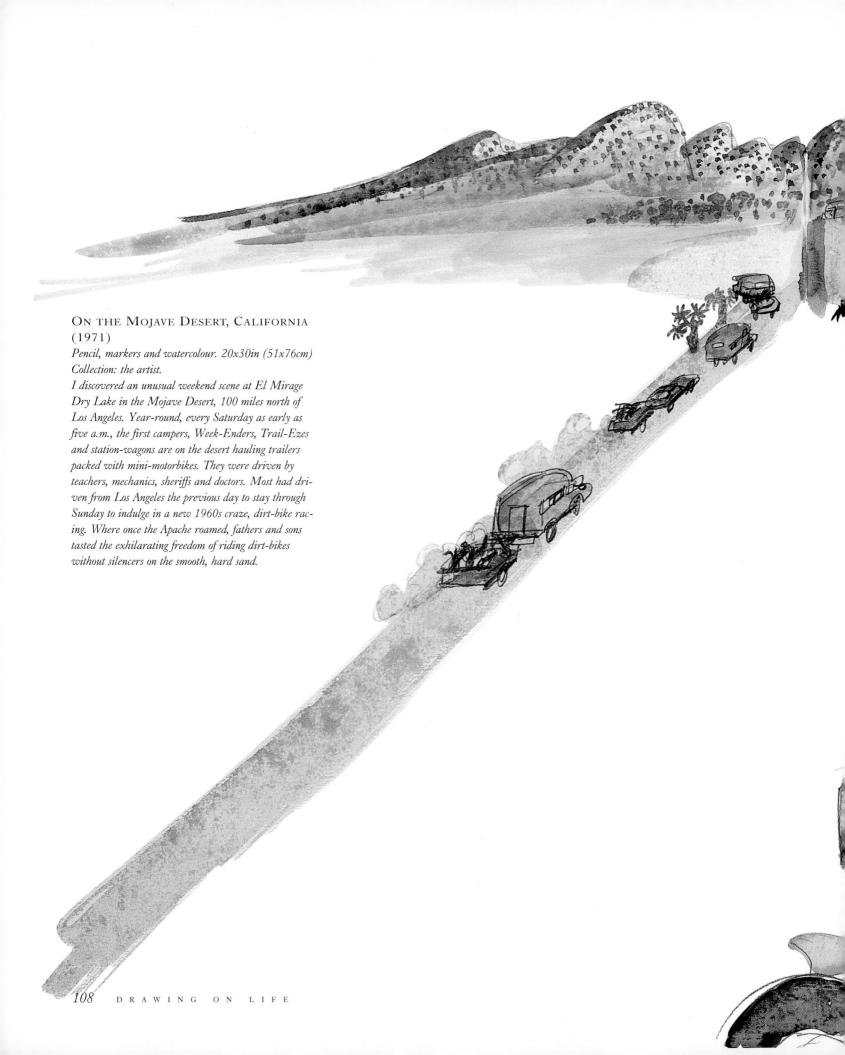

ON THE MOJAVE DESERT, CALIFORNIA (1971)

Pencil, markers and watercolour. 20x30in (51x76cm)
Collection: the artist.

I discovered an unusual weekend scene at El Mirage
Dry Lake in the Mojave Desert, 100 miles north of
Los Angeles. Year-round, every Saturday as early as
five a.m., the first campers, Week-Enders, Trail-Ezes
and station-wagons are on the desert hauling trailers
packed with mini-motorbikes. They were driven by
teachers, mechanics, sheriffs and doctors. Most had dri-
ven from Los Angeles the previous day to stay through
Sunday to indulge in a new 1960s craze, dirt-bike rac-
ing. Where once the Apache roamed, fathers and sons
tasted the exhilarating freedom of riding dirt-bikes
without silencers on the smooth, hard sand.

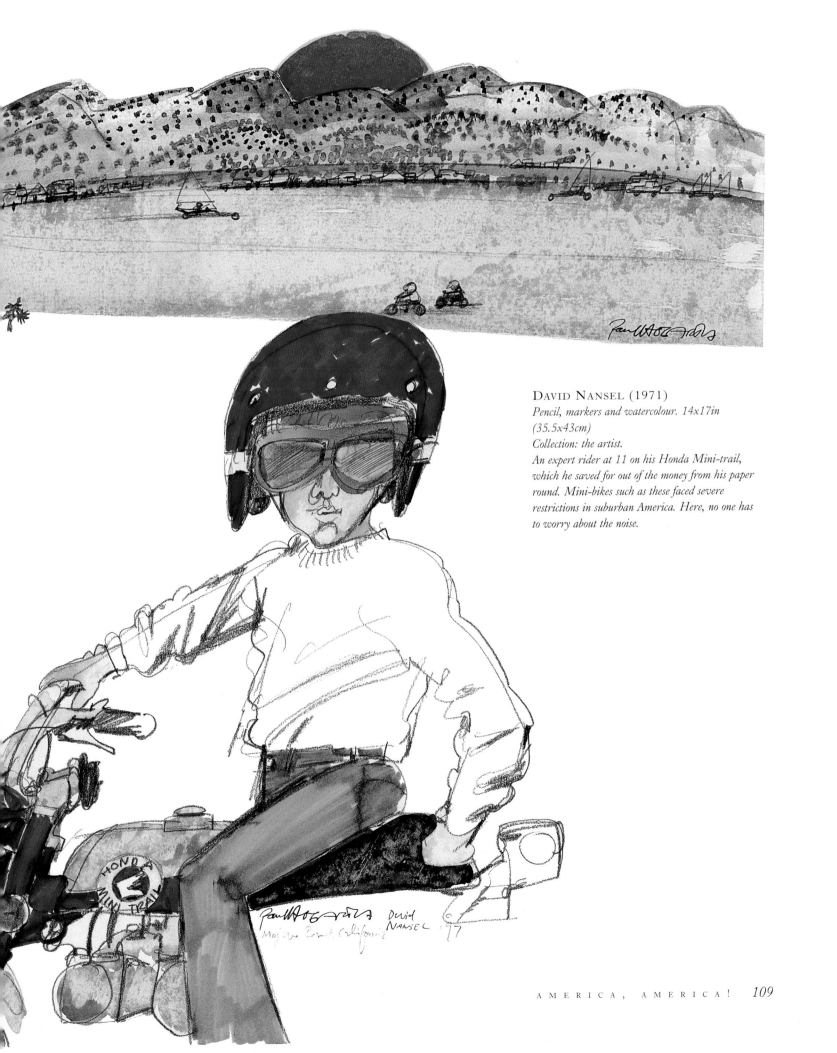

DAVID NANSEL (1971)
Pencil, markers and watercolour. 14x17in
(35.5x43cm)
Collection: the artist.
An expert rider at 11 on his Honda Mini-trail,
which he saved for out of the money from his paper
round. Mini-bikes such as these faced severe
restrictions in suburban America. Here, no one has
to worry about the noise.

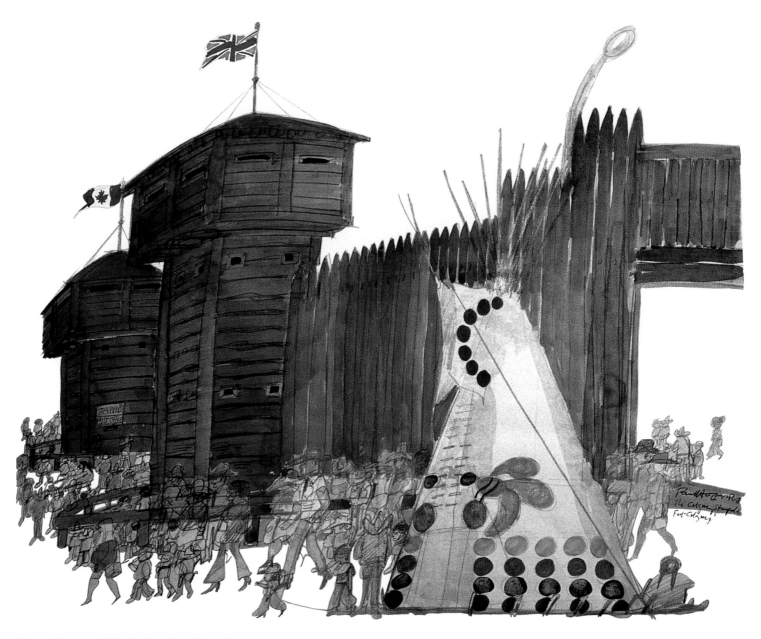

For ten days every July, the Canadian oil city of Calgary, Alberta, dresses up in western gear. There is square-dancing in downtown city streets, neighbouring Indians pitch their wigwams, and North America's top rodeo performers compete for the big prizes ('The Calgary Stampede' Sports Illustrated 13 July, 1970).

FORT CALGARY (1969)
Watercolour over pencil. 11 x14in (28x37cm)
Courtesy: Riveredge Foundation, Calgary.
A reconstruction of the North-West Mounted Police post that preceded what is now Calgary.

itself reverted to the time when Alberta was a producer of beef, not oil, and the entire city succumbed to stampede fever. Leading citizens dressed up in Levis, Stetsons and high-heeled boots, and invited their friends to view the Grand Opening Day Parade from balconied suites in the Canadian Pacific Hotel, where I found myself as a guest of Nicholas Grandmaison, White Russian emigré painter of Indians and boyhood friend of the novelist Vladimir Nabokov.

One breathtaking feat followed another. Bareback riding, saddle bronco-riding, calf-roping, bull-riding, steer-wrestling and the *pièce de résistance*, the Chuckwagon Race, or rangeland Derby. Gary Leffew of California survived by

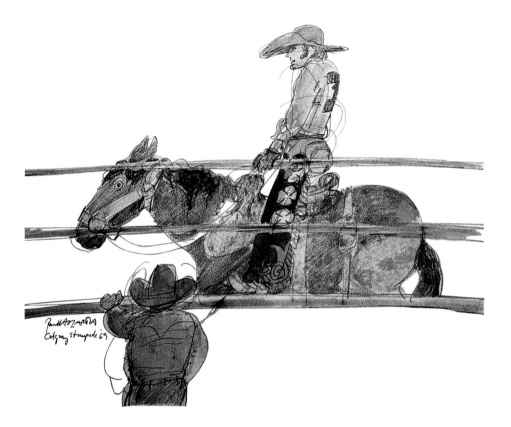

CALF-ROPING
Watercolour over pencil. 11x14in (28x37cm)
Courtesy: The Riveredge Foundation.

Left: FATHER COUNSELS SON, NOVICE
CHAMPIONSHIP COWBOYS BRONCO-
RIDING CONTEST
Watercolour over pencil. 11x14in (28x37cm)

the skin of his teeth and won the Brahma Bull-Riding Championship. Another American won the North American calf-roping contest. An Alberta cowboy, however, took the top honours in steer-wrestling, or 'bull-dogging'. All these men were so hefty that my sympathy was with the animals, which only occasionally outwitted their opponents.

My most enjoyable assignment, however, was depicting night-time baseball during the 1970s. The introduction of night games had been especially successful in Boston and Los Angeles, two locations that could not have been more different. The *fin-de-siècle*, cast-iron Fenway Park Stadium in Boston represented the traditional ball-park, small and compact: the home of the Boston Red Sox. The Dodgers Stadium in Los Angeles, then America's biggest, was the size of an airport, with its own entrance and exits on the freeway and with parking for 100,000 vehicles, plus its own landing strip.

The great American game remained a complete mystery to me. I saw it all as a pagan festival reminiscent, perhaps, of the ritual ball-games that have appeared in most cultures since the times of ancient Egypt and Greece. Going to a baseball game on a pleasant summer's evening appeared more like an excuse for

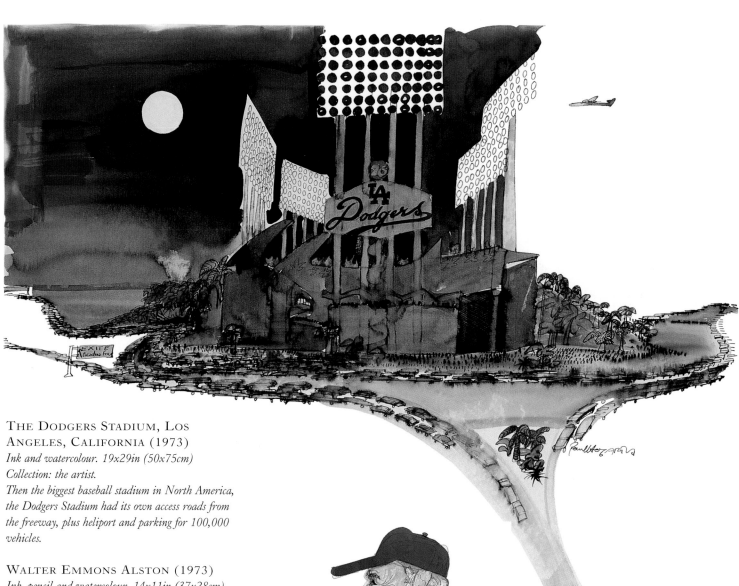

THE DODGERS STADIUM, LOS
ANGELES, CALIFORNIA (1973)
Ink and watercolour. 19x29in (50x75cm)
Collection: the artist.
Then the biggest baseball stadium in North America,
the Dodgers Stadium had its own access roads from
the freeway, plus heliport and parking for 100,000
vehicles.

WALTER EMMONS ALSTON (1973)
Ink, pencil and watercolour. 14x11in (37x28cm)
Collection: the artist.
Boss of the Los Angeles Dodgers.

an evening of exuberant relaxation in the company of friends. At the Fenway Park Stadium, I was so struck by the spectacle of mass gluttony that I decided to make it my underlying theme. Long before the game even started, I noted popcorn being consumed in vast quantities. Two friends, who looked like construction workers, particularly fascinated me. They had already gone through five large bags each. Later, they moved on to hamburgers, hot-dogs and ice-cream, washed down with several cans of Coke. Yet when the game was over, they were still hungry. I transformed a row of pizza parlours, hamburger havens and restaurants into a strip of gaping mouths, into which the two friends and hundreds of other fans entered to indulge themselves still further.

Back in New York, the baseball editor was appalled. These drawings never appeared in *Sports Illustrated*, but Ted, unabashed, sent them down to Washington

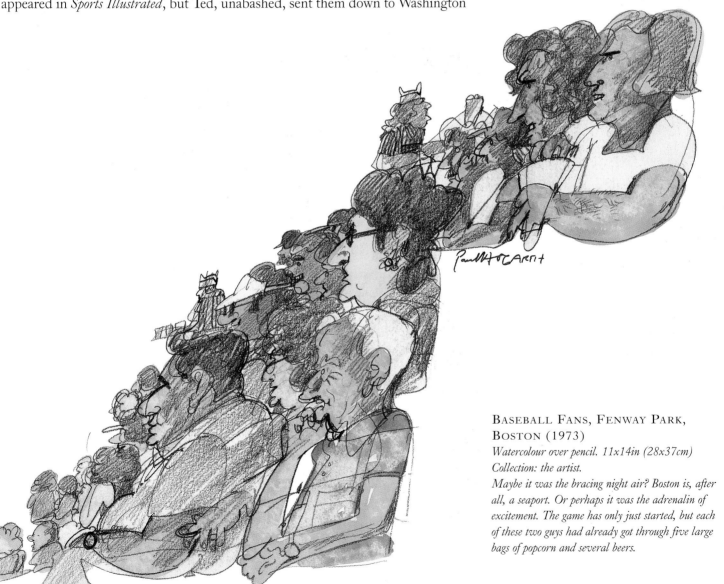

BASEBALL FANS, FENWAY PARK, BOSTON (1973)
Watercolour over pencil. 11x14in (28x37cm)
Collection: the artist.
Maybe it was the bracing night air? Boston is, after all, a seaport. Or perhaps it was the adrenalin of excitement. The game has only just started, but each of these two guys had already got through five large bags of popcorn and several beers.

AFTER THE GAME AT FENWAY PARK,
BOSTON (1973)
Ink and watercolour. 19x29in (50x75cm)
Collection: the artist.
When the game was over, hundreds of fans flocked
to a row of pizza-parlours, hamburger-havens and
restaurants outside the stadium.

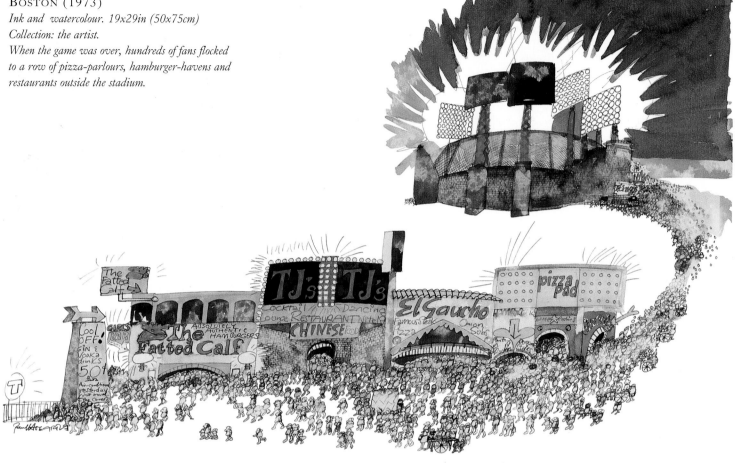

to the United States Information Agency. Some time later, they appeared as a lavish six-page feature on the American way of life in the Agency's Russian-language monthly, *Amerika*, entitled 'Batter-Up! An English Artist looks at Baseball' (258: May, 1978).

ABROAD IN AMERICA (1976–84)

Early in the 1970s, another facet of America caught my attention; that of a nation renewing itself in preparation for the Bicentennial Year of 1976. I set forth with the travellers' sense of release, all the more eagerly to depict what Henry James once described as 'the absent past'.

This new phase of my 'American' period had begun during the autumn and winter of 1968–69. I had been given a sabbatical year by the Royal College of Art

to be associate professor at the Philadelphia College of Art. While there, I walked a great deal in what had been the old colonial city, and sometimes took my students to draw it. I discovered that the modest house Benjamin Franklin (one of my heroes) designed and built for himself still stood on Orianna Street, a colonial enclave in the Quaker City. On the way, I passed through the most historic neighbourhood in the United States, and experienced the extraordinary sensation of being back in colonial America. Crossing Fourth Street, and continuing west along cobblestoned Library Street, I found myself in Independence Square with its trio of splendid Georgian buildings (Independence Hall, Congress Hall and Old City Hall), where the foundations of Federal government were established and Independence itself was declared on 4 July, 1776.

MYSELF, SUITABLY ATTIRED TO PORTRAY THE FORMER AMERICAN COLONIES (1976)
Ink. 10x8in (25.5x21.5cm)
Collection: the artist.

Except for Independence Square, it hadn't always looked as it now did. By the 1950s, William Penn's 'greene Countrie Towne', once a rival to Boston as the most enlightened city of colonial America, had almost disappeared. Whereas other old American cities had grown upwards, Philadelphia had expanded sideways, leaving Society Hill, the original eighteenth-century heart of the city, to become a run-down business district, a fearsome slum of dereliction and decay, where elegant mansions and imposing public buildings languished as rooming-houses, workshops and warehouses until 1951. Then, the Federal government and the State of Pennsylvania stepped in to purchase the entire site, and the National Park Service implemented a long-term programme of rehabilitation. Listed houses were sold to private buyers willing to restore them to their former glory. By the time I visited again in 1974, Old Philadelphia had reappeared as if by magic. Overnight, I became a fervent conservationist, and wrote and illustrated *Walking Tours of Old Philadelphia*.

Boston, the largest and most important American city in the eighteenth century, was my next subject for a book of walking tours. I already knew it well as I had first visited the city, briefly, in 1969, and delighted in discovering Beacon Hill and North End. I had visited again in 1972, when I drew hippies and hard-hats arguing the political toss on the Common for *Smithsonian Magazine*. The following year I covered night baseball at Fenway Park for *Sports Illustrated* as well as the Locke-Obers Restaurant and the new City Hall for *Pastimes* (the in-flight magazine of Eastern Airlines). The most English of American cities, with its downtown giant shop signs of watches, steaming kettles and pipes, reminded me of what Victorian London must have looked like. During the spring and autumn of 1976, I decided to explore and draw the city in much greater depth. I rented a

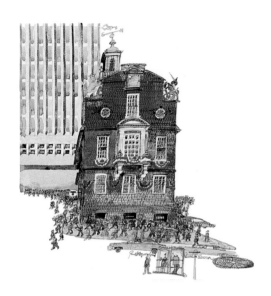

small flat in Revere Street on Beacon Hill, where, sustained by weekly Saturday lunches given by the convivial spirits of the Club of Odd Volumes (a *very* Boston institution), I wrote and illustrated *Walking Tours of Old Boston* (1978).

Boston also provided me with more than its share of comments. I was busily drawing a fine Charles Bulfinch mansion (85 Mount Vernon Street, Beacon Hill). An elegantly dressed old lady looked over my shoulder with what I felt had to be a terrible ambivalence about the drawing. Unable to restrain herself any longer, she exclaimed, 'Do you know the history of that house, young man?' 'Yes, ma'am,' I replied, 'I do.' 'Well, maybe you do,' she retorted, 'but *I* was born in it!'

Another American project, which I undertook in the summer of 1975, was to draw the battlegrounds of the War of Independence for the *Daily Telegraph Magazine*. These watercolours never were published by the *Telegraph*, but ended up as a seven-page feature in *Amerika* ('An Englishman Looks at the Revolution' 241: December 1976). In Boston, the ideological heart of that momentous struggle, I drew the Old State House, built to serve the Crown; although dwarfed by skyscrapers, it is indeed, a Georgian gem. Behind me was the equally handsome Fanueil Hall, where American leaders mounted their attacks on George

I must confess a weakness for drawing American architecture of the Colonial period. Although Georgian in style, the American derivation is more dynamic, even more eccentric, than the original British. I have drawn many such buildings on extended visits to Alexandria, Boston, Charleston, Philadelphia and Newport; and also in New York, Nantucket and Williamsburg for the London Daily Telegraph Magazine, *the National Trust of America and the National Geographic Society of America.*

Above: THE OLD STATE HOUSE, BOSTON (1977)
Ink and watercolour. 22x15in (56x38cm)
Courtesy: Department of Prints, Drawings and Watercolours, Boston Public Library.
The Old State House was the location for the first town hall, built in 1657 but destroyed by fire. This one was built in 1713. The Royal Government of the Massachusetts Colony met here to discuss matters of moment. There was plenty to talk about after 5 March, 1770. Just in front of the East Gable, a patrol of British redcoats panicked and fired on a mob of rioting ropemakers led by a former slave, Crispus Attucks. Rioters and bystanders alike were killed or injured. The Boston 'Massacre' enabled lawyer-politician Samuel Adams to make the most of the story that citizens were being shot down in their own streets, and thus hastened the cause of independence.

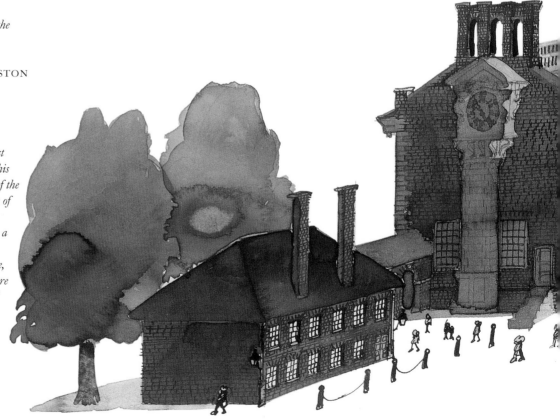

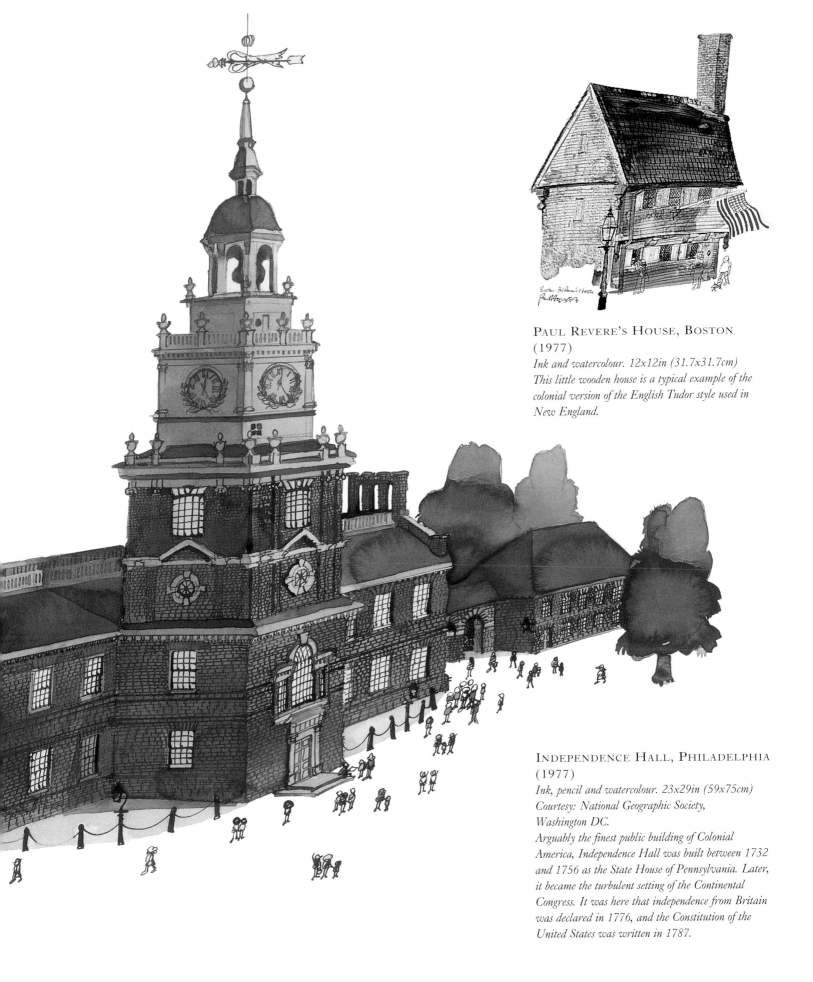

PAUL REVERE'S HOUSE, BOSTON (1977)

Ink and watercolour. 12x12in (31.7x31.7cm)
This little wooden house is a typical example of the colonial version of the English Tudor style used in New England.

INDEPENDENCE HALL, PHILADELPHIA (1977)

Ink, pencil and watercolour. 23x29in (59x75cm)
Courtesy: National Geographic Society,
Washington DC.
Arguably the finest public building of Colonial America, Independence Hall was built between 1732 and 1756 as the State House of Pennsylvania. Later, it became the turbulent setting of the Continental Congress. It was here that independence from Britain was declared in 1776, and the Constitution of the United States was written in 1787.

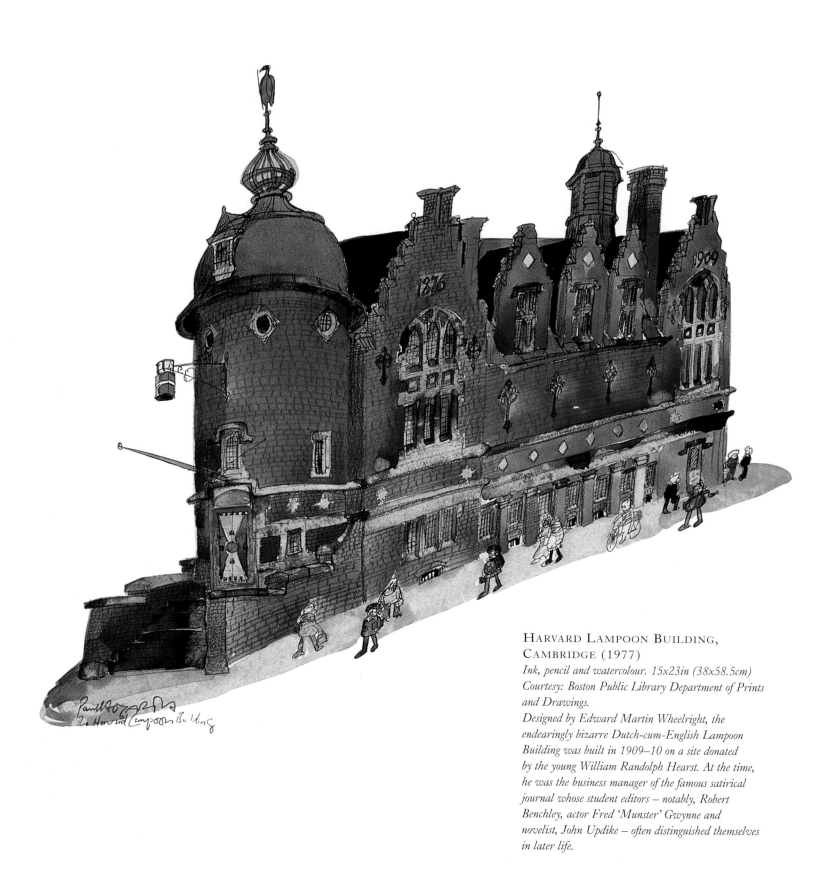

HARVARD LAMPOON BUILDING,
CAMBRIDGE (1977)
Ink, pencil and watercolour. 15x23in (38x58.5cm)
Courtesy: Boston Public Library Department of Prints
and Drawings.
Designed by Edward Martin Wheelright, the
endearingly bizarre Dutch-cum-English Lampoon
Building was built in 1909–10 on a site donated
by the young William Randolph Hearst. At the time,
he was the business manager of the famous satirical
journal whose student editors – notably, Robert
Benchley, actor Fred 'Munster' Gwynne and
novelist, John Updike – often distinguished themselves
in later life.

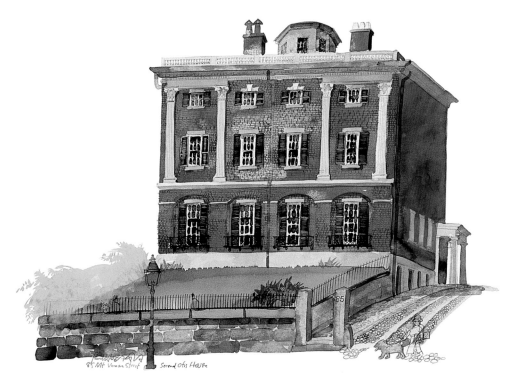

III and Parliament. I went on to Concord to draw the famous North Bridge, where the first shots rang out; up to Fort Ticonderoga overlooking Lake Champlain; to Fort Mifflin on the Delaware River, Germantown and Valley Forge, and finally south to Yorktown, Virginia where it all ended in inglorious defeat for the British forces.

My books on Philadelphia and Boston were well received. Together with *Drawing Architecture* (published there in 1973), they firmly established my reputation in the United States as a painter of the urban landscape. Ted Riley was delighted as the assignments rolled in; so delighted, in fact, that he thought I should move to America.

When my son, Toby, had completed school in 1976, Ted suggested that we live in Washington. He had two major assignments for me there: to depict historic American architecture for a National Geographic Society book entitled *Visiting Our Past*; and an even bigger project, to write and illustrate a book on Washington itself. As Pat had decamped to Edinburgh by now, a move to America seemed a good idea, and I settled there for three years.

Toby and I arrived in Washington in fine autumn weather. For a few days, we stayed in the Old Tabard Inn near Dupont Circle. Then Ira Glackens, an old

RENWICK GALLERY, WASHINGTON DC
(1978)
Ink, pencil and watercolour. 15x23in (38x58.5cm)
Courtesy: Ms Betty Shinkman, Georgetown,
Washington DC.
Designed in 1859 as the Corcoran Gallery of Art to
house the collection of banker William Wilson
Corcoran, this French Empire style building is named
after its architect, James Renwick, and was the first
outstanding example of that style in the United States.

friend, performed the near-miracle of persuading an old friend of his in Georgetown real estate to rent us a handsome little clapboard house on Twenty-Eighth Street. From then on, our spirits rose as we grappled with the challenge of living in America.

There was much to do. I had enrolled Toby at the Corcoran School of Art for a design and photography course, and until he began there in spring 1977, he worked as my assistant on the formidable task of making watercolours of stately homes, from the Hudson Valley to the Virginia Tidewater Country, the lowlands of the Carolinas and the mansions of the Mississippi Delta. In addition, the

Washington book required a massive amount of research, which involved looking through the files of the Columbia Historical Society and the Historic American Buildings Survey.

The constant activity helped us to settle down and enjoy the vast range of free cultural entertainment on offer. We went to the National Archives and saw classics of world cinema; to the Library of Congress for poetry readings and Black Theatre; to Anderson House for chamber music. It was the Jimmy Carter era, and bluegrass and country music became almost obligatory in the hallowed precincts of the Smithsonian Institute.

Being a single parent, and an artist to boot, I could stay at home during the day like the proverbial housewife. Moreover, Georgetown was a congenial place to live, and Scheele's, our neighbourhood grocery store, added much to its flavour. Mr Scheele himself, wearing a bow-tie, white shirt, apron and half-eye spectacles, looked as though he had stepped out of a Norman Rockwell *Saturday Evening Post* cover.

Being the political capital of the United States of America, Washington was especially fascinating to draw. Lafayette Square, its epicentre, was originally the location of a republican counterpart of court residences, and still contained a

MILES BREWTON HOUSE, CHARLESTON (1984)

Ink, pencil and watercolour. 17x29in (44.5x62cm)
Private collection, UK.
Designed by Ezra White (of London) for Miles Brewton, a wealthy merchant of colonial Charleston, this handsome mansion later became the headquarters of two armies of occupation: General Sir Henry Clifton, Commander-in-Chief of the British Army during the War of Independence; and General Schimmelfennig, Commander of Union troops during the Civil War.

nucleus of historic mansions: a set-piece of the Federal or Georgian era. The White House, the Octagon, Blair House, Decatur House, St John's Church, the Cutts-Madison House and Taylor-Cameron House belonged to the stormy decades of the young republic in the early 1800s. Nearby, the ornate Renwick Gallery (Old Corcoran Art Gallery), St John's Parish Building (the Old British Embassy) and the chateau-esque Willard Hotel, reflected the flamboyance of the *belle époque*.

The colonial character of the White House neighbourhood changes as one passes the huge Treasury Building that stands at the beginning of a triumphal way stretching over a mile to the Capitol. Pennsylvania Avenue was planned by the original architect of the city, Pierre L'Enfant, and includes the most important elements of his grand design, joining the White House to Capitol Hill. The Capitol itself was the work of other hands. Its massive, pearl-grey façades, like those of the Supreme Court nearby, express the awesome power of government;

which prompted Dylan Thomas to remark that Washington looked more like Rome than America.

Downtown – for many decades official Washington – was much more sedately Victorian. Most of the old government buildings were concentrated here between the Capitol and the White House, north of Pennsylvania Avenue. Many were associated with the Civil War period. The Old Patent Office (now the National Portrait Gallery and National Museum of American Art) was the scene of President Lincoln's second inaugural ball in 1864. Surratt House, where much of the conspiracy to assassinate Lincoln was planned, is not far away. When I was working at drawing it, a parking-lot attendant glanced over my shoulder. 'After what happened there,' he said, 'they should have torn the place down!'

No other part of Washington reflects the hopes and aspirations of American society as does Massachusetts Avenue. Lined with some 300 enormous edifices dating back to the turn of the century, it is the longest and grandest of the capital's boulevards; it reflects that ostentatious era of high living that followed the Spanish-American War and ended with the Great Depression. During that time, merchant princes from New York and New England, industrialists and railway tycoons from Pennsylvania and Ohio, timber barons and mine-owners from the Far West, meatpackers and newspaper magnates from the Midwest, all converged

GAMIR DOON, NEWPORT, RHODE ISLAND (1973)
Ink and watercolour. 23x18in (47x58.5cm)
Courtesy: Boston Public Library, Department of Prints and Drawings.
Formerly the CH Baldwin House, Gamir Doon was built in 1878 on a modest scale before Newport became the social capital of tycoon America.

HUGUENOT HOUSES, CHARLESTON (1984)
Ink, pencil and watercolour. 18x23in (46.7x58.5cm)
Collection: the artist.
In 1690 English planters and merchants in Charleston were joined by the Huguenots, who had fled persecution as Protestants in Catholic France. Many of their houses survive, like this block in King Street.

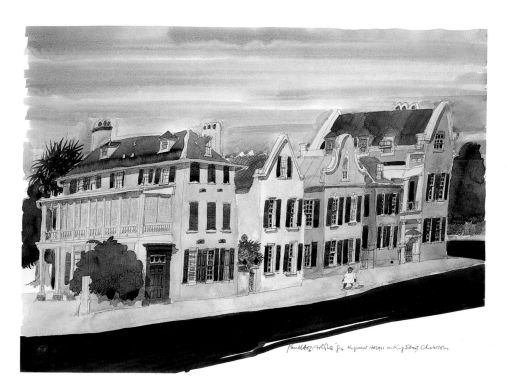

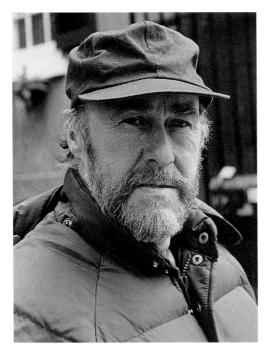

on the capital, vying with one another to build palaces, villas and mansions which they occupied, in many instances, only during the winter social season. These newly rich and their usually profligate descendants flourished in their private palazzi until the prolonged effect of the 1929 crash finally forced them to sell their heritage for use as embassies, offices or clubs.

During the summer of 1979 I said goodbye to Washington, the Glackenses and my other American friends, albeit with mixed feelings, and returned to Europe. Although I felt sympathetic towards the cut-and-thrust, make-or-break nature of the American way of life, the role that my kind of art could play in the context of the periodical had declined to the point where Ted Riley found it increasingly difficult to find me work. Once again I needed to re-invent myself, to work with writers, especially British writers, to evolve book projects and, hopefully, to exhibit the fruits of such collaborations.

MYSELF IN A SOMBRE MOOD,
CHARLESTON (1973)
Photo: Toby Hogarth.

THE ROPER HOUSE, CHARLESTON
(1984)
Ink, pencil and watercolour. 18x23in (46.7x58.5cm)
Private collection, UK.
An elegant example of the 'Charleston style' with a piazza or veranda copied from the houses of Barbados to catch the cool sea breezes in the stifling summers. This Greek-revival mansion on East Battery was designed by Edward Brickell White and built in 1838 for the philanthropist Robert William Roper.

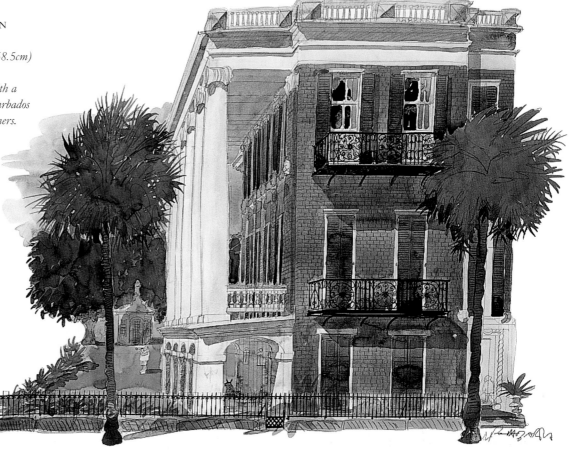

CHAPTER SIX

After the Fall

ON MY VISITS TO RUSSIA IN THE 1950S THERE HAD BEEN FEW
OPPORTUNITIES TO DRAW, OTHER THAN A HANDFUL OF HASTY IMPRESSIONS
OF MOSCOW, LENINGRAD AND ARMENIA. I LONGED TO RETURN AND TO
DEPICT ITS PRE-REVOLUTIONARY GLORIES. WHEN DESMOND FLOWER
ASKED IF I WOULD LIKE TO DO ANOTHER TRAVEL BOOK, I SUGGESTED
RUSSIA. BUT WHO WOULD WRITE THE TEXT?

IT HAD TO BE someone *au fait* not only with Russia, but also with the closed
doors of an autocratic régime. I thought of Alaric Jacob, a former Reuters
diplomatic correspondent in London and Washington (and later a war
correspondent in North Africa and Burma). Our friendship went back some 20
years. Alaric's involvement with Russia had begun in boyhood, when his parents
acquired Mrs Birse, a Russian housekeeper who, besides introducing the family
to Russian *haute cuisine*, also introduced Princess Troubetskoy and other
distinguished emigrés of the last Tsar's Court. Both Jacob and his first wife Iris
Morley had seen Russia with its back to the wall during World War II, he as a war
correspondent for the *Daily Express* and she as correspondent for *The Observer* and
the *Yorkshire Post*. His view was unusual in that, as an urbane upper-class
Englishman, he was more inclined to accept Russia's Stalinist past than the Soviet
'success'. It proved very difficult to get a visa. I was now, it transpired, on the
USSR's blacklist, having long been unofficially branded a heretic. Moreover, I
contributed to American magazines such as *Fortune* and *Sports Illustrated*, which
made me doubly suspect. Somehow, through his old colleagues, Alaric was able to
calm the fears of Soviet officialdom, although it took almost a year to pull off.

RUSSIA REVISITED (1967)

We landed at Moscow's Sheremeteyvo Airport in April 1967. Snow was falling
from a dark sky as we were taken by car to the Hotel National, where once again

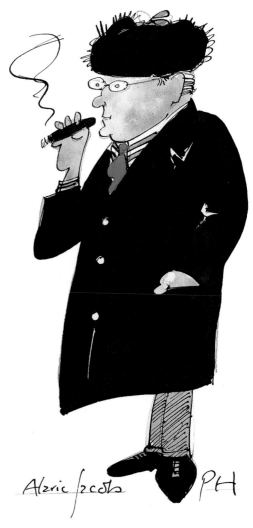

ALARIC JACOB (1967)
Ink and watercolour. 11x8in (29x20.2cm)
Collection: the artist.
*Jacob's enthusiasm for Stalin's wartime leadership
and his belief that Soviet society was basically 'just'
provoked many heated arguments between us, but we
shared a sense of humour and without him I would
never have been admitted.*

Top: BUKHARA STORK (1967)
Above: BUKHARA BAZAAR (1967)
Sketchbook studies in ink and wash, and watercolour.
6x5in (16.5x12.5cm) Collection: the artist.

I savoured the old-fashioned charm of this Russian Algonquin. We remained in Moscow for a few days to obtain the internal permits and visas required for travelling inside the country. We then left for Samarkand and Bukhara and the welcome warmth of Soviet Asia. We planned to return to Moscow and Leningrad by way of Georgia and the Ukraine when the weather had become milder.

Marco Polo had described Samarkand as one of the greatest cities in the world, and Tamerlane, the Tartar conqueror of much of Asia and eastern Europe in the fourteenth century, had made it his capital. All that was now left were the resplendent ruins of the Gur-i-Amir (Ruler's Tomb), Tamerlane's azure-domed tomb and the Shah-i-Zinda, an avenue of royal mausoleums, on which storks had built their nests. Yet the city was not without fascination. Ancient tea houses, or *chaiharna*, flourished. In one, I drew a circle of farmers in their turbans and flowing robes. They became my models inadvertently as they sat sipping tea and reading newspapers. Bukhara, once a holy city, was much more Islamic in character. It had once ranked with Damascus, Baghdad and Mecca as a place of pilgrimage. In Registan Square, I drew the winter residence of the Emirs of Bukhara, with its infamous snake pit. It was here that the unfortunate Colonel Charles Stoddart and Captain Arthur Connolly, envoys sent by Queen Victoria in 1842 to establish relations with the Emirate, languished from snake bites before they were finally executed.

Flying to Tbilisi, capital of Georgia, we descended through a ring of mountain peaks and swirling clouds. The city sprawled untidily beyond its ancient boundaries, but its inner core, the Kura, situated on and below a huge rock crowned by a fortress, preserved much of its medieval flavour. Turkish-style wooden houses jostled with hexagonal fifth-century churches.

We had heard that the Georgians were a pleasure-loving people, living for the moment, and this was certainly the case with the poet, Joseph Nonashivili, who took us to dinner at a cellar restaurant in the old quarter of Tbilisi. Waiters hurried to and fro with huge steaming plates of *shashlik* and earthenware pitchers of wine siphoned from *amphorae* sunk, Roman-style, in the red-tiled floor. Clusters of affluent bureaucrats toasted one another with huge terracotta goblets full of this excellent local red wine.

As we seated ourselves, we were joined by a big, genial Russian in a well cut American suit, who looked and talked strangely like Peter Ustinov. Our new acquaintance turned out to be one Vladimir Babkin, Director of Information, Foreign Tourism, of *Intourist,* the all-powerful state tourist organisation, who said

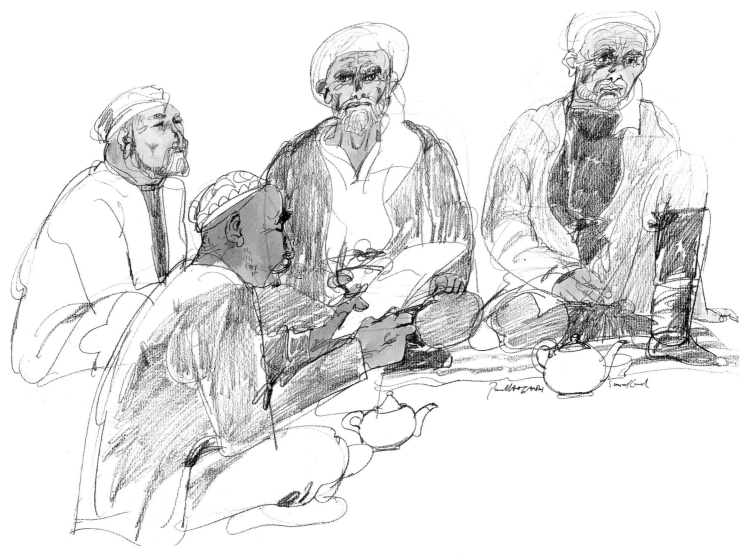

he was paying a flying visit to resorts throughout the country. ''Ullo, 'ullo,' he bellowed, 'what are you two doing in Tbilisi? The artist and the *homme de lettres* — what ho!' He urged us not to forget Suzdal, the ancient capital of Muscovy. 'It's now restored and open to tourists for the first time,' he chortled, 'since we moved our nuclear defence system back 300 miles from Moscow!'

From Tbilisi, we went on to Kiev. The city looked so Polish that I immediately thought of Cracow; for centuries, the Ukraine had been part of the Polish kingdom. Much restoration was going on: domes were being re-gilded and roofs painted. Kiev had not been as devastated by the vicissitudes of World War II as we had been led to expect. Podoli, the old quarter, had been almost untouched. The gilded domes of Pechersk Monastery, designed by Bartolomeo Rastrelli in the eighteenth century, were intact, as was its vast complex of cathedrals, ornate gateways and seminaries. The blue-and-white baroque

UZBEK FARMERS TAKING TEA,
SAMARKAND (1967)
*Faber 702 pencil and ink wash. 18x25in
(46x63.5cm)
Courtesy: Ms Eunice Twist, Thriplow, UK.
I depicted this group in a* chaiharna *or tea house.
I had not intended to draw them as this can be tricky
in Moslem countries, but they appeared absorbed. I did
not know how long they might remain seated, but I
quickly saw who was essential and who was not,
before lightly sketching a rough outline with an HB
pencil. The first figure, a hawk-eyed elder, had a
turbaned head of great character interest, so I placed
him in the centre. Next I drew a companion to his
right, then another seated in front reading a
newspaper. In each case, I concentrated on the head as
I could complete the rest from memory.*

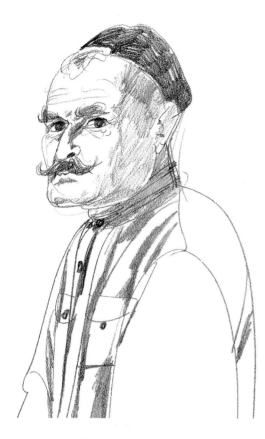

GEORGIAN FARMER, SIGNACHI (1967)
Faber pencil. 13x10in (35x27cm)
Collection: the artist.
There are people who accept that candid portrayals of
themselves are the prerogative of the itinerant artist.
Such people I call 'naturals'. This 'natural' was
drawn before a lunch party in his house in the
Georgian highlands. Although bewildered by the influx
of foreigners – which included officials from the
American Embassy – as well as local bigwigs, the old
farmer confided to Jacob that there had not been a day
like it since his son got married!

cathedral of St Andrew and the Imperial Palace, also designed by Rastrelli, looked in good order.

We returned to Moscow to find the snow vanished and the trees in blossom. From my previous visits, I knew the city to be a goldmine of exotic and unusual architecture. I started with the cathedral of St Basil, with its fairytale cluster of multi-coloured onion domes and galleried redbrick turrets. I depicted the Kremlin with its massive red seventeenth-century towers from the Moskva River side: the Saviour Clock, the Little Tsar and the Alarm. Inside the Kremlin, I drew the Tsar's Cannon against the backdrop of the elegant massed domes of the cathedral of the Assumption.

I also drew the interior of the Upper Trading Arcades, after 1921 renamed GUM, or Gosodarstveny Universalny Magazin (Universal State Store), the largest in Russia. Designed by Aleksandr Pomerantsev and built in 1889–93, this immense, bazaar-like building served 350,000 customers a day, many of them bemused country people visiting Moscow for the first time. Ornate iron staircases, bridges and balconies linked three enormous floors crowded with scurrying shoppers in search of what appeared to be non-existent merchandise.

My most exciting discovery was the rich legacy of art nouveau or Russian *Moderne*. The more impressive buildings were designed by Feodor Shekhtel, then unknown to me, but clearly a great architect. These included his masterpiece, the exquisite Ryabushinksy House on Ulice Kachalova, with its yellow glazed walls and exotic floral friezes. The villa was built in 1900 for a wealthy banker, Nikolai Pavlovich Ryabushinsky. From 1931 until his death in 1936, Maxim Gorky had occupied the house. It is now the Gorky Museum.

Just off Gorky Street, in the Khudozhestvennogo Teatra Proyezd (Arts Theatre Lane), I found Shekhtel's original Moscow Arts Theatre with its ceramic bas-relief, *The Wave*, designed by the painter, Anna Golubkina. His most fabulous building, however, is the Yaroslav Station on the Square of the Three Railway Stations, a Kremlin-esque edifice with redbrick towers and steeply pitched pinnacled roofs. The station was built in 1904 and is the terminus for the Trans-Siberian Railway, but it looked more like an illustration for a Russian fairytale than the starting point of one of the world's most celebrated railway journeys. Great architectural genius as Shekhtel was, he was condemned to obscurity. After the Revolution, his own palatial house (now the residence of the Uruguayan ambassador) was confiscated, and in 1926 Shekhtel died in poverty in a one-roomed flat.

I found a similar fairytale quality in the whimsical Pertsov House, a warren-like apartment block built during 1905–07 from the designs of the painter and illustrator, Sergei Malyutin. Originally intended as studios for artists, the building has been occupied mainly by writers since the Revolution. Its residents have included the satirists Ilf and Petrov, and also Feodor Gladkov, author of that eminently forgettable epic of Socialist Realism, *Cement*.

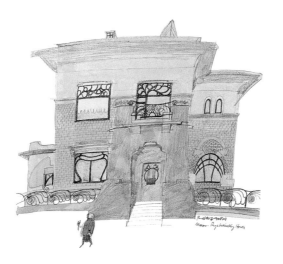

One of the advantages of working with journalists is their awareness of the so-called 'human interest' story. Jacob, in touch with Soviet colleagues, made various suggestions for 'copy', one of which led us to spend a nostalgic day at the House of the Veterans of Stage and Screen in south-eastern Moscow. In old age, actors and dancers possess an irresistible pathos; surrounded by the memorabilia

In the GUM Department Store, Moscow (1995)
Ink and watercolour. 10x8in (25.5x21.5cm)
Courtesy: The Oldie. *Collection: the artist.*
'Pozhalsta, your honour, on what floor did you buy these long underpants of such fine quality?'

Left: The Pertsov House, Moscow (1967)
Ink, pencil and watercolour. 21x15in (53x38cm)
Private collection, UK.
A warren-like studio apartment block built during 1905–07 from the designs of the painter and illustrator Sergei Malyutin. Residents included Ilf and Petrov the satirists, and the author Feodor Gladkov.

Top left: The House of Nikolai Ryabushinsky, Moscow (1967)
Pencil and watercolour. 21x15in (53x38cm)
Courtesy: Lund Humphries Collection.
Designed by Feodor Shekhtel and built in 1900, this pale yellow villa once belonged to the wealthy banker Nikolai Pavlovich Ryabushinsky, patron of the arts and publisher of the sumptuous art magazine Golden Fleece *(1906–09), which championed the avant-garde in Russia. It is now the Maxim Gorky Museum.*

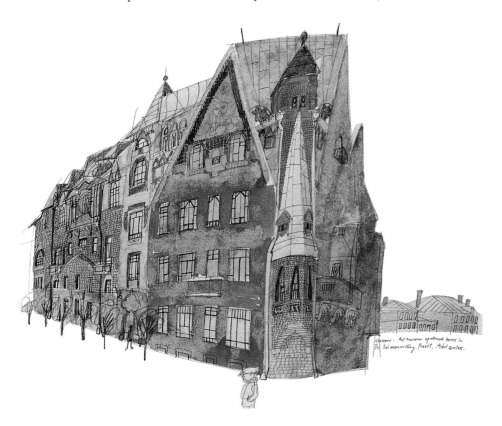

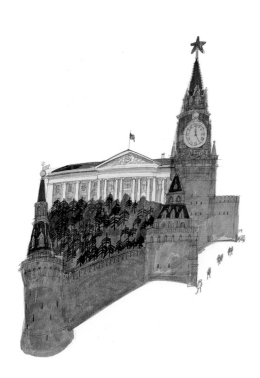

THE KREMLIN: THE SENATE WITH SAVIOUR'S TOWER (1967)

Pencil, markers and watercolour. 21x15in (53x38cm)
Courtesy: Eunice Twist, Thriplow, UK.
A country's present can often be seen in its past, and Russia's architectural past is brutally impressive to say the least. The Kremlin is an immense citadel of power; of golden domes behind crenellated red walls and innumerable towers, which guard a complex of palaces and cathedrals from enemies within and without Russia. Even more impressive was the Spasso-Efimovsky Monastery in Suzdal, encircled by a high wall three miles in length with innumerable watchtowers. To depict this grim place, I worked mainly with watercolour, using a pointed Japanese brush, blotting washes of colour to simulate the layers of ancient brick and stonework. The flocks of crows and ravens were drawn with a fully charged brush of Indian ink and blotted. It took me about three hours, working on a double-page spread in a custom-made sketchbook of Basingwerk Antique drawing paper, ideal for soft graphite pencils and watercolour.

Right: THE SPASSO-EFIMOVSKY
MONASTERY, SUZDAL (1967)
Pencil, ink and watercolour. 36x25in (92x63.5cm)
Courtesy: Eunice Twist, Thriplow, UK.

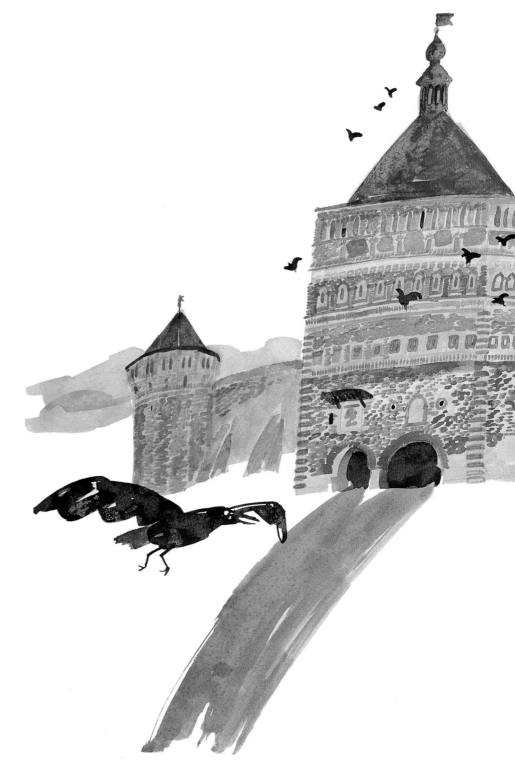

of their careers, they posed for me with a rare sense of dignity and achievement. There was, for example, the celebrated actor and film director, Vladimir Gardin, then 85, who was trained by the great Stanislavsky and played Romeo and Hamlet at the Moscow Arts Theatre. Lydia Nelidova had been a ballerina in Michael

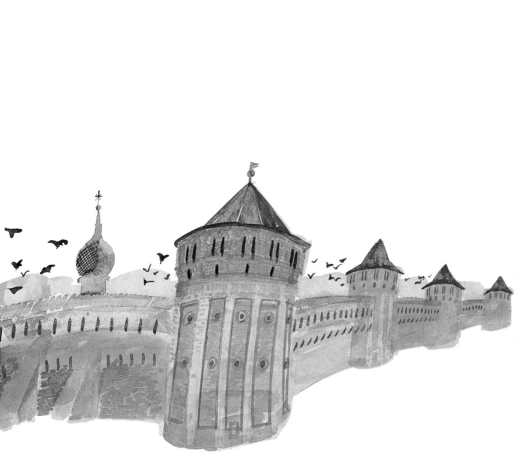

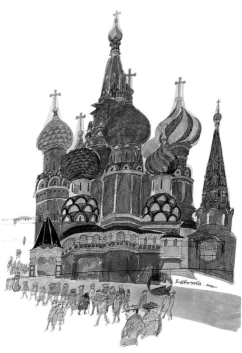

Above: THE CATHEDRAL OF ST BASIL,
MOSCOW (1967)
*Pencil, markers and watercolour. 21x15in
(53x38cm)
Courtesy: Eunice Twist, Thriplow, UK.
This multi-coloured and multi-domed, fairytale
structure was built by Ivan the Terrible to
commemorate his historic victory over the Tartar
hordes. The story goes that after congratulating
the architects – Barma and Posnik – the capricious
autocrat ordered that their eyes be put out so
that they might never again design anything so
enchantingly beautiful.*

Fokine's company based in New York, as well as ballet mistress for Fyodor Chaliapin's Opera Company. She had returned to Russia as a widow, and her room, plastered with posters of past triumphs and faded photographs, was overwhelmingly redolent of her life in the theatre.

It was a different story, however, when we were given an audience with a high-ranking official who asked what he could do for us. Alaric requested that we be allowed to visit Star City, the headquarters of the Soviet's space programme, then very much off-limits to foreign observers. Utter silence descended. 'But,' Alaric persisted, 'you *did* let De Gaulle go there!'

St Petersburg is a northern Venice of such haunting beauty that it would have taken five years to have done justice to its grandeur. I had only five days, and as a result my choice of subjects tended to be idiosyncratic. We set out to find the Literatorskiye Mostki (Literary Necropolis), in the grounds of the cathedral of Alexandr Nevsky. Here, scattered about in splendid profusion, were the marble and stone urns, obelisks, tombs and mausoleums housing the mortal remains of

THE ADMIRALTY, ST PETERSBURG
(1967)
Ink and watercolour. 21x15in (53x38cm)
Private collection, UK.
This superb example of the Russian classical style, the
work of A. D. Zakharov, was built in 1806–23. It is
one of a pair of pavilions on the Neva side.

the old intelligentsia of St Petersburg. Here were the writers Turgenev, Blok and Dostoevsky; the physicist Pavlov; the composers Borodin, Scriabin and Rimsky-Korsakov; the pianist Rubenstein and the painter Brodsky.

Although the day was bitterly cold, my heavy winter outfit was soon too warm. As I walked out of the cemetery gate, I paused to take off my *shabka* (fur hat) and wiped the sweat from my brow. A little old *babushka* hurried by and, thinking I was a beggar asking for alms, tossed a 5-kopeck coin into it. 'It's an old Russian custom,' Jacob laughed, 'to be charitable.'

Pushkin, formerly Tsarskoye Selo, was our next stop. The great poet studied at the *lycée* there. On the centenary of his death in 1937, the former royal village was renamed in his honour. It was another bitterly cold day. The strains of a Mozart concerto could be heard from the school of music in the nearby Catherine Palace. Thus inspired, I braved the cold once more and drew the entrance façade of Charles Cameron's elegant Gallery, the Scots architect's first commission for the autocratic Catherine the Great.

Back in Moscow, we attended a party for licensed dissidents at the pre-Napoleonic Arbat mansion of the Canadian journalist, Edmund Stevens, the *doyen* of the foreign press corps and a man of mystery who always denied being an apologist for the Soviet regime. He was then the correspondent of the London *Sunday Times*, and lived like a Hollywood producer, the master of the licensed leak who – to paraphrase Lenin – gave the West what they wanted to believe.

We had time for one final excursion, and recalling Babkin's enthusiasm, we chose Suzdal. After a fast ride on a gleaming new electric train, we reached Vladimir, some 150 miles north-east of the Soviet capital. Vladimir, the capital of Muscovy before Moscow was even thought of, had become a drab provincial industrial city. Suzdal, on the other hand, although but 20 miles away, remained starkly medieval.

We walked through the cobblestone streets, silenced by its brooding ambience. Forty churches – some in pairs for use in winter and summer – and almost as many convents and monasteries, formed an immense museum of the Russian past, linked by clusters of wooden houses, each with its garden and orchard. Indeed, I drew Suzdal as though I had been an eyewitness to its turbulent history. I began with the Prokovsky Convent with its leaning bell towers and eye-like windows, used by Tsars to dump errant wives and unwanted children. Ivan the Terrible made the greatest use of its facilities: the crypt contained the tombs of many victims.

Even grimmer was the Spasso-Efimovsky Monastery, encircled by a high wall two miles long with watchtowers and a huge gateway. Catherine the Great had been the first to turn this vast and sinister place into a prison for her political opponents, who, anticipating the KGB's treatment of dissident intellectuals, were declared madmen in need of peace to recover their sanity. Many Decembrists lost their reason here as they never knew where they were. Tolstoy was privately informed that a cell had been prepared for him (with bookshelves) should he continue his unorthodox thinking beyond the limits of the Tsar's patience. At least they were allowed to write and read, whereas old Bolsheviks such as Victor Serge, and literary incorrigibles such as Alexander Solzhenitsyn, along with many others, were denied all access to books and newspapers.

The more I saw of Russia, the more I marvelled at the idea that I could ever have thought of it as a model society for the future, or even of the present. So many of its strictures on what could or could not be drawn or photographed, and on movement within the country, exceeded those of Tsarist days.

The powers-that-be were determined to view the overall result of my travels before I was allowed to leave the country. I was invited to the neo-Gothic House of Arseny Morosov (another Shekhtel merchant mansion) to show my portfolio to a comrade Nesterov, an urbane official who, according to Jacob, had been a counsellor at the Soviet Embassy in London. He was now head of the Press Department of the State Committee for Cultural Relations. He eyed me warily and did not shake my hand. Why had I not made my work available for publication in the Soviet press? I replied that I had agreed with the editors of *Life*'s Atlantic edition that they should have world rights. No further comment was made as he carefully inspected each of over 100 watercolour drawings. Finally, he raised his head, looked me straight in the eyes and asked who would write the captions?

'I have no idea,' I replied, adding that I supposed *Life* would ask me for descriptive copy for a staff writer to work on, as was customary.

'And what are your impressions of our country now that you are no longer a friend?'

'I still think it a remarkable country,' I parried, 'and I still believe in understanding between nations. I hope these drawings will contribute towards that.'

The *apparatchik* grudgingly accepted my reasons for retaining my work – but *Life* never did publish the drawings. The Atlantic edition folded soon after I returned to London. Moreover, our handsome book, *A Russian Journey: from Suzdal to Samarkand*, which appeared in 1969, was not even a modest bestseller.

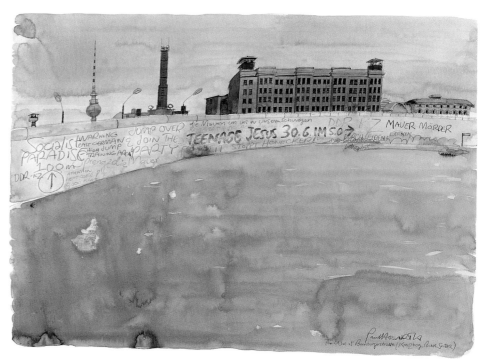

RUSSIAN OFFICER (1981)
A page from my Berlin sketchbook. Pencil, 11x8in (29x21cm)
Collection: the artist.
This symbol of unremitting hostility was captured at the annual Soviet parade at the Memorial to the Russian Dead, then in the British sector.

A WALL IN BERLIN (1980–81)

On 13 August, 1961, East German forces had begun the closure of all crossing points between East and West Berlin, an event which culminated in that monstrosity of the Cold War, the Berlin Wall. Twenty years later, in December 1980, the Artistic Records Committee of the Imperial War Museum commissioned me to visit Berlin to survey aspects of the city and the Wall that had divided the former German capital for so long. I arrived at Tegel Airport in a snowstorm. Berlin, East or West, has a special winter look of misty dreariness, and the bleak streets revived memories of the many times I had passed through Berlin in the 1950s.

The Wall, I quickly discovered, was not a rational edifice. In many places it had been driven through apartment blocks or down the middle of a street. Yet this 16ft-high barrier was only the first of a series of formidable obstacles that created a strictly off-limits death zone along West Berlin's 100-mile boundary. Dog lanes, tank pits and hidden trip wires that set off automatically triggered guns and listening devices made the Iron Curtain a terrifying reality. As I floundered about in the snow and climbed checkpoints and observation posts, a melancholy chronicle took shape in my sketchbook.

I returned to Berlin in April 1981 and stayed for five weeks to work up my preliminary sketches from the previous trip into finished watercolours. The

British Army was my host. I was given a driver and guardian angel and quartered in the Tiergarten district at the Akademie der Künste, in a modestly pleasant studio apartment reserved for visiting artists.

I began at Checkpoint Bravo, the Allied checkpoint which was located on an enclosed bridge spanning the entrance to the autobahn leading to Hanover. Here, bemused truck-drivers and civilians were obliged to show their papers before they were allowed to drive along the corridor through the German Democratic Republic to the Federal Republic. In the distance, a line of concrete watchtowers stretched away to infinity. A huge Soviet war memorial consisting of a battle tank perched atop a gigantic column and garnished with thickets of anti-tank obstacles, stood close by.

THE BRANDENBURG GATE, BERLIN (1981)

Ink and watercolour. 18x24in (47x63cm)
Courtesy: Imperial War Museum, London.
For two centuries, the Brandenburg Gate welcomed the visitor entering Berlin from the West.
On 13 August 1961, it was occupied by East German troops and made inaccessible until 1989.
My painting shows British military police making a routine check while West German tourists gazed at what had become an unpalatable fact of everyday life in a divided Germany.

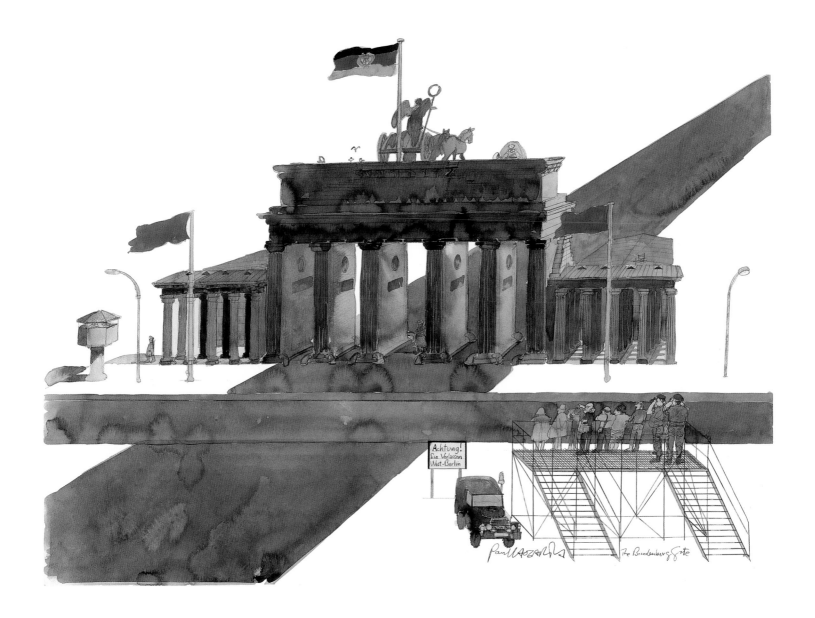

The south side of Potsdammer Platz, the Piccadilly or Times Square of pre-war Berlin, was our next stop. Here, the concrete barrier snaked across a vast no-man's-land of mud and litter. Caustic graffiti reflecting the spectrum of opinion that opposed the Wall's existence, enlivened the Western side. The former *Luftwaffe* headquarters of the Nazi era had escaped destruction when the Wall was built, and dominated the desolate scene.

The tragic aftermath of Hitler's costly gamble was prevalent in the *Mitte* (city centre), yet Berliners, being indefatigable survivors, clung stubbornly to their history. The Reichstag, once the parliament of Imperial Germany, then of the Weimar Republic, remained a symbol of national pride; almost desperately so. After years as an empty shell, it had been restored as the Museum of German History, a place of pilgrimage for West Germans. As I drew its pockmarked façade, buses disgorged tourists from the Federal Republic.

Border posts bristled with watchfulness. Combat troops of the East German Army shared the task of surveillance with *Grepos* (border guards). British military police on 'wire patrol' kept an eye on things from the Western side, while Federal German police looked on from observation platforms. If that was not enough, guard-dogs occupied the open space behind the Wall. These German Shepherd dogs came in two types: security dogs trained to attack on command, and 'War

Dogs', which would attack at any time. The latter, kept in a state of semi-starvation, were capable of tearing anyone limb from limb.

Two military parades provided me with additional subjects. The first, a Soviet Army parade, took place at their huge war memorial in the British Sector, near the Brandenburg Gate. Built from the ruins of Hitler's Reich Chancellery, the memorial had been the target of anti-Soviet demonstrations. It consisted of a semi-circular arch, topped by a colossal bronze figure of a cloaked Red Army infantryman, and was the focal point of the annual May Day parade in honour of the Russian dead. Goose-stepping guardsmen of a Soviet élite regiment received the salute of overweight, over-medalled Soviet top brass, Eastern bloc diplomats and East German *apparatchiks*.

THE OBERBAUM BRIDGE, KREUZBURG, BERLIN (1981)
Ink and watercolour. 18x24in (47x63cm)
Courtesy: Imperial War Museum, London.
The bridge figured prominently in John Le Carré's novel Smiley's People *(1980) as the venue where Karla of the KGB defected to the British spycatcher. 'The bridge spanned (the river)' wrote Le Carré, 'on fat stone piers, which swelled into crude shoes as they reached the water. Behind the bridge, like its vastly bigger shadow, ran the railway viaduct, but like the river it was derelict, and no trains ever crossed.'*

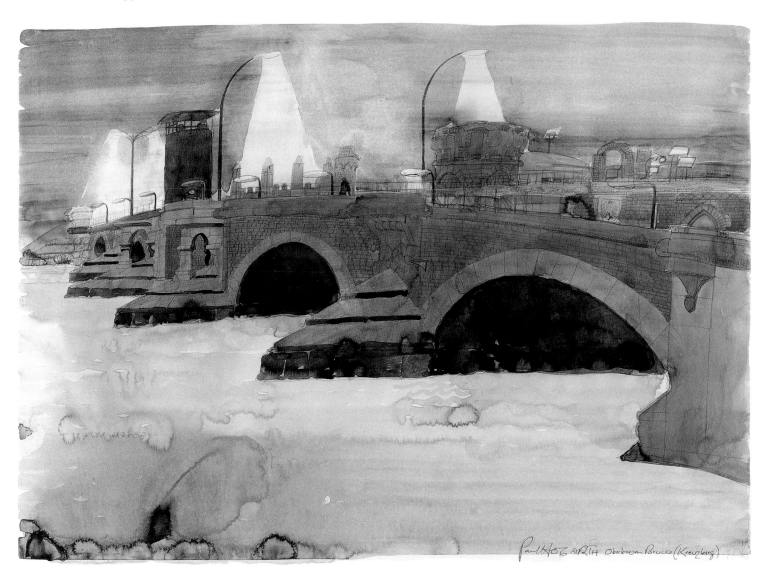

THE ROMANESQUE HOUSE,
POREČ (ISTRIA) (1995)
Ink and watercolour. 15x11in (38x28cm)
David Mlinaric Collection.

The following week, I attended the Allied Forces Day Parade on the Strasse des 17. Juni in the Western sector. Formerly Charlottenburg Chaussée, the handsome old boulevard was renamed in 1953 in memory of East German victims of the uprising of that year. Tanks and troops of the Allied garrison rolled by. A free-fall of British, French and American paratroopers over the *Siegessäule* (Victory Column) unexpectedly provided the inspiration for a companion-piece.

One of the advantages of an official commission of this kind is that whenever or wherever I needed to go to make drawings, it was always possible. I was anxious to depict a panoramic view of the Bernauerstrasse in the French sector, a street in the Wedding district synonymous with the dark history of the Wall. Here, the houses on the East German side had been demolished, leaving a massive, Victorian Lutheran church – the Church of Reconciliation – stranded among the tank traps and dog lanes. (The church, with its statue of Christ holding out his hands in mute appeal, was blown up in January 1985, in order to improve the border guards' field of fire.) On the pavement below, clusters of wreaths bore eloquent witness to those who had lost their lives attempting to cross at this point. I decided to depict this chilling scene against the skyline of distant East Berlin from a vantage point above the Wall. An officer was sent to persuade a somewhat fearful Turkish housewife to permit me to work from the balcony of her sixth-floor apartment.

Perhaps the most nightmarish image of all was the Oberbaum Bridge in Kreuzberg, which lay in the American sector. The bridge was situated in a seedy proletarian neighbourhood of gloomy blocks of battered flats, which took on the appearance of giant tombstones in the ghastly yellow glare of sodium street lights. *Grepos* controlled the entire bridge, once part of the Kreuzbergerbahnhof (Kreuzberg railway station). It was an apocalyptic scene that symbolised East and West, grimly and irrevocably at bay, or so it seemed then. But now the trains are running again. The demolition of the Wall has put an end to the nightmare I depicted.

IN CROATIA (1995–96)

Following the outbreak of war in the former Yugoslavia in 1991, the painter Sir Roger de Grey (then President of the Royal Academy of Arts, London) called upon Academicians to support the Croatia Appeal of the International Monuments Trust. Together with other artists who sympathised with the

fledgling democracy, I donated a work for an auction that raised £25,000 to help restore war-damaged historic buildings. My picture, a watercolour of the castellated Grand Hotel Dolder overlooking Lake Zurich, was snapped up by the owner for a handsome sum. Following this, I was delighted to receive an invitation from the government of Croatia to depict whatever aspects of the country appealed to me, and, accompanied by Diana, I went there in 1995.

Our first stop was Zagreb, where I experienced a deep sense of *déjà vu*. I had last visited the city more than 30 years previously to make drawings for a *Fortune* portfolio on the free-market economy of the former Yugoslavia: in Croatia, I had depicted the shipyards of Split, the Sesvete meat products plant at Sljeme, and in Zagreb itself, the huge pharmaceutical Pliva enterprise and the Koncar electrical engineering plant ('Adam Smitovic on the Sava', *Fortune*, May 1967). This time, however, Zagreb was at war, and had been the recipient of several savage missile attacks earlier in the year. With a sense of foreboding, I hastened to depict the baroque splendours of the Upper Town and such grandiose late nineteenth-century buildings as the Central Railway Station, the National Theatre and the Art Pavilion.

The Zagorje, some 25 miles to the north-west of Zagreb, was a picturesque region behind the hills of Zagrebacka Gora. Roughly translated, Zagorje means 'the land beyond the mountains': a pleasant Ruritania of wooded hills fringed with cornfields and vineyards, topped by onion-domed churches and some 50 or so ancient castles and manorial estates. Among the more visually dramatic were Varazdin (an entire town), Trakosčan, and especially Veliki Tabor, medieval and once occupied by Oton Iveković (1869–1939), Croatia's celebrated history painter. Said to have been built on the site of a Roman fortress, Veliki Tabor, with its 12 different roofs each of a different hue of orange or crimson, was indeed a castle *par excellence*. I sat drawing beneath its great twin round towers and looked up at its time-weathered walls. Arched loopholes peered down like a myriad encrusted eyes. I then visited the eighteenth-century mansion, Gornja Stubica, once the seat of Count Kristo Orsic, housed the Museum of the Peasant Revolt (1573), where I viewed an exhibition of ancestral portraits; faces good, bad and just plain ugly, a truly nostalgic evocation of an era lost through war and revolution.

Not far away was Kumroveč, Tito's birthplace. The parental home of the Broz family, built in traditional whitewashed cabin style, had been restored some years ago, along with the rest of the picturesque old village, and become a Communist Mecca. But, although it was Sunday, I was the only visitor. Parking

PEASANT WOMAN, KUMROVEČ (1995)
Ink and watercolour. 15x11in (38x28cm)
Kumroveč, Tito's birthplace, is a picturesque old
village in western Zagorje. Its only street was lined
with traditional galleried cabin-like houses. I was the
only visitor on this Sunday in spring.

LOTRŠĆAK TOWER, ZAGREB (1995)
Watercolour. 22x13in (58x35cm)
Private collection.
The historic tower on the old medieval walls of the
Gradec or Upper Town. Peasant women like to come
here, and are usually dressed in traditional costume.

VELIKI TABOR CASTLE (1995)
Watercolour. 22x13in (58x35cm)
David Mlinaric Collection.
Built on the site of a Roman fortress, this huge
medieval citadel was a magnificent castle with its
multi-coloured roofs and arched loopholes.

bays for tourist buses were thickly overgrown with weeds. In the family house, the visitors' book was filled with ribald inscriptions. *Tempora mutantur!*

After World War II, the local nobility had fled from the Zagorje. Many family mansions were confiscated and survived as hospitals, hostels for the delinquent or simply warehouses. Since independence, however, Croatia had developed a new pride in its heritage and sought to make amends. A few descendants of the old aristocracy bravely returned to re-occupy what was left of their estates. Many, however, have not been reclaimed, and languish, stripped of their oak panelling, ceramic stoves and forests. Bežanec, the eighteenth-century seat of an adviser to Metternich, Baron Franjo Ksaver-Gschwind, was ransacked and used as a meat-smoking plant. Now it flourishes as an excellent country hotel owned by the remarkable Siniša Križanec, a Croat counterpart of the British *entrepreneur* Richard Branson, who has bought more dilapidated mansions to restore them to their former glory as five-star hotels.

A sturdy peasantry, invigorated by sojourns in Germany as *Gastarbeiter* (guest workers), cultivated modest plots of rich farmland. Little girls watched over flocks of geese, while pigs and goats munched contentedly; turkeys and

chickens ran around. Each farmstead had its own wine-house, where a peculiarly potent local Riesling was on offer. Not that Croatia doesn't make good wine.

I drove westwards to Istria and the Adriatic to depict the medieval fishing ports of Rovinj and Poreč. Both were bereft of tourists. The economic impact of the war had been catastrophic. In 1990 more than a half-million British holiday-makers had thronged Croatia's Adriatic resorts. By 1994 the figure had dropped to 7,000. Nothing could have been more peaceful. Cats stretched in the sun as fishermen repaired their nets. Many, however, had ceased to fish, as so few people visited the local restaurants. As I depicted the Venetian clock tower in the central town square, I did hear the occasional English voice. 'I like it 'ere,' one North Country tourist told me, 'war or no bloody war!'

From Rovinj I took the ferry to the island of Brioni, or Brijuni. This former Garden of Eden with its resort or Veliki Brioni once belonged to the Viennese tycoon Paul Kupelwier. Tito liked to spend part of his summers here, and the island was not accessible to the public; only party *apparatchiks* were allowed to stay at the Hotel Neptune. Now, Brioni is open to all as a National Park.

Remembering my first brief glimpse of Dubrovnik in 1967, I longed to depict this fabulous walled city that Samuel Pepys thought to be 'the Mother of Venice', but my time had run out.

I returned in the autumn of 1995, starting with Split. This bustling seaport reminded me of Palma de Mallorca. I explored Diocletian's Palace with its multi-layered accretians from Roman times, interspersed with humble medieval chapels and Venetian watchtowers. There were Secessionist villas too, and here and there, as in Zagreb, a starkly larger-than-life bronze statue by the famous Dalmatian-born sculptor, Ivan Meštrović (1883–1962).

North of Split I discovered Trogir, a golden-brown, medieval-cum-Renaissance city in miniature, unchanged since its independence from Venice in 1797. The magnificent clock tower with its adjacent *loggia*, or open-air Court of Justice, gave the little city an air of beguiling enchantment further enhanced by Gothic *palazzi* with balconies and trellised windows. Nearby, the massive Venetian fortress of Kamerlengo was also a priority for a drawing.

Still further south were the magical islands of Hvar and Korčula. Hvar is wholly Venetian in character with a *placa* lined with old palaces and a huge arsenal. Built in 1612, its upper floor housed the first theatre built in Croatia. On the other side of the island, in Stari Grad, I visited the summer residence of the poet Petar Hekterović, with its sunken goldfish pool, and wondered how poets

LANDSCAPE WITH CYPRESSES, HVAR
Watercolour. 23x16in (58.5x42cm)
Collection: the artist.
The island of Hvar resembles a forgotten Garden of Eden. Ilex, aleppo pine and cypresses thrive amid venerable vineyards and fields of lavender. To complete my picture, an Adam-like peasant obligingly made an appearance.

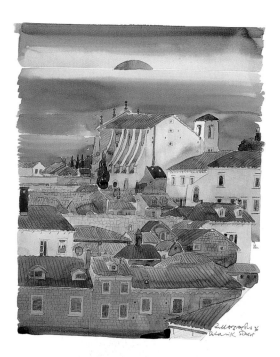

DUBROVNIK SUNSET (1996)
Watercolour. 23x18in (58.5x45.7cm)
Francis Kyle Gallery, London.
Now largely restored after 13 months of Serb
bombardment, this precious jewel of the Adriatic
carried its wounds with dignity.

always find such idyllic places. I was inclined to be more tolerant after a delicious lunch of *Sivila* barbecued on vine cuttings and fig-leaves, accompanied by a bottle of *Bogdanusa* (God's Gift), an exquisite, crisp white wine made by one Zlatan Plenković of Hvar. As I was the first Englishman to visit the town for some time, a second bottle appeared to celebrate the event. More was to come! An album of photographs was produced that turned out to be a nostalgic record of a visit to Hvar made by Edward VIII and Wallis Simpson on the royal yacht in August 1936. It was before his abdication and the couple looked serenely happy.

On Korčula, the southernmost island of the Dalmatian coast, 'the pagan past and the Christian present' were, to quote Lawrence Durrell, 'indivisible'. Obviously, its earliest inhabitants had found its bays, forests and rich arable land ideal for settlement. Stone villages set in landscapes of lavender alternated with dense black pine forests, olive groves and venerable vineyards: all set against a sea of the darkest blue. Korčula Town abounded with retired sea captains preoccupied with the arrival and departure of coastal vessels. The traveller and explorer Marco Polo was born and died there; his partially ruined house was to have been restored before war intervened.

Croatia is worth visiting for Dubrovnik alone. The uniform whiteness of its palaces, fortresses, churches and courtyards induces a unique harmony of visual impact. Now largely restored after 13 months of ferocious Serb bombardment from the sea and the land, this precious jewel of civilisation, although still scarred, carried its wounds with pride. The sun shone, as if anticipating peace, and along the *placa*, or Corso, cafés had reopened, crowded with citizenry sipping wine or coffee. I was told of irreplaceable losses of manuscripts and ornate interiors. But there had also been startling discoveries, like the frescoes of nymphs and troubadours, as fresh as the day they were painted, found behind the burnt-out panelling of the palace that housed the Summer Festival offices.

War had indeed left its mark on this fiercely independent land. Yet so much beauty remained: the unique heritage of medieval and baroque architecture of Gradec or upper town in Zagreb; the mansions and castles of the Zagorje; and lastly, Dalmatia, where such beauty had been created. It was difficult to imagine that the rule of the Venetian Republic had been so oppressive to its Croat inhabitants. Paradoxically, it had also bequeathed a paradise to record.

CHAPTER SEVEN
In Writers' Footsteps

JACKET ILLUSTRATION FOR THE
POWER AND THE GLORY (1962)
Ink drawing in pen and brush. 7x10in (19x26.7cm).
Courtesy: Penguin Books. Collection: the artist.
My early designs were black and white, and almost
all strongly symbolic: in this case, the conflict between
Church and State in 1930s Mexico.

ONE DAY DURING THE AUTUMN OF 1962 I RECEIVED A TELEPHONE CALL
FROM PENGUIN BOOKS IN LONDON ASKING ME TO DO THE JACKET
ILLUSTRATIONS FOR A NEW EDITION OF GRAHAM GREENE'S NOVELS.
THUS I BEGAN A WORKING RELATIONSHIP WITH GRAHAM GREENE THAT
FLOURISHED FOR ALMOST 30 YEARS, AND INVOLVED ME NOT ONLY IN
CREATING THE JACKET DESIGNS FOR THE PENGUIN EDITIONS OF HIS BOOKS,
BUT ALSO IN A YEAR-LONG ODYSSEY TO DEPICT THEIR ACTUAL SETTINGS
AND LOCATIONS.

FOR THE REST of the 1960s, all through the 1970s and 80s, and up until
1991, I created designs for one title after another. Every now and then, a new
art director would have a go at introducing a new artist, but Greene would have
none of it. During that time, the jackets were constantly being restyled, ranging
from moody evocations of protagonists and heroes to more conceptual vignettes;
and from close-up, portrait-like characterisations to larger narrative illustrations.

Ink and watercolour. 11x8in (29x12cm)
Courtesy: Penguin Books. Collection: the artist.
Greene's greatest novels inspired me to create the
appropriate image. This example, depicting a pair of
professional killers, employed by the dictator of Haiti,
Dr Duvalier, or 'Papa Doc', appeared on the jacket
of the 1967 Penguin edition of The Comedians.

Wherever I was living, in Britain, Majorca or the United States, I gave them priority. Greene himself provided a special bonus by writing the occasional letter, either making a critical comment or expressing his appreciation. He especially liked my characterisation of Scobie for *The Heart of the Matter* and the sinister pair of Tonton Macoutes for *The Comedians*. Anthony Farrant, the unpleasant anti-hero of *England Made Me*, was not, however, acceptable: 'It's quite a good portrait of the character,' he wrote, 'but somehow it seems to me too realistic and repellent to the reader.'

Greene and I kept in touch as additional illustrations were required for his last books, *The Captain and The Enemy* and *The Last Word*. He remained as diligent an editor of my work as ever, and thought my papal skull-cap – for the latter title, a collection of short stories – looked 'more like a night-cap'. So that had to be put right.

There was also the occasional surprise purchase of a drawing or watercolour. 'I much admire your work,' he wrote in October 1969, 'and have one of your Far Eastern drawings of a bird-fisher on my wall.' This was gratifying news, as it had been acquired under another name from the exhibition of my Chinese drawings at the Leicester Galleries as long ago as 1955! He loved making a mystery of his life. In 1971, he visited my retrospective 'The World of Paul Hogarth' at the Royal College of Art and purchased another picture. A female emissary arrived with instructions to confirm the purchase of a watercolour of an obscure Canadian prairie town entitled *High River, Alberta*. In due course, a large and picturesque cheque arrived, drawn on the Ottoman Bank, with the request that the picture be shipped forthwith to Switzerland!

ADVENTURES IN PURGATORY (1985–86)

I can be forgiven if I harboured hopes of a more ambitious collaboration, and an opportunity arose when I suggested a book of watercolours on the locations of Graham Greene's novels to Pavilion Books in London.

Once Greene had given the project his blessing, I planned an itinerary. It was no easy task listing the key places I would have to visit for what was to be *Graham Greene Country*. Although he never invented, but always described actual places, he had forgotten many of them, or if he remembered, his letters arrived too late for me to include them. As it turned out, my travels for the project would take me to over 20 countries and 50 cities spread over Central and South America,

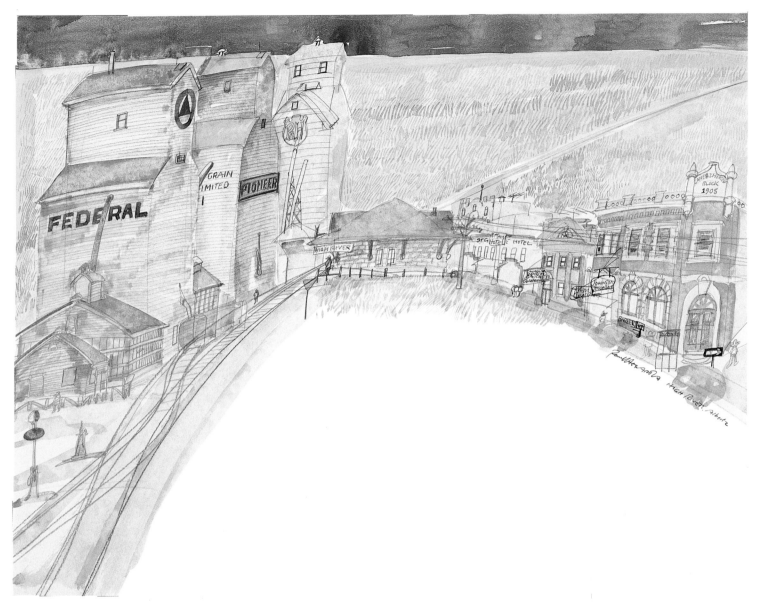

Africa, Asia and Europe. The plan of the book followed the chronological sequence of publication, but my travels had to be made at the best time for working outdoors. Another potential problem was that not all the countries welcomed the lone artist-traveller, although Greene's great fame usually overrode any difficulties. Argentina, for example, which provided settings for both *The Honorary Consul* and *Travels With My Aunt*, was still officially at war with Britain three years after the Falklands conflict in 1982. However, following a candle-lit dinner in a gracious Victorian mansion in Belgravia, London, hosted by a suave Argentinian diplomat and his wife, I was given both a visa and a letter of introduction that enabled me to enter the country.

I began my travels early in March 1985, when I drove to Harston, a village that straddles the busy London to Cambridge road. Hiding from intruders

HIGH RIVER, ALBERTA, CANADA (1969)
Pencil, markers and watercolour. 18x23in (46x58.5cm)
Courtesy: estate of the late Graham Greene.
In 1971, a mysterious female emissary wrote to confirm Graham Greene's purchase of the above watercolour, an obscure Canadian prairie town. I was delighted, but baffled. Had he been involved in counter-espionage activities in western Canada during World War II? Perhaps he had been holed up in the very grain elevators I had depicted, carrying out a stake-out of Nazi saboteurs trying to make their way south to the United States after being landed by U-boats in Hudson Bay. Only in 1987 did he tell me that he had bought the picture as a gift for his daughter Lucy, for whom he had previously bought a horse-ranch in Alberta.

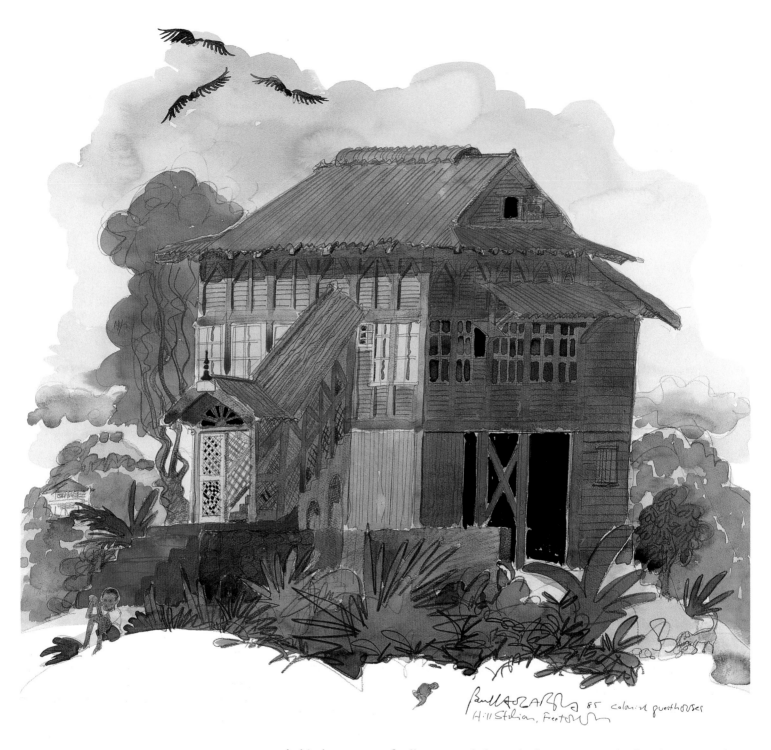

behind a screen of tall trees and dense hedgerows was the handsome Jacobean
façade of Harston House, once the home of Greene's bachelor uncle, Sir William
Graham Greene, and long the summer retreat of Graham and his brother, Hugh.
The old house and its gardens are described as 'Winton Hall' in Greene's short
story *Under the Garden*, and also in the dreams of Rowe, hero of *The Ministry of
Fear*. The graciously decayed gardens bustled with tumescent snowdrops and

crocuses. Darkling thickets of beech and fir evoked past joys and fears. The Greenesian ambience was unexpectedly heightened by the chance discovery of a tiny, nude doll from some bygone cracker. It seemed like an omen, a key that might enable me to open a door – to what, I was uncertain.

Shortly after this visit, I plunged into the heat and poverty of West Africa, followed by South America; into Freetown, Sierra Leone, unchanged since Greene lived there during World War II; into the flyblown streets of Havana and troubled Haiti; and into the frontier reaches of northern Argentina and authoritarian Paraguay. Like Greene, I found beauty in the ugliest of places and ugliness in the most beautiful: a contradiction that kept me in a permanent state of suspense. Seedy slums and shanty-towns, magnificent hotels and elegant neighbourhoods followed on one another like the pieces of a giant jigsaw puzzle of self-induced purgatory.

In Havana, accompanied by the artist Juan Moreira and a tough-looking minder, I started with the Calle Lamparilla, where Wormold and his daughter Milly lived above their shop. The house was identified but impossible to draw as the street was very narrow. I would only be able to do so from a balcony opposite, which belonged to a pioneer infant school. We entered to confront the headmistress, who was ensconced in a den-like office decorated with posters of Lenin, Brezhnev and Castro. Permission was requested to draw from the balcony, but refused. 'Comrades,' she bellowed, 'you know as well as I do, the request has to go through the proper channels!' (the security police). The comrades exchanged glances. But Juan was equal to the occasion. Not only was I a distinguished British artist, but I had come to Cuba especially to depict places described by Grayhem Grinne in *Our Man in Havana*.

'Grayhem Grinne?' she shrieked. 'Why did you not say so before?' A milling throng of bewildered youngsters was then bundled into another classroom so I could work undisturbed.

In Zaire both drawing and photography were strictly forbidden, but such was Greene's reputation that Father Piet Hens, the stalwart missionary in charge of the leper colony at Iyonda, took matters into his own hands and I was able to draw the Congo River from the Jesuit Seminary at Mbandaka.

Two months into the project, when I was at work on the settings of *Loser Takes All* in Monte Carlo, I telephoned Greene at his apartment in Antibes. Despite our long association we had never actually met. As it turned out, we got on well, especially after I had confessed to my loss of faith in Communism. I found

SHOE STORE, PUERTO DE FRONTERA, MEXICO (1985)
Watercolour. 14x10in (37x25.5cm)
Courtesy: Christopher Martin.

Opposite: FORMER COLONIAL GUESTHOUSES, HILL STATION, FREETOWN, SIERRA LEONE (1985)
23x18in (58.5x46cm)
Private collection, UK.
After Graham Greene's death, his beloved companion Yvonne Cloetta told me that he thought my watercolours portrayed the places as he recalled them; sometimes painfully so. 'This house, built for a Syrian trader' was 'the house I occupied in 1942–43.'
'There were seldom less than six vultures on the roof, and I suffered badly from rats and ants.'

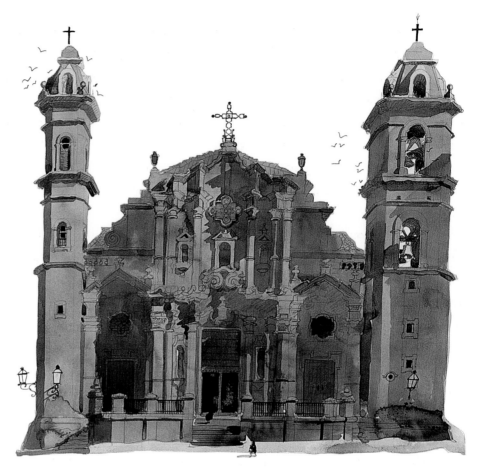

HAVANA CATHEDRAL (1985)
Ink, pencil and watercolour. 18x23in (46x58.5cm)
Private collection, UK.
On arrival in Cuba, I was shadowed for 48 hours in
Havana. Then, as I had put the finishing touches to this
large watercolour, a bearded Cuban in his early forties
introduced himself as Juan Moreira, fellow-artist and
illustrator. Was I 'Pablo Ogarte who had come to draw
Grayhem Grinn's Habana?' I then realised he should
have been at the airport to welcome me as had been
arranged. Obviously, those who had put me under
surveillance had pronounced me kosher. When I had
satisfied him that I was indeed Ogarte, I was given a
whirlwind tour of the locations I had been unable to find!

MOSAKA INNOCENT, LEPER (1985)
Pencil and watercolour. 10x6in (25.5.x16cm)
Collection: the artist.
A sketchbook study made at the Léproserie de Iyonda,
Zaire.

a tall, priest-like man with a stoop, who greeted me outside the lift to his modest apartment with unexpected warmth. His ice-blue eyes and tormented face relaxed briefly into a courteous smile as we shook hands. I was introduced to Yvonne Cloetta, his companion of many years.

I had brought along a selection of the watercolours of Sierra Leone, Mexico, Cuba and Haiti. Greene examined them with obsessive interest, occasionally pausing, visibly moved, as if some detail had inadvertently touched the nerve of a past experience or memory. Then we talked about the ordeal of travelling alone. 'But one should always do so,' he counselled. I asked him if he accepted Paul Theroux's definition of travel as an exercise in optimism. 'Not in my case,' he replied darkly. Yvonne emitted a throaty ex-smoker's chuckle. 'Grayhem,' she cried, 'zat ees not zo!'

It was on this occasion that I realised he *did* care about not having been awarded the Nobel Prize. In the summer of 1986 I had given an interview to Birgitta Rubin of *Dagens Nyheter* in Stockholm. She asked if Greene still thought he should have received that accolade. When I told Greene that I thought Artur

Lundqvist, one of the Nobel Prize committee members, was to blame, he nodded, eyes briefly agleam. I had met Lundqvist in China in 1954. Poet, critic and man of the extreme left, he, in common with the majority of Communist writers during the Cold War years, thought Greene a profoundly reactionary influence. Even as liberal a Communist man-of-letters as Randall Swingler had his doubts, citing the works of Greene and their film versions as evidence of the baleful influence of Hollywood on English literature. To a certain extent, Swingler was right. On the other hand, Greene was critical of Hollywood and generally unhappy with the film versions of his novels even though they made him wealthy.

After each journey, I usually reported back. Sometimes he would reply and sometimes not, but Iyonda, the leper colony in Zaire, prompted a special response. 'I'm delighted to hear that your visit went off so well. I can only hope you won't come out with leprosy in ten years' time. Edith Sitwell was afraid to kiss me when I came back!'

I was relieved when I heard that he had decided 'not to insist' that I go to Nicaragua or Panama and leave *Getting to Know the General* out of our book. Neither Omar Torrijos or his Chief of Military Intelligence, Noriega, in Panama, nor, for that matter, the Sandinista supremo Daniel Ortega in Nicaragua were to my taste.

My last stop – Vietnam – proved to be something of an anti-climax. The primary Greenesian buildings, such as the celebrated dance-hall, the Grande Monde, and the extraordinary brothel known as the House of Five Hundred Girls, had disappeared. The city fathers of Saigon, like those of Brighton, had demolished their most characteristic Greeneland settings.

I realised how profoundly Graham Greene's melancholia had taken hold; my own travels had indeed been excursions in his self-induced Purgatory. As I rose from my bed, nearly always before sunrise, D. H. Lawrence's *cri de coeur*, 'Why must one go?' came to mind. I *must*, I would tell myself; the only thing I can do properly is to draw my travels. But they were the last I was ever to make alone. In 1986, I met Diana at a dinner party given by mutual friends. We fell in love. That summer I invited her to join me in Majorca and discovered on the long drive down that she was the ideal partner – easy-going, interested in everything, and more than willing to cope with the ups and downs of life and travel. Even Graham approved!

I saw him again early in August 1985. He was on a visit to London, and I invited him for lunch at the Reform Club. He was in an expansive mood, and on

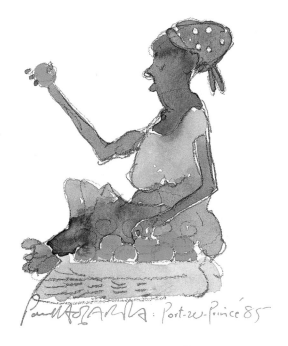

FRUIT VENDOR, PORT-AU-PRINCE, HAITI (1985)
Sketchbook study in pencil and watercolour. 9x7in (23x18cm)
Collection: the artist.
Haiti was not for the faint-hearted. Most people did not like to be drawn, and if someone did agree, you would soon attract an enormous crowd. To avoid unwelcome attention, I concealed myself in doorways or behind trees. Usually, but not always, I got away with it.

our way gave me an impromptu tour of the St James's he had known during World War II as an officer of the Secret Intelligence Service. These places included his old flat above Overton's; White's club, where he frequently lunched with Evelyn Waugh; the Edwardian building in Ryder Street of his SIS days, and the Red Lion, an SIS 'local'. He recalled that this was the first time he had set foot in the Reform since he resigned in disgust when Kim Philby and himself were refused a full English breakfast after they had worked a night of air-raids.

The launch of *Graham Greene Country* took place at the Francis Kyle Gallery in October 1986. It proved to be an extraordinary occasion. Outside, a uniformed guard kept a growing band of paparazzi at bay, as a large crowd fought to get inside. Once inside, an air of expectancy prevailed as everyone waited for the maestro to appear. 'It's a bit like waiting for God, isn't it?' giggled a well

GRAHAM GREENE AND PAUL HOGARTH
AT WORK, ANTIBES (1985)
Photo: Toby Hogarth.
I had brought a further selection of work for Graham Greene Country. *This was examined by Graham while he made notes for his commentary. Not that he wrote overmuch – I recall thinking that it was like getting blood out of a stone. The morning slipped by, and then Graham invited Toby and I to lunch at his favourite restaurant, Chez Felix au Port. As we toasted one another, he suddenly exclaimed: 'I do hope, after all your travels, that the book won't turn out to be a white elephant!'*

CHEZ FELIX AU PORT (1985)
Watercolour. 20x18in (51x46cm)
Courtesy: estate of the late Graham Greene.
'This has been my home from home for many, many years,' said Graham. 'I usually dine alone, as I can then eavesdrop outrageously! Many stories have been served with my meals – at least two found their way into May We Borrow Your Husband?'
Remembering his love of the restaurant, I gave him the original.

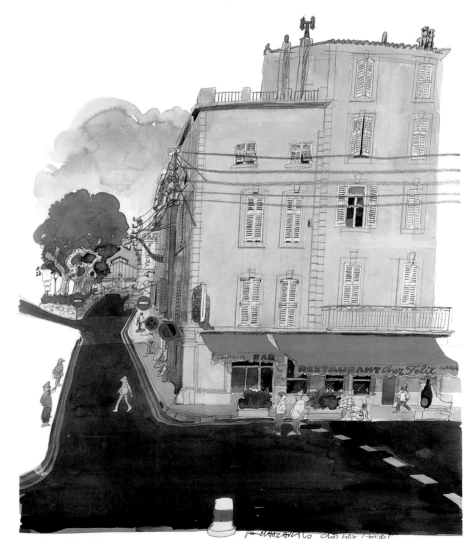

dressed matron. It was a joyous occasion because Graham was obviously intrigued by my chronicle of his travels. 'You have seen so very much of my past,' he whispered. 'How I wish I could have all these pictures on my walls.'

THE MEDITERRANEAN SHORE (1987–90)

Despite Greene's fear that *Graham Greene Country* would turn out to be, as he put it, 'a white elephant', it proved a modest success. This prompted the publishers to ask for another book, 'perhaps a little less sordid'. My art dealer, Francis Kyle, also wanted fewer scenes of low life (such as cemetery walls where Catholics had been shot), and this prompted me to suggest the Mediterranean as a more acceptable theme, with Lawrence Durrell as a collaborator. My visit to Greece in 1952 had left me with a longing to return and do greater justice to the country's life and landscape, and the book provided just such an opportunity. In May 1987, Diana and I went to the islands of Mykonos, Paros and Santorin, where I drew labyrinthine streets and awe-inspiring configurations of rock, sea and sky. This time, however, it was a more modest odyssey, depicting the settings and locations of Durrell's novels and travel books.

I did not meet Durrell until I had returned from Greece, although he had been enthusiastic about the idea of a travel album, which he thought might re-focus attention on what he felt to be his largely forgotten canon. And he proposed that we talk the idea through at his house in Sommières, on the eastern border of the Languedoc. There could not have been a greater contrast between the tall, coolly aristocratic Graham Greene and Lawrence Durrell, an endomorphic colonial extrovert. I remembered that he had been a diplomat, but it was nonetheless difficult to resist his tribute to the 'authority and eloquence' of my line; and his remark that I reminded him of Henry Miller at 40!

We talked non-stop for over two hours about the Mediterranean and its impact on mankind, eagerly discussing the mouth-watering variety of subject-matter for illustrations. These ranged from the Nile delta and encompassing desert of *The Alexandria Quartet*, the Acropolis and Golden Horn of *The Revolt of Aphrodite*, the Grecian and Minoan backcloth of *Sicilian Carousel* and *The Dark Labyrinth*, the Roman and medieval settings of *The Avignon Quintet*. The only departure would be Switzerland, linked to the Mediterranean, Larry hastened to add, by the umbilical cord of the Rhône, and Yugoslavia (as it was then), the setting of *White Eagles over Serbia*, although Dalmatia was Mediterranean.

DANCING FISHERMAN, MYKONOS (1987)
Watercolour over pencil. 15x11in (58x35cm)
Private collection, USA.
The exuberance of Mediterranean life is best expressed by the Greeks, especially the fishermen of the islands, who, with a glass or two of OUZO *under their belts, are liable to execute a Zorba-like routine at the drop of a hat.*

THE CAMARGUE AT STES-MARIES-DE-LA-MER (1987)
Watercolour. 20x20in (51x67cm)
Private collection, UK.
In Quinx, *the final volume of his* Avignon Quintet, *Durrell described the Camargue as 'a country of marsh and rivulet and lake, where the characteristic cowboy of the land, the* gardien, *prevailed with his broad-brimmed sombrero and the trident sported like a sceptre of office.'*

Lawrence was most concerned about his failing health. He had smoked five packets of Gauloise a day for years and now had emphysema as a result. As we strolled around the wildly overgrown gardens of his old villa, which he called 'the Vampire house', I wondered why he did not use his pool.

'Why not have it cleaned out,' I cheerfully suggested. 'The gentle exercise of a morning swim would help you to build up your strength again.'

He gazed at me like a good-natured gnome.

'My dear dear Paul,' he began, 'if I did so, my dear brother Gerald [the writer and zoologist] would *never* speak to me again! Have you not observed,' he continued, 'that there are creatures in there, for example an especially rare toad which dear Gerald assures me can only survive and reproduce itself in my pool!'

Larry was most anxious that we meet Gerald, whom he loved dearly although not without a great deal of sibling rivalry. Gerald and his wife, Lee, had bought Larry's old Provençal house, *Mazet Michel*, in the *garrigues* between Uzès

and Nimes. They were there to enjoy a much-needed break from the twin demands of their incessant travels and the Jersey wildlife park. Would I like to meet them?

Looking like Falstaff at 40, Gerald made us welcome by thrusting a goblet of hearty Provençal wine into our hands. Larry had urged me to show him the fruits of my visit to Mykonos, Paros and Santorin. Gerald, who had spent much of his childhood on Corfu, examined the watercolours with emotion.

'Why on earth aren't you working with me,' he suddenly exploded, 'instead of my much less successful brother? *My* books,' he added, with a twinkle in his intensely blue eyes, 'are read by millions!'

'True enough,' I parried, 'but your own drawings do a much better job than mine ever could.'

'Try telling my publishers that,' he retorted.

Durrell's novels – especially *The Alexandria Quartet* – seemed enigmatically poetic, even metaphysical. To interpret such writing with large topographical imagery seemed, at times, inappropriate. Moreover, Larry was not exactly precise in telling me where they were to be found, or even admitting that they existed outside his imagination.

'Then use *your* imagination,' he would say.

After our first meeting, I went on to Avignon, where, following the illustrious example of both Henry James and Lawrence Durrell, Diana and I established ourselves at the agreeable Hôtel d'Europe, a former sixteenth-century palace, coolly elegant within a shady courtyard, which provided a congenial base for sorties into the neighbouring countryside to depict locations described in *The Avignon Quintet*. The majority of these were in Avignon itself: the Gare, Palais des Papes, Chapelle des Penitents Gris, Musée Calvet and Fort St André. These presented few problems as they simply had to be drawn to a size that corresponded with their importance as settings. The same was true at Fontaine-de-Vaucluse and Montfavet. Fictitious settings, however, such as 'Château Tu Duc', the nostalgic focus for the characters of the *Quintet*, proved much more elusive, as I had to get them absolutely right. I searched for days for a possible candidate for 'Tu Duc', but without success. Then, just off the D750 between Arles and Tarascon, I spotted a big old farm set in a small wood. I drove up a quiet lane to discover *Mas Mottet*, an abandoned but uniquely Romanesque manor, complete with *pigeonnier* and walls draped with ivy and vine. Like 'Tu Duc', it was in a state of disrepair, its gutters twisted and full of leaves, and, as described in *Livia*, hares gambolled

THE MONASTERY OF ARKADHI, CRETE (1987)
Watercolour. 20x20in (51x67cm)
Private collection, UK.
Edward Lear journeyed on horseback along mountain trails to depict the craggy island of Crete. It seemed hardly less arduous reaching Arkadhi by car in 1987. Two years after Lear painted the monastery in 1866, it became a refuge for some 1,000 Cretan patriots who, after holding out against 12,000 Turkish troops, decided to blow themselves up rather than surrender.

MYKONOS (1990)
Lithograph. Sheet size 21x28in (55x72cm). Printed at
the Curwen Chilford Studio, Cambridge.
Courtesy: Contemporary Art Publishing.
I had worked with Stanley Jones of the Curwen
Studio since the early 1970s and together we produced
many lithographs for Christie's Contemporary Art.
My travels during the 1970s prompted me to make a
new series for Contemporary Art Publishing.

about as I drew it for most of a tranquil autumn afternoon. Such intervals are precious indeed in the restless life of the itinerant draughtsman.

I then entered the strange and somewhat desolate delta of the *Petit Camargue*. Red-tipped bands of ochre-stemmed bulrushes marked off vast salt marshlands, the haunt of the black long-horned Camargue bull and attendant herds of half-wild cattle. I arrived at the little fishing port of Stes Maries-de-la-Mer, the destination of the Romany pilgrimage every May, and a setting in *Quinx*. Fishing boats, not nearly as picturesque as those painted by Van Gogh a century ago, were tied up by the quayside to disgorge their catches.

I had hoped to find a wealth of material for *The Alexandria Quartet* in Lower Egypt, especially in Alexandria, but Nasser's revolution of 1956 had put the lid on that. The Hotel Cecil remained largely itself, but the Alexandria of the *Quartet* had long since disappeared. David Hockney, I recalled, was no less frustrated when he visited Alexandria in 1963, to illustrate a volume of verse by the Greek poet, Constantine Cavafy; in the end he found what he wanted in Beirut.

Below: THE PALACE OF MONTAZA, ALEXANDRIA (1987)
Watercolour. 29x18in (73.5x47cm)
Private collection, UK.
Once the summer palace of King Farouk of Egypt, Durrell described this as his 'first exposure to Egyptian Baroque... a combination of the Taj Mahal and Eiffel Tower... a huge temple of inconsequencies.'

Right: THE HOUSE OF ALEXANDROS PADIAMANTIS, SKIATHOS (1987)
Watercolour. 20x20in (67x51cm)
Private collection, UK.
What makes the houses of artists and writers so appealing? I do not know, but I invariably draw them. This summer home of the distinguished Greek writer, Alexandros Padiamantis, possessed a beguiling simplicity framed, as it seemed, by a parasol pine that had not got its act together. I added the inevitable old lady clutching a loaf of freshly baked bread, and I had a picture.

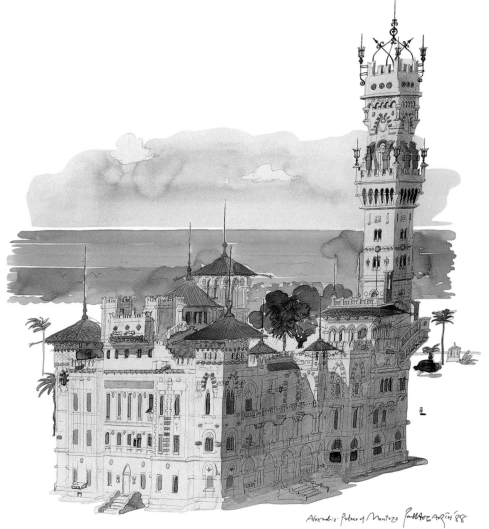

Above: SIDI BOU SAID, TUNISIA (1990)
Watercolour. 23x18in (58.5x46cm)
Collection: the artist.
During the 1960s and 70s I visited the Mediterranean's other shore – Morocco, Tangier, Tunisia and Libya. In 1990 I returned to Tunisia and the exquisite Moorish village of Sidi Bou Said, a confection of domes, arched doors, balconies and grilles perched on a headland in dazzling turquoise and white, set against the bluest-ever sea.

PIGEON HOUSE, NILE DELTA (1987)
Watercolour. 15x11in (38x28cm)
Private collection, UK.
There is always an element of the unforeseen when you work on location, when everything threatens to go wrong. One day in the Nile Delta at Wadi-al-Fayyoum, I searched for a pigeon house, a small but significant subject in Balthazar. *I was happily drawing one when a line of shouting fellaheen appeared, like a troupe of strolling players. Their leader demanded £20 Egyptian (then £5 sterling) at once, or my instant departure. Apparently, my guide had crossed the palm of an aged gate-keeper, posted to keep away unwelcome visitors. Someone, it seemed, had let the cat out of the bag, but an alternative materialised and all ended well.*

Greece, and especially its islands, more than compensated for the lack of subjects in Egypt, despite the ubiquitous bands of giggling tourists who seem to enjoy desecrating the tranquil precincts of monasteries and palaces with beer cans, *graffiti* and cigarette ends. Tourists of this type were not so common in Crete, with its evocative Venetian maritime past.

Rhodes's Crusader heritage, its Ottoman edifices and, unexpectedly, its art deco features, cast such a spell that I found it hard to leave. Gate towers and crenellated palaces dominated the skyline, broken here and there by a windmill or a mosque's minaret. I found the art deco studio house that Durrell had dubbed Villa Cleobolus after a native of Rhodes who was allegedly one of the seven wise men of antiquity.

A week spent in Cyprus and another busy working in the Turkish-occupied zone left me with a much greater awareness of the island's savage and turbulent history. As I drove the sun-baked road from Larnaca to Nicosia, an image of a country divided presented itself in the most dramatic terms. Near Dhali, the main highway entered a lunar landscape of white, cone-shaped hills. On the highest of these, the observation towers of the Turkish Army were situated, overlooking the blue-flagged United Nations Forces Truce observation posts. Across a stark no-man's-land of desolate minefields and tangled razor-wire lay the strongpoints of the Greek Army. It was such an appropriate postscript to *Bitter Lemons* that I threw all caution to the winds and worked – with the help of binoculars – concealed in an abandoned house.

The task of tracking down locations and deciding how best to depict them continued unabated throughout the autumn and winter of 1987–88. In addition to the places I had already visited, there were Belgrade, Geneva, Istanbul, Sicily, Venice and Zurich. The challenge of finding places that reflected Durrell's way of seeing and writing tested my energy and ingenuity to their limits. Deciding *what, when* and *how* to draw was just as vital as making the drawing itself. In addition, I lived in a constant state of suppressed excitement once I had made the drawings, as I worried whether they would come up to my own expectations after working on them further, or reworking them, as was now my practice, when I got back to my London studio.

Our travels soon came to an end and I completed my paintings. Larry, too, finished his lengthy introductory essay. We celebrated the occasion by descending on his house at Sommières like a band of vigilantes: Diana and myself, together with our indispensable editor Robin Rook and my son Toby, who had been asked

to take photographs for the jacket. At Larry's request, we drove to the Chapel of St Julien de Montredon at Salinelles.

'What happens here?' Toby queried.

'This is where I'm to be buried, or rather my ashes will be,' replied Larry. 'It's all paid for!' he chuckled with a grimace and a shrug.

We returned to Sommières, where we assembled for a boisterous lunch at the Café Glacier. Alain the barman, without being asked, brought several bottles of the white Languedoc wine that Larry was especially fond of. We spent much of a sunny afternoon drinking it and consuming delicious omelettes.

Larry's death in November 1990 was not unexpected. Nonetheless, it came as a great shock. We had grown accustomed to seeing him and Françoise, his neighbour and companion. On our way to and from Majorca, we usually called at the gloomy villa where he had lived since the mid-1960s, where there was no bell on the peeling front door, only an oval brass plate bearing the name of its former owner, a 'Mme Tartes'. Lunch or dinner would follow, usually at the Maison Quatre Vents, by the entrance gates of the Château Villevieille.

I had again derived much inspiration from depicting a writer's world. After all, in the annals of British art and literature there are many precedents for artists and writers working together, but no writer could have been more generous of spirit than Lawrence Durrell. When I presented him with an advance copy of *The Mediterranean Shore*, he stayed up until the early hours to check every word and image, before pronouncing the book 'a wonderful intellectual adventure'.

IN THE FOOTSTEPS OF D. H. LAWRENCE (1989–94)

Following in D. H. Lawrence's footsteps was rather like discovering the lost continent of Atlantis. I visited the terraced Victorian houses where he had grown up; the chapels and churches of his youth; the cottages lent by fellow writers, friends and family; the boarding-houses, inns, grand hotels and stately homes; the towns and cities he and his wife Frieda visited. Incredibly, the locations of his peripatetic life had remained largely intact despite the depredations of two world wars and modern tourism.

At times, however, such places would not be quite as I expected. Eastwood, the mining town where he was born, was much less forbidding after the demise of deep coal-mining than I had imagined. The lush green Erewash valley formed a

RICHMOND PARK (1990)
Watercolour. 21x14in (55x57cm)
The Francis Kyle Gallery, London.
As an elementary school teacher in Croydon, Lawrence was homesick for his birthplace, Eastwood, and its lush countryside. 'To cure me of my madness for the country,' he wrote Louie Burrows, a girlfriend, 'I took a trip over to Richmond Park and back over Wimbledon Common.' 'Richmond Park,' he added, 'is glorious; it is history, it is romance, it is allegory, it is myth. The oaks are great and twisted like Norwegian tales, the beeches are tremendous, black like steel.'

HOSPENTHAL, SWITZERLAND (1990)
Watercolour. 17x17in (43x43cm)
The Francis Kyle Gallery, London.
Until tuberculosis got the upper hand, Lawrence was a
prodigious walker. On an expedition in September
1913, he travelled by riverboat from Konstanz,
Germany to Switzerland, where he continued on foot
and by post-bus through Zurich, Lucerne, the Gotthard
and Lugano to Como, where he took the train to Milan
to join Frieda. En route, he passed through Hospenthal,
where he stayed the night. 'I came in the early
darkness,' he wrote, 'to the little village, with the
broken castle that stands for ever frozen.'

picturesque backdrop to the rows and squares of miners' homes. Once blackened by coal soot, their walls had now reverted to their original light red or burnt sienna. The miners and their wives, however, were still there. Many, now pensioners, limped along the steeply inclined streets to 'wet their whistles' at the still numerous pubs.

My first subject, 8a Victoria Street (now Birthplace Museum), was much the same as when the Lawrence family had lived there. In fact, all the four family houses remained more or less in their original state. The Breach (28 Garden Road) looked more East European than East Midlands in style, and reminded me of the miners' tenements of what was once German, and is now Polish, Silesia. In 1891 the family had moved to Walker Street, which gave Lawrence a grandstand view of the countryside he described so passionately. A few minutes away was 97 Lyncroft Road, the family's last home.

Nottingham yielded many locations, notably the High School for Boys on Arboretum Street high above the city; Castlegate, where he took a job as a junior clerk in a Dickensian firm of surgical garment manufacturers (originally located in the lower half of the street, but Lawrence's description fitted the upper part); and the original, ornate university building itself, where he took his teaching certificate. I visited half-forgotten resorts such as Robin Hood's Bay, Skegness and Trusthorpe, on the coasts of Lincolnshire and Yorkshire, where Lawrence had stayed for his health or holidays with his family. His love of the manors and country houses of Old England – acquired during his student days – provided a welcome excuse to draw Wingfield Manor and Hardwick Hall, both in Derbyshire. The most evocative location, without doubt, was in Mapperley Park, Nottingham, at the scene of Lawrence's greatest romantic adventure – 'Cowley', 32 Victoria Avenue. In this gabled Queen Anne-style house, in March 1912, Lawrence had fallen under the spell of the voluptuous Frieda Weekley (née von Richthofen), the young German wife of his favourite professor, Ernest Weekley, and mother of Weekley's three children.

I then followed Lawrence and Frieda after their fateful encounter. This took us to Metz, where I drew the scene of their dawn arrival in May 1912 – the huge *Hauptbahnhof* (*Gare Centrale*) built in the Arts-and-Crafts-cum-Rhenish Romanesque style – a magnificent symbol of the former German occupation of Alsace-Lorraine. Frieda, the second daughter of Baron von Richthofen, was born in Metz. Her family had gathered to celebrate the jubilee of the Baron's military service. The Richthofen matriarchy liked Lawrence, but opposed Frieda

leaving Weekley and the children. Unexpectedly, however, matters took a dramatic turn after Frieda and Lawrence were overheard speaking English in a forbidden area of what was then the second-largest military zone of the Second Reich. Lawrence faced arrest as an English spy, but the Baron was informed and requested he be let off the charge. After this Lawrence fled to Trier, whose sleepy ambience reminded him of Matlock, the Derbyshire spa town.

Reunited in Munich, the lovers set off by post-bus, on foot, and occasionally by train; sleeping in hay-huts, inns and chapels through Bavaria and over the Alps into Italy. I recorded the salient places along their trail through brooding pine forests fringed by snow-capped mountains. Their odyssey brought them to a temporary haven at Villa Igea on Lake Garda, at the start of a series of disasters and delights, of pain as well as passion. They left Italy for England in June 1913, for the publication of *Sons and Lovers*, arguably Lawrence's

GARE CENTRALE, METZ (1992)
Watercolour. 16x23in (40.5x58.5cm)
The Francis Kyle Gallery, London.
Lawrence's affair with Frieda, the voluptuous German wife of Ernest Weekley (his favourite professor at University College, Nottingham), enticed Lawrence out of England for the first time. He planned to visit relatives in Germany, Frieda to visit her parents in Metz (then part of Germany). Both travelled to Metz from Ostend and arrived at what was then the Hauptbahnhof *in May 1912. Built of yellow-ochred stone, this immense station probably overwhelmed Lawrence as much as it did me – though he had more on his mind. Designed by Jurgen Kroger, a Berlin architect, and completed in 1908, it was a delight to draw the Arts-and-Crafts-cum-Rhenish Romanesque detail.*

RENISHAW HALL, DERBYSHIRE (1993)
Watercolour. 21x16in (55x42cm)
The Francis Kyle Gallery, London.
The Sitwells (Osbert and Edith) had invited
Lawrence to stay with them at their family seat,
Renishaw Hall, but he was late in accepting the
invitation and arrived after the Sitwells had returned
to Italy. Nonetheless, he was shown round by the
butler, and the house provided him with the main
source for 'Wragby Hall' in the third version of
Lady Chatterley's Lover.

1 BYRON VILLAS, VALE OF HEALTH,
HAMPSTEAD (1990)
Watercolour. 21x17in (55x43cm)
Courtesy: Richard Ingrams.
Lawrence and Frieda – now married – moved into
the lower half of this red-brick Edwardian terrace
house in August 1915. Many friends lived nearby:
Dora and Ernest Radford in Well Walk, Mark
Gertler in Rudall Crescent and Anna Wickham in
Downshire Hill. A milkman made his rounds as
I worked, and further down the quiet little street, the
slam of letterboxes heralded the approach of the local
postman. It was as though it were 1915.

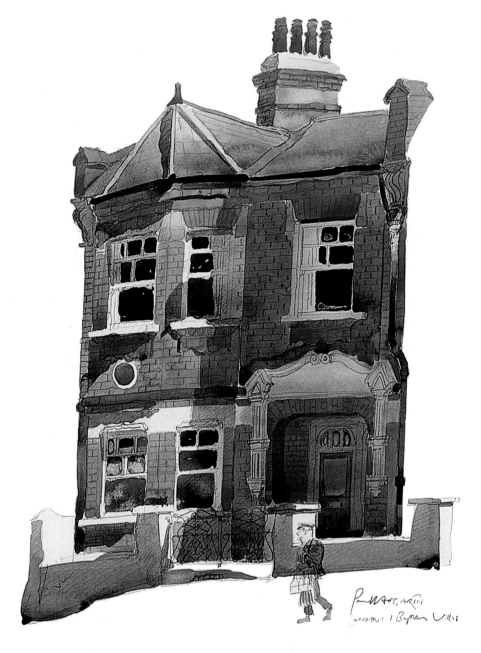

masterpiece. They returned to Italy in August, Frieda via Germany, Lawrence through Switzerland. They moved back to England the following year, and were married in July 1914. Less than a month later, Britain declared war on Germany.

Between June 1913 and November 1919, they lived at 14 different addresses, not to mention overnight and weekend visits with friends. Yet they longed for a permanent home of their own. The Vale of Health, Hampstead, provided their first rented accommodation in England: the lower half of a semi-detached red-brick Edwardian house at 1, Byron Villas in August 1915.

The suppression of Lawrence's fourth novel, *The Rainbow* (1915), forced the couple to leave Hampstead for the wilds of Cornwall, steeped in myth and legend, it seemed, and even today beyond the English pale. The novelist J. D. Beresford lent them his handsome Georgian farmhouse at Porthcothan. Later, they settled near Zennor at Higher Tregerthen, where once again they endeavoured to create a home, but again it was not to be. Situated high above the Atlantic ocean, they came under surveillance and suspicion after Germany declared unrestricted submarine warfare on Allied shipping. In October 1917 they were expelled from Cornwall. 'They were right to kick 'em out,' growled the proprietor of the so-called Wayside Museum in Zennor, who then told me a tale about a U-boat captain who had signed his name in the visitors' book of the local pub, The Tinner's Arms!

The critical acclaim of *Sons and Lovers* established Lawrence as a major writer and he was offered accommodation by several fellow writers: Viola Meynell lent Shed Hall, Greatham, Sussex; the poet Dollie Radford let them stay at Chapel Farm Cottage in Hermitage, Berkshire. In London, Hilda Doolittle allowed them to stay at her flat in Mecklenburgh Square, Bloomsbury. Perhaps the most glamorous of all the locations associated with Lawrence is Garsington Manor. Built of honey-hued Cotswold stone, this exquisite Elizabethan country house was a delight to draw.

At long last the war ended, but the wanderings of Lawrence and Frieda had only just begun! Between 1919 and 1923 the number and variety of their lodgings increased dramatically as they travelled south to the Mediterranean and across the Indian Ocean to Ceylon and Australia, then on to the United States. This took Diana and me on our first visit to Australia. In Sydney we discovered the very boarding-house where Lawrence and Frieda stayed for a few days after disembarkation. Incredibly, number 133 was the last surviving mansion in Macquarie Street. Besides briefly housing Sydney's Reform Club, it was also home to the parents of the actor Leo McKern, who recalled living in the basement after the house was divided into flats in the 1940s. It is now known to all as the headquarters of the Royal Australian Historical Society.

We left Sydney by train from Central Station for Thirroul, some 60 miles to the south. Once a popular resort, Thirroul is now a residential suburb of the nearby city of Woollongong. Like Sydney, it is full of locations associated with the Lawrences, notably 'Wyewurk', the California-style bungalow where he wrote *Kangaroo*, now eerily silent and unoccupied. My thoughts were disturbed by the

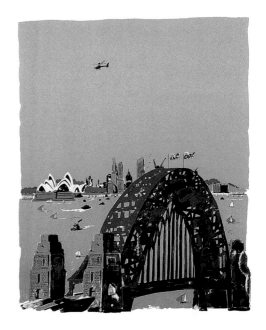

SYDNEY HARBOUR (1993)
Lithograph. Sheet size 28x22in (73x57cm)
Edition size 150. Printed at the Curwen Chilford
Studio, Cambridge.
Courtesy: Contemporary Art Publishing.
To the left and right of the arch of the Harbour Bridge
lies the spectacular panorama of bays and coves so
justly celebrated by Trollope, Kipling, Mark Twain,
R. L. Stevenson and, of course, D. H. Lawrence,
who arrived here in 1922. There have been many
changes around what Lawrence described as the
'many-lobed harbour': Bennelong Point, formerly the
P&O Wharf, where the Lawrences disembarked, is
now occupied by Joern Outzon's Opera House, but
ferries still ply back and forth, 'threading across the
blue water'.

WYEWURK, THIRROUL, NEW SOUTH
WALES (1991)
Watercolour. 27x17in (70x43cm)
The Francis Kyle Gallery, London.
The prime location of Lawrence's stay in Australia is
the Federation-style bungalow where he wrote
Kangaroo *(1923). The house, which has been empty*
for years, was eerily silent as I peered through dirt-
encrusted windows. The walls were still red and the
jarra-wood furniture – even Lawrence's writing table
and chair – still there! It was as if he and Frieda had
gone out for the day, forgetting that I was to call!

Top right: ENCOUNTER IN THIRROUL
(1991)
Sketchbook study in pencil and watercolour. 9x7in
(23x18cm)
Collection: the artist.
'G-day. Waddya up to?'
'D. H. Lawrence.'
'Dee-Haitch-OO?'
'The English writer.'
'We 'aven't got any Pom writers 'ere, mate. The only
Lawrence we've got is Lawrence Hargrave (a pioneer
of aviation and one-time resident). Where are you from?'
'England.'
'I might 'ave guessed it. Well, you can take my word
for it. I'm the Mayor of Wolloongong, the second-fastest
growing city in New South Wales!'

squawking cries of a flock of cockatoos as they
alighted on the spiky branches of a trio of
enormous Norfolk pines. From the 'little grassy
garden' I looked out on a turbulent Pacific where
the last of the season's 'surfies' skimmed the
pounding breakers.

Lawrence's first stay in America, in
1922–23, brought about a dramatic improvement
in his finances: short stories were published on both
sides of the Atlantic and the American edition of
Women in Love (1922) became a bestseller. From
then on, he stayed in much more congenial hotels,
though the more flamboyant of these have
vanished without trace: the original Santa Monica Miramar, Los Angeles;
Garlands, London; the Grand Hotel at Chexbres-sur-Vevey on Lake Geneva,
derelict when I drew it in 1990. Many survived, however, among them the
magnificent Palace Hotel on Market Street, San Francisco's grandest (now the
Sheraton Palace), which opened in 1885, the year Lawrence was born, and the
marvellously *modernista* Principe Alfonso, which survived as the Canton Chinese
Restaurant on the Avenida Miro, Palma de Mallorca.

The American South West – New Mexico and Arizona – made a profound
impression on Lawrence. The 1920s, the first golden age of the car, enabled him
to see not only the Indian festivals of the Hopis and Zunis, but also the strange
Navajo country adjacent to St Michaels, Canyon de Chelly, Chinle and Shiprock.
Shiprock, the eroded neck of an ancient volcano, was the most impressive
landscape of my Lawrence travels. A few miles north of Taos, the Kiowa Ranch –
or, as it is now officially called, the D. H. Lawrence Ranch at Cristobal – has
remained an idyllic place in a setting not unlike a scene from a Victorian
production of Puccini's opera, *The Girl of the Golden West*.

Then it was back to Europe and London, especially Hampstead, where so
many of Lawrence's friends and literary colleagues lived at various times: Edward
Garnett in Downshire Hill, Katherine Mansfield and John Middleton Murry on
East Heath Road, and Hollybush House, adjacent to the famous Hollybush pub,
where Lawrence and Frieda stayed with Catherine Carswell.

Finally, I followed Lawrence to the Ile de Port-Cros in the South of France,
where he stayed in the autumn of 1928 before he and Frieda fled to Majorca in

April 1929 to seek solace and sunshine. After their return to France, they rented the Villa Beau Soleil. Here, much weakened by tuberculosis, he spent his days in bed. By the end of January 1930 his condition had become critical, and he died on 2 March in the now-demolished Villa Robermond. It was here, in Vence, that my five-year pilgrimage ended with a visit to the little *cimetière* where, until 1935, Lawrence's mortal remains lay buried. The graveyard is staunchly Provençal, with lines of ornate tombstones of various vintages, interspersed with the occasional palm or cypress. Old ladies in black wandered about clutching tiny bunches of wild flowers, as if seeking his grave. I wished that Frieda had left him there, instead of moving him to the mausoleum in New Mexico.

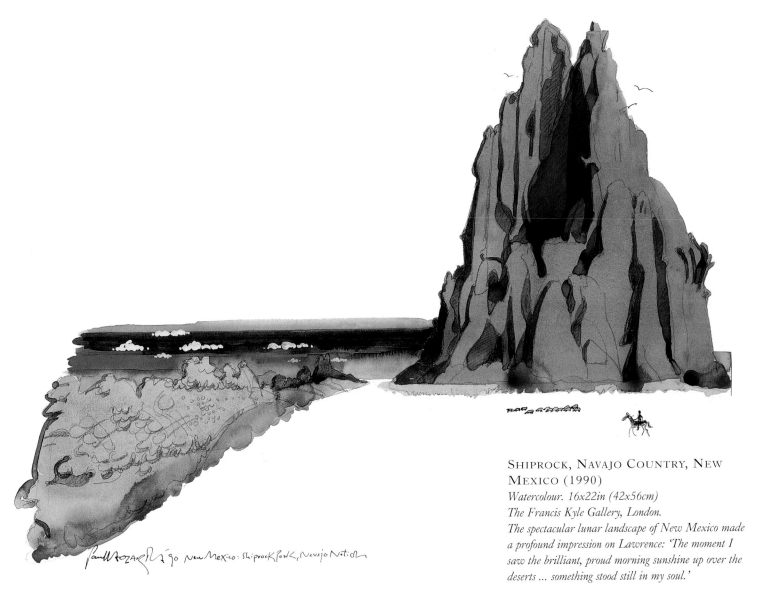

SHIPROCK, NAVAJO COUNTRY, NEW MEXICO (1990)
Watercolour. 16x22in (42x56cm)
The Francis Kyle Gallery, London.
The spectacular lunar landscape of New Mexico made a profound impression on Lawrence: 'The moment I saw the brilliant, proud morning sunshine up over the deserts ... something stood still in my soul.'

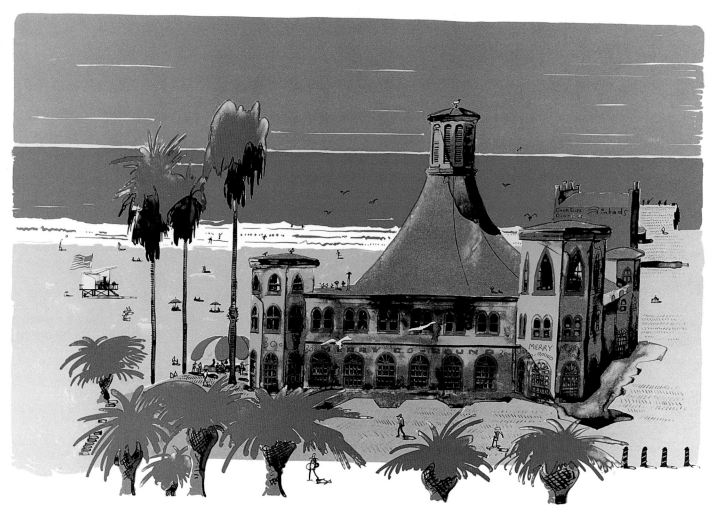

With my wife Diana before the preview of Escape to the Sun, Djanogly Gallery of the University of Nottingham Arts Centre, 11 July 1996.
Courtesy: John Sumpter, Nottingham.
The first tranche of my travels in the footsteps of D. H. Lawrence was shown by Francis Kyle at his London gallery during the autumn of 1994. The Nottingham exhibition (in association with the Francis Kyle Gallery) encompassed a larger series of watercolours, which were displayed during the Sixth International D. H. Lawrence Conference at the University, 13–20 July, 1996. The exhibition was later shown at the Hull University Gallery, the King's Lynn Arts Centre, and the Francis Kyle Gallery.

SANTA MONICA BEACH (1993)
Lithograph. Sheet size 21x29in (54x74cm). Edition size 150. Printed by the Curwen Chilford Studio, Cambridge.
Courtesy: Contemporary Art Publishing.
In 1923, the year of Lawrence's stay in Los Angeles, Santa Monica was still the exclusive resort it had been before World War I, when the Hotel Miramar was the place to stay. Originally, the hotel had been the summer home of the Nevada silver tycoon, John P. Jones. All that remains today is the immense fig tree that stands at the entrance to what is now the Sheraton Miramar. The Santa Monica pier, however, survives. Once a stop for coastal steamers, the ageing pier possessed a forlorn ambience. It was here that Lawrence's friends, the Danish artists Gotzsche and Merrild, tried to get him into a bathing suit, but without success!

CHAPTER EIGHT
La Belle France

I HAD FALLEN IN LOVE WITH FRANCE AS LONG AGO AS 1939, AND ALL
THROUGH WORLD WAR II, I RECALLED MY ALL-TOO-SHORT SUMMER
IN PROVENCE WITH PROFOUND NOSTALGIA. AS SOON AS THE WAR WAS
OVER, I WAS BACK THERE ON A CYCLING TRIP WITH MY BROTHER-IN-LAW,
ALBERT COURTMAN.

BY 1950, I had become a frequent visitor, especially to Paris, which, in
contrast to a visibly shattered London, was a city of renewed vitality.
Sometimes I stayed at the old Hôtel d'Alsace in the rue des Beaux-Arts on the
Left Bank, at others I stayed with the caricaturist André François and his English
wife Margaret at Grisy-le-Platres, near Pontoise. We had become friends in
London, which he then visited frequently in search of work, and I had published
his drawings in *Our Time* and *Circus*. André returned the compliment by

NOTRE DAME, PARIS (1959)
Conte Pierre Noir. 20x16in (51x35.5cm).
Courtesy: Gordon Fraser Collection.
This enduring symbol of the French capital was one of a
series commissioned by Gordon Fraser as greetings
cards. I resorted to an open composition, which enabled
me to focus on the ship-like shape of the great cathedral.

'LA VIE EST BELLE!' LES BAUX,
PROVENCE (SUMMER 1946)
Courtesy: Albert Courtman.
As soon as the war in Europe ended, I resumed my
love affair with France, this time on a cycling tour
with my then brother-in-law, who took the photograph
at the Auberge de la Jeunesse *in Les Baux.*

introducing my chronicles of Spain, Greece and China to the editors of *Action*, *Les Lettres Françaises* and *Tribune des Nations*.

In Paris one could study a much wider range of modern drawing and print-making than was available in London. At the Bibliothèque Nationale I browsed through *La Vie Moderne* to find the reportorial drawings of Renoir, Degas and Lautrec; *Le Rire* and *l'Assiette au Beurre*, where I discovered the early drawings of Kupka and Van Dongen, besides those by such unrecognised masters as the Hungarian Miklos Vadasz, and the Spaniard Francisco Xavier Gosé. This prompted me to write my *Artist as Reporter*. Such visits recharged the batteries of my ambition to develop a distinctive personal style.

LES TROIS GLORIEUSES (1970)

I had to wait many more years before I was able to *draw* France itself. In 1970 John Anstey, editor of *The Daily Telegraph Magazine*, asked me to visit Beaune, the wine capital of Burgundy, to depict *Les Trois Glorieuses* (the Three Glorious Days) of feasting which precede the auctions that set the price of the new wine, and the assignment revealed a France hitherto unknown to me. I feasted on delectable dishes, washed down – if one dare to put it thus – by more than 50 examples of the finest burgundy. Somehow, I kept my wits about me and managed to record my impressions (*The Daily Telegraph Magazine*: 360, 17 September 1971).

Colin Anderson of Grants of St James's – my guide and mentor – offered me a ride there in the company Rolls. Our Channel crossing was tempestuous and much delayed our progress, and lunch at a gourmet rendezvous near Versailles had to be cancelled. We made do with an autoroute meal, and whoever chose the best wine out of those on offer did not have to pay. I selected Côtes du Rhône. 'Very good choice,' said Colin. 'Why?' I asked. 'Because it is a wine that doesn't get any better or, for that matter, any worse,' he chortled. We arrived at Beaune after a long, wet journey to find that the ancient capital of the Dukes of Burgundy had a carnival atmosphere. Balloons and bunting hung from casements. Flags of every wine-imbibing nation flapped in the breeze. *Tastevins* (silver tasting cups) were displayed in every shop window. Excited children chased one another. Bells chimed folksongs.

I glimpsed the vast medieval Hôtel Dieu or Hospices de Beaune from my hotel window, its multi-coloured tile roof and cobbled courtyard glistening in the sunshine. Aged inhabitants, bent almost double, scurried about labyrinthine

passageways and along balconies like characters from a fairytale. The analogy did not end there. The Hospices de Beaune (now a museum) was then a unique charity hospital that had served the poor since 1443. Its founder, a wealthy nobleman, Nicolas Rollin, was chancellor of Burgundy to Louis XI. 'He has ruined the people with taxes,' the king said, 'it is therefore fitting that he should provide them with an almshouse.' Until the 1970s, the Hospices did this through its own resources as its founder, and subsequent patrons, had endowed it with some of the richest vineyards in the world. Every year on the third Sunday in November, their fine wines are sold by public auction; the climax of *Les Trois Glorieuses*.

My first day began in the vast cellars of the Hospices. Avenues of hogsheads stretched as far as the eye could see, above which signs proudly proclaimed famous vineyards: Nuits St Georges, Clos de Vougeot, Volnay, Pommard, Gevrey-Chambertin, Aloxe-Corton. The customary pre-auction sampling took place. Wine buyers sniffed, sipped and spat. Older men coached sons or apprentices on the finer points as cellarmen hovered around, refilling their tasting cups as necessary.

That evening we had dinner at the town house of Monsieur Gagey, master winemaker and *négociant* to Grants of St James's. His wife and daughters prepared the traditional *négociant's* dinner to complement a selection of the finest wines

produced by Maison Louis Jadot. We were seated at a splendidly set table that shone and glistened with antique silver and wine glasses of every type. A battery of decanting machines stood on a nearby mahogany dresser.

It turned out to be a Homeric evening of refined drinking. As an aperitif, a Tattinger Comte de Champagne of 1961, served very cold, was both exquisitely dry and refreshing to the palate. At dinner, a fish course was served to accompany a Chevalier-Montrachet Les Demoiselles 1959, a white burgundy as feminine as its name implied, until its strength became apparent after adjusting to the warmth of the dining room. Tantalising slivers of beef and lamb were then served with a superb Gevrey-Chambertin 1952, a burgundy of nobility and elegance, surpassed only by an older darker Gevrey-Chambertin of even greater age. It was extremely volatile and had to be decanted with great care using a finely geared machine.

Our host asked us to guess its age, and even Anderson and Edward Hale (Chief Wine Taster, Harvey's of Bristol) failed to do so. But then, how was anyone to know that a great burgundy could last so long? 'A truly great burgundy,' intoned Monsieur Gagey in his Maurice Chevalier English, 'veel last a 'undred years.' However, much of this astonishingly great grape harvest of World War I, he added, was lost. Every able-bodied man had been called up, and despite the desperate efforts of the women, children and the old to take their place, it had been only a partial success.

The next morning we visited the fifteenth-century cellars of Maison Louis Jadot beneath a Jacobin convent in the rue Petit Tribunale. Black, mould-encrusted ceilings festooned with cobwebs made it more like a setting for a horror movie than the ideal environment for the maturing of fine burgundies. Six hundred thousand bottles were stored here, the oldest dating back to 1949, all kept at an even temperature, winter and summer, of 15°C. Anderson and Hale got to work, tasting one wine against another, bathing their taste buds before spewing the wine out in long, curved streams. They gazed critically at colour against the candle's flame. Held to the light, red wine varies in hue from deep purple through various shades of red to mahogany, depending on vintage, district and vineyard.

During *Les Trois Glorieuses*, there were parties and banquets, the most impressive being the mammoth annual ritual of the *Trois Glorieuses* chapter of the *Confrérie des Chevaliers du Tastevin* (Brotherhood of the Knights of Wine-Tasting) in the huge cellars of the fourteenth-century Château Clos de Vougeot. On this splendid occasion, the *Confrérie* gathers in gregarious mood to welcome new members and to hear its choir sing Burgundy's praises; and last, but not least, to invite 600 guests to sample fine wines and a six-course dinner. While countless dignitaries made mostly incoherent speeches, we were entertained by a merry band of red-faced *cavistes* (cellarmen) and *vignerons* (vineyard workers). Known to all as *Les Cadets de Bourgogne*, they were a remarkable group of men clad in a Sunday-best version of their traditional caps, light blue shirts and dark blue, ankle-length aprons.

After the initiation of the Italian ambassador to France as an honorary *Chevalier du Tastevin*, the great banquet commenced; it was a formidable menu, dedicated to Rabelais, which promised to emulate the legendary feasts of the great humanist's day. Naturally, the wine gave much greater accents to the succession of palatable courses. 'Excellent wines,' murmured Colin Anderson, giving the wine list a quick professional glance, 'in the medium price range.'

The feasting continued unabated as *Les Cadets* made another appearance, looking considerably worse for wear. Half-empty glasses were promptly refilled by a brigade of red-nosed waiters dressed as *cavistes*. Second helpings were diligently supplied by a regiment of Burgundian womenfolk constantly on the trot. There were rumours of mass tippling in the kitchen, punctuated by roars of raucous laughter. Finally, at midnight, coffee was served, accompanied by a fine old Marc Prunelle de Bourgogne.

On the last day, I joined a jostling throng of buyers at the front of the

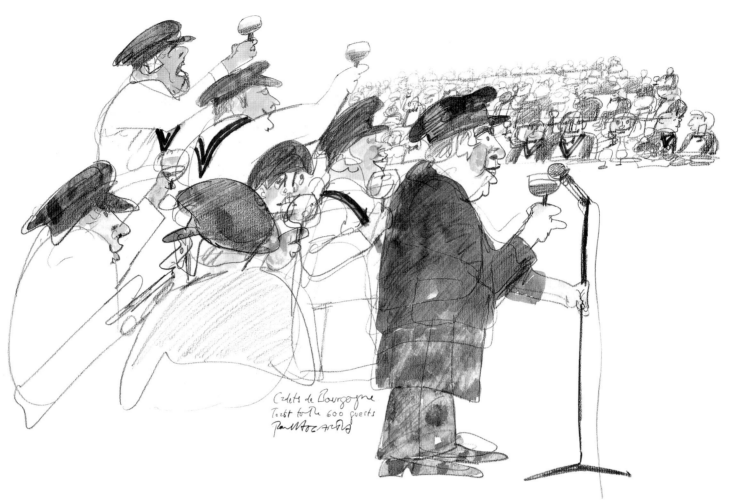

CADETS DE BOURGOGNE (1970)
Pencil and ink wash with watercolour.
18x25in (46x63.5cm)
Courtesy: Clarkson Potter, USA.
Unsurprisingly, their repertoire was devoted to good
fellowship induced by incessant imbibing, their songs
becoming more uninhibited as the wine they drank had
its effect. The youngest member was 65; their leader (at
the microphone) was 82 and had a face like the great
French comedian, Fernandel. It was a good life, he
confided, the daily wine allowance of a caviste was
6 litres! The Cadets, *he added, were in great demand.*
Tempting offers from the wine festivals of California
and Australia had been turned down, on the orders
of Général de Gaulle himself! All must come to France
to hear us.

auction of the wines from the vineyards of the Hospices de Beaune. The bidding was brisk. Total sales again reached a record figure. Midnight celebrations were reported in the dorms of the Hospices. Outside, the good news was greeted with trumpet blasts and beating drums as the Place Carnot filled with dancers in folk costume, providing a joyful finale to this festival of Bacchus.

'Back agin' ah yer,' said my mother, when I telephoned on my return. 'Bin livin' like a fightin' cock I do suppose!'

For once I found it difficult to disagree!

A MONTH IN PROVENCE (1991–92)

I returned to France many times. Both Graham Greene and Lawrence Durrell lived there, and in the course of the 1980s I depicted many of the *locales* throughout the country that had featured so prominently in their short stories and novels. D. H. Lawrence, too, had spent much of his short life moving from

hotel to hotel in Bandol, Carcassone, Monte Carlo, Metz and Paris.

In 1991 I found myself in France again, Provence this time, to create a series of watercolours for an illustrated edition of Peter Mayle's hugely successful *A Year in Provence*. I threw my baseball cap in the air. I could return to the same agreeable *pension* each night, besides enjoying the wine and cuisine of Provence at the very restaurants described with such relish by Peter Mayle! The book itself described the agony and the ecstasy of creating a home in the Mediterranean sunshine and evoked a sympathetic response. I chuckled appreciatively at the passages involving stonemasons and carpenters, plumbers and electricians. '*Normalement*' was very like '*manana*'. Mayle's genial neighbour Faustin vividly recalled to my mind Baltazar, a local farmer who had helped Toby and myself to bring back to life the abandoned orange farm in the Soller Valley, north-east Majorca, which I had bought in 1983.

MONSIEUR BEAUCHIER (1991)
Pencil and watercolour. 15x11in (38x28cm)
Private collection.
Monsieur Beauchier, chef des vignes, *a man with 40 years' experience of planting vines in the Luberon.*

Far left: CAVE SIGN, LUMIÈRES (1991)
Watercolour. 15x11in (38x28cm)
Courtesy: Christopher Martin.

THE PROPRIETOR OF 'LE SIMIANE'
LACOSTE (1991)
Pencil and watercolour. 15x11in (38x28cm)
Private collection.
Shortly after they had moved to Provence, Peter and Jenni Mayle lunched at Le Simiane, whose genial host greeted them with a bottle of pink champagne and wished them a happy New Year.

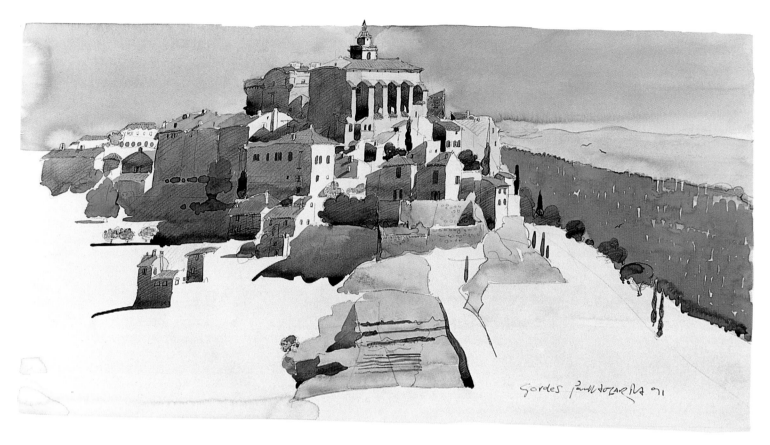

GORDES (1991)
Watercolour. 23x29in (58.5x73.7cm)
Private collection, UK.
Perched on the Vaucluse plateau, the old hill town of
Gordes rises in rugged splendour above the thickly
forested Imergue valley, topped by a Renaissance
château built on the site of a twelfth-century fortress.

Work began in June 1991. A week of intensive research introduced a part of France previously unknown to me – the Luberon, or as it came to be dubbed, 'Peter Mayle's Provence'. Picturesque hill villages, similar to but more prosperous than those of Majorca, dominated tranquil valleys of vineyards, orchards and fields of lavender, tended by a vigorous peasantry with accents as broad as their shoulders. Culturally, Provence and Majorca are very much alike. Both were, after all, provinces of the former Roman Empire.

Peter Mayle was easy-going and much less awe-inspiring than Robert Graves or Graham Greene. Maybe it was just that, for the first time, I was the older partner. But I liked to think that our mutual appreciation of the virtues and eccentricities of country people guaranteed a close and sympathetic collaboration. The original edition of *A Year in Provence* had, as one critic put it, 'sold like hot croissants' – one million copies in hardback and paperback, plus translations into Dutch, Danish, Swedish and German. This had made Peter an international celebrity. His village, Ménerbes, became a Mecca for hordes of affluent readers, who beat their way to look at his house and ask him questions. Most brought a copy to be signed. Not all, however, had even read the book.

Right: THE HUNTER (1991)
Ink and watercolour. 15x11in (38x28cm)
Private collection, UK.
A sure sign that it is now September.

Far right: MONSIEUR RAMON ROBERT
(1991)
Pencil and watercolour. 15x11in (38x28cm)
Private collection.
Formerly Peter Mayle's plasterer and now the proud owner of a pizzeria in Cheval Blanc, M. Robert is puzzled by British visitors who regularly insist on being conducted around his house!

Below: VENDANGE NEAR BONNIEUX
(1991)
Watercolour. 24x26in (60.5x93cm)
Private collection, France.
Below the old hilltop town of Bonnieux, the Roman heritage of Provence unexpectedly revealed itself as I depicted the grape-harvest in the vineyard of a Roman-style mas, or farmstead.

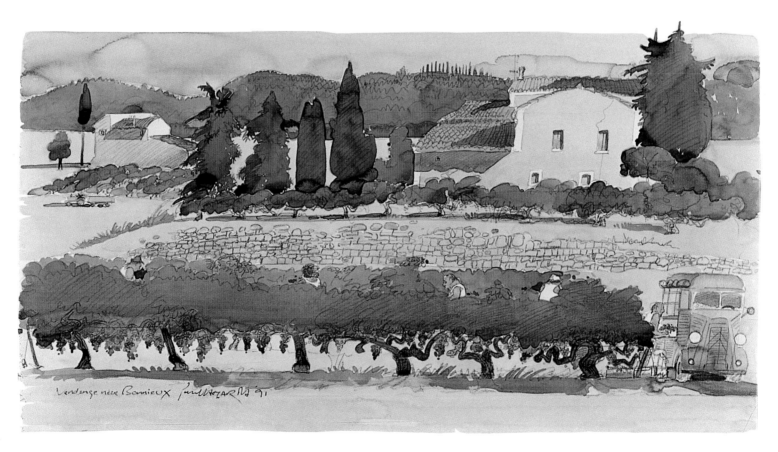

I spent three more weeks making working drawings on location, later to be fleshed out in colour in my London studio. Twelve large scenes, one for each month of the year, depicting the villages of the Luberon, plus an even larger image for a wrap-around jacket, were all that had been asked for. But once I got started, I could not stop re-creating the local characters; and fountains, road and shop signs also seemed to evolve as if out of thin air.

The illustrated *A Year in Provence* was published in autumn 1992, and quickly took on a life of its own. At the end of the following week it was in *The Sunday Times* top ten, and remained there for over a month. As Peter and I travelled throughout Britain on a signing tour, we discovered that the book had become the essential Christmas present. In Watford and Kingston-on-Thames, Birmingham, Leeds, York and Manchester, long lines of Francophiles patiently waited for their copies to be signed. We flew north to Edinburgh to find that city a hotbed of Francophilia. We signed 2,500 copies, in addition to 3,000 signed between London and Manchester in the back of a chauffeur-driven car. The exhibition of the originals at the Francis Kyle Gallery surpassed both *Graham Greene Country* and *The Mediterranean Shore*. By the end of the first week, every picture had been sold.

PRUNING THE VINES, GOULT (1991)
Watercolour. 24x36in (60.5x93cm)
Private collection, UK.
As I beheld this classic scene I wondered why I do not paint more landscapes. The slim columns of whitish-blue smoke rising here and there from the vineyards are from the fires of clippings or sarments.

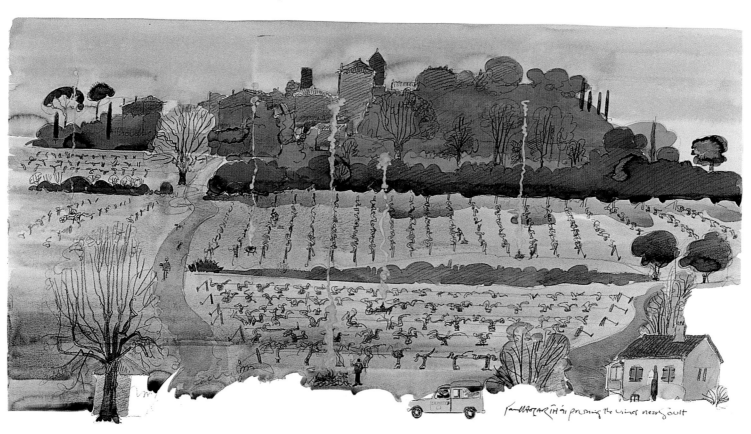

CHAPTER NINE
Return to Albion

Since buying the house in Deia in 1969, I had made Majorca my home, but my election to the Royal Academy, London, in 1974 put in motion a longing to spend time in Britain once more. I had at last received a measure of recognition by some, if not all, my peers, and I no longer felt such an outsider.

Toby, too, needed to reintegrate. After attending the British School in Palma de Mallorca, he had to prepare for his GCE O-Levels. On our return to London in the autumn of 1975, I enrolled him at the King Alfred School, Hampstead. The move proved to be a far from easy process. Since I last lived in Britain during the 1960s, I had lived in and travelled to many places. Pat and I had all but separated; I found myself trying to readjust to a mood of quiet despair.

I rented the bottom half of an early Victorian villa at 194 Regents Park Road, Primrose Hill, London, large enough for Toby and me to spread ourselves and provide me with working space. But the rent was high, and work thin on the ground. Moreover, inflation had risen 25 per cent under Prime Minister Callaghan's Labour government. I executed the occasional jacket design for the Penguin editions of Graham Greene's books during this time, as well as the odd lithograph for Christie's Contemporary Art, but that was about it. I soon found myself living on an overdraft with the occasional advance from Ted Riley, my US agent, on work to be done at some future date in the United States.

From time to time, however, the unexpected materialised. I was asked by Jim Bishop, a former *Time-Life* journalist then editing a reborn *Illustrated London News*, to go ahead with an idea for depicting famous artists' houses, which would appear the following year. I could leave my studio and work on location, and be back to make dinner for Toby and myself.

One fine day, I unfolded my stool outside 16 Cheyne Walk, Chelsea. The painter Dante Gabriel Rossetti had lived there for 20 years (1862–82). I was halfway through this agreeable chore when a chauffeur-driven Bentley glided to

The Selection & Hanging Committee of a Royal Academy Summer Exhibition (1995)
Ink and watercolour. 11x9in (30x23cm)
Collection: the artist.

'NOT SO MANY THIS YEAR, RON' (1995)
Ink and watercolour. 11x9in (30x23.5cm)
Collection: the artist.

'PERFECT FOR THE SMALL SOUTH
ROOM!' (1995)
Ink and watercolour. 11x8in (30x20cm)
Collection: the artist.

a halt close by. A long-haired, well dressed, youngish middle-aged man got out and watched me work for a few minutes.

'You're drawing my house,' he murmured in a slight upper-class American accent. 'When you're through I'd like to invite you in for a drink. Just press the front door bell.'

'If I was you mate,' chortled the chauffeur, after his boss disappeared, 'I'd accept that invite. 'E's loaded!'

I duly complied, and found myself face to face with a gilded youth who took me down to a luxuriously appointed basement kitchen. 'You're expected,' he whispered, glancing up at a closed circuit video screen, 'but please wait a second. OK,' he then added, 'please go in,' and opened a huge door that led into an ornately furnished drawing-room. A cluster of well heeled, long-haired couples sipped champagne against gilt-framed Victorian paintings hung on William Morris wallpaper. As I entered, the long-haired American came up to me, grinned and held out his hand. 'Welcome,' he said, 'my name is Paul Getty Two. What's yours?'

Getty confessed to being obsessed with 16 Cheyne Walk from the day he bought it. He had had the house restored to exactly how it was in Rossetti's day. The artist's original furniture and paintings were identified from an insurance inventory, and this had enabled him to acquire almost all the original pieces, as well as the majority of Rossetti's collection of pictures by fellow-Pre-Raphaelites and their followers. After my tour of the house, Getty asked if I would show him my watercolour drawing. I did so, and he immediately said, 'I have to have it!' It would be available, I replied, after publication some six months hence. He said he would wait, and invited me to join him for lunch the following week.

A week passed, and I went round to Cheyne Walk, only to discover the house locked and shuttered. Tessa Sayle, my literary agent, was of the opinion that the encounter had been the product of my fevered imagination. Then two years and several months later, in response to one of her famously acerbic letters, a messenger arrived at her office bearing a cheque for £500.

ROYAL ACADEMICIAN (1974)

Strangely enough, my becoming a Royal Academician had its origin in Moscow during the opening of the 'Looking at People' exhibition in 1957. Ruskin Spear had taken me on one side to add his congratulations on the exhibition's success. 'Look

'ere, Paul,' he growled, 'if you can a pull a caper like this 'orf, you should be one of us, an RA. I'm not taking nah for an answer. I'm going to put yore nime dahn in the book!'

He was as good as his word, and Hugh Casson seconded the proposal. The years went by. After 1964 I saw more of Ruskin and Hugh at the Royal College of Art, where Ruskin and I were senior tutors and Hugh a professor. From 1966 I sent works to the annual Summer Exhibition; usually they were accepted and hung. But I thought no more about it until the customary congratulatory note from Hugh – now President of the RA – arrived on my doorstep in Majorca: 'Hooray,' it read, 'ARA.'

I was delighted, but I wondered if I could possibly fit into this august temple of high art, run, it appeared, by a league of gentlemen? I ceased to have any doubts once I had served on the Council for a year, and on the Selection Committee for two Summer Exhibitions. Essentially, the Academy was first and foremost a society of painters and architects, run for and by painters and architects, in which I was encouraged to play my part.

One part I especially relished playing was that of a member of the Selection and Hanging Committee of the Summer Exhibition. Until the turn of the century, the annual exhibition was restricted to 'artists of distinguished merit' who were, of course, strictly professional. But besides Academicians and candidates for election as such, a growing number of unqualified students and amateurs began to submit work, anxious to have the seal of approval that only being hung on the walls of Burlington House could provide. By 1980, the number of these submissions had grown to a record 15,000, from which some 1,200 could be hung.

Members serve on the Committee in rotation, which occurs every five or six years. Each Committee has a Senior Hanger, chosen not by age but date of election. Almost invariably, they would be painters. In 1980 Ruskin Spear (elected 1954) was Senior Hanger. In 1984, it was John Ward (elected 1965). The Senior Hanger decides which pictures should go where, and puts a committee member in charge of a gallery or two to supervise the hanging of the kind of work for which he has sympathy, if not necessarily understanding.

During selection for the exhibition, the usually dignified galleries presented a daunting spectacle: huge stacks of pictures and crates of sculpture lay about in

JOHN HOYLAND: 'GOOD GOD, WHO FRAMED THAT – THE FLINTSTONES!' (1995)
Ink and watercolour. 11x8in (29x20cm)
Collection: the artist.

OVERHEARD IN THE GENTS (1995)
Ink and watercolour. 11x8in (29x20cm)
Collection: the artist.
Allen Jones: 'The standard is definitely down this year!'
Peter Blake: 'But the cat pictures are much better!'

apparent chaos. In 1980, Hugh Casson was chairman, assisted by Roger de Grey, Ruskin Spear, Peter Greenham, Leonard Rosoman, Ian Stephenson, Colin Hayes and myself. For six days we assembled at 10 o'clock each morning to view an endless procession of amateur and professional works.

The pictures rarely rested on the famous stool for more than a few seconds. There were pictures of gardens and cottages, bad portraits of good friends, mums and dads, aunts and uncles, babes, clowns and nymphets. There were still lifes depicting every kind of fruit, potted plants and freshly baked bread. Every animal known to man was represented, especially cats, dogs, horses, pigs, goats and sheep. There were sailing ships, barges and trawlers, landscapes and farmsteads and county fairs.

Only a collective sense of humour sustained us in the formidable task of culling the occasional well-executed or original image. The traditional mug of beef tea served at 11o'clock did much to boost morale, as did a substantial lunch. Then, apart from a brief tea break, we continued until 6 o'clock. A further two weeks

MIDNIGHT AT WHEELERS, 1980 (1995)
Ink and watercolour. 11x8in (28x20cm)
Collection: the artist.
Francis Bacon turning down my invitation that he become a member of the Royal Academy.

AT THE ANNUAL BANQUET 1979 (1995)
Ink and watercolour. 10x8in (26.5x21cm)
Collection: the artist.
Cardinal Hume: 'Let artists return to truth, goodness, love and beauty, in order to explore the mystery of God.'
Robert Buhler: 'With all due respect, isn't it a bit too late?'

were spent hanging; an even more demanding, but much more satisfying task.

As hanging got into its stride, the pressure mounted. We lost weight with the endless walking around. I bought a pedometer and in three days clocked 21 miles! There was also the unexpected pressure from friends of friends, artists' widows and well known artist-mothers and fathers with lesser-known artist-sons and daughters, lobbying and counter-lobbying for their works or those by others to be hung. But there is space for less than 10 per cent of the works submitted, which sometimes prompts artists to petition the Committee with great bitterness.

'The Royal Academy does not give me any opportunity or hope,' wrote one young painter, who had submitted work for ten years, 'but takes considerable sums of money from me to refuse and damage my confidence.' On the other hand, many a young artist has achieved immediate success with a work exhibited for the first or second time.

Once again, I found myself taking part in cultural politics. With a distinct feeling of *déjà vu*, I participated in a campaign to approach celebrated artists outside the Academy to ascertain if they would accept an invitation to become members and thus broaden and develop the influence and standing of the Royal Academy. Despite knowing the unpredictable Francis Bacon from my Soho days, I rashly volunteered for this daunting task. Bacon, I thought, could not possibly be more formidable than Picasso had been, on whose doorstep I had stood to ask for a painting for an 'Artists for Peace' exhibition in 1952. I approached Bacon one midnight at Wheelers', Old Compton Street, his favourite restaurant as it was mine at the time. With a pallor of light green set off by his intensely black hair, Bacon looked very like Bela Lugosi as Dracula.

'Francis,' I stammered, thinking that a visit to my dentist would be much easier, 'you must feel pleased that so much of your work has been included' (in the *British Art Now* exhibition, Royal Academy of Arts, 1980). He grunted so amiably that I was encouraged to continue: 'Why not,' I heard myself saying, 'join us?', instantly regretting my words. Bacon drew himself up as if to sink his teeth into my neck. 'I *never*,' he hissed, 'join *anything*, not even a dinner party!'

The annual dinner that takes place a day or so before the opening of the Summer Exhibition is a splendid, if at times long-winded occasion, although it is the speeches that are the focus of everyone's interest. One of the more memorable dinners took place when an inebriated Laurie Lee repeated his speech as he couldn't remember his lines. Diana, Princess of Wales, however, came to his rescue by tugging on the tails of his dinner jacket. At first, there was no response, and

AT THE HANGING OF THE SUMMER EXHIBITION 1987 (1995)
Ink and watercolour. 11x9in (28x24cm)
Collection: the artist.
Sir Roger de Grey: 'Congratulations, Paul. I can now reveal that you've inadvertently hung your first Prince Charles watercolour!'
It was the first and only time Prince Charles exhibited at the Summer Show.

THEATRE ROYAL, HAYMARKET, LONDON
(1979)
Watercolour. 20x15in (51x38cm)
Courtesy: William Mullins.
Designed by John Nash and completed in 1820, the
Theatre Royal and the houses behind it in Suffolk Street
are all that remain of Nash's triumphal way from
Carlton House Terrace to Regents Park. The monumental
portico of six Corinthian columns make it the grandest of
London's theatres ('London Theatres', Illustrated
London News, *February 1984–January 1985)*

only when his bow-tie ended up under his ears did he finally sit down to grateful applause.

The Private Dining Club dinners, to which guests are invited from time to time, also produced memorable and joyous occasions. The dinner that follows the re-election of the President is a notable example, providing the excuse for 'Owed [sic] to the Founders' or 'Sydney's Song', a *pièce de résistance* written and rendered by Sydney Hutchison, the esteemed archivist. This is sung to the robust air of 'Widdicombe Fair' and 'Uncle Tom Cobley'. The names in the last chorus are changed to include those present (I quote the first and last of the four stanzas):

> I'll sing you a song of yesterday year,
> All along, down along, out on the spree,
> Of General Assemblies fought without fear
> With Will Chambers, Richard Wilson, Paul Sandby, Francis Hayman,
> Tom Gainsborough, Benny West,
> Sir Joshua Reynolds and all, Sir Joshua Reynolds and all.

> It's easy to see that the followers-on,
> All along, down along, out on a spree,
> Have little to learn about such goings-on,
> Not Bill Bowyer, Robert Buhler, Tom Phillips, Trevor Dannatt,
> Philip Sutton, John Ward,
> And Roger de Grey, PRA, and Roger de Grey, PRA.

During my second term on the Council, I was again on the Selection Committee of the Summer Exhibition of 1987. As always, there were too many good pictures the wrong size, involving constant changes: the French call the process *repêchage*, or 're-fishing'. As I brooded on the horns of this perennial dilemma, Roger de Grey, then our genial President, advanced with a mischievous glint in his eyes, holding a small, well framed watercolour of a barn overshadowed by tall trees. The picture was well above average; even so, I suspected Roger might be lobbying for one of his many talented pupils. I turned the work over to discover who the artist might be. The label revealed the artist to be one Arthur G. Garrick, the title *Farm Buildings in Norfolk*, but not for sale.

'Never heard of him,' I said, but hung the picture in a section devoted to rural life and landscape in Gallery VII. Roger, usually the soul of discretion, could

not contain himself any longer. 'It's the *nom de plume* of Prince Charles!' he cried. 'Tell him to send us more,' I replied.

BRITAIN REVISITED (1979–98)

After returning to Britain from three years in Washington, in the autumn of 1979, I decided to stay in London and re-invent myself as an Englishman. I drove up to Cumbria to comfort my increasingly frail mother, and Toby and I spent weekends rediscovering quintessential England. I depicted Bath, Rye and Hastings. I explored the courts and lanes of the City of London, marvelling at what had survived the Blitz. I had my first London one-man show for over a decade at the newly established, up-and-coming Francis Kyle Gallery. In the context of economic recovery and increased foreign travel, Francis Kyle had revived, with great success, the peculiarly English tradition of the artist-traveller, showing the work of my former students – notably Adrian George and Glynn Boyd Harte – as well as myself. Our partnership, always a source of great encouragement to me, has lasted ever since. At the crowded opening, old friends, colleagues and former students implored me not to return to America. 'Travels through the Seventies' – as the exhibition was called – was such a success that I found myself overwhelmed with work.

But finding a place to live and work almost put me off. I spent several weeks with Richard and Nancy Carline at their old house in Pond Street, Hampstead. It was then a rambling, early Victorian house with a huge, equally old garden, which I had known since my AIA days: redolent of the tolerant liberalism of Bloomsbury and really the heart of that organisation. Paintings and drawings by Richard, Nancy, his sister Hilda and brother Sydney, as well as by his one-time brother-in-law, Stanley Spencer, hung everywhere above oriental bric-à-brac and thickets of walking-sticks and tweedy coats. During the 1930s, the Carline house had been the headquarters of the Artists' Refugee Committee and had provided shelter for John Heartfield, Oskar Kokoschka, Kurt Schwitters and many others. Now its gracious atmosphere made me feel like a refugee too.

I lived and worked in a succession of temporary studio-flats from Bloomsbury to Edinburgh, seeking to exorcise my homelessness by working outdoors on assignments such as 'London's Theatres' for *Illustrated London News*. Then one day the telephone rang. A friendly voice from the Community Housing Association offered me a purpose-built studio-flat in Primrose Hill for as long as

JACKET DESIGN FOR *THE SPIRE* BY WILLIAM GOLDING
15x11in (38x28cm)
Collection: the artist. Courtesy: Faber and Faber, London.
William Golding had jacket approval in his contract. Usually, he approved of my designs for his novels, except when the image involved ships! Then he could be difficult. My design for his sea trilogy, To the Ends of the Earth, *was, he thought, 'flawed' until I pointed out that the good ship that sailed to the Antipodes was in fact based on various ships' models in the National Maritime Museum, Greenwich.*

Opposite: JACKET DESIGN FOR *HAMLET*, PENGUIN NEW SHAKESPEARE SERIES 1980
15x11in (38x28cm)
Private collection, UK.
David Pelham, then art director at Penguin, asked me to create a series of images for a new edition of Shakespeare. My designs for Graham Greene's Penguin jackets featured the dramatic juxtaposition of historical forces or social elements. Both Pelham and I felt that Shakespeare's plays were ideal for this approach.

THE WATER TOWER, RYE (1982)
Watercolour. 23x18in (58.5x47cm)
Private collection, UK.
After years of travel abroad, I delighted in rediscovering England. Rye was one such place. The sea might have receded, but the town had kept its marked individuality. Besides, two of my heroes had lived there – Edward Burra and Paul Nash.

I paid the rent. I then recalled that I had put my name down for an Auden Place studio seven years previously!

Many more events conspired to renew the broken bonds with England. A trip with Jessica (Decca) Mitford in June 1983 enabled me to renew my old acquaintance with the north of England. *The Observer* had asked her to take a sounding of the pre-general election mood of the country and I was asked to accompany her. We started in Manchester, where we established ourselves at what used to be the Midland Hotel. Here, Decca held court with a procession of Labour activists in daily attendance. I was intrigued to find they had not changed a bit. I sought to rediscover the city where I began my studies as an artist. Inevitably, there had been changes. Rusholme had become a flourishing Asian ghetto. Victoria Park was still there, but the Repertory Theatre where I saw Ernst Toller's *Draw the Fires* (in which the youthful Joan Littlewood had a part) had disappeared; likewise 111 Grosvenor Street, which had housed Theatre Union and Barbara Niven's studio. The art school, however, and the lime-green Grosvenor Cinema were still there.

My last glimpse of Jessica Mitford's England was at a drinks-and-brunch party in the Conservative county of Buckinghamshire. There was much solemn talk of horses and roses; dogs were admonished for eyeing ham sandwiches. At a Royal British Legion barbecue, retired colonels carved beef. I drew stalwart livestock farmers and their rosy-cheeked wives who, much to Decca's dismay, heartily endorsed Mrs Thatcher's policies.

Although the delightful Decca's company was stimulating as always, I had outgrown her unreconstructed radicalism. I preferred the equally iconoclastic Richard Ingrams, who had no illusions about politics or politicians. I had been an avid reader of his *Private Eye* for some years. Then, for some reason I've never understood, he resigned from the *Eye* and launched – as a joke – *The Oldie*, which

STRANGEWAYS GAOL, MANCHESTER (1983)

Ink, pencil and watercolour. 18x24in (47x61cm)
Collection: the artist.
While drawing a 'dole' (benefit) queue in Manchester, I made the acquaintance of a 17-year-old youth who had shared a cell with two other unfortunates in Strangeways Gaol. I recalled my mother saying that if I did not behave myself, I would end up there. I had no idea what that really meant until I confronted this vast Victorian penitentiary, forbidding yet splendid, behind high iron-spiked walls. Obligingly, being Manchester, it rained!

STAMP DESIGNS FOR EUROPA 1990
Watercolour. 41x30mm
Courtesy: Royal Mail.
On New Year's Eve, 1989, Glasgow received confirmation that it had been named European City of Culture for 1990. The Royal Mail decided to celebrate the accolade and combine it with two other places associated with the Royal Mail: Alexandra Palace, the venue for Stamp World London, and the British Philatelic Bureau in Edinburgh. I chose Charles Rennie Mackintosh's School of Art (top left; date of issue 4 March 1990) and the Templeton Carpet Factory (top right; date of issue 6 March 1990).

Designed by Charles Rennie Mackintosh, the School of Art was built between 1897 and 1909. Without doubt, it is one of the great buildings of the late nineteenth century.

Carpet manufacturer James Templeton told his architect, William Leiper, to copy any building that was a masterpiece. Leiper chose the Doge's Palace in Venice. Carpets are no longer woven here; it is now a centre for small businesses.

ST MICHAEL'S MOUNT, CORNWALL (1996)
Watercolour. 29x23in (73.7x59.7cm)
Courtesy: The Foundation for Art, National Trust, London.
My brief from the National Trust was to depict their 'top ten' properties visited by the general public during the summer and on bank holidays. This involved studying each subject to understand how I could best put this over. In the case of St Michael's Mount, was it better to have the tide in, or out? Should I make the distant sea darker or light? To resolve such questions, I made several thumbnail colour sketches in a pocket sketchbook. I then took colour photographs. I also made studies of different types of visitor.

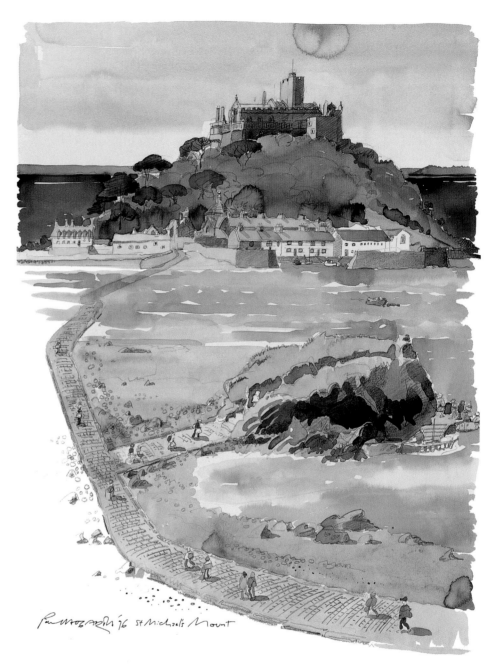

everyone took seriously since it celebrated maturity as a valid point of view.

I sensed a kindred spirit and sent him my story about John Paul Getty II for the 'I once met...' column (*The Oldie*: 17 October, 1992). After this appeared, I was suddenly upgraded to features and contributed two pages of comic interludes involving Robert Graves, Brendan Behan, Graham Greene, Lawrence Durrell, Francis Bacon and Peter Mayle saying odd things while I made drawings ('A Speaking Likeness', *The Oldie* 53: 18 February, 1994). The caricaturist lurking within me had been painlessly extracted by a remarkable editor. Aware that there

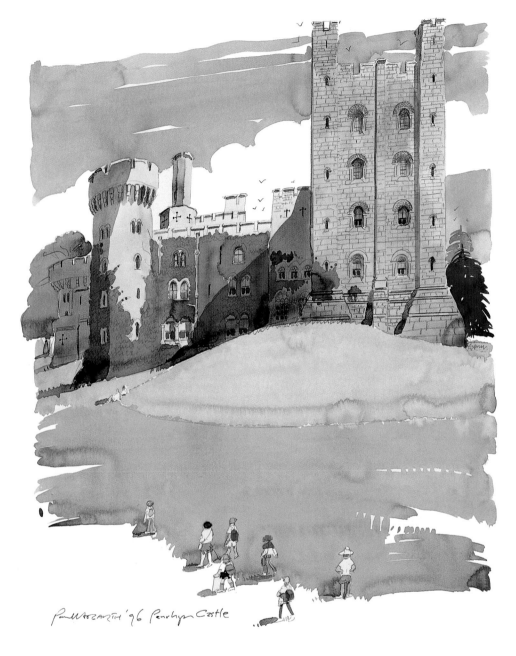

had to be more material, Richard then asked for something on the Royal Academy
Summer Exhibition. Fearing expulsion, I responded with a feature that recalled
my experiences as a member of the Selection and Hanging Committee of four
summer shows ('Hogarth the Hanging Judge', *The Oldie* 60: 27 May 1994).

In July 1994 Diana and I had leased Hidcote Manor in Gloucestershire
from the National Trust. Sensing a good story for a spring number on the theme
of gardening, Richard asked that I write and illustrate life in one of England's
most beautiful, albeit much-visited, gardens. I wrote of the delights of living in the

ST MARY THE VIRGIN FROM THE
RADCLIFFE CAMERA, OXFORD (1995)
Watercolour.15x11in (38x28cm)
The Francis Kyle Gallery. Courtesy: John Murray
Publishers, London.
This was drawn for an illustrated anthology of John
Betjeman's writings, In Praise of Churches *(1996).*
It involved a perilous ascent to the roof of James
Gibbs's famous Camera building, but I was rewarded
by a most dramatic view of the celebrated church in a
setting of trees and pinnacles.

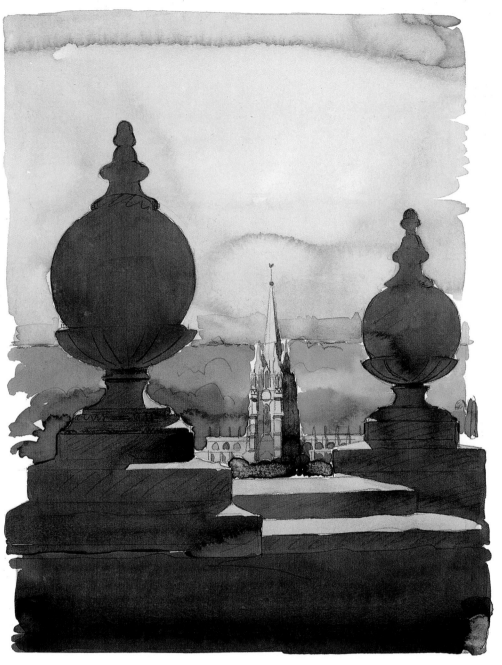

ancient manor. I had observed some unusual sights from various windows: plant-bandits eyeing blue scillas with undisguised lust; pheasants who made unfavourable comments on back-packers; and urchins running off with prize blooms ('Artist in Residence', *The Oldie* 74: May, 1995). Such irreverence delighted Ingrams, but he didn't always encourage it. A proposed feature on my double-hip replacement failed to arouse the slightest interest.

My rehabilitation as an Englishman reached its apotheosis when I was asked by Grant McIntyre of John Murray to illustrate an anthology of the late Sir John Betjeman's verse and essays, entitled *In Praise of Churches* (1996). Betjeman

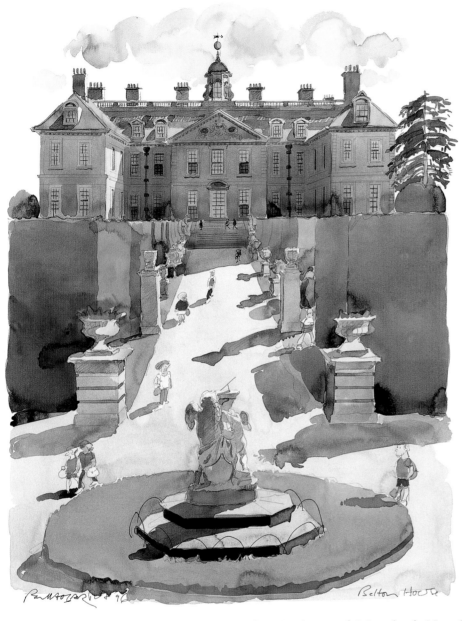

BELTON HOUSE, LINCOLNSHIRE
(1996)
Watercolour. 25x19in (63.5x49.5cm)
Courtesy: The Foundation for Art, National Trust, London.
A gem of Restoration country house architecture, its somewhat stern Classicism made the visitors appear like intruders. Yet, as I looked more closely, all were fascinated and not a little awed, and grateful for the privilege of walking around the magnificent formal gardens.

had long ago opened my eyes to the indefinable charm of Metroland. Now I embraced not only village churches, but nonconformist chapels and meeting houses, as well as High Victorian city churches, with equal enthusiasm. More was to come when in March 1996, Dudley Dodd of the National Trust commissioned a series of watercolours of their most popular domains: St Michael's Mount, Stourhead, Corfe Castle, Penrhyn Castle, Fountains Abbey, Belton House, Osterley and Bodiam Castle.

Such sorties into the heartlands of Britain led me to make a trip into Scotland in 1998. This had long been planned since I spent the winter of 1979–80 in

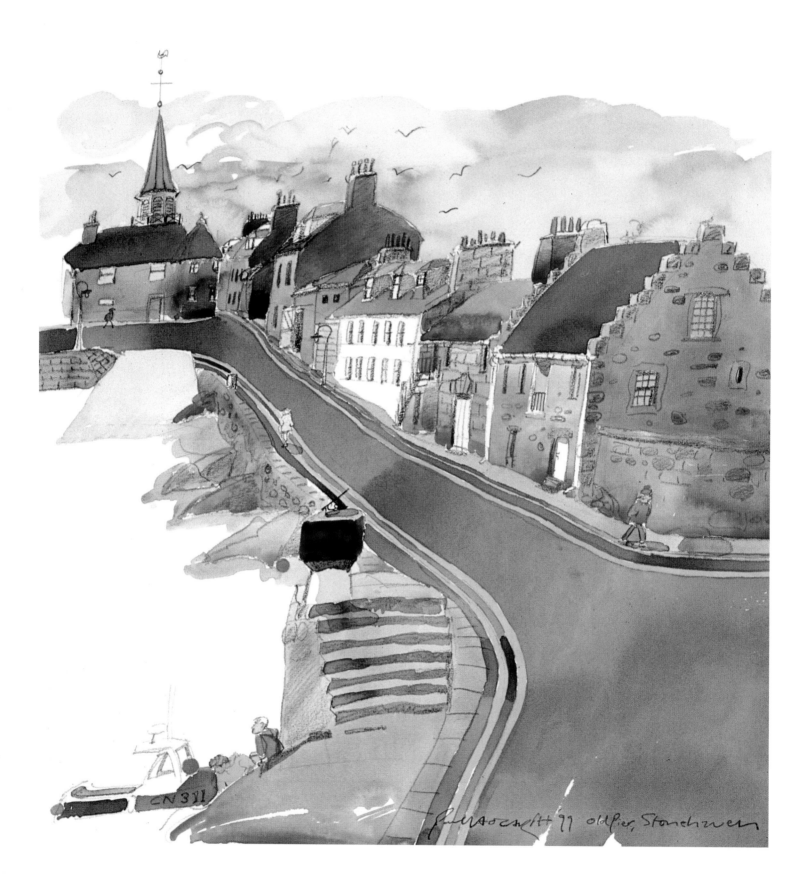

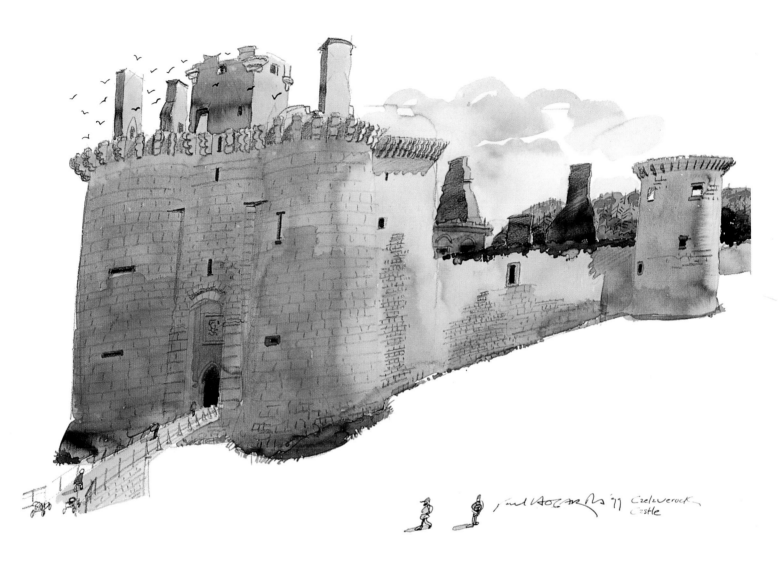

Edinburgh, during which time I would frequently spend weekends exploring Culross, Melrose and Stirling. Both Pat, my former wife, and my present wife Diana are Scots, Pat from the belligerent West and Diana (née Cochran) a well-bred Highland lassie.

We based ourselves at Birse near Aboyne on Deeside where Diana has a cottage on Balfour, the Cochran family estate. There for the month of August I depicted the austere beauty of the so-called 'Misty Country' of prehistory, in villages like Stonehaven and Catterline, the latter so beloved of the painter Joan Eardley. There are castles galore, long war-ruined but still awesome, such as Dunottar, and to the south, Caelaverock in Dumfries and Galloway. Baronial residences too, like Craigievar, Crathes, Cawdor, Huntly and Eileen Donan, abound

STONEHAVEN (1998)
Watercolour. 20x20in (51x51cm)
Collection: the artist
There's a distinctly Scandinavian ambience to this seventeenth-century Grampian fishing village.

CAELAVEROCK CASTLE (1998)
Watercolour. 17x20.5in (43x51cm)
Private collection
Overlooking the north shore of the Solway Firth, this outwardly formidable fortress has an inner courtyard lined with ornate façades in the style of the Scottish Renaissance. The great Keep gatehouse is at the apex of its triangular shape.

in the Highlands. We took the ferry from Oban to Tobermory on the Inner Hebridean island of Mull where I was intrigued to discover the last resting place of Lachlan Macquarie (1761–1824), the liberal pro-Emancipist Governor of New South Wales who transformed a shoddy Sydney into a handsome Georgian city. Encircled by a massively-built stone wall, the Victorian gothic mausoleum is shaded by a stand of umbrella pines which give it a distinctly antipodean look.

After nearly half a century of globetrotting I had discovered the haunting beauty of another country. This time, however, it was my own.

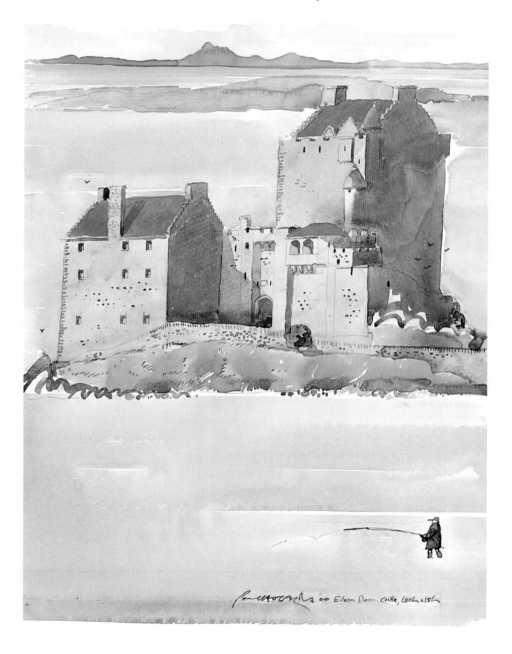

CHAPTER TEN
Later Horizons

HIDCOTE WAS NOT WITHOUT ITS LIGHTER SIDE. OVERSEAS VISITORS TO THE GARDENS, MOSTLY AMERICANS, WOULD KNOCK AT THE FRONT DOOR EXPECTING TO BE SHOWN AROUND BY LAWRENCE JOHNSTON, THE AMERICAN EXPATRIATE WHOSE MOTHER GERTRUDE BOUGHT THE PLACE IN 1907. PATIENTLY, I WOULD EXPLAIN THAT IF THEIR MAN WAS STILL ALIVE HE WOULD NOW BE 120, NOT MY MERE 80-PLUS! THEY WERE USUALLY VERY UNDERSTANDING ABOUT IT.

DOWN EAST AND SOUTH OF BOSTON (1997)

RELATIVELY LITTLE IS known about Lawrence Johnston apart from the fact that both his parents were independently wealthy. His father, Elliot, had joined the United States Navy at 15, resigning after seven years to become a planter. During the Civil War he served in the Confederate Army and lost a leg at Antietam. Gertrude's family was descended from a founder of Connecticut, John Waterbury, who had emigrated as a yeoman from Suffolk in 1646 to establish a dynasty of shrewd Yankee entrepreneurs. Gertrude's father prospered as a manufacturer of rope products, or cordage, which in the days of sailing ships were very much in demand. After Elliot Johnston died, Gertrude remarried, her second husband being Charles Francis Winthrop, a prominent New York lawyer. After his death in 1898, she and Lawrence shuffled between France, England and the United States, uncertain of where they might eventually settle. In the end, she chose England, buying the Hidcote estate in order that her son might become an English country gentleman. It was a family history that moved me to reflect on the restless and often ill-starred lives of the many American expatriates who formed part of the general exodus to Europe that followed the Civil War.

Many settled in the Cotswolds, especially in and around the Worcestershire village of Broadway, some eight miles south-west of Hidcote. Here, on the recom-

WHITE CHRISTMAS, HIDCOTE (1999)
Watercolour. 14x13.5in (37x35.5cm)
Private collection
In our fifth year at Hidcote, I felt it was high time that I celebrated the occasion and expressed our affection for the old place. I set my winter scene against the Arts & Crafts wing of the Manor and introduced a pair of topiary yews shaped like conversing cuckoos from another part of the gardens. Gardener Philip Bowel soldiers on, clearing a snow-covered path, ignoring both robin and fox in their respective quests for nourishment.

mendation of William Morris, the American painter Francis Davis Millet (1846–1912) bought and restored Jacobean houses, using their interiors as backdrops for his genre scenes of Cavaliers and Roundheads (his *Between Two Fires* is in Tate Britain). Other American artists joined him, including Edwin Austin Abbey, John Singer Sargent and the Anglo-American painter George Henry

Boughton (Royal Academicians all). Among the many visitors was Henry James, who agreed with Burne-Jones that Millet had 'reconstructed the Golden Age' in the Cotswolds.

All this was heady stuff and served to kindle my interest in returning to America to visit the old townships of New England, especially those south of Boston along the eastern shore to Plymouth, Providence and Cape Cod – places I had never visited during my years travelling about the States. Not that all Massachusetts was of interest, a prime example being the reconstructed 'Plimoth Plantation'. I much preferred the Plymouth Harbour with today's reality of its colourful medley of Whale Watch excursion boats. Provincetown, too, was a disappointment. I had arrived too late for the raucous spectacle of the summer season and half a century too late to depict some aspect of its heyday as a fishing port, or indeed its later fame as a haven for artists and writers.

Salem, on the other hand, was quintessentially New England. One of several fishing stations established by the Pilgrim Fathers, its ship owners and merchants had been among the richest in America. Their square white houses (mostly designed by the carpenter-architect Samuel McIntire), with widows' or captains' walks, evoked the era of Yankee maritime glory. Here too, was the House of the Seven Gables, a rambling colonial structure of steeply-pitched roofs and huge chimneys.

In Marblehead, too, another Pilgrim fishing station, there were eloquent symbols of the past. Looking at its focal point, the Old North Church on Main Street, I was intrigued by its huge weather vane, an outsize golden codfish, once the greatest source of wealth in New England, now almost extinct from decades of over-fishing.

In New Bedford, on the other hand, the weather vanes were either sperm whales, whaleboats or whale men blowing the trumpets that were used for calling from one ship to another when sighting whales. These huge mammals were then commonplace in the Atlantic where intrepid seamen faced unimaginable perils in tumultuous seas. The austere Seamen's Bethel, built in 1832 on Johnny Cake Hill with its rows of marble memorial plaques, commemorates their courage.

And, finally, Gloucester – not what it was but still the leading fishing port on Cape Ann, if not in all New England. A distinctive odour of tar, salty sea air and fish assailed my nostrils as I entered the town. Above the old harbour, wooden merchant's houses looked down upon a silent sea. Lining the waterfront are wharves where, over three centuries, fishing boats disgorged their once abundant catches.

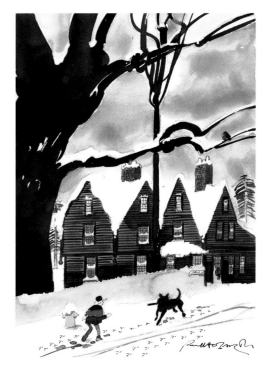

THE HOUSE OF THE SEVEN GABLES, SALEM (1998)
Watercolour. 18x13.5in (46x35cm)
Collection: the artist
Salem, it has been said, has architectural treasures so numerous and varied as to re-create the entire Colonial period of New England. Among them is this celebrated house (built ca. 1688) which is associated with Nathaniel Hawthorne, although there is some doubt that this is the one described by one of America's great literary figures.

Anglo-Saxon for much of that time, Gloucester and other ports were given a new lease of life by Portuguese, Italians and Scandinavians, seafarers all. Henry James, writing his *American Scene* in 1906, revisited New York and Boston and found the architecture unchanged but the languages he heard spoken around him no longer English. As Stephen Spender so eloquently put it in our book, *America Observed* (1979), 'He was hearing the crude sound of the onrushing molten lava – a new stratum of American history overlaying an earlier one.' Perhaps this was what made Gertrude and Lawrence Johnston return to the land of their Pilgrim ancestors.

IN TUSCANY (1998)

As always, there remained the question of my next show. Francis Kyle had suggested Venice, but, much as I love the place, Venice has literally been done to death. There are just too many of the wrong kind of tourist; the city is invariably crowded at any time of the year. I recalled drawing the Grand Canal some years ago, searching for a vantage point from which I might depict 'the water-wobbled orchestra of divine buildings', as Lawrence Durrell put it. Eventually I found a spot on the Ponte dell'Accademia but alas, tourist groups got between me and the subject. I almost gave up after being asked to take snapshots of bubbly Japanese teenagers with their one and only camera.

Michael Spender's essays *Within Tuscany* (1992), however, revealed a very different Italy that might be a good place to avoid the wrong kind of tourist. I recalled an earlier visit to find the Villa Mirenda, the house that Frieda and D. H. Lawrence had rented in the 1920s near Scandicci. It was still there, flanked by countryside as yet unspoilt, although Scandicci itself was now a bustling suburb of Florence. I recalled too arriving in the hill town of Volterra, once the Etruscan capital, to plunge immediately into its medieval past. I depicted its entrance gate and the sinister Porta dell'Arco, a tunnel-like gateway lined with featureless, amoebic faces. The occasional tourist plodded past but here they were of a different kind, more given to writing postcards expressing their sense of respectful wonderment. Yes, indeed, *this* Italy was different.

This time, however, our visit began in Chianti Classico country, at a farmhouse near Radda where we were the paying guests of Ursula McCreagh, a wryly worldly-wise English expat. We made her place a base for daily trips to the villages of the Chianti: Gaiole, Volpaia, Vertine, Meleto, Barbischio, Badia a Coltibuono, Greve, Montegrossi and Siena itself.

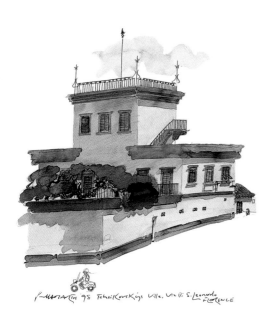

TCHAIKOVSKY'S VILLA, FLORENCE (1998)
Ink and watercolour. 20x15in (51x38cm)
Private collection
In great demand as a conductor, the composer travelled widely in Western Europe between 1878 and 1884. In Italy, he rented this modest villa at Via San Leonardo 63, close to the Boboli Gardens.

Back at the farmhouse, it was startling to discover that Ursula, our genial hostess, was in fact the granddaughter of Frieda Weekley, later D. H. Lawrence's wife! She had been named by her mother Barbara after Ursula Brangwen, the heroine of Lawrence's controversial 1915 novel *The Rainbow*. Encouraged by Lawrence, Barbara had studied at the Slade. Many of her excellent portraits lined the walls of our bedroom.

An even more extraordinary coincidence was the fact that Ursula knew a man who had literally changed the course of my younger life. This was the inimitable Leo Lionni, painter and designer, who lived nearby. As the outgoing art director

ARCETRI (1998)
Watercolour. 22x18in (56x46cm)
Private collection
South of Florence I found Arcetri to which the great Galileo was exiled by the Inquisition.

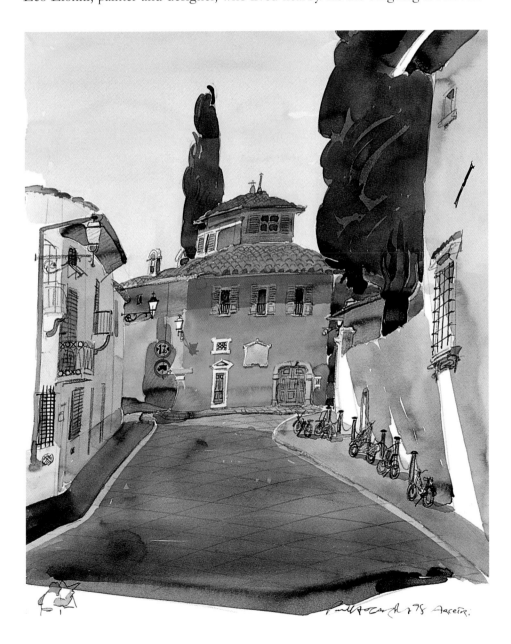

of *Fortune*, Leo had persuaded his Bauhaus-trained successor, Walter Allner, that I was God's gift to the magazine. We had met in a publisher's office in Paris and, after seeing my drawings of China, Leo took me to lunch at the Brasserie Lipp during which he impulsively leapt to his feet and called New York. A few weeks later, in August 1962, I found myself in the Deep South drawing the transcontinental oil pipeline, the Colonial System (see Chapter Five). Now 88, Leo was still his ebullient self, teeming with ideas for new projects.

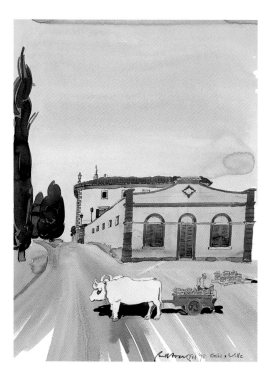

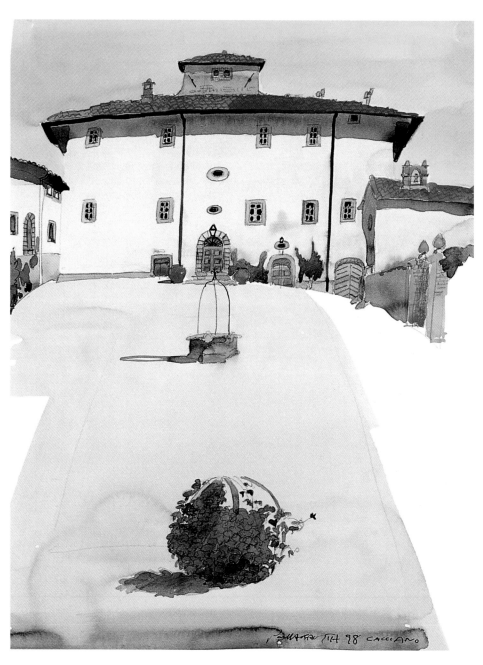

CASTELL N' VILLA (1998)
Watercolour. 22x18in (56x46cm)
Private collection
I would sometimes encounter scenes of life and landscape unsullied by the gritty reality of modern times. An unpaved road in the south-eastern corner of Chianti led me to a renowned wine estate redolent of the eighteenth century when the Grand Duke of Tuscany established the boundaries of the Chianti Classico region.

CACCHIANO (1998)
Watercolour. 25x20in (63.5x51cm)
Private collection
Another unexpected discovery: an ancient wine estate dating from 1203 and still noted even today for its big, traditional-style Chiantis. There was no one to disturb me. Such moments are rare in the life of the itinerant artist.

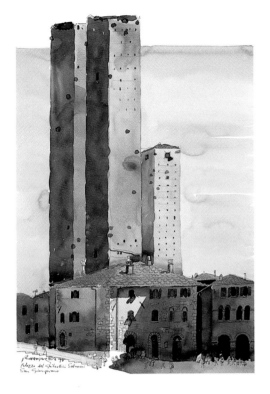

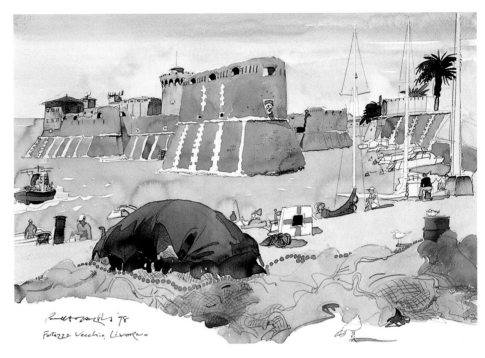

Driving south, we established ourselves at a second base in Montecalcino. I depicted Montepulciano, where Henry James got so drunk on its *vino nobile* that he never explored the fascinating old town. Nearby lies Pienza, conceived by Pope Pius II in 1459 as a utopian 'new town', and later, much later, used as the setting for Franco Zeffirelli's film of *Romeo and Juliet*.

We made Lucca our third base, from where I portrayed San Gimignano's *belle torri*. Lucca itself stimulated me to make a further group of watercolours of its stunning Stile Liberty villas in the San Marco neighbourhood, and, inevitably, I depicted the Anfiteatro, which involved wrestling with my vertigo to climb a 200ft tower and gaze down on its toy-like houses, lining what had once been a Roman amphitheatre.

A PORTRAIT OF PORTUGAL (1999–2000)

My visit to Portugal had much to do with the amiable Antonio Silva, a remarkable man given to materialising like a genie at my private views. Now and then he would buy a work, usually an original of a jacket illustration for the Penguin edition of a Graham Greene novel. He collected the Master's books in their various editions. Had I ever thought of visiting his country? I had not, but found it impo-

PALAZZO DEI GHIBELLINI SALVUCCI,
SAN GIMIGNANO (1998)
Watercolour. 22.5x15.5in (57x39.5cm)
Private collection
No one can agree how many of the famous towers there used to be – seventy, eighty or even a hundred. Now only thirteen remain. Built as fortresses, they sheltered the adherents of warring noble families, notably the Guelph Ardinghelli and the Ghibelline Salvucci.

FORTEZZA VECCHIA, LIVORNO (1998)
Watercolour. 36x25in (92x63.5cm)
Private collection
Livorno or Leghorn was almost wiped out during World War II. Yet fragments of its historic past as a free port of the Medicis, like these massive harbour bastions, obstinately remain.

DOURO GRAPE PICKER (2001)
Pencil and watercolour. 14x10in (35.5x25.5cm)
Private collection
The grapes are collected in tall wicker baskets.

MARDI GRAS MASK, MINHO (2000)
Ink and watercolour. 10x10in (25.5x25.5cm)
Private collection

IN THE MINHO (2001)
Watercolour. 22x18in (56x46cm)
Private collection
*Not an easy subject. The young peasant woman was
intensely self-conscious but she relaxed when I included
her splendid oxen. In the background is a tomb-like
granite corn-barn, typical of the Minho. Slatted for
ventilation, it is raised on columns, keeping grain at
the right temperature and beyond the reach of poultry
and rodents.*

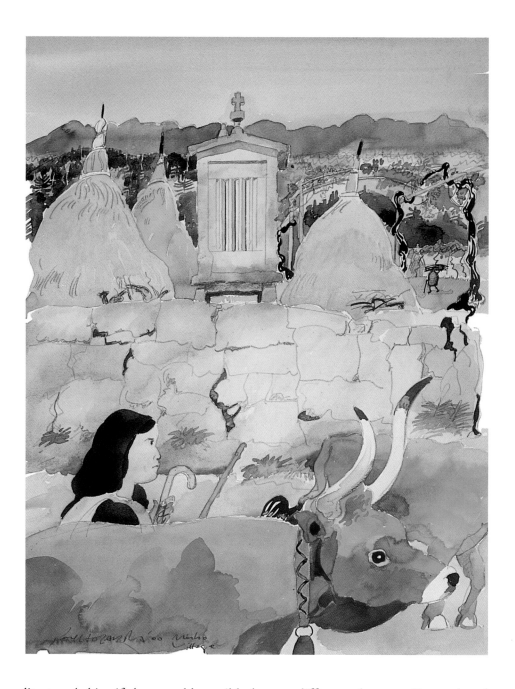

lite to ask him if there could possibly be any difference between Portugal and
Spain. I could not have been more mistaken!

My first stop was Oporto, Portugal's second city where I soon found my first
subject – the port-wine lodges along the River Douro. Displayed on their
frontages were the great names – Croft, Calem, Cockburn, Dow, Graham,
Sandeman and Warre – of descendants of the English and Scots port barons of the
early nineteenth century. Although the discovery of port itself dates from the sev-

enteenth century, it was they who introduced the wine to the colleges of Oxford and Cambridge, the clubs of London and the taverns of Bristol, Edinburgh and Norwich.

Driving north-east along the steeply-terraced valley of the Douro, I came across the *Quintas* (wine estates) themselves, with an indomitable peasantry toiling in the vineyards, pruning the precious vines. Continuing north, I passed through Viane do Castello before entering the National Park of Peneda-Geres. Here, I found the mountain hamlets of the misty Minho with their extraordinary, temple-like granite corn-barns or *espigueiros*. I stepped backwards in time and followed the example of the nineteenth-century ruralist Jules Bastien-Lepage to enable me to portray a young amazon-like peasant woman, coaxing her long-horned oxen to their bier.

Then I turned west to look at Guimaraes, the so-called 'Cradle of Portugal', Braga, Caminha, Lamego and Villa Real with its splendidly baroque manor, the Casa de Mateus. En route to Lisbon, I stayed a night at Bucaco, a former royal hunting lodge, now a *pousada*, built for King Carlos in the flamboyant neo-Manueline style reminiscent of our High Victorian buildings. The hotel had numbered Agatha Christie, Cole Porter, Anthony Eden, General Franco and Henry Kissinger among its guests. 'Why leave out Jack Nicholson?', quipped an American tourist, 'He would have loved the place!' Nearby, Wellington's victory over the French in the Peninsular War is commemorated by a magnificent obelisk encircled by a row of upturned cannon barrels.

I found Lisbon itself a metropolis of great charm, abounding with old, charismatic restaurants and literary cafés. Lisbon's cuisine is excellent – the fish is superb, the meat less so, and there is a surprising range of excellent wines. Alfama, the old quarter of the city, reminded me of Montmartre with its winding cobbled streets along which ancient red trams clattered noisily. Back-street cafés nurtured Fado (literally 'fate'), the melancholy folk music of Portugal. In the Baixa there was much to satisfy my taste for the eccentric in the neo-Manueline Rossio Station, with its horseshoe-arched doorways, and the neo-Gothic Elvador de Santa Justa, a cast-iron, filigreed edifice built at the turn of the century by Raoul Mesnier du Ponsard, an apprentice of the great Gustave Eiffel. The lift provides a link between the Baixa and the Barrio Alto, another fascinating quarter, with its celebrated Art Deco café, A Brasiliera, once the sanctum of Lisbon's *literati*. One of its regulars was Fernando Pessoa (1888–1935), Portugal's most famous modern poet, who is commemorated by a seated bronze figure at a table outside.

ALFAMA (2000)
Watercolour. 20x15.5in (51x39.5cm)
Private collection
The old Arab or Moorish quarter of Lisbon is a cobbled kasbah-like maze of twisting streets and alleys cut by steps and archways.

Elsewhere, near the Jardim da Estrella, an old crone reluctantly admitted me to the English Cemetery to depict the tomb of Henry Fielding (1707–54), erected, so it is said by the French consul, in honour of both Fielding and France!

In Sintra I based myself at Byron's old hotel, Lawrence's, now restored as an English-style country hotel. Sintra has long been a Mecca for the *literati*. Besides

Lord Byron, Robert Southey and the aesthete William Beckford loved the place. Lord Alfred Tennyson, however, did not. Heavily-bearded, he arrived in the heat of August and complained of flies and mosquitoes. Other pilgrims have included Evelyn Waugh and Angus Wilson. Perhaps not surprisingly, Graham Greene used the wildly overgrown Gardens of Montserrate as a rendezvous for MI6 agents and their informants when he worked as head of the Portuguese Desk during World War II.

LARGO PORTO DE MOURA, EVORA (2000)
Watercolour. 20x17in (51x43cm)
Private collection
This unusual fountain provided George Borrow with a pitch to practise his Portuguese on bemused locals while they accepted his free biblical tracts. Evora's great cathedral is in the background.

PORTA DA VILA, MONSARAZ (2000)
Watercolour. 20x15.5in (51x39.5cm)
Private collection
*This medieval hilltop town perches above the frontier
with Spain. Its main street is lined with houses built
in the sixteenth and seventeenth centuries. On their
roofs, storks keep a watchful eye on things.*

THE PALACE OF THE COUNTS, OUREM
(2000)
Watercolour. 22x18in (56x46cm)
Private collection
*This medieval town is dominated by an enormous twin-
towered citadel overlooking the surrounding countryside.*

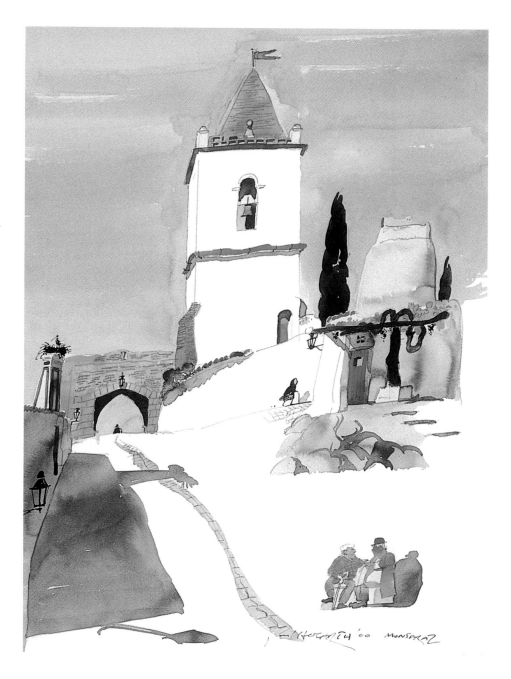

I left Lisbon by the great new suspension bridge across the Tagus, heading south-east over the rolling, sun-baked plains and cork forests of the Alentejo. I had decided to follow the itinerary of the indomitable George Borrow, author of *The Bible in Spain*, which took him to ancient hilltop towns like Evora, Elvas, Monsaraz and Vila Vicosa. There was much to draw in these tourist-free places, especially in Monsaraz, with its whitewashed façades glaring in the sunlight.

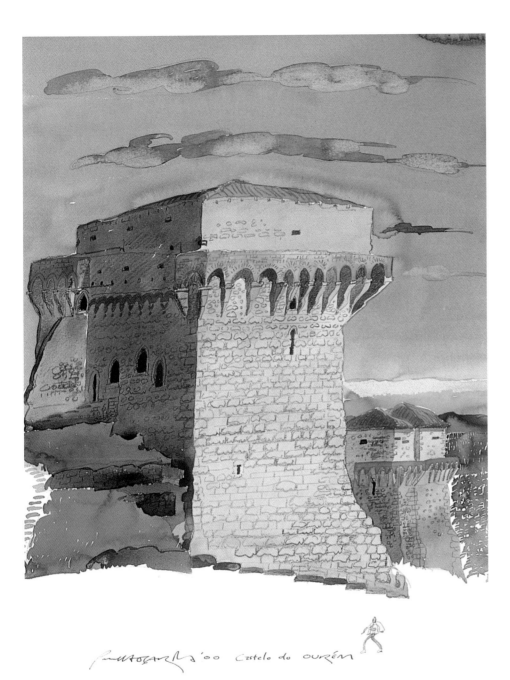

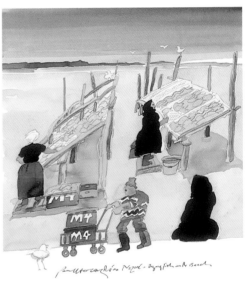

YOUNG FISHERMAN, SAGRES (2000)
Pencil and watercolour. 14x10in (35.5x25.5cm)
Private collection
Trawling in the treacherous Atlantic is mostly done by young men as broad and blunt of beam as the boats they sail.

DRYING FISH, NAZARÉ (2000)
Ink, watercolour and pencil. 20x20in (51x51cm)
Private collection
Nazaré is famous for its traditional fishing community. The men wear woollen bonnets and check shirts while the women dress in black shawls and voluminous long skirts. My picture depicts the surplus catch of herring which is gutted and left to dry in the sun.

By the time I got to the Algarve, my batteries were in dire need of recharging. Thankfully, Portugal's equivalent of the Costas of Spain had little real interest for me pictorially. My last image, the windswept fortress at Sagres, where five hundred years ago Henry the Navigator laid the foundations of Portugal's great maritime expansion, completed my portrait of what I can only describe as the enchanted western edge of Europe.

Postscript

LA GARE, BANDOL (1989)
Watercolour. 16x22in (41.3x57cm)
Private collection, UK.
I find railway stations irresistible subjects in most countries, and French provincial stations especially so. The Impressionists and Post-Impressionists are to blame. Monet, Pissarro, Sisley, and even Cézanne featured the railway in their landscapes.

Sadly, the 'crude sound of onrushing molten lava' was about to overlay our tenancy of Hidcote Manor. During the spring of 2001 the National Trust informed us that they planned to change the visitor route into the gardens through the Manor and that we would have to go. Their plans also sought to restore Johnston's original scheme as well as to improve the maintenance of the gardens. One couldn't quarrel with that. Yet Peter Dennis, the highly experienced Assistant Head Gardener who had worked at Hidcote for fourteen years, was made redundant at the age of 48. And, breaking with the rules of seniority, a newcomer was appointed Head Gardener which eventually led to the resignation of one gardener and the early retirement of another. It seemed to us that the Trust's proud image was tarnished by such insensitivity and that its regional leadership was far more interested in power than people or, indeed, places.

In the style of a true Dickens novel, all was to end well. Peter Dennis and his good wife Cathy urged us to join them in the South Cotswolds where we would surely find an old house in Cirencester, and we did, thus opening yet another chapter of my life.

Meanwhile, I have looked back over the years with few regrets, except to admit that as a slow starter, I must have been difficult if not impossible to live with, as far as my first two wives were concerned. My third broken marriage gave me the greatest pain, as I tried my damnedest to be a good husband. Yet I have much to be thankful for. My only son Toby has remained close to me. More recently, Diana has provided a contentment and tranquility that has all but eliminated the troubled past.

Artists work in isolation, and although this can be depressing, especially if things do not go well, we would not really want it any different. Or would we? Those who are not artists cannot possibly guess the personal cost, not to mention the fear of failure. You need *total* dedication. Work comes first all the time because it alone provides peace of mind. Artistry lies in discovering one's own identity, making a protest against the humdrum reality of one's own *persona*, and in creating an artistic world in order to survive. Without this incentive, I doubt if I could have endured my travels. Even now, in my eighty-fifth year, the magic of making drawings, of sending them to persons unknown and then having them come back in the pages of books and magazines, in addition to the stimulus of exhibiting the originals, has never failed to gratify. And, as my mother once said, 'it beats working'.

Tragically, Paul died of a heart attack in the early hours of December 27, 2001. The magic of making drawings stayed with him to the very end. The night before he died, he laid out his materials, ready to work on a lithograph of Portugal the next morning.

Diana Hogarth

Appendices

Books by Paul Hogarth

James Aldridge (intro.), *Defiant People: Drawings of Greece Today*, London (Lawrence & Wishart), 1953

Looking at China: With the Journal of the Artist, London (Lawrence & Wishart), 1955

Father Trevor Huddlestone (intro.), *People Like Us: Drawings of South Africa and Rhodesia*, London (Dobson), 1958; US: *Sons of Adam*, New York (Nelson), 1960

Ronald Searle (intro.), *Creative Pencil Drawing*, New York (Watson-Guptill), 1964 (paperback edition, 1981); London (Studio-Vista), 1964 (Pitman paperback edition, 1981)

Malcolm Muggeridge (intro.), *London à la Mode*, London (Studio-Vista), 1966; New York (Hill & Wang), 1966

Creative Ink Drawing, New York (Watson-Guptill), 1968, 1971; London (Pitman), 1971

Drawing People, New York (Watson-Guptill), 1972

John C. Ewers (preface), *Artists on Horseback: The Old West in Illustrated Journalism*, New York (Watson-Guptill), 1972

Artist as Reporter, London (Studio-Vista), 1967; , New York (Reinhold), 1967

Sir Hugh Casson (intro.), *Drawing Architecture: A Creative Approach*, New York (Watson-Guptill), 1973 (paperback, 1980); London (Pitman), 1979 (paperback, 1980)

E. Digby Baltzell (intro.), *Paul Hogarth's Walking Tours of Old Philadelphia*, New York (Barre/Crown), 1976

Peter Blake and Sinclair Hitchings (forewords), *Paul Hogarth's Walking Tours of Old Boston*, New York (Dutton), 1978

Arthur Boyd Houghton, London (Gordon Fraser), 1982

Walking Tours of Old Washington and Alexandria, Washington DC (EPM Publications Inc.), 1985

Artist as Reporter, revised and enlarged edition, London (Gordon Fraser), 1986; Paris (Editions Casterman), 1986

Graham Greene (intro. and commentary), *Graham Greene Country*, London (Pavilion-Michael Joseph), 1986; New York (Viking), 1987

Lawrence Durrell (intro. and commentary), *The Mediterranean Shore: Travels in Lawrence Durrell Country*, London (Pavilion-Michael Joseph), 1988; New York (Viking), 1988

Richard Ingrams (intro.), *Drawing on Life: The Autobiography of Paul Hogarth*, London (David & Charles), 1997. Revised and expanded paperback edition, London (Royal Academy of Arts), 2002

Books Illustrated by Paul Hogarth

Charlotte Brontë, *Jane Eyre*, Prague (Mlada Fronta), 1954

Charles Dickens, *Pickwick Papers*, Prague (SNDK), 1956

Jane Walsh, *My Life* (*Vzpominam*), Prague (Mlada Fronta), 1956

Doris Lessing, *Going Home*, London (Michael Joseph), 1957

Peter Knight, *Gold of the Snow Geese*, London (Nelson), 1958

Conan Doyle, *Adventures of Sherlock Holmes*, London (The Folio Society), 1958

H. Rider Haggard, *King Solomon's Mines*, London (Penguin), 1958

Elizabeth Sheppard-Jones, *Welsh Legendary Tales*, London (Nelson), 1959

William Croft Dickinson, *Robert Bruce*, Edinburgh (Nelson), 1960

O. Henry, *Selected Short Stories*, London (The Folio Society), 1960

Olive Schreiner, *The Story of an African Farm*, New York (Limited Editions Club), 1960

C. H. Rolph (ed.), *The Trial of Lady Chatterley*, London (Penguin), 1961

Brendan Behan, *Brendan Behan's Island*, London (Hutchinson), 1962; New York (Bernard Geis), 1962; London (Readers Union), 1963 (paperback: London [Corgi], 1965); Paris (Denoel), 1967 (*Mon Dublin*); Prague (Nakladatelstvo Epocha), no date; London (Hutchinson), 1984; Boston (Little Brown), 1984

Brendan Behan, *Brendan Behan's New York*, London (Hutchinson), 1964; New York (Bernard Geis), 1964 (paperback, London [Corgi], 1966). New paperback edition: London (Hutchinson), 1984. New hardback edition: Boston (Little Brown), 1984

Robert Graves, *Majorca Observed*, London (Cassell), 1965; New York (Doubleday), 1965; Palma de Mallorca (Ediciones Sa Foradada-Olaneta), 1997

Phillip Sherrard and Editors of Time-Life Books, *Byzantium*, New York (Time Incorporated), 1966

James Atwater and Ramon E. Ruiz, *Out from Under*, New York (Doubleday), 1969

Doris Whitman, *The Hand of Apollo*, Chicago (Follett), 1969

Alaric Jacob, *A Russian Journey*, London (Cassell), 1969; New York (Hill & Wang), 1969

The Smithsonian Experience, Washington DC (Smithsonian Institution), 1977

Visiting Our Past, Washington DC (National Geographic Society), 1977

Probation and After-Care Service in a Changing Society, London (Central Office of Information for the Home Office), 1977

James Joyce, *Ulysses*, Philadelphia (Franklin Library), 1978

Siegfried Sassoon, *Memoirs of a Fox-Hunting Man*, New York (Limited Editions Club), 1978

Nigel Buxton, *America*, London (Cassell), 1979

Bernard Shaw, *Three Plays*, Philadelphia (Franklin Library), 1979

Robert Graves, *Poems*, New York (Limited Editions Club), 1980

Siegfried Sassoon, *Memoirs of an Infantry Officer*, New York (Limited Editions Club), 1981

Hugh Johnson, *Hugh Johnson's Wine Companion*, London (Mitchell Beazley), 1983; New York (Simon & Schuster), 1983

Albert and Michael Roux, *New Classic Cuisine*, London (MacDonald), 1983

George and Weedon Grossmith, *The Diary of a Nobody*, London (Hamish Hamilton), 1984

Joseph Conrad, *Nostromo*, London (The Folio Society), 1984

William Trevor, *Nights at the Alexandria*, London (Century-Hutchinson), 1987

Peter Mayle, *A Year in Provence* (illustrated edition), London (Hamish Hamilton), 1992; Paris (NIL Editions), 1995

William Trevor, *The Piano Tuner's Wives*, London (Clarion Publishing), 1995

John Betjeman, *In Praise of Churches*, London (John Murray), 1996

Josephine Tey, *The Franchise Affair*, London (The Folio Society), 2001

Albums and Portfolios

At the Vienna Peace Congress, Paris (Editions Defense de la Paix), 1953

Ignacy Witz (intro.), *Paul Hogarth: Drawings from Poland*, Warsaw (WAG), 1955

Edward Booth-Clibborn (intro.), *Deyá: A Portfolio of Five Lithographs with Poems by Robert Graves*, London (Motif Editions), 1972

Paul Hogarth's American Album: Drawings 1962–65. With the Journal of the Artist, London, Royal College of Art (Lion & Unicorn Press), 1974

Stephen Spender (intro.), *America Observed*, New York (Crown Publishers), 1979

Periodical and Book Contributions by the Artist

'The Artist and Reality', *Ark* (Royal College of Art, London), 3, 1951

'Kathe Kollwitz', *Modern Quarterly* (London), 3, 1952

John Berger, *Paul Hogarth*, Prague (KLHU), 1955

Derek Kartun, *Das Antlitz Europas* (*The Face of Europe*), Dresden (Verlag der Kunst), 1956

'Artist and Newspaper', *Typographica* (London), 7, 1963

Robin Jacques, *Illustrators at Work*, London (Studio), 1963

'In Strydom's South Africa', *New Reasoner*, 2, 1957

'The Artist as Reporter', *Penrose Annual*, 55, 1961

Diana Klemin, *The Illustrated Book*, New York (Clarkson Potter), 1970

'Paul Hogarth on Himself', *Designer*, 11, 1979

Chris Mullen and Philip Beard, *Fortune's America: The Visual Achievements of Fortune Magazine 1930–1965*, exh. cat., University of East Anglia Library, Norwich, 1985

'Paul Hogarth', RDI papers, Royal Society of Arts, 1997

Interviews and Articles on the Artist

J. S. Whittet, 'Paul Hogarth: Social Realist', *Studio*, 2, 1951

John Berger, 'Portrait of the Artist: Paul Hogarth', *Art News & Reviews*, 12 December 1952

Graeme Shankland, 'Polonia Restituta', *Architectural Review*, 688, April 1954

Robert Melville, 'Paul Hogarth', *Architectural Review*, 704, August 1955

Charles Rosner, 'Paul Hogarth: From His China Sketchbook', *Graphis*, 79, 1958

Charles Rosner, 'Paul Hogarth', *Graphis*, 103, 1962

Norman Kent, 'Paul Hogarth: Drawings (of New York)', *American Artist*, April 1963

James Boswell, 'The World of Paul Hogarth', *Graphis*, 148, 1970

James Laver, 'Paul Hogarth', *Financial Times*, March 1970

Edward Booth-Clibborn, 'Art on Mutual Terms: Robert Graves and Paul Hogarth Collaborate', *Daily Telegraph Magazine*, 8 December 1972

Pearson Phillips, 'The Hogarth Art of Leaving Things Out', *Telegraph Sunday Magazine*, 23 March 1980

Colin Amery, 'Paul Hogarth', *Financial Times*, 31 March 1980

Byron Rogers, 'His Studio, The Street', *Telegraph Sunday Magazine*, 27 February 1983

Emma Dent Coad, 'A Roving Eye', *Royal Academy*, 12, 1986

Txema Gonzalez, 'Paul Hogarth en Fornalutx', *Diaro de Mallorca*, 12 July 1986

Rupert Christiansen, 'Graham Greene Country', *Telegraph Sunday Magazine*, 21 September 1986

'Paul Hogarth Talks with John Kemp', *Ritz*, October 1986

Mary Dowey, 'Paul Hogarth', *Cara* (Aer Lingus magazine), July 1992

Tony Warner, 'A Roving Eye', *Artists & Illustrators*, February 1999

Byron Rogers, 'Hogarth's World', *Saga*, April 1999

Simon Tait, 'Never Mind the Backlash' (Tuscany), *Times*, 4 August 1999

Margaret Moore, 'Paul Hogarth', *Hemispheres* (United Airlines magazine), March 2001

Giles MacDonogh, 'Lighter Side of Life', *Financial Times*, 30 June/1 July 2001

Nicolette Jones, 'Journey of a Lifetime', *Times 2*, August 2001

SELECTED ONE-MAN EXHIBITIONS

Drawings of Greece Today, London, Galerie Apollinaire, 1952; Lodz, City Art Gallery, 1953; Warsaw, International Press Club, 1953; Prague, Slovansky Ostrov, 1953

Drawings and Prints of Poland, London, AIA Gallery, 1953; Glasgow, McLellan Gallery, 1954

Buildings and People, London, Architectural Association, 1953

Drawings and Watercolours of the New China, Peking, Central Academy of Fine Arts, 1954

Looking at China, Watercolours and Drawings, London, Leicester Galleries, 1955

Rhodesia 1956, Salisbury Arts Club, 1956

Drawings, Watercolours and Lithographs. 1950–56, Sofia, Committee for Cultural Relations with Foreign Countries, 1956

Drawings and Prints. 1950–56, Bucharest, Institute for Cultural Relations with Foreign Countries, 1956

People Like Us. Drawings of Southern Africa, Prague, Mlada Fronta Gallery, 1958

Muscovy, Johannesburg and Points West, London, The Folio Society, 1958

Drawings by Paul Hogarth, Cambridge, King Street Gallery, 1961

The Irish Drawings of Paul Hogarth, New York, ACA Gallery, 1962

Paul Hogarth's New York, London, USIS Gallery, American Embassy, 1964

Paul Hogarth's New York, New York ACA Gallery, 1965

London à la Mode, London, Zwemmer Gallery, 1966

Five Years of Art for Time Inc: A Selection of Graphic Coverage for Life, Fortune, Sports Illustrated and Time-Life Books, 1962–67, London, Time-Life Building, 1968

Paul Hogarth's England, Battle, Sussex Festival, 1968

The World of Paul Hogarth. Drawings and Watercolours, 1953–69, London, Royal College of Art, March 1970, in association with the Arts Council. Afterwards shown, 1970–71: Edinburgh, College of Art; Manchester, College of Art; and Kendal, Abbott Hall Art Gallery

Drawings from Four Continents, Santa Cruz, University of Southern California, 1971

Watercolour Drawings of Philadelphia, Philadelphia, Gross-McLeaf Gallery, 1976

Drawings by Paul Hogarth: An Exhibition in Honour of His Sixtieth Birthday, Cambridge, Fitzwilliam Museum, 1977

Paul Hogarth's Boston Watercolours, Boston Architectural Center, 1978

Travels Through the Seventies: A Retrospective Exhibition, London, Francis Kyle Gallery, 1981

Working with Writers: An Exhibition of Drawings, Watercolours and Illustrations, London, Langton Gallery, 1981

The West Side of the Wall: Berlin 1981. Watercolour Drawings by Paul Hogarth, ARA, London, Imperial War Museum, 1981

From the Rioja to the Napa Valley. Travels Through the Winelands in Watercolour, London, Francis Kyle Gallery, 1983

The Urbane Traveller: From Bloomsbury to Charleston's Battery, London, Francis Kyle Gallery, 1985

The Other Hogarth: Drawings, Watercolours and Lithographs 1954–84. A Retrospective Exhibition, Kendal, Abbott Hall Gallery, 6 July – 1 September 1985. Afterwards shown, 1985–86: Carlisle, City Art Gallery; Middlesborough, City Art Gallery; Whitehaven, Public Art Gallery

Travels in Graham Greene Country. Recent Watercolours, 1985–86, London, Francis Kyle Gallery, 20 October – 20 November 1986

Paul Hogarth's Shakespeare. Original Watercolour Illustrations for the New Penguin Shakespeare, Stratford-upon-Avon, The Shakespeare Centre, 25 June – 16 July 1988; London, The Theatre Museum, Covent Garden, 11 August – 9 September 1988

Travels in Lawrence Durrell Country. Recent Watercolours, 1987–88, London, Francis Kyle Gallery, 1 November – 1 December 1988

Cold War Reports 1947–67. Drawings, Prints and Watercolours, Norwich, The Norwich Gallery, Norfolk Institute of Art and Design, 30 October – 2 December 1989; Ramsgate, Library Gallery, Kent County Council Libraries and Museums, 10 March – 7 April 1990

Ports of Call: The Mediterranean, Points West and Down Under, London, Francis Kyle Gallery, 3–26 September 1991

Paul Hogarth Paints Peter Mayle's Provence, London, Francis Kyle Gallery, 6–29 October 1992

Ports of Call 1984–94, Edinburgh, Open Eye Gallery, 13–30 August 1994

Travels in D. H. Lawrence Country, London, Francis Kyle Gallery, 27 September – 13 October 1994

Paul Hogarth in Croatia, London, Francis Kyle Gallery, 5 October 1994 – 25 January 1995

Escape to the Sun: In the Footsteps of D. H. Lawrence, Nottingham, University Art Gallery (Djanogly Art Gallery), 13 July – 11 August 1996; Hull University Gallery, 8 October – 8 November 1996; King's Lynn Arts Centre, 19 July – 16 August 1997; London, Francis Kyle Gallery, 4 November – 5 December 1997

Paul Hogarth 'Pristanista' (Ports of Call). Drawings, Watercolours and Lithographs 1963–95, Croatia, British Council/MGC Gradec Zagreb, September – October 1996

80th Birthday Retrospective, London, Royal Academy of Arts, 4–31 October 1997

In Tuscany, Francis Kyle Gallery, London, 3 August – 9 September 1999

In Portugal, Francis Kyle Gallery, London, 31 July – 13 September 2001

SELECTED GROUP EXHIBITIONS

Artists for Peace, London, Chenil Galleries, 1951; London, Royal Hotel, 1952, 1953, 1954, 1955

Looking Forward, London, Whitechapel Art Gallery, 1953, 1954, 1955 and 1957 (in association with the Arts Council)

Looking at People. Paintings, Drawings and Sculpture by Carel Weight, Betty Rea and Paul Hogarth, Manchester, Whitworth Art Gallery, 1956. Enlarged version: *Paintings, Drawings, Lithographs and Sculpture by Carel Weight, Ruskin Spear, Derrick Greaves, Paul Hogarth, Edward Ardizzone, Alistair Grant, Betty Rea and George Fullard*, London, South London Art Gallery, March – April 1957; Moscow, Pushkin Museum of Fine Arts, September 1957

The Contemporary Chinese Scene. Five English Artists in China: Sir Hugh Casson, Stanley Spencer, Richard Carline, Denis Mathews and Paul Hogarth, London, Agnews, 1957

Contemporary English Drawings, American Federation of Arts, 1958–59

Contemporary English Book Illustrations, London, Arts Council, 1958–59

Artists from East Anglia, Cambridge, Arts Council Gallery, 25 November – 23 December 1967

British Drawings Since 1945, Manchester, Whitworth Art Gallery, University of Manchester, March 1979

Lutyens: An Appreciation. Watercolours by Glyn Boyd Harte, Ian Beck, Liz Butler, Sir Hugh Casson, Christopher Corr, Paul Gell, Janet Haigh, Paul Hogarth, Graham Jones, Daniel Martin, Gerald Mynott and Paul Webb, London, Francis Kyle Gallery, 24 November – 20 January 1982

400 Years of Cumbrian Portrait Painting, Kendal, Abbot Hall Art Gallery, 8 July – 5 September 1982

Eye for Industry. Royal Designers for Industry, 1936–86, London, Victoria & Albert Museum, November 1986

Acuarelistas Britanicos Contemporaneos (Contemporary British Watercolourists). Watercolours by Ten Artists of the Francis Kyle Gallery, London: Glyn Boyd Harte, Hugh Buchanan, Helen Gardener, Keith Grant, Paul Hogarth, Harry More Gordon, Donald Morgans, Jake Sutton, Una Woodruff and Poul (sic) Webb, Bilbao, Museo de Bellas Artes, May – June 1987

Cities and Water, London, Francis Kyle Gallery, in association with London Docklands Development Corporation, The Gallery, West India Quay, 4–24 September 1995

A Golden Age of British Illustration: 1950–80, Oxford, Ashmolean Museum, July–September 2002, and UK tour

WORKS IN PUBLIC COLLECTIONS

Asia: Ministry of Culture, Beijing

Canada: Glenbow Museum, Calgary; Riveredge Foundation, Calgary; University of Victoria, Victoria, British Columbia (Special Collections Department)

Continental Europe: RPR Art Museum, Bucharest; City Art Gallery, Ostrava, Czech Republic; National Museum, Warsaw

United Kingdom: Fitzwilliam Museum, Cambridge; Trinity College, Cambridge; City Art Galleries of Bradford, Bury, Manchester, Newcastle-upon-Tyne and Salford; British Museum, London; Chinese Embassy, London; Victoria & Albert Museum, London; Imperial War Museum, London; Whitworth Art Gallery, University of Manchester

United States of America: Boston Public Library; Philadelphia Public Library; Library of Congress, Washington DC

RADIO

'Paul Hogarth', BBC Radio Cumbria, 8 September 1985. Interviewed by Nigel Holmes

'Paul Hogarth', 'Third Ear', BBC Radio 4, 23 February 1990. Interviewed by Frank Whitford. Produced by Judith Bumpus

'Desert Island Discs', BBC Radio 4, 11 January 1998. Interviewed by Sue Lawley

TELEVISION

'The Other Hogarth', Border TV, 8 July 1985. (Covers the Hogarth retrospective at the Abbot Hall Art Gallery, Kendal, 1985)

'Paul Hogarth Visits Graham Greene Country', 'Saturday Review', BBC2, 18 October 1986

'The Picture Teller. Paul Hogarth: Artist as Reporter', Border TV, 3 September 1998. Written and directed by John Mapplebeck

VIDEO

'Spirit of Place: The Art of Paul Hogarth OBE RA', The Royal Academy Collection, APV Films, 2001. Directed by Anthony Parker

Index